White Trash

White Trash

Race and Class in America

Edited by Matt Wray and Annalee Newitz

ROUTLEDGE

NEW YORK AND LONDON

Published in 1997 by

Routledge
29 West 35th Street
New York, NY 10001

Published in Great Britain by

Routledge
11 New Fetter Lane
London EC4P 4EE

The editors gratefully acknowledge *Arizona Quarterly*, vol. 49, no. 3 (Fall 1993) for permission to reprint "Acting Naturally: Cultural Distinction and Critiques of Pure Country," by Barbara Ching.

White trash : race and class in America / edited by Matt Wray and
Annalee Newitz.
 p. cm.
 Includes bibliographical references and index.
 ISBN 0-415-91691-7. -- ISBN 0-415-91692-5 (pbk.)
 1. Whites--United States--Social conditions. 2. Whites--United States--Race identity. 3. Social classes--United States. 4. United States--Social conditions--1980- I. Wray, Matt, 1964- . II. Newitz, Annalee, 1969-
E184.A1.w397 1996
305.5'6--dc20
 96-28339
 CIP

Design and typesetting by MartinWest Media Design

Contents

Acknowledgments

Both of us would like to thank: the production team at *Bad Subjects*, our friends as well as our true intellectual and political community; the Critical Studies in Whiteness group; and the American Studies Working Group, especially Jeffrey Akeley, for supporting the panel on "White Trash in America" that grew into this book. We'd like to thank our editors at Routledge, particularly Eric Zinner and Alan Wieder, who guided us through the early and final stages of this book. Also, thanks to Niko Pfund at New York University Press, who believed in this project from the very beginning. Special thanks to our contributors—their hard work, intellectual creativity, and enthusiasm for this project have made editing this anthology a pleasure for both of us.

Annalee would like to thank: my friends, who have provided constant intellectual engagement and emotional support. So, in no particular order, thanks to my cool pals: Jillian Sandell, Freya Johnson, Jeremy Russell, Matt Wray, Joel Schalit, Joe Lockard, Charlie Bertsch, and my partner in all things, Ed Korthof. Also, profound thanks to my professors and mentors in and outside of academia, who have inspired me with their teaching, their writing, and their good humor: for all this and more, thanks to Kathleen Moran, Richard Hutson, Gerald Vizenor, Carol Clover, Susan Schweik, and Jim Goad. Finally, thanks to Cynthia and Marty Newitz for the financial support which allowed me to spend time working at writing instead of working for money.

Matt would like to thank Jill Gurvey, Sean Heron, Robert Kaplan, Bill Mosca, Faye Robson, and the entire Wobb family—Peter, Mary Ann, Jessie, Luke, Mollie, and Kiri. This book project would not have been possible without their kindness, generosity, and deep friendship. For providing intellectual energy, one could not ask for a better mentor than José David Saldívar—he has guided me in my studies and in this project, offering words of encouragement and support every step of the way. Other mentors include Norma Alarcón, Paul Duguid, Susan Harding, John "Psychobilly" Hartigan, John Hurst, and Katie Stewart—all have shaped my intellectual development in both subtle and profound ways. In addition, I want to thank the members of the study groups who have sustained me in graduate school: the Bay Area Sex and Politics Group—Martha Baer, Allan Bérubé, Linnea Due, Robin Stevens, David Conner, Eric Rofes, and Gayle Rubin—they, more than anyone else, taught me how to think through questions of class, sex, and gender—and the Social and Cultural Studies Diaspora Group—Amalia Aboitiz, Sharon Bernstein, Julio Cammarota, Desiree French, Amy Scharf, and Eber Stello. Learning social theory should always be this stimulating and this much fun. Special thanks to Annalee Newitz—my co-editor and friend.

Introduction

In six months, no one will say "white trash". . . it's the last racist thing you can say and get away with.
— John Waters[1]

ANNALEE NEWITZ
and Matt Wray

Americans love to hate the poor. Lately, it seems there is no group of poor folks they like to hate more than white trash. Despite John Waters' optimistic prediction, "white trash" is not likely to go away. Six months have come and gone and, for better or worse, the term looks like it's here to stay. It's here to stay, we argue, because so many Americans find it useful. In a country so steeped in the myth of classlessness, in a culture where we are often at a loss to explain or understand poverty, the white trash stereotype serves as a useful way of blaming the poor for being poor. The term white trash helps solidify for the middle and upper classes a sense of cultural and intellectual superiority. But, as Waters points out, "white

trash" is not just a classist slur—it's also a racial epithet that marks out certain whites as a breed apart, a dysgenic race unto themselves.

-------------- A SHORT HISTORY OF THE TERM

According to historical dictionaries, the earliest recorded use of the term white trash dates back to the early part of the nineteenth century. Sources attribute the origin of the term to black slaves, who used it as a contemptuous reference to white servants. While there is some reason to doubt these accounts, the emergence of white trash in the context of black slavery and white servitude speaks to the racialized roots of the meaning of the term.[2]

More recently, current stereotypes of white trash can be traced to a series of studies produced around the turn of the century by the U.S. Eugenics Records Office (ERO). From 1880 to 1920, the ERO and affiliated researchers produced fifteen different "Eugenic Family Studies," wherein the researchers sought to demonstrate scientifically that large numbers of rural poor whites were "genetic defectives." Typically, researchers conducted their studies by locating relatives who were either incarcerated or institutionalized and then tracing their genealogies back to a "defective" source (often, but not always, a person of mixed blood). Many of these accounts became popular with the American public, and family clans like "The Jukes" and "The Kallikaks" became widely known, entering the public imagination as poor, dirty, drunken, criminally minded, and sexually perverse people. As Nicole Hahn Rafter puts it, the central image these studies created was "the degenerate hillbilly family, dwelling in filthy shacks, and spawning endless generations of paupers, criminals, and imbeciles."[3]

The eugenic family studies had a very pronounced influence on social policy and medical practice in the early twentieth century. Conservative politicians used them effectively as propaganda in their call to end all forms of welfare and private giving to the poor. The burgeoning medical and psychiatric establishments used them to enlarge their fields, resulting in the involuntary sterilization and forced institutionalization of large numbers of rural poor whites. While the adoption of eugenic theory and practice by the Nazis in the 1930s and 1940s did much to discredit eugenics in the United States, the stereotypes of rural poor whites as incestuous and sexually promiscuous, violent, alcoholic, lazy, and stupid remain with us to this day. Alarmingly, contemporary conservative thinkers like Charles Murray have

resurrected this line of biological determinist thinking, blaming white trash for many of the nation's ills and using pseudoscientific eugenic theory to call for an end to the welfare state. Indeed, the widespread popularity of Herrnstein and Murray's *The Bell Curve* speaks to a renewed interest in U.S. social Darwinism as an explanation for cultural and class differences.[4]

------------------- WHY WHITE TRASH?

Little scholarly work exists which directly addresses the representations and experiences of white trash. Recently, however, a great deal of critical writing has centered around the notion of whiteness[6] and white racial identity. For all the differences among these writers, their shared focus on the meanings of whiteness in U.S. culture has helped constitute an emerging field of whiteness studies. Critics of whiteness understand race to be socially constructed, not a biological category. Racial difference is viewed primarily as a result of socially and historically contingent processes of racialization, constituted through and embodied in a wide variety of discourses and practices rather than as a biologically determined product of genes and DNA. Many works on whiteness call for recognition of the ways in which whiteness serves as a sort of invisible norm, the unraced center of a racialized world. Whiteness is different from blackness (or any other "racial-ness") in that it has long held the privileged place of racial normativity. In the minds of many scholars, writers, and activists working in this area, whiteness is an oppressive ideological construct that promotes and maintains social inequalities, causing great material and psychological harm to both people of color and whites. Thus, shifting the diagnostic gaze of critical race theorization from non-whites to whites will better enable whites to focus on the ways in which white racism brings harm not only to people of color, but to themselves as well. Ultimately, many critics of whiteness share a desire not only to deconstruct whiteness and dismantle white racial privilege, but also to imagine and foster anti-racist forms of white identity.

It has been the invisibility (for whites) of whiteness that has enabled white Americans to stand as unmarked, normative bodies and social selves, the standard against which all others are judged (and found wanting). As such, the invisibility of whiteness is an enabling condition for both white supremacy/privilege and race-based prejudice. Making whiteness visible to whites—exposing the discourses, the social and cultural practices, and the material conditions that cloak whiteness and hide its dominating effects—is

a necessary part of any anti-racist project. The question, of course, is how one can best accomplish this task.[5]

As critical studies of whiteness assume greater importance for cultural theorists and workers, there is a growing need for developing our understanding of how the construction of whiteness varies across lines of class, gender, and sexuality and how these constructions vary according to the politics of place and region. Our anthology is intended as an intervention in this field, offering a critical understanding of how differences within whiteness—differences marked out by categories like white trash—may serve to undo whiteness as racial supremacy, helping to produce multiple, indeterminate, and anti-racist forms of white identity. Because white trash is, for whites, the most visible and clearly marked form of whiteness, it can perhaps help to make all whites self-conscious of themselves as a racial and classed group among other such groups, bringing us one step closer to a world without racial division, or, at the very least, a world where racial difference does not mean racial, symbolic, and economic domination.

Furthermore, white trash, since it is racialized (i.e., different from "black trash" or "Indian trash") and classed (trash is social waste and detritus), allows us to understand how tightly intertwined racial and class identities actually are in the United States. White trash speaks to the hybrid and multiple nature of identities, the ways in which our selves are formed and shaped by often contradictory and conflicting relations of social power. White trash is "good to think with" when it comes to issues of race and class in the U.S. because the term foregrounds whiteness and working-class or underclass poverty, two social attributes that usually stand far apart in the minds of many Americans, especially American social and cultural theorists.

White trash is "useful," then, not just as a naming practice that helps define stereotypes of what is and is not acceptable or normal for whites in the U.S., but also as pedagogical incitement to critical thinking about cultural identities and social power. White trash is a complex cultural category. Analyzing the shifting and often contradictory ways in which this term is used by different groups to mark out and identify certain whites, their practices, and their attitudes can help us to understand recent changes in social relations in an increasingly multicultural nation.

-------------- WHITENESS IN MULTICULTURALISM

A critical discussion of white trash identity, which is both a particularized and hybridized form of "whiteness," can provide one model for reconceiving whiteness itself within the evolving political project of multiculturalism. Minority intellectuals like Toni Morrison and bell hooks, among others, have called for whites to reevaluate themselves and their identities self-consciously, eschewing a vision of whiteness as the "norm" for a more realistic and fair-minded understanding of whiteness as a specific, racially marked group existing in relation to many other such groups. With this collection, we hope to respond meaningfully to their suggestions by exposing one form of whiteness that "sees" whiteness from a distance, as it were. Unlike many white people, white trash have the potential to perform the work of racial self-recognition and self-consciousness that bell hooks has found absent in dominant forms of whiteness;[6] possibly, one might argue, it is more difficult for white trash to Other others. In part because white trash is a classed and racialized identity degraded by dominant whiteness, a white trash position vis-à-vis whiteness might be compared to a "racial minority" position vis-à-vis whiteness. Such a comparison—however problematic it may be— bespeaks certain commonalities between oppressed whites and oppressed racial groups. Hence, white trash is one place multiculturalism might look for a white identity which does not view itself as the norm from which all other races and ethnicities deviate. Perhaps white trash can also provide a corrective to what has been called a "vulgar multiculturalist" assumption[7] that whiteness must always equal terror and racism. It is our wish that "white trash," and White Trash, start to lay the groundwork for a form of white identity that is comfortable in multiculturalism, and with which multiculturalism is comfortable as well.

Looked at from a different perspective, however, white trash explodes the idea of what might be an acceptable, multicultural form of white racial identity. White trash as whiteness under multiculturalism reminds us that, far too often, admission into the multicultural order depends upon one's ability to claim social victimization. This social victimization is often the result of very real barriers that anti-racist whites face in a world shot through with racial hierarchies. But white trash can also be a version of victim chic, where glamorously marginalized white folks attempt to emulate what they perceive to be the privileged authenticity of victimized multicultural groups. TV star Roseanne and the late grunge rocker Kurt Cobain are

two examples of white trash who, having escaped poverty and disempow-
erment through fame, nevertheless used a sense of social victimization as
their own, "white" form of hip authenticity. Faux white authenticity is not
what we aim to foster, nor is it something we consider useful to the strug-
gles against racism and for multicultural coalition-building.

An important goal of this book is to criticize the idea that whiteness can
only be assimilated into a multicultural society once it is associated with vic-
timhood ("trashed"). If we admit that it is sometimes hard for us to imag-
ine a non-victimized form of whiteness joining the ranks of multiculturalism,
we create space for a twofold critique that attacks both conventional
assumptions about whiteness and conventional assumptions about multicul-
turalism. Briefly, such a critique would aim to undermine the notion that
multicultural identities are victim identities. Further, it would question why
we believe that whites (or anyone) need to be victimized before they can
adopt an anti-racist, multiculturalist perspective. Critical multiculturalists like
members of the Chicago Cultural Studies Group[8] have begun to trouble
dominant notions of multicultural identity as essentialized, authentic, and
unrelated to economic class. But a great deal of work still needs to be done
before multiculturalism—and whites' participation in it—is associated with a
progressive, interracial political strategy rather than victim chic and racial
divisiveness. "White trash," ultimately, calls attention to the extent to which
many people still associate all racially marked identities with victimhood,
rather than with the potential for strong community organization and the
power to generate social change. It is time we use our imaginations to
invent alternative forms of white racial identity which, without having
known victimization at the hands of other whites, nevertheless understand
the disasters which constitute all forms of racial domination.

----------------An Identity "Test Object"

Identities are produced, in part, by historically specific social systems.
Just as social groups produce physical objects peculiar to their notions of
ritual, interaction, and ideology, so too do they produce idealized concepts
of identity that seem suitable to a specific way of life. It has often been
the task of critics and theorists to "read" such objects and identities as a
way of gauging how a particular culture works and why. Recently, cultur-
al critics like Raymond Williams, Stuart Hall, and Fredric Jameson have
suggested new ways to understand human society in the dialectical rela-

tionship between material objects and idealized concepts: that is, they each offer a way to use Marx's early formulation of base and superstructure as a means to interpret cultural change as it is occurring. We consider white trash identity to be what Sherry Turkle has called a "test object,"[9] something we can use to think about how identities are being reconceived in the U.S. at the end of the twentieth century.

White trash is an ideal test object of this sort because it refers to actually existing white people living in (often rural) poverty, while at the same time it designates a set of stereotypes and myths related to the social behaviors, intelligence, prejudices, and gender roles of poor whites. That is, white trash is an identity generated in the dialectic of base and superstructure. White trash is, moreover, becoming an increasingly popular and relevant term in mainstream U.S. culture: celebrities of various sorts are calling themselves white trash or, in the case of Jeff Foxworthy, "redneck;" a top-selling cookbook is dedicated to white trash cooking; and, increasingly, the dirty, low-down villains of Hollywood film are trashy whites like the serial killer played by Harry Connick Jr. in *Copycat* (1995). The question thus becomes What function does white trash perform in U.S. culture right now? To which material conditions and ideologies does it refer?

No doubt a renewed interest in white trash is partly a response to mainstream versions of multiculturalism, for reasons we've already described. Beyond that, the currency of the term white trash allows us to chart an example of what Stuart Hall calls "a displacement . . . always implied in the concept of culture."[10] By this Hall means that culture, or the superstructure, often operates as a displacement of material reality, the base. If we consider that the popularity of the term white trash is associated mainly with stereotypical representations of low-class, ill-mannered white folks, we might be tempted to say that such "culture" is a displaced method of talking about real impoverished whites in what Michael Harrington called "the Other America" three decades ago. To a certain degree, this is a valid explanation. As the economy and unemployment figures in the U.S. worsen, more whites are losing jobs to downsizing and corporate restructuring, or taking pay cuts. While it used to be that whites gained job security at the expense of other racial groups, whiteness in itself no longer seems a sure path to a good income.[11] Hence, one might argue, mass-marketed books and TV sitcoms about poor white trash are

one way the dominant culture acknowledges that whites are the victims of poverty these days, too.

But why whites? Why not just more stereotypes of poor people in general if it is true that culture is exhibiting the displaced signs of economic trouble? Jameson has characterized the late twentieth century as a time period in which people are looking for allegories suitable to map their social worlds.[12] We contend that white trash is an allegory of identity which is deployed to describe the existence of class antagonisms in the U.S. Because the U.S. has an extremely impoverished political language of class, certain racial representations are used as allegories for it. An example would be the standard stereotyping of blacks and Latinos as poor, while whites and many Asian-Americans are viewed as middle-class. White trash becomes a term which names what seems unnamable: a race (white) which is used to code "wealth" is coupled with an insult (trash) which means, in this instance, economic waste. Race is therefore used to "explain" class, but class stands out as the principle term here, precisely because whiteness is so rarely connected to poverty in the U.S. imaginary. As a test object, white trash helps to represent a new connection between race and class in the U.S. Yet, importantly, it also delineates a separation between race and class, for with white trash we are made aware that class actually cuts across race lines—stereotypically "well off" whites are also poor. White trash is thus one way people living in the U.S. try to describe class identities, and the material conditions of poverty, which divide racial communities and non-racial communities alike.

------------------------- THE ESSAYS

This anthology brings together the work of scholars, writers, and activists who attempt to understand U.S. culture by reading and writing white trash America. Taken together, the essays articulate and explore the many different meanings of "white trash," showing us how class, race, gender, and sexuality all figure in this category of trash. Each of us is concerned with representations of poor marginal whites in America, and with how those representations are produced, circulated, and consumed. Perhaps most importantly, the authors in this volume are motivated by a need and a desire to respond creatively and critically to the largely negative stereotypes of poor whites which are increasingly apparent in everyday life.

We hope that this collection will be of value to cultural workers and activists organizing around issues of racism and poverty among whites. In a

time when conservative forces are clamoring for the end of affirmative action and moving to defund and dismantle welfare programs, these issues take on a particular urgency. Therefore, we have included articles which critically address these issues in popular and academic cultures. Because debates around whiteness, race, and class are staged in the public realm, and not just the classroom, we made it a priority to include essays which will appeal to readers both in and out of the academy.

With *White Trash*, we seek to reflect the principle ways white trash identity gets constructed, circulated, and subverted in the U.S. today. The title of the first section, "Defining and Defying Stereotypes," refers to the task of explaining how stereotypes of poor whites work, and how such stereotypes work to define and constrain people. The authors pay special attention to local politics of place that often inform these stereotypes. What emerges is a sort of rough geography of trash. Where you live, all too frequently, does determine who your neighbors perceive you to be within the U.S. "meritocracy." Allan Bérubé's "Sunset Trailer Park" opens this section by providing a window into 1950s New Jersey trailer park life. Bérubé skillfully weaves together stories and memories of his class and sexuality, reflecting on how much history has changed the meaning of both for him. In "Name Calling," anthropologist John Hartigan, Jr.'s fieldwork in three different white neighborhoods in post-industrial Detroit gives ample ethnographic evidence that white trash is primarily a way of localizing and specifying whiteness; it is a form of naming which marks out and upholds social decorum and class distinctions among whites and people of color.

Timothy Lockley offers an historical exploration of poor white identities in his essay on the relations between African Americans and non-slaveholding whites in early-nineteenth-century Georgia. His study of legal documents and court cases illuminates the significance of interracial alliances forged by criminals and how such "partners in crime" may change our historical understanding of Southern race relations. The section closes with "Bloody Footprints," Roxanne A. Dunbar's social autohistory of growing up poor in Oklahoma. Dunbar's reflections show how economic shifts and migrations are linked to her personal journey across class lines. She meditates on the consequences of marrying "up" and moving west, from rural poverty to urban professional success.

The next section, "White Trash Pictures," brings together work concerned with the representation, self-presentation, and performance of white

trash identities in the visual media. Constance Penley begins with "Crackers and Whackers," her exploration of pornography as a form of popular culture, and as a "trash" protest against class privilege and bourgeois social values. Tracing the connections between tabloid media, *Beavis and Butthead*, and pornographic movies like *John Wayne Bobbitt Uncut*, she argues that "low-class" humor associated with dirty jokes often achieves the status of social and moral protest. In "White Savagery and Humiliation," Annalee Newitz looks at how media stereotypes of violent, self-destructive white trash help to distance middle- and upper-class whites from their guilt and rage towards racial minorities. Focusing on cult films, television, and academic criticism, she explores how images of white-on-white class warfare and white self-loathing set up a form of white racial self-criticism which, in the end, only serves to strengthen class and racial conflicts. Laura Kipnis follows with "White Trash Girl," a consideration of white trash as a performative identity; she interviews Jennifer Reeder, a performance artist who calls herself White Trash Girl. The interview speaks to ways class and gender get written on and lived through the body. Wrapping up this section is Mike Hill's meticulous analysis of white racial "marking" within the context of discourse theory. Beginning with the question "Can Whiteness Speak?", Hill draws our attention to the ways whiteness gets split by class and ideological conflicts. These splits are in turn "mended" through the formation and maintenance of a normative sexuality.

The final section, "Producing and Consuming Poor Whites," features essays that describe how the process of commodification turns actually existing impoverished people into products which are bought and sold as "culture." The authors each take up the question of how such commodification provokes resistance as well as complicity in capitalist social relations. With "Trash-o-nomics," New York journalist and radio commentator Doug Henwood responds to the conventional liberal leftist wisdom that says poverty is primarily a social problem affecting people of color. Tracking poverty rates across race and gender lines, and using statistical evidence from U.S. Census reports, Henwood concludes ironically, "The poor are a wonderfully diverse assemblage . . . most officially poor people are white." Matt Wray explores the role of charismatic and end time religion in the making of poor white identities. Writing from an auto-ethnographic perspective, Wray explains how religious identity and economic crisis coincide to produce apocalyptic visions of the future. Yet these same apocalyptic

visions, he argues, can provide the basis for building alternative communities which, through the sharing of resources and labor, resist the uncertainties of crisis-prone capitalist economies.

Jillian Sandell, in her reading of Dorothy Allison's life and stories, explores how Allison's hybrid mix of classed, racial, and sexual selves has given her a greater understanding of how poverty shapes and constricts our lives. Allison's life history as "queer white trash" from South Carolina, Sandell argues, has enabled her to elude objectification as a specific stereotype in the cultural imaginary, hence freeing her to explore the fluidity of self and memory. Country music is the focus of Barbara Ching's essay on cultural distinction. Taking a critical look at how the middle class holds country music and its listeners to standards of "authenticity," Ching explains that the idea of "authenticity" generates taste distinctions which are used to naturalize class division and hierarchy. Another, quite different white trash icon is explored in Gael Sweeney's "The King of White Trash Culture." Sweeney's article is a theoretical romp from the shag-covered Jungle Room of Graceland to the halls of academe. She explores the "aesthetics of excess" which typify the kitschy culture of poor and working-class whites by focusing on the making and reception of Elvisiana and the Elvis Cult. As is fitting in a book devoted to poor whites, The King has the last word.

------------------------- NOTES

1. Quoted in Tad Friend, "White Hot Trash," *New York Magazine*, August 22, 1994.

2. See Mitford Mathews, *A Dictionary of Americanisms on Historical Principles* (Chicago: University of Chicago Press, 1951), entries under "white trash" and "poor white trash." Mathews dates the earliest usage from 1833.

3. Nicole H. Rafter ed., *White Trash: The Eugenic Family Studies* 1877–1919 (Boston: Northeastern University Press, 1988).

4. Richard Herrnstein and Charles Murray, *The Bell Curve: Intelligence and Class Structure in American Life* (New York: Free Press, 1994). An interviewer summarized Murray's position: "[In the past], people were poor because of bad luck or social barriers. 'Now,' [Murray] says, 'what is holding them back is that they're not bright enough to be a physician.' In Murray's words, the white kids who drop out of school are the low IQ, low income 'White trash.'" Quoted in Holly Sklar, *Chaos or Community: Seeking Solutions, Not Scapegoats for Bad Economics* (Boston: South End Press, 1995). See Murray's full remarks in Jason DeParle, "Daring Research or 'Social Science Pornography'?" *New York Times Magazine*, October 9, 1994.

5. In one example of criticism aimed at dismantling white privilege, Noel Ignatiev and John Garvey,

editors of the antiracist journal *Race Traitor*, refer to this task as the "abolition of whiteness." In their analysis, "[t]he key to solving the social problems of our age is to abolish the white race, which remains no more and no less than abolishing the privileges of the white skin . . . The existence of the white race depends on the willingness of those assigned to it to place their racial interests above class, gender or any other interests they hold. The defection of enough of its members to make it unreliable as a predictor of behavior will lead to its collapse." See "What We Believe," *Race Traitor*, no. 5 (1996).

6. See bell hooks, "Representations of Whiteness in the Black Imagination," *Black Looks: Race and Representation* (Boston: South End Press, 1992), 167.

7. "Vulgar multiculturalism" is a term coined by the Bad Subjects Collective on our Internet mailing list. It refers to essentialist multiculturalisms which reject the possibility that white people can ever cease to be racist, and which simultaneously valorize as "authentic" and "emancipatory" all forms of marginal identity, no matter how problematic or internally oppressive (i.e., patriarchal, sexist, homophobic, etc.) certain marginal cultures might be. The Bad Subjects Collective uses the term "vulgar multiculturalism" in opposition to "critical multiculturalism," which recognizes social construction and historical contingency as major aspects of minority and dominant identity formation.

8. See The Chicago Cultural Studies Group's "Critical Multiculturalism," in David Theo Goldberg, ed., *Multiculturalism: A Critical Reader* (Cambridge: Blackwell, 1994).

9. In *Life on the Screen: Identity in the Age of the Internet* (New York: Simon and Schuster, 1995), Sherry Turkle describes computers as "test objects" that can tell us how people interpret their identities and social systems both at the level of material reality and in the realm of ideas. Like the computer, white trash identity as we know it is a contemporary invention with both material and imaginative aspects. Clearly, we don't mean so much to compare white trash to computers here, but rather to examine how each functions as a material object/idea in the U.S..

10. Stuart Hall, "Cultural Studies and its Theoretical Legacies," in Lawrence Grossberg, Cary Nelson, and Paula Treichler, eds., *Cultural Studies* (New York: Routledge, 1992), 284.

11. For a suggestive analysis of how white racism helped shape labor politics, see David Roediger, *The Wages of Whiteness* (New York: Verso, 1991) and Noel Ignatiev, *How the Irish Became White* (New York: Routledge, 1995).

12. See Fredric Jameson, *The Geopolitical Aesthetic* (Bloomington and Indianapolis: University of Indiana Press, 1992).

PART I
DEFINING AND DEFYING STEREOTYPES

Sunset Trailer Park

Allan Bérubé with
Florence Bérubé

"I cried," my mother tells me, "when we first drove into that trailer park and I saw where we were going to live." Recently, in long-distance phone calls, my mother—Florence Bérubé—and I have been digging up memories, piecing together our own personal and family histories. Trailer parks come up a lot.

During the year when I was born—1946—the booming, postwar "trailer coach" industry actively promoted house trailers in magazine ads like this one from the *Saturday Evening Post*:

TRAILER COACHES RELIEVE SMALL-HOME SHORTAGE THROUGHOUT THE HOUSE-HUNGRY NATION

Reports from towns and cities all over the United States show that modern, comfortable trailer coaches—economical and efficient beyond even

the dreams of a few years ago—are playing a major part in easing the need for small-family dwellings. Returning veterans (as students or workers), newlyweds, and all others who are not ready for—or can't locate—permanent housing, find in the modern trailer coach a completely furnished (and amazingly comfortable) home that offers the privacy and efficiency of an apartment coupled with the mobility of an automobile.

When I was seven, my parents, with two young children in tow, moved us all into a house trailer, hoping to find the comfort, privacy, and efficiency that the "trailer coach" industry had promised. But real life, as we soon discovered, did not imitate the worlds we learned to desire from magazine ads.

Dad discovered "Sunset Trailer Park" on his own and rented a space for us there before Mom was able to see it. On our moving day in January 1954, we all climbed into our '48 Chevy and followed a rented truck as it slowly pulled our house trailer from the "Sunnyside Trailer Park" in Shelton, Connecticut, where we lived for a few months, into New York State and across Manhattan, over the George Washington Bridge into New Jersey, through the garbage incinerator landscape and stinky air of Secaucus—not a good sign—then finally into the Sunset Trailer Park in Bayonne.

A blue-collar town surrounded by Jersey City, Elizabeth and Staten Island, Bayonne was known for its oil refineries, tanker piers and Navy yard. It was a small, stable, predominantly Catholic city of working-class and military families, mostly white with a small population of African Americans. When we moved there, Bayonne was already the butt of jokes about "armpits" of the industrial Northeast. Even the characters on the TV sitcom *The Honeymooners*, living in their blue-collar world in Brooklyn, could get an easy laugh by referring to Bayonne. "Ralph," Alice Kramden says to her husband in one episode, "you losing a pound is like Bayonne losing a mosquito." My mom was from Brooklyn, too. A Bayonne trailer park was not where she wanted to live or raise her children.

Along with so many other white working-class families living in fifties trailer parks, my parents believed that they were just passing through. They were headed toward a *Better Homes and Gardens* suburban world that would be theirs if they worked hard enough. We moved to Bayonne to be closer to Manhattan, where Dad was employed as a cameraman for NBC. He and his fellow TV crewmen enjoyed the security of unionized, wage-labor jobs in this newly expanding media industry. But they didn't get the income that people imagined went with the status of TV jobs. Dad had to work overtime nights and on weekends to make ends meet. His dream was

to own his own house and start his own business, then put us kids through school so we would be better off and not have to struggle so much to get by. My parents were using the cheapness of trailer park life as a stepping-stone toward making that dream real.

As Dad's job and commuting took over his life, the trailer park took over ours. We lived in our trailer from the summer of 1953 through December 1957, most of my grade school years. And so I grew up a trailer park kid.

Sunset Trailer Park seemed to be on the edge of everything. Bayonne itself is a kind of land's end. It's a peninsula that ends at New York Bay, Kill Van Kull and Newark Bay—polluted bodies of water that all drain into the Atlantic Ocean. You reached our trailer park by going west to the very end of 24th Street, then past the last house into a driveway where the trailer lots began. If you followed the driveway to its end, you'd stop right at the waterfront. The last trailer lots were built on top of a seawall secured by pilings. Standing there and looking out over Newark Bay, you'd see tugboats hauling barges over the oil-slicked water, oil tankers and freighters carrying their cargoes, and planes (no jets yet) flying in and out of Newark Airport. On hot summer nights the steady din of planes, boats, trucks and freight trains filled the air. So did the fumes they exhaled, which, when mixed with the incinerator smoke and oil refinery gasses, formed a foul atmospheric concoction that became world-famous for its unforgettable stench.

The ground at the seawall could barely be called solid earth. The owner of the trailer park occasionally bought an old barge, then hired a tugboat to haul it right up to the park's outer edge, sank it with dump-truck loads of landfill, paved it over with asphalt, painted white lines on it and voila!—several new trailer lots were available for rent. Sometimes the ground beneath these new lots would sink, so the trailers would have to be moved away until the sinkholes were filled in. Trailers parked on lots built over rotten barges along the waterfront—this was life on a geographic edge.

It was life on a social edge, too—a borderland where respectable and "trashy" got confused.

⊕ ⊕ ⊕

"Did you ever experience other people looking down on us because we lived in a trailer park?" I ask my mom.

"Never," she tells me.

"But who were your friends?"

"They all lived in the trailer park."

"What about the neighbors who lived in houses up the street?"

"Oh, they didn't like us at all," she says. "They thought people who lived in trailers were all low-life and trash. They didn't really associate with us."

In the 1950s, trailer parks were crossroads where the paths of poor, working-class and lower-middle-class white migrants intersected as we temporarily occupied the same racially segregated space—a kind of residential parking lot—on our way somewhere else. Class tensions—often hidden—structured our daily lives as we tried to position ourselves as far as we could from the bottom. White working-class families who owned or lived in houses could raise their own class standing within whiteness by showing how they were better off than the white residents of trailer parks. We often responded to them by displaying our own respectability and distancing ourselves from those trailer park residents who were more "lower-class" than we were. If we failed and fell to the bottom, we were in danger of also losing, in the eyes of other white people, our own claims to the racial privileges that came with being accepted as white Americans.

In our attempt to scramble "up" into the middle class, we had at our disposal two conflicting stereotypes of trailer park life that in the 1950s circulated through popular culture. The respectable stereotype portrayed residents of house trailers as white World War II veterans, many of them attending college on GI loans, who lived with their young families near campuses during the postwar housing shortage. In the following decades, this image expanded to include the predominantly white retirement communities located in Florida and the Southwest. In these places, trailers were renamed "mobile" or "manufactured" homes. When parked together, they formed private worlds where white newlyweds, nuclear families and retirees lived in clean, safe, managed communities. You can catch a glimpse of this world in the 1954 Hollywood film *The Long, Long Trailer*, in which Lucille Ball and Desi Arnaz spend their slapstick honeymoon hauling a house trailer cross country and end up in a respectable trailer park. (The fact that Arnaz is Cuban-American doesn't seriously disrupt the whiteness of their Technicolor world—he's assimilated as a generically "Spanish" entertainer,

an ethnic individual who has no connection with his Cuban American family or community).

A conflicting stereotype portrayed trailer parks as trashy slums for white transients—single men drifting from job to job, mothers on welfare, children with no adult supervision. Their inhabitants supposedly engaged in prostitution and extramarital sex, drank a lot, used drugs, and were the perpetrators or victims of domestic violence. With this image in mind, cities and suburbs passed zoning laws restricting trailer parks to the "other side of the tracks" or banned them altogether. In the fifties, you could see this "white trash" image in B-movies and on the covers of pulp magazines and paperback books. The front cover of one "trash" paperback, "Trailer Park Woman," proclaims that it's "A bold, savage novel of life and love in the trailer camps on the edge of town." The back cover, subtitled "Temptation Wheels," explains why trailers are the theme of this book.

> Today nearly one couple in ten lives in a mobile home—one of those trailers you see bunched up in cozy camps near every sizable town. Some critics argue that in such surroundings love tends to become casual. Feverish affairs take place virtually right out in the open. Social codes take strange and shocking twists . . . 'Trailer Tramp' was what they called Ann Mitchell—for she symbolized the twisted morality of the trailer camps . . . this book shocks not by its portrayal of her degradation—rather, by boldly bringing to light the conditions typical of trailer life.

This image has been kept alive as parody in John Waters' independent films, as reality in Hollywood films such as *Lethal Weapon*, *The Client* and *My Own Private Idaho*, and as retro-fifties camp in contemporary postcards, posters, t-shirts and refrigerator magnets.

I imagine that some fifties trailer parks did fit this trashy stereotype. But Sunset Trailer Park in Bayonne was respectable—at least to those of us who lived there. Within that respectability, however, we had our own social hierarchy. Even today, trying to position ourselves into it is difficult. "You can't say we were rich," as my mom tries to explain, "but you can't say we were at the bottom, either." What confused things even more were the many standards by which our ranking could be measured—trailer size and model, lot size and location, how you kept up your yard, type of car, jobs and occupations, income, number of kids, whether mothers worked as homemakers or outside the home for wages. Establishing where you were on the trailer park's social ladder depended on where you were standing and which direction you were looking at any given time.

To some outsiders, our trailer park did seem low-class. Our neighbors up the street looked down on us because they lived in two- or three-family houses with yards in front and back. Our trailers were small, as were our lots, some right on the stinky bay. The people in houses were stable; we were transients. And they used to complain that we didn't pay property taxes on our trailers, but still sent our kids to their public schools.

On our side, we identified as "homeowners" too (if you ignored the fact that we rented our lots) while some people up the street were renters. We did pay taxes, if only through our rent checks. And we shared with them our assumed privileges of whiteness—theirs mostly Italian, Irish, and Polish Catholic, ours a more varied mix that included Protestants. The trailer park owner didn't rent to Black families, so we were granted the additional status of having our whiteness protected on his private property.

The owner did rent to one Chinese American family, the Wongs (not their real name), who ran a Chinese restaurant. Like Desi Arnaz, the presence of only one Chinese family didn't seriously disrupt the dominant whiteness of our trailer park. They became our close friends as we discovered that we were almost parallel families—both had the same number of children and Mrs. Wong and my mother shared the same first name. But there were significant differences. Mom tells me that the Wongs had no trouble as Asian-Americans in the trailer park, only when they went out to buy a house. "You don't realize how discriminatory they are in this area," Mrs. Wong told my mother one day over tea. "The real estate agents find a place for us, but the sellers back out when they see who we are." Our trailer park may have been one of the few places that accepted them in Bayonne. They fit in with us because they, unlike a poorer family might have been, were considered "respectable." With their large trailer and their own small business, they represented to my father the success he himself hoped to achieve someday.

While outsiders looked down on us as trailer park transients, we had our own internal social divisions. As residents we did share the same laundry room, recreation hall, address and sandbox. But the owner segregated us into two sections of his property: Left courtyard for families with children, right courtyard for adults, mostly newlyweds or retired couples. In the middle were a few extra spaces where tourists parked their vacation trailers overnight. Kids were not allowed to play in the adult section. It had bigger lots and was surrounded by a fence, so it had an exclusive air about it.

The family section was wilder, noisier and more crowded because every trailer had kids. It was hard to keep track of us, especially during summer vacation. Without having to draw on those who lived in the houses, we organized large group games—like Red Rover and bicycle circus shows—on the common asphalt driveway. Our activities even lured some kids away from the houses into the trailer park, tempting them to defy their parents' disdain for us.

We defended ourselves from outsiders' stereotypes of us as low-life and weird by increasing our own investment in respectability. Trashy white people lived somewhere else—probably in other trailer parks. We could criticize and look down on them, yet without them we would have been the white people on the bottom. "Respectable" meant identifying not with them, but with people just like us or better than us, especially families who owned real houses in the suburbs.

My mom still portrays our lives in Bayonne as solidly middle-class. I'm intrigued by how she constructed that identity out of a trailer park enclave confined to the polluted waterfront area of an industrial blue-collar town.

"Who were your friends?" I ask her.

"We chose them from the people we felt the most comfortable with," she explains. These were couples in which the woman was usually a home-maker and the man was an accountant, serviceman or salesman—all lower-middle-class, if categorized only by occupation. As friends, these couples hung out together in the recreation hall for birthday, Christmas and Halloween costume parties. The women visited each other every day, shared the pies and cakes they baked, went shopping together and helped each other with housework and baby-sitting.

"There was one woman up the street," my mom adds, "who we were friends with. She associated with us even though she lived in a house."

"Who didn't you feel comfortable with?" I ask her.

"Couples who did a lot of drinking. People who had messy trailers and didn't keep up their yards. People who let their babies run around barefoot in dirty diapers. But there were very few people like that in our trailer park." They were also the boys who swam in the polluted brine of Newark Bay, and the people who trapped crabs in the same waters and actually ate their catch.

When we first entered the social world of Sunset Trailer Park, our family found ways to fit in and even "move up" a little. Physical location was important. Our trailer was first parked in a middle lot. We then moved up

by renting the "top space"—as it was called—when it became available. It was closest to the houses and furthest from the bay. Behind it was a vacant housing lot, which belonged to the trailer park owner and separated his park from the houses on the street—a kind of "no-man's-land." The owner gave us permission to take over a piece of this garbage dump and turn it into a garden. My dad fenced it in and my mom planted grass and flowers which we kids weeded. Every year the owner gave out prizes—usually a savings bond—for the best-looking "yards." We won the prize several times.

Yet the privilege of having this extra yard had limits. With other trailer park kids we'd stage plays and performances there for our parents—it was our makeshift, outdoor summer stock theater. But we made so much noise that we drove the woman in the house that overlooked it crazy. At first she just yelled "Shut up!" at us from her second-story window. Then she went directly to the owner, who prohibited the loudest, most unruly kids from playing with us. After a while we learned to keep our own voices down and stopped our shows so we, too, wouldn't be banned from playing in our own yard.

My mom made a little extra money—$25 a month—and gained a bit more social status by working for the owner as the manager of his trailer park. She collected rent checks from each tenant, handled complaints and made change for the milk machine, washers and dryers. "No one ever had trouble paying their rent," Mom tells me, adding more evidence to prove the respectability of our trailer park's residents.

Our family also gained some prestige because my dad "worked in TV" as a pioneer in this exciting new field. Once in a while he got tickets for our neighbors to appear as contestants on the TV game show *Truth or Consequences*, a sadistic spectacle that forced couples to perform humiliating stunts if they couldn't give correct answers to trick questions. Our neighbors joined other trailer park contestants who in the fifties appeared on game shows like *Beat the Clock*, *Name That Tune*, *You Bet Your Life* and especially *Queen for a Day*. The whole trailer park was glued to our TV set on nights when our neighbors were on. We rooted for them to win as they became celebrities right before our eyes. Even the put-down "Bayonne jokes" we heard from Groucho Marx, Ralph Kramden and other TV comics acknowledged that our town and its residents had at least some status on the nation's cultural map.

My dad wasn't the only trailer park resident who gained a little prestige from celebrity. There was a musician who played the clarinet in the NBC

orchestra. There was a circus performer who claimed he was the only man in the world who could juggle nine balls at once. He put on a special show for us kids in the recreation hall to prove it. There was a former swimming champion who lived in a trailer parked near the water. Although he was recovering from pneumonia, he jumped into Newark Bay to rescue little Jimmy who'd fallen off the seawall and was drowning. He was our hero. And there was an elderly couple who shared a tiny Airstream with 24 Chihuahua dogs—the kind pictured in comic books as small enough to fit in a teacup. This couple probably broke the world's record for the largest number of dogs ever to live in a house trailer. You could hear their dogs yip hysterically whenever you walked by.

Trailer park Chihuahua dog collectors, game show contestants, circus performers—lowlife and weird, perhaps, to outsiders, but to us, these were our heroes and celebrities. What's more, people from all over the United States ended up in our trailer park. "They were well-traveled and wise," my mom explains with pride, "and they shared with us the great wealth of their experience." This may be why they had more tolerance for differences (within our whiteness, at least) than was usual in many white communities during the fifties—more tolerant, my mom adds, than the less-traveled people who lived in the houses.

⊕ ⊕ ⊕

Dangers seemed to lurk everywhere. To protect us, my parents made strict rules we kids had to obey. They prohibited us from playing in the sandbox because stray cats used it as their litter box. We weren't allowed to walk on the seawall or swim in Newark Bay, in which little Jimmy had nearly drowned, and whose water, if we swallowed it, would surely have poisoned us. And they never let us go on our own into anyone else's trailer—or house—or bring any kids into ours.

"Why did you make that rule?" I ask my mom after wondering about it for years.

"Because there were lots of working couples," she explains, "who had to leave their kids home alone with no adult supervision. We didn't want you to get into trouble by yourselves."

But I did break this rule. Once the Chihuahua-dog couple invited me inside their Airstream to read the Sunday comics with them. I went in. But I

was so terrified by the non-stop, high-pitched barking, the powerful stench and my own act of disobedience that I couldn't wait to get back outside.

At other times I visited schoolmates in their homes after school. One was a Polish kid who lived two blocks away in a slightly nicer part of town. His house made me think his family was rich. They had an upstairs with bedrooms, a separate kitchen and dining room, a living room with regular furniture, doors between rooms, a basement and a garage. I fantasized about moving into his house and sharing a bedroom with him as my brother. When I visited an Italian boy who lived in a downtown apartment, I learned that not everyone who lived in buildings was better off than we were. Their smelly entry hall had paint peeling from the cracked walls and a broken-down stairway. I was afraid to go upstairs. I visited another schoolmate who lived with his grandfather and a dog inside the Dickensian cabin of a deserted barge on the docks at Newark Bay. They heated their cabin with wood scavenged from the piers and vacant lots nearby. I felt sorry for him because he seemed like the orphans we prayed for in church who had something to do with "alms for the poor." I visited a boy who lived in another trailer park. He was an only child who was home alone when his parents were at work. I envied his privacy and dreamed about us being brothers, too. At times, I'd even go down to the seawall to watch the bad boys swim in Newark Bay.

Alone like that with other white boys in their homes or by the water, I sometimes felt erotic charges for them—affectional desires that moved up, down or across our class positions in the form of envy, pity and brotherliness. Only years later did I learn to identify and group all these feelings together as a generic "homosexual" attraction. Yet that "same-sex" reading of those erotic sparks erased how they each had been differentiated by class and unified by race during my disobedient excursions around Bayonne. Even today, a predominantly white gay identity politics still regards race and class as non-gay issues, refusing to see how they have fundamentally structured male homoerotic attractions and socially organized our homosexual relationships, particularly when they're same-class and white-on-white.

I wasn't the only person around who was a little queer.

"Did I ever tell you about the lesbian couple who lived in the trailer park?" my mom asks me.

"No, Ma, you never did."

I'm stunned that after all these years, she's just now telling her gay historian son about this fabulous piece of fifties trailer-park dyke history coming right out of the pages of her own life!

"They were the nicest people," she goes on. "Grade school teachers. One taught phys ed, the other taught English. Military veterans. They lived in a trailer bigger than ours over in the adult section. I forget their names, but one dressed like a woman and the other dressed like a man. The woman who dressed like a woman had a green thumb. She kept her trailer filled with house plants and took good care of them. She did all the housekeeping—the inside work. The woman who dressed like a man did the outside work—waxed the trailer, repaired their truck. In their yard she built a beautiful patio with a rose arbor and a barbecue—did all the cement work herself. They threw barbecue parties there in the summer—with finger food, hamburgers and wine. They were lots of fun."

I'm as intrigued by Mom's description of a "woman dressed like a woman" as I am by her description of a "woman dressed like a man." The logic of seeing the butch partner acting like the man led to Mom seeing the femme partner acting like the woman, rather than just being a woman. Yet this female couple created a domestic relationship that was familiar enough for my parents and their friends to accept as normal. And like the Wongs, their class respectability—in the form of good jobs, large trailer and well-kept yard—seemed to make up for differences that in other neighborhoods might have set them apart.

"Did you know then that they were lesbians?"

"Oh yeah," Mom says. "We never talked about it or used that word, but we all knew. They were a couple. Everybody liked them. Nicest people you'd ever want to meet!" The protection of not having their relationship named as deviant allowed these women to fit into our trailer park world.

It was another woman from the adult section who helped nurture my own incipient queerness. On one of the rare nights when my parents splurged by going to the movies, this woman baby-sat for us. An expert seamstress, she spent her time with us sewing outfits for my sister's Ginny Doll. I was jealous. "Boys can have dolls, too," she reassured me. Sitting on our sofa with me right next to her eagerly watching her every move, she pieced together a stuffed boy-doll for me (this was years before Ken or GI Joe appeared), then sewed him little pants and a shirt. When my parents saw this present, they let me keep him. For a while I cherished this peculiar toy—a hand-made gift that acknowledged my own uniqueness. But before long, "unique" evolved into "weird" and even "queer." My boy-doll embarrassed me so much that I threw him away.

My parents' protective rules *were* based on an important truth. Whenever I went into other peoples' houses and trailers, or when they came into ours, I *did* find myself getting into trouble—queer trouble, too.

⊕ ⊕ ⊕

"Let's Look Inside . . .

No one who has not actually BEEN INSIDE a modern trailer coach can fully appreciate the roominess, convenience and downright comfort to be found there. (A 22-foot trailer is longer than most BIG living-rooms!) Study the illustrations on this page. Imagine yourself seated on that soft couch . . . using that efficient kitchen . . . hanging your clothes in spacious closets . . . going to sleep on that well-sprung bed. Here is good living, coupled with freedom from unnecessary obligation and expense— in A HOME OF YOUR OWN!"

—1946 *Trailer Coach* magazine ad

House trailers were a lot like cars—metal shells built on wheels, manufactured on assembly lines, that varied by price, style, width and length. As companies produced new models, old ones grew outdated and depreciated in value. If you lived in one trailer for a long time, you lost status, like driving around in an old, run-down car while this year's newer, shinier, spiffier models passed you by. The older your trailer got, the more important it was that you did what you could to "keep it up."

Living in our house trailer was like living in a big car. Ours was an 8–by– 36 foot Pacemaker that had been manufactured around 1950. Post-stream-line in style but pre-dating the fifties "popu-luxe" fins, it was enamel-paint-ed in a two-tone design—maroon body and top with a cream band around the middle at window level. In the summer it felt like an oven as the sun beat down on our metal roof, until we bought an air conditioner to save us from baking to a crisp. In the fall we were terrified of hurricanes and torna-does. Like schoolyard bullies, these windstorms have an uncanny ability to seek out all vulnerable trailers in their path so they can turn them over, tear them apart or crush them under fallen trees.

Inside we had three "rooms." At the front was a living-dining-kitchen area; in the middle the bedroom; and at the back the kids' room with two bunk beds and a tiny bathroom. There were no real doors separating these areas, because each was a passageway to the next. We had a small TV set in the front room. The rest of our "furniture" was built-in: beds, dressers,

couch, cabinets, lighting. Free-standing furniture was a status symbol we didn't enjoy—except for our Formica dinette set and a plastic-covered rocking chair. Stored in the closets, under the beds and behind things were folding items—a spare chair, a card table—that we brought out whenever company came. Everything was tiny, compact, multi-purpose and convertible. Even today, the lavatories at the rear of jet planes give me an eerie sense of déjà-vu.

We quickly adjusted to the restrictions of our cramped living space. Before my mom married, she had made extra money as a piano teacher, so she wanted to teach me piano, too. But no piano would ever fit in our trailer. So she rented a small accordion—we pretended it was a little piano—and sent me to the Police Athletic League up the street to take lessons from a retired policeman. On rainy Saturdays our parents made us go to the all-day kiddie matinee at the local movie theater, which we loved. This was to get us out of the trailer so we wouldn't drive Mom crazy in that small space. One Christmas my parents gave me a plastic toy house trailer as a present. The roof came off and inside the layout was identical to our own. It contained a little white family of four, just like ours. This toy was the logical extension of the miniaturization of our lives. And it was small enough to fit in the tiny, tightly packed space under the bunk beds that was reserved for our toys.

In 1955 my mom gave birth to a baby girl. When the baby outgrew her crib, our trailer developed its own housing shortage. My parents' solution was to put my new sister in my bunk bed and put me in their own bed. When they were ready to go to sleep, they moved me to the couch in the front room. Before long, I could wake up in the morning with no memory of having been moved. That's how I started sleepwalking. One night I got out of bed, walked into the front room and told my parents, who were watching TV, that I had to go to the bathroom. "So go," they said. I turned around, walked over to the refrigerator—which was only slightly smaller than our bathroom—and slowly opened the door. "No!" my parents yelled as they jumped up to stop me from peeing all over the food in the fridge.

In those days I had a recurring dream that I'd found a hidden door in our trailer that opened to a tiny stairway leading up to a space no one knew about which I claimed as my own secret room. Dreams, fantasies and disorientation were all ways to rearrange the immovable furniture and expand the diminutive interior of our house trailer, which seemed to get smaller as our family grew in size and we kids got bigger.

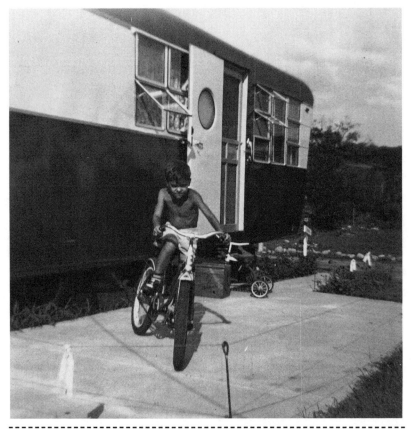

Allan showing off his bicycle on our patio at Sunnyside Trailer Park in Shelton, Connecticut. It's the summer of 1953, a few months before we moved to Bayonne, New Jersey.
Courtesy Allan Bérubé and Florence Bérubé.

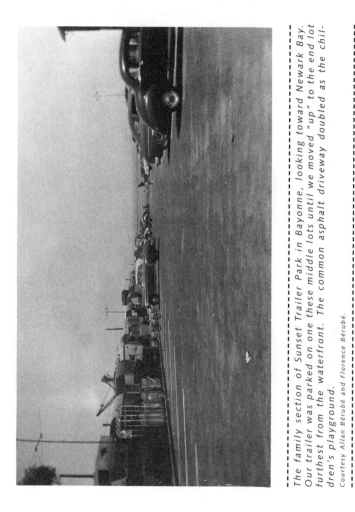

The family section of Sunset Trailer Park in Bayonne, looking toward Newark Bay. Our trailer was parked on one these middle lots until we moved "up" to the end lot furthest from the waterfront. The common asphalt driveway doubled as the children's playground.
Courtesy Allan Bérubé and Florence Bérubé.

Our "backyard" above our end lot. We had just begun to convert this junk
heap into a prize-winning lawn and a vegetable and flower garden.
Beyond the fence and across the street were the houses from which our
neighbors could look down on us.
Courtesy Allan Bérubé and Florence Bérubé.

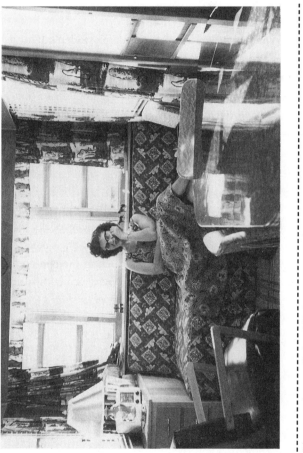

Florence in our living/dining area inside the house trailer. Dad is taking the picture from the kitchen area of the same "room." The couch became Allan's bed in 1957 after the fourth child was born.
Courtesy Allan Bérubé and Florence Bérubé.

⊕　　　⊕　　　⊕

Most of the trailer park's children went to Roosevelt Grade School, up the street and behind the Police Athletic League. This public school, like Catholic schools, required boys to dress up in uniforms, in our case, a white shirt and tie. But a dress code to make working-class students look respectable did not cover up other differences that were still visible among us.

It was at Roosevelt School in the second grade that I first had African American classmates. When I told my mom about these students by using the "N" word, she warned me never to say that word again and to use the word "colored" instead. This is my first memory of being taught to respect people of other races. But the lesson didn't extend far enough for me to learn where the Black students lived. I knew it wasn't in our neighborhood. The social distance between our white lives in the trailer park and the lives of the Black students in Bayonne remained too great for me to cross, even in my disobedient visits into other boy's homes.

More than once our school used white students—including me—to extend that racial distance. One Easter week Roosevelt School decided to put on a children's fashion show for the parents. The producers of the show, who were from a downtown department store, auditioned the students to see who they'd like to use as fashion models. I was among the chosen few because, as they said, I had "dark features"—this in a school with African American students whose "features" were darker than mine, but who were not chosen to be fashion models. My school granted me fashion status for my dark features—hair, eyes and skin—but only because I was white. When I walked down that runway in the school auditorium, I was mortified. Modeling clothes in public was stuff that sissy boys did, and to make things worse, I was wearing clothes my parents couldn't really afford to buy. Exactly whose fantasies was our school's fashion show acting out, anyway?

White kids from the houses, trying to position themselves as better than us trailer park kids, experimented with ways to challenge us as not "white enough" or even not "really white." My own dark "features" made me vulnerable to their name-calling. During the summers, I ran around the trailer park barefoot and shirtless in shorts—a slip in my parents' commitment to respectability—so my skin reached a dark tan. One day, some white boys from up the street cornered me in the alley beside our recreation hall and started pushing me around. They might have called me a sissy or a host of

other names, but this time they taunted me with racial epithets. "Look at the nigger-boy," I remember one boy saying as he hit me. "Naw, he's just a monkey-boy," the other mocked back. They hit me until I denied that I was either of these, then let me run home crying. My experience as the target of their racism was mild compared to what Black children had to deal with at school from these same boys. Yet these bullies successfully taught me— a "dark" white child living in a trailer park—that other whites who looked down on us because of where we lived could call my whiteness into question. Ashamed, I kept these and other social injuries to myself, channeling them into desires to learn how to act and look more white, and to find other ways to move up and out of this life that more and more felt like a trap I had to escape.

School seemed to offer me the best way out. When I was in the fourth grade, a white university student came by the trailer park to talk to my parents. He was doing a study for his thesis, he told them, and would like their permission to give me and my sister psychological and intelligence tests, for which they would be charged nothing at all. Was he studying the psychology and intelligence of the white working class? Did he pick us because we were in a trailer park, or in a blue-collar town? No one remembers. Dad called the university to make sure he was legit, then my parents agreed to let us be part of his study.

A few days later he came by again. I got in his car and he drove me to a house in another part of Bayonne where we went upstairs into a dark garret. For hours I described ink blots, put blocks into holes, drew stick figures on paper and made up stories about what was happening in pictures he showed me. As he drove me back home, we passed by a big street sign for a loan company and he warned me, "Never, ever borrow money from those people!" I never did.

He reported to my parents that our test results indicated we would do well in school and that we were college material. "It was that young man's tests," my mom now explains to me, "that first got us thinking about how we could find a way to send you kids to college."

⊕ ⊕ ⊕

My parents' dreams of someday buying a house, starting a small business and sending the kids to college were the engines that drove their lives. They

pinched pennies, bought cheaply or did without, and developed such schemes for making a little extra money as managing the trailer park or entering contests for the best-looking yard. Saving to buy a house was always their first priority. Next came putting us through school and starting the small business, like our friends who had their own Chinese restaurant, that would get them where they wanted to go with some security and independence.

"It always seemed like a constant struggle," Mom tells me. "You couldn't take a breather long enough to feel like you were getting ahead." She budgeted every cent. She did our back-to-school and other kinds of shopping at John's Bargain Stores, Two Guys From Harrison and Robert Hall— where the "values go up, up, up," and the "prices go down, down, down," because they've got "low overhead," as their radio jingle went. My sisters wore hand-me-down clothes from each other, our older cousins and me. We did our part by studying hard in school to get good grades. Illnesses, uninsured dental work, strikes at NBC, a broken down car and an exploded hot water heater periodically set their savings plan back to zero or even less.

In 1957 my mother gave birth to another baby girl. Now there were six of us in our little home, pushing our living space to the breaking point. There was no denying that the longer we stayed put, the more we were slipping down rather than moving up. We were a large family packed into a small trailer that looked older every day compared to the brand new models that surrounded it. These were two- and even three-bedroom "mobile homes," 10 feet wide and 50 feet long, with chrome exteriors, screened-in porches, even double-deckers with an upstairs sleeping "loft."

"When the new mobile homes were pulled into the park," my mom tells me, "we'd all go over to the lot and watch them set up—not just the women, but the men, too! Sometimes they'd invite us inside to show us what they had—big kitchens, regular furniture, even a step up from the kitchen to the living room, like a split-level house. Dad would say, 'Boy, they've sure come a long way since we bought ours.' Then we'd go back to our old trailer, envious."

On Sunday drives we'd visit model homes at the housing developments that were sprawling all over the New Jersey suburbs in the late fifties. These were almost as exciting as going to Disneyland. Our fantasies went wild as we imagined ourselves living in four-bedroom homes with dens, two-car garages and lots of space in layouts packaged as Split-Levels, Colonials,

Ranches or Cape-Cods. On Sunday nights we drove back to Sunset Trailer Park. These new homes were too expensive for us to afford.

My parents wanted to *buy* a house so badly that they, like other upwardly mobile working-class adults, took a real estate course to learn how to make money *selling* houses. They never managed to sell any, but they did learn how the housing market worked. One day they found an ad for a cheap, run-down mansion at the edge of a nearby suburb. It had been on the market as a "White Elephant" for over a year because no one wanted a big old Victorian house during the fifties craze for suburban newness. Combining their savings with a loan from a real estate broker's acquaintance, they scraped together enough money for a down payment, sold the trailer and finally moved into their own house. The whole trailer, we wrote our relatives, could fit into our new front hallway.

Finally we'd escaped the trailer park to begin what became our brief entry into white middle-class suburban life. The dramatic change was exciting yet awkward for me, as I mistakenly believed that we'd arrived in the land of the rich and famous. For my first day as the new kid in school, I dressed up in my Sunday hat, suit and tie, expecting to fit into the wealthy world I'd imagined. Instead, to my horror, I became the laughing stock of the schoolyard. Hearing my foreign-sounding last name (we were "French Canadian" in the fifties, "Franco American" now) and seeing me in my peculiar outfit, the other students somehow got the idea that I'd migrated to their suburb all the way from Peru. I denied this, but knew right away that to fit into this new world I had to keep my trailer park past a tightly guarded secret.

It took me a long time to figure out where we'd ended up. But I knew enough to take advantage of the rare opportunities that this high-caliber school system now offered me.

Our suburban dream world lasted only a few years. By 1962 Dad left his job as NBC began replacing its technical crews with automated machinery. My parents sold the house and moved back to Massachusetts to live with Dad's father on the family farm. There they tried to start a small-business bookkeeping service, but it never brought in enough money to live on. When Dad got seriously ill without health insurance and couldn't work, Mom took a job in a local mascara brush factory earning $45 a week. Although they tried very hard, my parents never did save enough to send any of us to college.

"You were smart," my mom tells me now. "Getting a good education was your way out." When in 1964 I graduated from high school with honors and did win a full college scholarship to the University of Chicago, she adds, "You kept up your part of the bargain." The bargain, I think, was that if they worked hard enough and I studied hard enough, we would all succeed. But in 1968, during my senior year, I dropped out of college. A crisis hit me in April as I started to confront my homosexuality before gay liberation, faced class panic when I was rejected for graduate school and didn't know what came next, feared for my own life as I witnessed murders on the streets during the Chicago riots following the assassination of Dr. Martin Luther King, Jr., and decided to resist the draft rather than fight in Vietnam. The world was coming apart around me, yet I blamed myself for not working hard enough to keep up my part of the bargain. "You had only one chance to get out and you blew it," I remember thinking at the time, still missing the truth that, for both me and my parents, the bargain itself had been a lie.

⊕ ⊕ ⊕

As the distance from the trailer park grew in years, miles and class, I began to manipulate my memory of that world so that it carried less shame. In college I met other scholarship students who adapted to our new middle-class surroundings by working their lower-class origins into cool, competitive, "class escape" stories in which they bragged about how far they'd come. I joined in, "coming out" about my trailer park past. Having grown up in Bayonne made my stories—and my ascent—even more dramatic.

By the nineties, a pop culture, retro-fifties nostalgia resurrected and then commodified the artifacts of trailer park life, reworking their meanings into a campy "trash" style. So I unearthed my own trailer park past once again, this time learning how to take an ironic, parodic, "scare quotes" stance toward it, even using it at times as a kind of white trash cultural—and sexual—currency. I now collect old paperback books, souvenirs and magazine ads having to do with fifties trailer parks. I love the stuff. And I'm glad that the current fascination with white trash icons, like house trailers, has opened up a public discourse big enough to include my own queer, working-class, trailer park voice. Today I can use that voice—and its identity—to challenge the class-based stereotypes that hurt real people. And I can enjoy the plea-

sures of campy nostalgia along with the pleasures of cross-class sex experienced from many sides. Now that there's a new "rock 'n roll fag bar" in San Francisco called "White Trash," I get to wonder what I'd wear, who I'd want to be and who I'd want to pick up if I went there.

But sometimes it's hard for me to distinguish the camp from the painful realities around which it dances. Ironic distancing has served me as a lens through which I've been able to re-view my trailer park past with less shame. But it has so distorted my vision that I misremember the "reality" of that part of my life. I've caught myself actually believing that we and our neighbors all had fabulous plastic pink flamingoes in our yards. I am sure—and so is my mom—that none of us ever did.

Lately I've searched flea markets for a plastic house trailer just like the one I had as a child. Today it would be a valuable collector's item, and my desire to find it is partly as a collector. But I also want to see it again because it once pointed this working-class boy's way out of being embarrassed about how his family lived, showing him that their trailer-park life was respectable enough to be made into a mass-produced toy.

Recently, at a gay gift shop on Castro Street in San Francisco, I bought a T-shirt that says "Cheap Trailer Trash" over a picture of a fifties trailer that's identical to the one I grew up in—except, of course, it has a pink flamingo. I now can be both cool and authentic when I wear this shirt. When people say, "I like your shirt," I get to say, "Thanks. And it's *true*, too." When some start telling me their own stories of growing up in trailer parks, I can feel us bond around this weird nineties identity that's built on shared—if distorted—memories rather than on current realities. Sometimes we slip into playing the old class-positioning game. "What kind of trailer did you live in? How wide and how long? How big was your family? Did you own or rent your lot? Did you call it a mobile home? How long did you live there? What kind of trailer park was it? What part of town was it in?" In an inverted form of social climbing, the player with the trashiest past gets to be the winner of this game. We can do this because the distance from our former lives gives us room to play with old degradations as contemporary chic. But back then, actually living inside a trailer park, those who won the game were the ones who got out for good. Nowadays, trailer park folks still try to get out by playing games—not as TV game show contestants, like our neighbors in the fifties who made fools of themselves for prizes, but as "guests" on so-called "trash" talk shows, like Geraldo, Richard Bey and Jenny Jones, who "win" celebrity—but no prizes—

if they can act out the real dramas of their lives as trashy stereotypes, reassuring viewers that it's someone else who's really on the bottom.

The whole country looks more like a trailer park every day. As our lived economy gets worse, more jobs are becoming temporary, homes less permanent or more crowded, neighborhoods unstable. We're transients just passing through this place, wherever and whatever it is, on our way somewhere else, mostly down.

"I get really scared sometimes," my mom tells me, "that the old days are coming back." She means the Great Depression days she knew in her childhood, and the trailer park days I knew in mine.

I get scared, too. Without any academic degrees, and with the middle dropping out of the book publishing world as it's dropping out of everything else, I find it increasingly difficult to survive as a writer. As I approach 50, I see how closely my economic life history resembles that of my parents as I'm pushed around the edges of lower-middle-class, working-class and "new Bohemian" worlds. Lately, I've been having a perverse fantasy that if times get too tough, I can always retire to a trailer park, maybe in Bayonne.

⊕ ⊕ ⊕

A few years ago, I actually went back to visit Bayonne, which I hadn't seen since 1957. I wanted to check my distorted fantasies against a tangible reality, to go back "home" to this source of memories that I mine for insights as I try to understand and fight the race and class divisions that are still tearing our nation apart. I asked my friend Bert Hansen to go with me for support because he also grew up white, gay and working-class. I didn't wear my "Trailer Park Trash" T-shirt that day. We took the Path Train from Christopher Street in Greenwich Village over to Jersey City, rented a car and drove out to Bayonne.

To my surprise the trailer park was still there, along with every house, store, bar and restaurant that used to be on our block, all still run by the same families. This was a remarkable testament to the death-defying—and too-often life-threatening—stability of this blue-collar town, despite the enormous social and economic odds working against it.

With my camera in hand, I walked into the trailer park and around both courtyards, taking pictures of the same lots we'd lived in four decades ago. The place was run down now, many lots were empty and littered with car

parts and old boards, almost no one was around. A man washing his car in front of his house up the street told me that the trailer park had just been sold to a condo developer. People who worked in Manhattan, he said, would be moving in because it would be cheaper and convenient for commuting. Up the street Roosevelt Grade School and the Police Athletic League buildings were still standing but closed. Slated for demolition, the school was surrounded by chain-link fence and barbed wire until a new one could be built.

When I walked around the trailer park one last time to take my final pictures, two white boys on bicycles suddenly appeared from around a corner. They followed us, keeping their distance, wary and unfriendly, as if protecting their territory from intruders. Watching them watching me, I realized that the distant memory of my boyhood in this trailer park, which was coming alive as I stood there, was now their hard reality. At first glance they seemed really poor. As a kid who never felt poor, did I sometimes look like they do to outsiders? Surely these boys were much worse off than I had been. They seemed hostile, but why should they be friendly towards me—a total stranger taking pictures of their trailers? I could be there to steal their possessions, or to expose their poverty to outsiders, or to design the condos that would replace their house trailers, forcing them to move against their will. Or I might be a graduate student earning an academic degree, wanting to use them as working-class subjects, like the grad student who came here so long ago to give me and my sister intelligence tests, for free, then disrupting our lives by telling us that our high scores might offer us a way out.

I can still see these two boys looking at me as if I am some kind of spy, which indeed I am. I don't belong here any more. Their days belonging here are nearly over, too.

November 1995

NaME CaLLiNg

OBJECTIFYING "POOR
WHITES" AND "WHITE
TRASH" IN DETROIT

JOhN HartigaN, Jr.

Jerry's wide gut, shirtless, sweating, dominated the porch; him holler-ing for another beer from his brother Sam who had gone back upstairs through the shattered door frame Jerry broke in a rage last night. Jessi Rae, her mouth grimaced, missing many teeth, sat on a dark green car seat across from him on the narrow side porch. They were talking about "hillbillies." It was one of many discussions on this topic, a subject that they savored with ever renewed fascination. All three of them, with varying degrees of pride, buffoonery, shamelessness, or gusto, made a point of letting me know that they were hillbillies. Jerry and Sam were hillbillies from "West Goddamn Virginia! That's how they say it down there." Except they both had been

born in Detroit. Their daddy left West Virginia in 1941 and came to Detroit to work on the assembly lines. He married a woman from Kentucky (or from Detroit—their stories varied) and they raised six kids together in an apartment building just a couple of miles from downtown. The building was full of other Appalachian migrants or hillbillies. Jessi Rae's family lived there when they arrived from Kentucky in the early 1960s. Jerry and Jessi Rae met as teenagers in 1968 and they have been together ever since.

The yard that spilled around the porch featured two vehicles (Sam's Ford pick-up, on blocks, and Jerry's barely running, multi-colored Gremlin), a barbecue grill fashioned from a rusted-out 55 gallon drum (they found it in the alley where some black neighbors had dumped it after they felt it was too rusted out to use anymore), a few tires, scrap lumber, a wood table for playing cards, useless car parts, and the bucket that held the empty 40 oz. beer bottles waiting to be returned for deposit money. The yard was a meeting place for the neighborhood hillbillies and blacks who knew Jerry well, who had something to trade, or who wanted to interest him in various "jobs," legit or otherwise. I wound up in the yard, looking for a place to live, after one of the old men at the corner bar suggested that Jerry had a place to rent. "But," he warned me, "I've never seen nothing but hillbillies up there."[1]

The status and the nature of hillbillies in the inner city of Detroit is a complicated matter. These whites were out-of-place when they first began to arrive in the city in the 1940s and through the 1960s. Later, many of them were left behind when "white flight" gutted Detroit by the 1970s.[2] In both cases hillbillies were shunned by the working-classwhites that once occupied this neighborhood less than a mile from downtown. Hillbillies, they said, were lazy, licentious and prone to violence. White Detroiters were appalled, too, at the way these character traits blurred a rapidly collapsing social line between black and white racial orders.[3] Southern migrants to Detroit, white and black, shared regional commonalities in speech and lifestyles that unnerved native white Detroiters, compelling them to abandon the city. Today, in an area where over 24,000 people once lived, there are less than 3,000 residents remaining, mostly hillbillies and blacks. The clumps of houses that have not burned down are few and far between, interspersed with grasslands and brush where pheasants and small animals dwell. Despite the ruins all around them, few of the whites that I spoke with during my fieldwork in this part of Detroit expressed an interest in leaving.

The decrepit conditions were not an affront to their social sensibilities. Rather, the empty lots provided them with space for car repairs, baseball games, and distance from nosy neighbors.

I was in Detroit to study whites, to examine how the significance of whiteness varied across class lines in this city that is 76 percent black. My fieldwork was based in this neighborhood called Briggs, and contextualized by working in Corkdale, an adjacent, predominantly white area that was undergoing gentrification, and in Warrendale, a working-class neighborhood over 80 percent white on the city's far west side. I worked in separate fieldsites across the city primarily to demonstrate how varied class backgrounds and conditions shape distinct articulations of white identity. By emphasizing poor whites, I hoped to frame the "problem" of whiteness from an angle that disrupted the assumed (and generally accurate) equation between whiteness and social privilege. However, I did not want to reproduce the tradition in social science research that first isolates, then pathologizes the lives and speech styles of the poor. In this tradition, poor whites occupy an emotionally impacted position in a racialized order of representation through which social knowledge is produced in this country.[4] I will sketch the contours of this representational order more fully below; for the moment, though, I want to note simply that a distorted image of urban poverty in America has been established and maintained, in part, through a willingness of social scientists to ignore "poor whites," while obsessively (over)representing the conditions of blacks living in poverty.[5]

An equally loaded, though much more studied and stylized, subject is the white working class. I was drawn to Warrendale by a fierce conflict that erupted there when the Board of Education for the Detroit Public Schools decided to reopen a closed community school as the Malcolm X Academy, instituting an Afrocentric curriculum. This shocked and terrified the white residents. The nuances of this conflict are beyond the scope of this essay, but I will briefly sketch its racialized contours.[6] White residents opposed the school for a number of reasons, but the overriding interpretation in the local media and in debates with city officials was that these whites were simply racist, objecting to the mere presence of blacks in their neighborhood. Flustered, Warrendale whites argued back, vainly, insisting that they were not racist just because they felt threatened and unnerved by the Academy's Afrocentric curriculum. They argued that they were not bothered by the fact that the school was almost exclusively black. As evidence, they pointed to

the way that white residents did not panic as blacks began moving into the neighborhood over the last ten years.[7] They stressed this point by describing the greater sense of threat they felt from poor whites who were moving into the neighborhood.

But getting back to "Jerry and them,"[8] while it is tempting to refer to them as they refer to themselves, as hillbillies, the connotations of this name are charged in such a way as to preclude using the term as a safe cultural abstraction or a neutral means of labeling "them." Ambivalence about the category hillbilly was a constant at Jerry's. Family members alternated between invoking the name as a heritage and trying to fix each other in the stupefying glare of its inscription as a comic image. Generally, they played with the stereotype. There was little interest in dignifying the label. "Hillbilly" was affixed to any sort of makeshift repair or any kind of not quite sufficient effort or resource. With car repairs, when a lost or damaged bumper was replaced by a piece of 2x6 lumber, this was called a "hillbilly bumper." Jerry replaced a missing muffler on his brother David's car by lashing a tin can with numerous punctures to the end of the exhaust pipe; they called this a "hillbilly muffler." When he jimmied up a poorly aligned headlight with a small twig, his buddy Willie commented right away, "nice hillbilly headlight." The circumstance of such naming did not have to be actual; it was also projected in jokes and riddles. One joke they passed around, picked up by Sam at a free country music concert downriver in Wyandotte was "What is a guitar case?—hillbilly daycare."

There was both humiliation and pride in these namings. The ineluctable basis of all such namings was the lack of money that made such makeshift repairs necessary. But, additionally, there was the basic innovation, the cheap, money-saving design that outwitted the economic system and the stigmatizing condition of constant poverty. Yet, there was always a painful ambivalence over the term: it never stopped being a "bad word." Its significance depended on the emphasis of the speaker and the mood of the receiver. This made for a volatile mix.

While hillbilly could easily be used as an insult, "Jerry and them" had a broader, harsher repertoire of stigmatized names that they also used on each other. Most of these terms were sexualized (i.e., "motherfucker") or scatological ("shithead" or "asswipe"). Some, though, were racial. Jim and his brothers, in particular, made use of "nigger" with some frequency when addressing one another or when referring to certain other whites. But one

charged name that I never heard them use (or heard them called) was "white trash." This only struck me as odd after I began working in Warrendale, where I heard the term used on a number of occasions by working-class whites.

Warrendale is wedged between the vastly white, wealthy suburbs and the collapsing wreck of Detroit's inner city. The deterioration that has struck the lives and homes in Jerry's neighborhood has steadily rolled out across the expanse of Detroit, now threatening the modest, quiet neighborhoods in the city's outermost reaches. Two distinct types of in-movers are changing Warrendale. Blacks from neighborhoods just to the north and the east of this area are moving in, as are whites from the suburbs. The suburban whites are moving from the neighborhoods where they had been raised mainly because they are unable to afford starter homes in these communities. The post-industrial economy in Michigan has been much less generous with this group than the post-wartime boom was for their parents.[9]

The racial character of the conflict over the Malcolm X Academy was an obviously critical issue in the neighborhood, and it was the exclusive interest of the media deluge that descended on Warrendale.[10] In my dealings with residents, however, I found them as deeply concerned (or worried in quite a different fashion) with the intraracial class shift that was occurring in the area. In describing the complex changes they were witnessing, these whites struggled to assess racial and economic matters simultaneously and neutrally. They did not want to "sound racial" as they described the effects of the demographic shifts occurring around them. But they were not as self-conscious about conveying class-based contempt of other whites, whether "renters" or "undesirables," who they succinctly referred to as "white trash."

Kevin, who runs his own auto repair shop, was one of the most vocal and strident opponents of the Malcolm X Academy. He had, however, been frustrated for a much longer time by the downwardly mobile whites that were moving into the neighborhood where he had been born and raised.

> KEVIN: [describing Warrendale] It's nowhere near what it used to be . . . not being race-wise either. Just being that of the type of people that are overall in the community now. The community's changed.
>
> JH: So the make-up of the white population has changed?
>
> KEVIN: Yeah.
>
> JH: How so?

KEVIN: Probably to where most of the people that are in here now, had troubles somewhere along in their lives, whether it was drugs or whatever. And you've got a lot of people in this community that . . . they don't . . . [whispers] they could give two shits about their kids.

He had pulled his kids from the local grade school, George Washington Carver Elementary, several years ago at his wife's prompting. He described his wife's response when she went one day to check out the school.

My wife came back and told me, "These people in this school are trash!" And she didn't say that they were people of the black race. She just plain out bluntly said, "That school is full of nothing but white trash."

In a school district where about 88 percent of the students are black, the Carver school is unique in that over 77 percent of its students are white; only 16 percent are black. Long before the Malcolm X Academy became an issue, Kevin and his wife had taken their kids out of the Detroit Public Schools. It was not the racial mixing that unnerved them, but the presence of whites who were of a lower status: white trash.

White trash was popping up all over Warrendale, it seemed. Wally, a retired autoworker who was the president of the neighborhood's community organization, told me that a family of white trash had moved onto his block.

They've got four cars in their backyard, and he's always messing around with them. Then they got two parked out on the street that don't run. And they got four more that they drive around. And these are white folks! . . . I would prefer to have black people move next door. As long as they keep up the house, I don't care what color they are. I really don't. All that matters is that we have some kind of harmony. We don't need all of this fighting and carrying on, at each other's throats.

In such descriptions, these whites referred to white trash as something worse than the unknown future presented by racial integration. In part, they talked about white trash to make the point that they were not simply racists. But, in Wally's exasperation ("And these are white folks!") there is a clear confusion of racial identities and stereotypes occurring. It is not simply that white "renters" or "trash" are acting black. Rather, by behaving in a manner considered indecorous by Warrendale whites, these recent arrivals (white trash) are disrupting implicit understandings of what it means to be white. Here, white trash designates ruptures of conventions that maintain whiteness as an unmarked, normative identity.[11] As Warrendale gradually becomes more heterogeneous, racially and in its class composition, white

residents objectify their anxieties by expressing concerns over the disruptive presence of a distinct class Other: white trash.

White trash presents a problematic subject for ethnography. As a cultural objectification, its connotations are enduringly debased.[12] This makes researchers uneasy about taking the term at face-value, as indicative of something "real." When the term has surfaced in the few ethnographies that treat poor whites, it is recorded without critical reflection or analytical speculation. "White trash," when it appears in a text, hangs on a page, a slice of life, a term the "natives" use to talk about "those people," without any theoretical consideration of what it means, how it is being used, or what function it serves.[13] This theoretical attention deficit derives, in part, from the conventions of social science that privilege the assignation of neutral terms that serve as abstractions of the assumed underlying dynamics in such stigmatized objectifications. However, as its uses in Warrendale demonstrate, white trash constitutes more than a derogatory exchange of name calling; it materializes a complicated policing of the inchoate boundaries that comprise class and racial identities in this country.

In Warrendale, "white trash" operates in a racialized setting where fairly drastic economic changes are also underway.[14] It would be easy to assume that such usage operates as a "smokescreen" for more fundamental racist sentiments, but such an assumption requires an assertion of the primacy of racial matters over class distinctions. It is more important to stress the relentless alteration between stresses on class and on race that mark social exchanges in the United States. In this regard, it seems that white trash is used in racialized contexts where class and race differences become conflated, overlapping rather than remaining clear and distinct. While white trash emphasizes a certain sense of class threat and contempt, it does so in a situation where the once emphatic cultural boundary between whites and blacks becomes unstable.

White trash also retains a strictly racial edge, and can serve as a means of insisting upon the difference between whites and blacks. Joyce, a white woman that I spoke with in Warrendale, both used and had been called "white trash." Her experiences are revealing. While she now owns her own home in the community, a previous divorce had left her without money or an income, trying to support her children by herself. She talked about this when asked if she had ever been the object of racial hostility.

Joyce: I was in a shelter for awhile. The one by the old Hudson building, in the YMCA down there. Lovely place [she laughed]. And yes I was harassed. I was the only white one in there after awhile. So, I don't know if they wanted my bus passes [laughs], I was threatened for those. I couldn't get 'em, though, cause they knew I had a car. So, she was threatening me for my bus passes, and . . . after awhile some of them started to hate me. And, y'know, they'd rag on me about the color of my skin and stuff.

JH: What were they saying?

Joyce: [smiles] Oh, just calling me white trash and stuff. I kept joking with them, though. I wanted to braid my hair [laughs a lot]. I wanted my hair all braided.[They said,] 'No way man, you've got angel's hair.' I guess it's too fine, but they wouldn't do it. [long pause] It wasn't that bad. They got to know me, and they kinda got an attitude . . . y'know, that's when they came after me. Not, 'Came after me,' but started with the racial slurs, and crap like that. But...I wasn't impressed. A lot of those people were on drugs or whatever, and they just got the shit knocked out of 'em. They go there for awhile, and then they go back with him . . . Y'know. I was there for a transmission of life.

In the setting of the shelter, black women used white trash to insist upon clear racial identities. Perhaps the class distinction present between Joyce and the black women in the shelter undergirded this insistence. While she was only in there for a "transmission of life," they were caught up in just another routinized episode of being poor and black and female in America.

Joyce's racialized experience of being labeled white trash did not prevent her from using the term in the same way that her neighbors Kevin and Wally did. In fact, she quite purposefully asserted that the term white trash conveyed a class-based divide between "people" and "trash" that was the same across the black/white racial divide. She compared whites renting in the neighborhood to blacks that she met in the shelter and where she works downtown in an open-air farmer's market: "Look, there's white trash and then there's white people. Just like there's black trash and there's black people. That's how I try to think about it and keep things in line." [15]

Wally, too, relied upon a certain interracial analogy when he addressed the subject of white trash moving into Warrendale.

I recall, I had a black man at work, on the midnight shift as a crane operator. And he lived down in the inner city, and then he moved over on Dexter. And he said, "Boy, it was real nice, until they started to build freeways." Then he said, and this is his words . . . He said, "The god danged niggers moved out into my neighborhood, and the next thing I know we've got fires and ambulances, and police cars, and sirens going all night long. So I'm having to move again so I can get out in a nicer neigh-

borhood, so I don't have to put up with all that crap." But, nowadays, it seems like it's not necessarily the blacks . . . We've got white trash moving into this neighborhood. We've got one family on Stahelin and Tireman, they park a vehicle right on the front lawn; they do car repair right in the garage, the place is strewn with junk.

Through the critical attention focused on the nature of racism—from both the onslaught of recent media coverage and the work of social scientists and community leaders over the past decade—Warrendale whites have grown quite circumspect in their discussions and reflections on racial matters. Such self-consciousness, however, was wholly lacking in their references to class differences. While these people would be loath to use the term "nigger," at least in my presence, they revealed no such uneasiness about using "white trash" to talk about their neighbors. In this regard, the conventions of class that maintain certain identities as contemptuous derive from an emotional reservoir that retains a naturalness bordering on "common sense." As astute as the Warrendale whites had become about the decorums around racial name calling, they recognized no similar need to be "tolerant" or "polite" in deriding class differences.

This classed form of Otherness, white trash, was mired in an ongoing confusion about the social differences that mattered most. Kevin summed up his sense of the threat facing the lifestyle of Warrendale residents with the following comment:

People aren't separated by race, they're separated by class. That's what happened to the cities, we've lost the middle class. Not just, not just white people left, but you lost the black middle class people. Black and white, you lost the middle class, that's what's hurt the city.

In these instances, Warrendale whites were more interested in asserting a sense of class solidarity over a reliance on racial identity to convey the anxieties and fears that tormented them. The class texture of their vulnerability in Detroit was prioritized over their fear of losing their neighborhood's racial homogeneity.

The uses of "white trash" in Warrendale aptly model the key difficulty in understanding this cultural figure. Simply put, is white trash real or is it a cultural stereotype? And if "it" is real, why not study "those people" directly, in their homes and in their yards, in order to generate a more accurate (humanistic) depiction? If it is a stereotype, why not find a more neutral, abstract designation, then investigate the underlying social dynamics that are motivating its use? These options derive from

core tenets of traditional social science practice; each tact requires that certain modes of detachment or decorum be observed by the researcher. But either approach would grossly distort the discursive operation of white trash. The source of this distortion becomes clearer by posing one more question: is studying white trash the same as studying poor whites?

This essay opened with an image both stereotyped and real of "poor white trash." But are Jerry and his family truly white trash? In a strictly positivistic sense, the answer is no. They never used the term and I never heard them called white trash by either their white or black neighbors. But, are they white trash in the eyes of whites in Warrendale? Clearly, they are, and that is the point of this essay. As I have argued elsewhere, white trash is a cultural figure and a rhetorical identity, it is a means of inscribing social distance and insisting upon a contempt-laden social divide, particularly (though not exclusively) between whites.[16] The name is applied, and sticks, with various results to a mutable group of people bearing certain socially stigmatized traits or characteristics. The context in which it is used and the position of those using the term are as con-stitutive of the reality of white trash as is the cultural and historical coherence of those so named. In this regard, white trash exists in the fears and fantasies of those middle and working-class whites who occu-py a place "just above" the class divide from poor whites, straddling a line they are forever fearful of crossing. In this sense, poor whites and white trash might look and sound the same, but they are quite different subjects.

In the decorums of social science research, though, neutral terms are preferred over charged stereotypes, on the supposition that using a derogatory term reproduces and authorizes the stigmatization of certain people. Given the pejorative connotations embodied by "white trash," it might seem appropriate simply to avoid using the term altogether, accepting "poor white" as an adequate abstraction of the underlying referent in the comments of whites in Warrendale. But such a resolution is shortsighted. White trash importantly objectifies, in a way no other word does, both the stigmatized condition of whites in poverty and the emotionally charged, fearful image that they present to working- and middle-class whites. White trash locates "those people" both in their homes and in the cultural imaginary of more "respectable" whites. And, most critically, explicit attention to white trash makes it less easy for the

assumption to stand that social scientists are detached from the class-con-stitutive relations and exchanges that they study.

Social scientists have yet to coin phrases and terms that do not implicit-ly or explicitly inscribe and convey the derisive judgments held by the broader society towards the "poor."[17] And it is deceptive to suppose that "poor white" is a strictly neutral term, sanitized of any stigmatizing conno-tations. Along with the "underclass," "economically disadvantaged," and "socially isolated," "poor white" resonates with all of the degrading inflec-tions of any name for those living in poverty.[18] The terms that social scien-tists use to describe these classed forms of Otherness are as intimately involved with confirming a perception of the-poor-as-different, as is "white trash." The charged, symbolic differences between the "poor" and every-body else are reconstituted by the very studies that seek to render them neutrally.[19]

Poor white and white trash represent two distinct but integrally related modes of name calling. One belongs to the social sciences, one to the mid-dle and working classes: the difference is that one is "proper" and the other "improper," though they adumbrate and inform each other. We cannot assume that using "poor white" in any way nullifies or achieves distance from the reservoir of social contempt implied by white trash. "Poor white" springs from a decorum for managing intraracial differences among whites, motivated by a long-running desire to, as Joyce does, draw "real" distinc-tions between "people" and "trash." In this regard, any effort to represent poor whites (ethnographically or statistically) must first account for the pre-determined reception of such people as white trash.

The matter of this reception, and the issue of the distinctions that Joyce and other Warrendale whites feel so palpably, brings us back to the prob-lem of the real. "White trash" is not simply a stereotype or a false and mis-taken preconception. Rather, it delineates a discourse of difference whereby class identities are relationally formulated. The social differences embodied by white trash do not exist in a vacuum; they are elements that the white middle class relies upon to distinguish themselves from the lower orders: "We are not that." Class identities operate as a cultural continuum; what-ever basis they draw from a relation to the means of production, they are, too, animated as a chain of signifiers and their connotations, defined in dif-ference from other positions in the social order.[20] Raising white trash to our critical attention, brings with it the often less-easy-to-examine figure of

"respectability"—the two entwined as a linked means of identifying differ-
ence within the body of the Same, in this case, whiteness.

It is the relational basis of class identities that speaks against a singular
ethnographic focus on either poor whites or white trash as a distinct cultur-
al group. Such studies have the potential to further ratify a belief that these
people live in "social isolation," warping our ability to recognize that class
identities are locked in a continuum of distinctions and difference. It is
tempting to seek the truth about poor whites by thoroughly objectifying
"Jerry and them," conveying in exacting detail the nuances and extremes
that constitute their daily lives. Attention to the micro-level of experience in
poor communities, rendered in dense, novelistic modes of description, is a
common approach to studying the "poor" in general.[21] This gesture towards
realism, however, has largely served the voyeuristic desire of the middle
class to have revealed for them the "uncouth" and "shocking" habits of the
lower social orders.[22] Though such an account may be compelling, it hardly
gets at one of the most critical aspects of class identity: the relational basis
upon which classed forms of identity and difference are constructed.

There are many compelling reasons why social scientists should turn
more attention to the situation of whites in the underclass. Prime among
these is that researchers and politicians have constructed a grossly distorted
image of poverty in this country. While whites constitute a vast majority of
the poor population in the United States, blackness composes the most
familiar visage in representations of poverty. The roots of this misrepresen-
tation are beyond the scope of this essay. But a key factor, relevant to the
preceding discussion, is that the whiteness of this poor majority renders
them almost invisible to those scholars trained to track culture as something
exotic and purely different from themselves.[23] As whites, they often appear
to be culture-less, to be part of that normative condition from which racial
differences are elaborated and inscribed. And until we fashion a means to
objectify that which still seems natural and unmarked, whiteness, we can-
not begin to grasp the core concerns and anxieties that white trash frames.

White trash, whether taken as a cultural figure, a rhetorical identity, or
an apropos means for designating "them," embodies a certain boundary
(and its transgression) for the production of social knowledge. Without tak-
ing the term as a serious object, it is doubtful that studies of poor whites will
ever do more than produce reassuring representations of "those people" as
a population apart and distinct from the white "mainstream." And by ignor-

ing the relational aspects of white trash—the way the term is used to differentiate between people who fit uneasily within the body of the Same— we gain no greater comprehension of the crucial role such categories play in the lives of working and middle-class whites as they constitute themselves socially.

White trash and poor whites form a continuum of means for designating "them." In between are similar terms with greater regional specificity: "cracker" in Georgia and Florida; "linthead" in the Carolinas; "okie" in the West; "hillbilly" or "ridge runner" in West Virginia and the Midwest. Each term is linked to either occupation (such as millworkers) or to migration and being out-of-place (okie and hillbilly). But they all entail a mode of name calling that whites rely upon in order to distinguish between those that match the class decorums of a certain racial identity (whiteness) and those who, through physical, emotional, or economic markings, fail to measure up. Here, I have relied upon white trash and poor white to convey the scope of such modes of objectification. But each of these names involves a specificity of place and purpose through which contests over signification unfold. In these contests, we must remember that the namer and the named are locked in an unending struggle where there is no neutral ground.

---------------------------- NOTES

1. I did field work in Detroit from July of 1992 through February of 1994. This project is the subject of a dissertation, "Cultural Constructions of Whiteness: Racial and Class Formations in Detroit" (Ph.D. dissertation, University of California, Santa Cruz, 1995).

2. Between 1950 and 1990, Detroit's white population declined by 1.4 million people. Similar stunning demographic shifts occurred simultaneously in urban areas across the nation as whites left the cities for the suburbs.

3. Detroit, like most Midwestern cities at the turn of the century, had a very small, segregated ghetto. Since Michigan had adopted anti-discrimination codes in the 1880s, this segregation was largely maintained through informal means by realtors, landlords, and white homeowners. But soon after the vast, black in-migration began in 1920s, this delimited residential area was swamped and overwhelmed. Whites, who had long been able to assume a "natural" racial order, found their sense of social status being physically challenged by blacks across the city, on streetcars, in parks, and, most disturbingly, in neighborhoods. The race riot in 1943 exploded many of these long-simmering tensions. When I refer to the "color-line" in Detroit, I am suggesting this complex, shifting situation when the informal social decorums that had maintained whites in a clearly superior position relative to blacks became stressed and finally ruptured. See Dominic Capeci and Martha Wilkerson, *Layered Violence* (Jackson: University

of Mississippi, 1991); Karl E. Taeuber and Alma F. Taeuber, *Negroes in Cities: Residential Segregation and Neighborhood Change* (Chicago: Aldine, 1965); Thomas Sugrue, "The Origins of the Urban Crisis: Race, Industrial Decline, and Housing in Detroit, 1940–1960" (Ph.D. dissertation, Harvard University, 1992).

4. Public and scholarly attention to poor whites over the last three decades is a complicated matter. They were quite purposefully drawn into the foreground of debates over initiating the War on Poverty in the mid-1960s. By highlighting the conditions of poor whites, white politicians and activists deracialized demands that the effects of racist institutions in the United States be examined and redressed. Recently, primarily through the writings of Charles Murray, the image of poor whites has again been highlighted, largely to underscore that the calls to dismantle the welfare system in this country are not racially motivated. In between these two "moments," there has been scant attention paid to poor whites. See Barbara Ehrenreich, *Fear of Falling: The Inner Life of the Middle Class* (New York: Harper Books, 1990); Frances Piven and Richard Cloward, *Poor People's Movements: Why They Succeed, How They Fail* (New York: Vintage Books, 1979); Charles Murray, "The Coming White Underclass," *Wall Street Journal*, October 29, 1993.

5. To my knowledge, there have been only two ethnographic treatments that concentrate on poor whites. These are: Joseph Howell, *Hard Living on Clay Street: Portraits of Blue Collar Families* (Garden City: Anchor Press, 1973), and Todd Gitlin and Nanci Hollander, *Uptown: Poor Whites in Chicago* (New York: Harper & Row, 1970). Robert Coles offers a very partial treatment of this group in *The South Goes North*, Volume 3 of *Children of Crisis* (Boston: Little, Brown & Company, 1971).

6. The conflict over the Academy was reported briefly in *The New York Times*, *The San Francisco Chronicle*, and National Public Radio.

7. This argument was one aspect of these whites' reaction that ran counter to the typical response to such incursions in white working and middle class neighborhoods. See Jonathan Reider, *Canarsie: The Jews and Italians of New York Against Liberalism* (Cambridge, MA: Harvard University Press, 1985).

8. This form of reference was quite common in Briggs. Families were typically designated by referring to one prominent family member followed by "and them."

9. The type of manufacturing jobs that gave working class people a chance to join the ranks of the middle class are rapidly disappearing across the nation. The metropolitan Detroit area has been particularly hard hit by this economic transformation. See Joe Darden, Richard Hill, June Thomas, and Richard Thomas, *Detroit: Race and Uneven Development* (Philadelphia: Temple University Press, 1987).

10. While the focus of this essay is on the stereotyped modes for representing poor whites, I need to note that there is also a well-developed tradition among whites of locating racism as primarily a character trait of the working class. This assumption was at work in the representations of whites in Warrendale. On this tradition, see David Wellman, *Portraits of White Racism* (Cambridge: Cambridge University Press, 1977).

11. I draw this analysis of whiteness as an unmarked order from Ruth Frankenberg, *White Women, Race Matters: The Social Construction of Whiteness* (Minneapolis: University of Minnesota, 1993).

12. My use of "objectification" follows from the use Virginia Dominguez makes of this term in *People as Subject, People as Object: Selfhood and Peoplehood in Contemporary Israel* (Madison: University of Wisconsin Press, 1989).

13. In addition to the texts on poor whites mentioned above, Douglas Foley, in *Learning Capitalist Culture: Deep in the Heart of Tejas* (Philadelphia: University of Pennsylvania, 1990), records numerous references to "white trash," and features an interview with a teenage girl, "white trash kicker" (74–77).

14. Since 1980, the rate of homeownership in Warrendale has fallen by 23 percent, the value of homes has dropped by 14 percent, and unemployment has been on the rise.

15. "Black trash" is a neologism that I have heard only in sporadic usage, mostly in the form of the comparison Joyce drew. In popular mediums, the best example I can find of this term is from an exchange between syndicated radio talk show host Ken Hamblin and filmmaker John Singleton. The discussion ran as follows:

> HAMBLIN: [Referring to Nicholas Lemann's origin myth of the black "underclass," which he claims was a product of the Great Migration.] . . . [W]hat he was writing about was black trash. Black trash. And in this room, we are debating the merits of including the values of black trash in the mainstream black effort. Now I know that's a hard pill to swallow because—
>
> SINGLETON: Black trash?
>
> HAMBLIN: Black trash. We all get access to a dictionary. If there's white trash, there is black trash. If there's a hot day, there's a cool day. I'm not here to ask for anyone's agreement. Black trash are the people who prey on us and then turn around and encourage us to sit here as intellectual wizards, filmmakers, columnists, talk show hosts, members of black organizations and talk about what whitey did to us.

See, "Who Will Help the Black Man?" in *New York Times Magazine*, December 4, 1994.

16. See, "Reading Trash: *Deliverance* and the Poetics of 'White Trash,'" in *Visual Anthropology Review*, Vol. 8, no. 2, Fall 1992, and, forthcoming, "Unpopular Culture: The Case of 'White Trash,'" in *Cultural Studies*, Vol. 11, no. 1, January 1997.

17. On the implicit biases encoded in social science terminology, see Barbara Wootton, *Social Science and Social Pathology* (Westport: Greenwood Press, 1978); Chiam Waxman, *The Stigma of Poverty: A Critique of Poverty Theories and Policies* (New York: Pergamon Press, 1983); Charles Valentine, *Cultures of Poverty: Critiques and Counter-Proposals* (Chicago: University of Chicago Press, 1968); Ithiel de Sol Pool, "Scratches on Social Science: Images, Symbols, and Stereotypes," in *The Mixings of Peoples: Problems of Identity and Ethnicity*, Robert Rotberg ed. (New York: Greylock, 1978).

18. Regarding uses of "underclass," Herbert Gans makes this point succinctly:

> Buzzwords for the undeserving poor are hardly new, for in the past the poor have been termed paupers, rabble, white trash, and the dangerous classes. Today, however, Americans do not use such harsh terms in their public discourse, whatever

they may say to each other in private. Where possible, euphemisms are employed,
and if they are from the academy, so much the better.

Quoted from "Deconstructing the Underclass: The Term's Danger as a Planning Concept," in *Journal of the American Planning Association*, Summer 1990, vol. 56, no. 5. A similar critique of the sanctioned stereotypes conveyed in popular usage of social science terms for the poor are made by Maxine Baca Zinn in "Family, Race, and Poverty in the Eighties," in *Signs: Journal of Women in Culture and Society*, 1989, vol. 14, no. 4, and Mimi Abramovitz, in "Putting an End to Doublespeak About Race, Gender, and Poverty: An Annotated Glossary for Social Workers," in *Social Work*, vol. 36, no. 5, September 1991.

19. Pierre Bourdieu makes this case most forcefully in *Distinction: A Critique of the Judgment of Taste*, trans. Richard Nice, (Cambridge: Harvard University Press, 1984). In particular, see the section, "Classes and Classification," pp. 466–477.

20. On this particular usage of "continuum," see Lee Drummond, "The Cultural Continuum: A Theory of Intersystems," *Man*, Vol. 15, 1986.

21. Ethnographies of poor whites, like *Hard Living* and *Uptown*, have followed in the novelistic style first established by Oscar Lewis, best evidenced in works like *La Vida* (New York: Vintage, 1965). In this mode, the lives of poor people are rendered in copious detail in the form of a stylized realism, eschewing analysis, as if the concrete presence of the travails of such people conveyed a simple, unalloyed or "natural" truth.

22. The entertainment value of accounts of poor whites is most clear in writings on Appalachia. See Allen Batteau, *The Invention of Appalachia* (Tucson: University of Arizona Press, 1990) and Henry Shapiro, *Appalachia on Our Mind: The Southern Mountains and Mountaineers in the American Consciousness, 1870–1920* (Chapel Hill: University of North Carolina Press, 1978).

23. The sense of culturelessness that pervades white Americans' sense of self has long been a frustration for ethnographers who work in this country. In particular, see Herve Varenne's *Symbolizing America* (Lincoln: University of Nebraska, 1986) and its criticism of the counter-obsession of fieldworkers who consider only the "exotic" aspects of life in the United States worthy of study.

PartNers iN Crime

AFRICAN AMERICANS AND
NON-SLAVEHOLDING
WHITES IN
ANTEBELLUM GEORGIA

TiMOTHY J. LOCKLEY

O n the night of Saturday, February 5, 1838, in Savannah, Georgia, two
men perpetrated a theft from the cabinet-making shop of Mr. Isaac
Morell, where they were both employed. Once they had entered the store,
these "partners in crime" attempted to pick the locks of Morell's desk,
where they knew the takings for the week were kept. This attempt failed,
and they eventually forced the lock with a pair of chisels, finding inside
$118 in bills and coins. With the theft completed, the pair made good their
escape on the Augusta road that same night. Thomas Walsh set off in pur-
suit of the fugitives and within a week of the theft had tracked the pair 135
miles to Augusta, arrested them, and returned them to Savannah. After

some interrogation by Isaac Morell, one of the criminals confessed in front of several witnesses. This confession was produced as evidence during the trial at the May session of Chatham County Superior Court.[1] Despite a plea of Not Guilty, no evidence was produced at the trial in favor of the defendant, and the prisoner was found guilty and sentenced to three years' hard labor at the state penitentiary in Milledgeville. The records of that institution record his admittance there on the 3rd of July 1838, and his eventual release on the 3rd of July 1841. While there is perhaps nothing unusual about his conviction itself, what is fascinating is the fact that this crime was planned and carried out by a male slave by the name of George and a white youth named Henry Forsyth. We have no records of what punishment if any was given to the slave, but the fact that Forsyth served three years at hard labor shows the relative severity with which his case was regarded. By his criminal involvement with an African American, Henry Forsyth had crossed the racial lines which divided Southern society. Why he chose to do this is in part the subject of this essay.

The daily life of the non-slaveholding white population in the antebellum South is generally underrepresented in current historiographic trends. Serious scholarly research in Southern history from U. B. Phillips onwards, has tended to delineate a paternalistic view of slavery and of Southern society generally.[2] This typology seems to have gained general acceptance as a convincing picture of the antebellum South. Recent studies of slavery have added significantly to our knowledge of religion, crime, society, and economics.[3] Yet these studies, while discussing the importance of the planter elite to everyday slave life, generally neglect the role of the non-slaveholders in the lives of slaves. Although it is difficult to give an exact figure for the number of non-slaveholding whites in the South, as such a figure would inevitably fail to take into account regional differences, current estimates state that 70 to 75 percent of the white population in the antebellum South did not own slaves.[4] Therefore it seems logical to begin a thorough exploration of the relationship African Americans had with the majority of the white population—the non-slaveholders.

Paul Buck was the first to highlight the difficult lives of non-slaveholding whites in a slaveholding society. While his depiction of the miserable existence of rural poor whites is most likely accurate, Buck's belief that the racial ties that existed between non-slaveholding whites and the white elite was the gel which held Southern society together in defense of slavery is more

open to question.[5] Avery Craven undermined Buck's racial solidarity view by arguing that the material existence of non-slaveholding whites and African Americans was similar in terms of housing, diet, and standard of living.[6] This conclusion was later backed up by archaeological research which discovered a startling similarity between the diet of slaves and overseers on many low-country plantations.[7] However, these archaeological studies also concluded that overseers maintained the visible social position of a white person by living in a brick instead of a wooden house, and by using china instead of earthenware. Being white in the antebellum South was clearly as much a sociological status as a biological fact. White people were perceived as superior to African Americans in almost every respect, and as such, they were expected to live up to certain standards of living and behavior. The lowly existence of non-slaveholding poor whites would seem to vitiate this racial stereotype by demonstrating to all that whiteness per se was not a ticket to the life of leisure. Living in a society which was based on a system of human bondage, and having little or no part in that particular system, gave non-slaveholding whites a unique social status.[8]

In his study of slave attitudes towards non-slaveholding whites, Eugene Genovese argued that the marginalized and degraded life of rural non-slaveholding whites earned them the derision of bondpeople.[9] Genovese characterizes this attitude of the slaves as primarily a class, rather than a race based world view. Yet he does not explore whether non-slaveholding whites shared this class based world view. In recent years two studies of poor white life in North Carolina and Mississippi have been published. Each defines non-elite whites in a different way; Bill Cecil Fronsman chose to include all but the planter elite, while Charles Bolton studied only the landless and slaveless population. Neither study attempts to treat the contacts between non-slaveholding whites and African Americans in a comprehensive way, but both note that these contacts did exist.[10] While this current essay explores only one aspect of non-slaveholding white and African American relations, namely the criminal, these groups also interacted on a social level, a religious level, and an economic level.[11]

Unlike some areas of the South, the South Carolina and Georgia low-country did not possess a numerical majority of non-slaveholding whites. The peculiar geography of the coastal plain which generously supported both rice and sea island cotton had led to the rise of an elite aristocracy living in luxury on the coastal plantations and in the gentrified towns of

Charleston, Beaufort, and Savannah. The premium placed on swamp land due to its rice-growing capability had effectively driven the poorer farmers from this area by the early nineteenth century, and had forced them to migrate to back-country areas to find affordable lands.[12] However, some non-slaveholding farmers did survive in the more inaccessible parts of the rice coast, in locations without river access, or in dense pine woodlands. The tax list for Liberty County in 1801 demonstrates this clearly.[13] Of the 289 people listed as taxpayers, 194 (68 percent) owned slaves. However, regional differences within the county make this figure somewhat artificial. In the main coastal areas around Sunbury and Newport, up to 85 percent of the population owned slaves, whereas the inland area near the Canochie River was generally populated by non-slaveholders, with less than 18 percent of residents owning slaves.

LIBERTY COUNTY TAX DIGEST 1801

District	Number of Taxpayers	Number of Non-Slaveholders	Percentage of Non-Slaveholders	Average Number of Slaves per Taxpayer
No. 1	101	16	15.84	11.6
No. 2: Newport	97	23	23.71	15.8
No. 3: Sunbury	35	10	28.57	11
No. 4: Canochie	56	46	82.14	0.5
Entire County	289	95	32.87	10.8

In 1838 Fanny Kemble, a famous English actress who married the planter Pierce Butler and lived on Butler's Point plantation near Darien in 1838 and 1839, described these rural people as those who "too poor to possess land or slaves, and having no means of living in the towns, squat (most appropriately it is so termed) either on other men's land or government districts—always the swamp or the pine barren—and claim masterdom over the place they invade till ejected by the rightful proprietors."[14] The obvious problem is that these non-slaveholding farmers rarely figure in the historical records. Often illiterate and highly independent, these farmers needed little contact with the outside world, and without legal contracts, business or family letters,

and other written documents it is almost impossible to describe their lifestyle accurately.

The historian fares rather better with municipal records. City government tended to create many different types of records; and while their survival is somewhat haphazard, they permit us to describe some aspects of the criminal relationship which existed between non-slaveholding whites and African Americans. Tax lists from both the city of Savannah and Chatham County allow us to isolate non-slaveholding whites because residents were, in part, taxed on the number of slaves they owned. City Council Minutes and Mayor's Court records show who was prosecuted for trading with slaves, who "entertained Negroes," and what the fines for such offenses were. The minutes from Chatham County Superior Court occasionally include trial testimony, thus providing an invaluable window into the mindset of criminals and detailed descriptions of their behavior. Hence we know significantly more about the lives of non-slaveholding whites in an urban rather than rural environment. In Savannah, non-slaveholding whites occasionally worked side by side with African Americans. The 1820 Federal Manufacturing Census for Chatham County listed seven industrial businesses which definitely employed both white and black workers, and since this census did not list traditional artisans such as carpenters or cabinet makers, it is likely that many more non-slaveholding whites (such as Henry Forsyth) were employed in shops or workshops that involved regular contact with African Americans.

It is the consequences of such personal contacts forged in the work place between the races that Henry Forsyth's case reveals.[15] During the trial Thomas Walsh testified to the fact the Forsyth worked for Mr. Morell but was not an indentured apprentice, and the records of the state penitentiary reveal that Forsyth was only eighteen at the time of confinement in 1838. It is certainly possible that this job, working for an important cabinet maker in Savannah, was Forsyth's first taste of employment. Forsyth was born in Georgia, and while he does not appear in any of the tax or census lists for the period, city residents without property, who were not heads of households, could often be overlooked by official statisticians. On his release from prison in 1841, Forsyth returned to marry in Savannah, despite having sought originally to leave the city. During the trial several witnesses testified to the fact that Forsyth had been unhappy in Savannah, stating that he quarreled frequently with his brother (who apparently also worked for

Morell), and that this was the original motive for the theft. Therefore we have a picture of a young man, newly employed in a trade, but most likely poorly paid, who for family reasons—and perhaps for a desire to start afresh in Augusta—decided to leave his place of birth and employment for the possibility of a new life. Forsyth's obvious problem was that relocation would cost money, something which he apparently lacked. Thus, most likely in an attempt to solve his financial problems and facilitate his migration, Forsyth turned to the idea of theft.

Isaac Morell was clearly a man of some substance. In 1837 he paid tax on merchandise valued at $11,000, and recorded his personal property as one slave (presumably George), a dog, and a house in Liberty Ward worth $1,250. As a cabinet maker, Morell could afford to charge high fees to his wealthier customers, and he was certainly prosperous enough to have sub-stantial amounts of ready money in his store. How then did George come to be involved in the crime? Clearly George and Forsyth knew each other fair-ly well, and it is certainly possible that a friendship of sorts had grown between them. In his confession to Morell once he had been returned to Savannah, Forsyth stated that the original idea of the theft had been George's, as George knew where the key to the store was kept. George's motive for participation in the theft is more difficult to determine. The fact that he joined Forsyth in traveling to Augusta, rather than seeking to escape to freedom in the Northern states, would seem to suggest that George's paramount objective was to leave Morell's service. By traveling with Forsyth, he received the protection afforded by any white person to an African American, while enjoying the freedom that being "owned" by Forsyth would have entailed. It is clear that to undertake this risk, George must have trusted Forsyth not to abuse the relationship they had.

Isaac Morell testified at the trial that there was $100 in bills, $15 in bills of exchange, and $3 in silver in his desk that Saturday night. However, Forsyth stated that when the money was divided at Sister's Ferry, he only took the change bills, one $10 bill, one $5 bill, and a silver dollar. Apparently George took the other $87—later he gave Forsyth another $8 or $10 when they were in Augusta. Why George took the larger share of the money is unclear. Maybe as Forsyth claimed, George was the main catalyst behind the theft, and as the mastermind, he claimed the lion's share of the pro-ceeds. Perhaps Forsyth was unwilling to carry such a large sum of money by himself, and preferred to place the responsibility and possible consequences

of detection firmly on the shoulders of the slave. Yet overall, the details of what happened to the money suggest that George was a true partner in this crime, and that he was able to assert himself sufficiently in the relationship to obtain his share of the proceeds.

Forsyth's case is just one example of a non-slaveholding white person interacting with a slave on terms which contravened the usual patterns of race relations in a Southern city like Savannah. The relationship between George and Henry Forsyth as outlined in the trial documents was clearly not one of domination or subordination based on race. Rather two people, who worked together on a daily basis, were able to overcome the obvious status differences between bondsman and freeman to mutual advantage and profit.

Nevertheless, the details of this case, however rich, do not prove that non-slaveholding whites interacted with slaves on a regular basis, or that such relationships were always on the same footing. Testimony from another trial in Chatham County Superior Court illuminates a different type of criminal relationship which could exist between non-slaveholding whites and African Americans. In 1839 John D. Roche was sentenced to five years' imprisonment for the simple larceny of a slave named January, the property of Colonel Stewart of Liberty County. Roche, in company with David Welcher, was traveling up the Georgia coast towards Savannah when they came across the slave, who called himself "Bob" and claimed to be on his way to Savannah after visiting family to the south. Gradually Roche came to believe that "Bob" was a runaway, which he communicated to Welcher before they reached Savannah. Once in Savannah, "Bob" was put to work for Roche and others, and occasionally Roche would claim ownership of the slave depending on who asked. Unfortunately for Roche a Savannah magistrate—William Pittman—recognized "Bob" as January belonging to Colonel Stewart of Jonesville, whom Pittman used to go hunting with. He took January to Daniel Stewart, the colonel's nephew, who agreed with this identification.

John Roche was a twenty-six-year-old Irishman whose professed trade was rum-selling. He received a five-year sentence for attempting to pass the slave off as his own, though he was pardoned eight months before the end of his sentence. The role of January in this crime reveals much about African American attitudes toward bondage. As a runaway January had little to lose by falling in with someone like Roche, who as a white person would offer a

measure of protection from the prying questions of the more suspicious-minded of Savannah's citizens. Indeed, Thomas Wilson testified at the trial that January had actually told him that he belonged to Roche. Maybe Roche was hoping that noone would claim January, and that he would be able to either keep or sell him as the occasion demanded. On his arrival in Savannah, Roche had apparently looked in the Savannah newspapers for an advertisement concerning this slave, but found none. As time went by, Roche no doubt became bolder in his belief that noone was going to claim the slave, and that he would be allowed to keep him, and but for the misfortune of meeting William Pittman he would probably have succeeded in his aim.

The relationship which existed between Roche and January was not the usual one of master and slave. Roche no doubt knew that if January talked to the right person and claimed to have been stolen, his own arrest would be the result. Equally Roche could easily have returned January to Colonel Stewart's plantation as a runaway, something January evidently did not relish considering that he had originally fled from there, and that he had made no attempt to leave Savannah during the several months the pair lived there. As an Irish immigrant, Roche may not have been aware of the seriousness with which his crime would be viewed by the white authorities.[16] As in the case of Henry Forsyth, a non-slaveholding white and an African American had managed to supplant the usual pattern of race relations with one of their own manufacture, based more on mutual advantage than on unilateral oppression.

Of course, not all non-slaveholding whites who helped runaway slaves intended to keep the slave for their own use. Moses Roper, a fugitive slave from Florida, described how during a journey across southern Georgia he managed to get tickets and pass for himself by pretending to ignorant farmers that he had lost his travel pass.[17] In January 1837, Cornelius McMannis was convicted of "concealing, harboring, & hiding a slave to the injury of the owner" and imprisoned in the common jail of Chatham County for fifteen days;[18] and in the 1840s Lewis Paine, a Rhode Islander who worked in Georgia as a schoolmaster, received a six-year prison sentence for trying to assist a slave named Sampson to escape to the North.[19] As an institution, slavery did little to help non-slaveholding whites as it was organized to preserve planter hegemony—thus it could not always hope to claim the loyalty of those whom it consigned to economic and social marginalization.

The severe sentences handed down to those believed to be conspiring against slavery exhibit the determination of the elite to limit the possible damage non-slaveholding whites could do to the "peculiar institution." Some historians disagree with this argument, citing the general consensus with which the Southern states proceeded towards secession in 1860 and 1861.[20] They attempt to account for the supposed support of non-slaveholding whites for the dissolution of the union by stating that white people of all social classes in the South based their world view in racial terms. Charles Bolton's recent book has undermined this argument somewhat by pointing out that in the North Carolina piedmont, a combination of fear and elite pressure ensured that unionist poor whites did not take part in the secession vote.[21] His argument would seem to be reinforced by the cases highlighted here, which show that some non-slaveholding whites were not prepared merely to ignore slavery but actively to undermine it by associating with slaves, thus blurring the racial divisions upon which the South was constructed.[22]

In order to establish that non-slaveholding whites and African Americans regularly rather than sporadically interacted in the cause of mutual advantage, we must turn to a slightly different source. While there are relatively few records of testimony from the antebellum Superior Court of Chatham County, Fine and Information Dockets from the Mayor's Court regularly detailed the prosecutions of Savannah residents for many petty crimes, including entertaining slaves after hours or on Sundays. Trading on a Sunday, whether to slaves or to freemen, had been made illegal in 1762, and subject to a five- or ten-shilling fine. Trading with slaves had been restricted in the first Georgia slave code of 1755. Slaves were only permitted to trade in fruit, fish, and garden produce by themselves, though they could purchase other goods on their masters' behalf. By 1818 those convicted of trading illegally with a slave in Georgia could be fined up to $500 and imprisoned for six months, though this docket reveals that the average fine for simply "entertaining Negroes" was more likely to be $5 or $10 unless there were aggravating circumstances. On June 22, 1837, Moses Fitts was fined $30 for entertaining Negroes after 11 p.m. and for "resisting the watch."[23] The fact that Fitts attempted to prevent the watch from discovering his crime, or that he resisted arrest, evidently made his crime more serious in the eyes of the law.

Nearly all of the people fined for "entertaining Negroes" or trading with slaves in Savannah were non-slaveholders.[24] It is therefore clear that some white people who didn't own slaves themselves were willing to trade with bondpeople, in contravention of the law, on a regular basis.

Of course, the slaves themselves must have believed that it was in their best interest to participate in this trade, otherwise it would not have flourished. Recent scholarship[25] has shown the high degree of informal economic activity by slaves in the Georgia lowcountry. Rice production, because of its labor intensiveness, had lent itself to the task system, which could mean that "active hands get through their proportion generally by the middle of the day, others in two-thirds of the day, after which, they are left to employ the balance."[26] While some slaves no doubt spent their free time in rest and recuperation, many others engaged in the production of goods, crops, and livestock. Masters generally accepted this economic activity due to the way it tied the slave to the plantation. As one slaveowner stated, "no negro, with a well stocked poultry house, a small crop advancing, a canoe partly finished, or a few tubs unsold, all of which he calculates soon to enjoy, will ever run away."[27] Philip Morgan posited the idea that slaveowners often did not care what their slaves did with their spare time, as long as the regular daily work routine did not suffer.[28]

What masters clearly disliked was the fact that goods stolen from the plantation could be sold under the cloak of legitimate trading. In May of 1836 the Grand Jury of Chatham County presented "as a nuisance that tends greatly to the fostering of crime, the practice of white persons within the precincts of this city buying of Negroes, cotton, iron and other articles that could scarcely come into the possession of the latter, but by theft. Although the law provides a punishment for this offense in ordinary cases, yet the requirements of proof are such and the difficulty of bringing home the charge to conviction so great, that the practice goes on with impunity to a great extent."[29] Examination of the minutes of the Superior Court reinforces the claim of the Grand Jury, with prosecutions for receiving stolen goods either being dropped for lack of evidence or resulting in an acquittal. Henry Bibb recalled that if a slave and a white person were caught trading in stolen goods, "the slave is often punished by the lash, while the white man is often punished with both lynch and common law."[30] It is certainly possible that planters operated a form of extra-legal justice to oust people suspected of trading with slaves from a particular locality.[31] Non-slaveholding

whites who deliberately purchased stolen goods from slaves were perceived as undermining the plantation discipline which planters strove so hard to maintain. If non-slaveholding whites allowed the slave the freedom of economic bartering, which trading with a shopkeeper usually entailed, the slave was implicitly recognized as a person capable of making decisions, and treated almost as an equal, thus weakening both the legitimization of slavery and the theory of white supremacy.[32]

The frequent complaints of Grand Juries throughout the Georgia and South Carolina lowcountry would seem to suggest that white shopkeepers placed great importance on this trade with the slaves. In 1835 a number of shopkeepers petitioned the Savannah City Council to allow slaves to trade on Saturdays rather than on Sundays, thus facilitating economic contacts.[33] This petition was an attempt to end the frequent prosecutions of shopkeepers for trading with slaves on Sundays, regardless of the law. Some shopkeepers remained open all night to trade with slaves, fully aware of the difficulty many slaves had in finding the time to trade. As an example of the amounts of money trading with slaves could bring in, Charles Manigault in his plantation journal for April 7, 1845, recorded that the purchaser of a $4,000 property near his own on Argyle Island was a Mr. Dillon who "has been keeping a grog shop in Savannah for several years, and made his money by trading with Negroes and has already established a grog and trading shop on his new purchase."[34] The illegal trade which existed between non-slaveholding whites and African Americans clearly worked on behalf of both. It gave the poor whites articles and foodstuffs normally beyond their price range, and it usually gave the slaves one of their more sought-after possessions—alcohol.

All three of Georgia's colonial slave codes prohibited the sale of liquor to slaves. In 1755 the penalty was set at 20 shillings for a first offense, and 40 shillings for a second offense, with a £20 good behavior bond. This evidently was not enough and in 1765 selling liquor to a slave would earn a £5 fine for a first offense and £10 for a second offense, and failure to pay the £20 good behavior bond would result in three months in jail. By 1826 selling alcohol to slaves in Savannah was punishable by a fine of up to $30. Yet despite these penalties most slaves seemed to have access to alcohol when they wanted it, and the obvious source of supply would seem to be the non-slaveholding white population. The loophole of permitting slaves to purchase alcohol with a ticket on behalf of their owners was clearly exploited

to the full by shopkeepers and bondpeople alike. In January 1830 the Grand Jury of Liberty County complained of "the retailing of spirituous liquors to our people of color under the alleged sanction of the law, a practice manifestly destructive of the good morals & best interests of this community."[35] Some members of the white elite evidently believed that any racial mixing would foster an alignment between the African Americans and the white non-elite against the established order.

The reaction of the elite to a perceived threat from non-slaveholding whites is shown in the formation of the Savannah River Anti-Slave Traffic Association in November 1846. The ostensible reason given for the formation of the association was "the extensive and growing traffic unlawfully carried on with slaves by white persons and chiefly by retailers of spirituous liquors." However, the lengthy preamble to the regulations shows how those who traded with slaves were regarded by slave owners. It was claimed that slaves were "supplied liberally with spirits in return for what they carry to the dram shops, instructed that they have the right to steal the fruits of their own labors, and indirectly, not infrequently directly taught to regard their owners, and especially their overseers, as unjust and unfeeling oppressors." The willingness of these shopkeepers to undermine slavery through encouraging slaves to see the fruits of their labor as their own made them, in elite eyes, potentially a more dangerous threat to the Southern way of life than Northern abolitionists: "The abolitionist declaims, the negro-trafficker acts. The one though an open and insolent, is a distant and comparatively harmless enemy; the other is the disguised fiend, who unless expelled from among us will surely and rapidly accomplish our ruin." Slaveowners were particularly concerned that the trade in stolen goods between slaves and poor whites was making the owner and their slaves "natural enemies," thus undermining paternalistic relations. The growth in the number of dram shops, which could not remain profitable "without carrying on this unlawful traffic with slaves," encouraged slaves to take "every article of value that is exposed; clothes hung out in our yards, household and farming implements, every thing that can be sold becomes their prey."[36] The counter-measures proposed by these slaveowners included a prohibition on slave hire, restrictions on the goods slaves could own and trade to certain crops, curfews at night, and economic boycotts of stores suspected of dealing with slaves. This response to illegal trading between non-slaveholding

whites and African Americans demonstrates the lengths to which some members of the elite would go to protect their own interests.

The willingness of non-slaveholding whites to participate in criminal activity with slaves and free people of color significantly alters our perception of what race relations, as a whole, were like in antebellum Savannah and the Georgia lowcountry. The economic and criminal contacts which clearly existed between non-slaveholding whites and African Americans undermine the idea that all Southern white people based their world view on race. To some white people, and apparently, especially the poorer white people, the necessity of making a living was certainly enough to override inbuilt racial prejudices and to contravene written law, as well as unwritten social norms. Some non-slaveholding whites perhaps acted out of opportunism, or exploitation of the slaves' willingness to steal from their owners. Others saw slaves as valuable customers whose business could not be lost. It is certainly feasible based on the evidence from Chatham County court documents that some non-slaveholding whites had lost faith in slavery and the Southern way of life. As Charles Bolton has argued, the enslavement of African Americans had not ensured the economic or social liberty of all white people.[37] Poverty, a trait which bound bondsman and some freemen together, could exert a powerful unifying influence. Trading with and committing crime with slaves fundamentally went against established patterns of race relations, and such actions were perhaps in part motivated by a realization by some non-slaveholding whites that Southern society was based on a hierarchy which they were not, and could not be, a part of.

-------------------------- NOTES

1. *The State vs. Henry E. Forsyth. Chatham County Superior Court, Criminal Testimony 1837–1840* (Georgia Department of Archives and History, Atlanta, Georgia—hereafter GDAH) and *Chatham County, Superior Court Minutes, 1836–1839, Book 14*—hereafter Book 14 (GDAH) May 14 and May 25, 1838.

2. See U. B. Phillips, *American Negro Slavery* (London: D. Appleton & Co., 1918) and *Life and Labor in the Old South* (Boston, Little Brown & Co., 1937); Winthrop D. Jordan, *White over Black: American Attitudes Towards the Negro* (Chapel Hill, University of North Carolina Press, 1968); Eugene D. Genovese, *Roll, Jordan, Roll: the World The Slaves Made* (New York: Pantheon Books, 1974).

3. See Ira Berlin and Philip Morgan, *The Slaves' Economy: Independent Production by Slaves in the Americas* (London: Frank Cass, 1991); Joyce Chaplin, *An Anxious Pursuit: Agricultural Innovation and Modernity in the Lower South, 1730–1815* (Chapel Hill: University of North Carolina Press, 1993);

Eugene Genovese, "Black Plantation Preachers in the Slave South," *Southern Studies* (1991) 203–229; Loren Schweniger, "Slave Independence and Enterprise in South Carolina, 1780–1865," *South Carolina Historical Magazine* 93 (1992) 101–125; Betty Wood, *Women's Work, Men's Work: The Informal Economies of Lowcountry Georgia 1750–1830* (Athens: University of Georgia Press, 1995)—hereafter Wood. Jeffrey Young, "Ideology and Death on a Savannah River Rice Plantation, 1835–1867: Paternalism Amidst 'A Good Supply of Disease and Pain,'" *Journal of Southern History* 59 (1993) 673–706.

4. Bill Cecil Fronsman, *Common Whites: Class and Culture in Antebellum North Carolina* (Lexington: University of Kentucky Press, 1992) 12.

5. Paul Buck, "Poor Whites of the Antebellum South," *American Historical Review* 31 (1925) 41–54.

6. Avery O. Craven, "Poor Whites and Negroes in the Antebellum South," *Journal of Negro History* 40 (1930) 16–17.

7. John Solomon Otto and Augustus Marion Burns III, "Black Folks and Poor Bukras: Archaeological Evidence of Slave and Overseer Living Conditions on an Antebellum Plantation" *Journal of Black Studies* 14 (1983) 185-200; Sue Mullins Moore, "Social and Economic Status on the Coastal Plantation: An Archaeological Perspective," in *The Archaeology of Slavery and Plantation Life*, ed. Theresa A. Singleton (Orlando: Academic Press, 1985), 141–160.

8. For a discussion of the importance of slaveholding to social status see James Oakes, *Slavery and Freedom: An Interpretation of the Old South* (New York: Knopf, 1990) 80, 94.

9. Eugene D. Genovese, "'Rather Be a Nigger than a Poor White Man': Slave Perceptions of Southern Yeomen and Poor Whites," in *Toward a New View of America: Essays in Honor of Arthur C. Cole*, ed. Hans L. Trefousse (New York: Burt Franklin & Co., 1977), 79–96.

10. The recent studies are Bill Cecil Fronsman, *Common Whites: Class and Culture in Antebellum North Carolina* (Lexington: University of Kentucky Press, 1992) and Charles C. Bolton, *Poor Whites of the Antebellum South: Tenants and Laborers in Central North Carolina and Northeast Mississippi* (Durham: Duke University Press, 1994)—hereafter Bolton. Bolton states that at harvest some poor whites were employed alongside blacks "on a similar ground of dependence and poverty," 105.

11. A full-length study is currently in preparation of the multi-faceted relationship between non-slaveholding whites and African Americans in lowcountry Georgia; see Timothy J. Lockley, "African Americans and Non-slaveholding Whites in Lowcounty Georgia, 1750–1830" (Ph.D. dissertation, Cambridge University, 1996).

12. See James Bonner, "Profile of a Late Antebellum Community," *American Historical Review 49* (1944), 663–680; Steven Hahn, *The Roots of Southern Populism: Yeoman Farmers and the Transformation of the Georgia Upcountry, 1850–1890* (Oxford: Oxford University Press, 1983); J. William Harris, *Plain Folk and Gentry in a Slave Society: White Liberty and Black Slavery in Augusta's Hinterlands* (Middletown: Wesleyan University Press, 1985).

13. *Liberty Tax List 1801, Margaret Davis Cate Collection* (Georgia Historical Society, Savannah

Georgia—hereafter GHS). It is likely that this tax list is complete rather than a fragment. The 1800 Federal Census (Washington, 1801) recorded 1346 white people in Liberty County; if 289 paid tax in 1801 this would make for a mean household size of 4.65, which is an acceptable figure for the antebellum South. For similar statistical conclusions see Philip D. Morgan, "A Profile of a Mid-Eighteenth Century South Carolina Parish: The Tax Return of Saint James, Goose Creek," *South Carolina Historical Magazine* 81 (1980), 51–65.

14. Frances Anne Kemble, *Journal of a Residence on a Georgian Plantation in 1838–1839* (London: Longman, 1863), 92.

15. David Roediger has argued that daily work contacts between slaves and non-slaveholding whites would undermine racist stereotypes held by both races. David R. Roediger, *The Wages of Whiteness: Race and the Making of the American Working Class* (London: Verso, 1991), 24.

16. For the life of immigrants in the South, see Herbert Weaver, "Foreigners in Antebellum Towns of the Lower South," *Journal of Southern History* 13 (1957), 62–73; ibid., "Foreigners in Antebellum Savannah," *Georgia Historical Quarterly* 27 (1953), 1–17; and Ira Berlin and Herbert Gutman, "Natives and Immigrants, Free Men and Slaves: Urban Workingmen in the Antebellum American South," *American Historical Review* 88 (1983), 1175–1200. Berlin and Gutman established that up to 60 percent of the working population of Southern towns such as Charleston and Savannah were immigrants (1182, 1186).

17. Moses Roper, *A Narrative of the Adventures and Escape of Moses Roper from American Slavery* (Philadelphia: Merrihew & Gunn, 1838), 69–72.

18. Book 14.

19. Lewis Paine, *Six Years in a Georgia Prison* (New York, 1851).

20. See for example H. Hoetink, *Slavery and Race Relations in the Americas* (London: Harper & Row, 1973) 15; J. Wayne Flynt, *Dixie's Forgotten People: The South's Poor Whites* (Bloomington: Indiana University Press, 1979) 11; David R. Roediger, *The Wages of Whiteness: Race and the Making of the American Working Class* (London: Verso, 1991) 12.

21. Bolton, 151.

22. For a discussion of the importance of race in the South, see U. B. Phillips, "The Central Theme of Southern History," *American Historical Review* 34 (1928), 30–43.

23. Fitts had paid tax on four slaves in 1833 (*Chatham County Tax Digest* 1833—GDAH); however, at the time of his offense he had evidently lost his slaves and all other property (*City of Savannah Tax Digest* 1837—GDAH).

24. Of the forty-two people prosecuted for offenses involving slaves between 1830 and 1838 in Savannah, only four were listed as slaveholders in contemporary documents. Of the other thirty-eight, twenty-three could be found in parallel sources. All twenty-three claimed to have no slaves. One offender, Pierre Howard, was fined three times in the space of two years for entertaining Negroes on Sunday.

25. Philip Morgan, "The Ownership of Property by Slaves in the Mid-Nineteenth Century Lowcountry," *Journal of Southern History* 29 (1983), 399–420; Lawrence McDonnel, "Money Knows No Master: Market Relations and the American Slave Community," in Winfred Moore et al., *Developing Dixie: Modernization in a Traditional Society* (London: Greenwood Press, 1988), 31–44; Ira Berlin and Philip Morgan, *The Slaves' Economy: Independent Production By Slaves in the Americas* (London: Frank Cass, 1991); Wood.

26. Report of Basil Hall in 1828, in Mills Lane, ed., *The Rambler in Georgia* (Savannah: Beehive Press, 1973), 66.

27. *Southern Agriculturalist* 1 (1828) 525.

28. Morgan, 411-413.

29. Book 14. Betty Wood has argued that whites who traded with slaves were evidently not sufficiently deterred by the penalties which could be imposed. Wood, 94–95, 147.

30. Henry Bibb, *Narrative of the Life and Adventures of Henry Bibb, An American Slave* (New York, 1849), 24–25.

31. Bertram Wyatt-Brown, "Community, Class, and Snopesian Crime: Local Justice in the Old South" in *Class, Conflict and Consensus: Antebellum Southern Community Studies*, ed. Orville Vernon Burton and Robert C. McGrath (Westport: Greenwood Press, 1985) 199; McDonnell, 36.

32. Bolton, 51; McDonnell, 31, 35.

33. Claudia Goldin, *Urban Slavery in the American South* (Chicago: University of Chicago Press, 1976).

34. James M. Clifton, *Life and Labor on Argyle Island: Letters and Documents of a Savannah River Rice Plantation, 1833–1867* (Savannah: Beehive Press, 1978), 22.

35. *Liberty County Superior Court Minutes 1822–1859* (GDAH). See also *Memorial of St. Andrew's Parish to Its Representatives in Columbia November 27, 1844* (South Caroliniana Library, University of South Carolina, Columbia, South Carolina—hereafter SCL), which describes the public houses of the area as "corrupters of the slave property of the planter."

36. Quotes in this passage are all from *Preamble and Regulations of the Savannah River Anti-slave Traffick Association* (SCL).

37. Bolton, 105.

BLoody Footprints

I have forsaken mine house, I have left mine heritage Mine heritage is unto me as a lion in the forest; it crieth out against me: therefore have I hated it. Mine heritage is unto me as a speckled bird, the birds round about are against her.

—Jeremiah 12: 7-9

I wish someone would look up the names on the roster of Washington's army at Valley Forge and trace the bloody footprints of their descendants across the North American continent until they were washed up and washed out on the shore of the Pacific. What an all-American Odyssey it would make! What a great history of the Rise and Fall of American Civilization.

—Oscar Ameringer, Socialist organizer, pre–World War I, Oklahoma

Labor cannot emancipate itself in the white skin where in the black it is branded.

—Karl Marx, Capital

REFLECTIONS ON GROWING UP POOR WHITE

ROXANNE A. DUNbar

W *hite Trash.* I believe the first time I heard that term was when I saw *Gone With the Wind,* referring to some pretty creepy people, dirt poor, sneaking, conniving, violent tenant farmers, or migrant cotton pickers maybe. At the time I saw that blockbuster picture show my father was alternately a tenant farmer, migrant cotton picker, and ranch hand, but I did not for one minute identify with those whom the planters and the enslaved Africans termed white trash in that movie.

Oh no, I identified with Scarlett, with the O'Hara family, the original Scots Irish settlers, agrarian masters of the savage indigenous Irish who brought their skills of civilization (read colonization) to America to take the

land from the savage indigenous Indians. The fact that my father's ancestors were original Scots Irish old settlers was what made me feel superior, even though my family surely could have fit the moniker, white trash. And those characterized as white trash in *Gone With the Wind* were surely also mostly descendants of Scots Irish old settlers. Their sons would die fighting to defend the very institution, slavery, which kept them poor. Their/our greatest heroes—Jesse James, the Younger and the Dalton brothers, Belle Starr—had been Confederate irregulars during the war and mythologized outlaws afterwards.

Once I asked my part Irish–part Native American mother, who had grown up orphaned and homeless in foster homes as a servant and in a reformatory, why my father's family name, Dunbar, was shared by a black person. In my high school English class we had just read some poems by the African American poet Paul Laurence Dunbar. I hoped my mother would say he was a relative of ours. But she said that my Dunbar ancestors were "Scotch Irish" and had once owned huge plantations and many slaves and that slaves took the names of the masters.

"How do we know we're related to the masters and not the slaves?" I asked.

"Because you are white," she answered, closing the discussion forever. Because I was white I was a descendant of the masters, whatever my economic or social situation, and it did not matter that my mother was a "half-breed."

My mother had married up, snagging a descendant of the old settler class. Never mind that he was a migrant cow puncher, then sharecropper. Upon marriage to him my mother became white, or at least her children would.

⊕ ⊕ ⊕

False consciousness. I learned this term much later, when a college Marxist friend, herself a child of blue-collar Greek immigrants, accused me of being a "class traitor," then apologized, amending her analysis to my having "false consciousness." I can't recall what the dispute was about but am certain she was right. At the time I thought she was a fanatic.

⊕ ⊕ ⊕

Poor, rural whites (the original white trash) have lived by dreams, at least the ones I come from did and, in a perverse way, still do, albeit reacting to

"broken dreams." (Someone or some force has hijacked their country and now controls the government—Jews through the supposed "Zionist Occupation Government," the Federal Reserve, Communists, Liberals, the United Nations, Gays and Feminists, Satan, etc.) Certainly it can be argued that all the immigrants from all over the world who have been drawn by the "American dream" from then to now believed and continue to believe in "it"—the American dream. But there is a distinct difference between the post industrial revolution, mostly urban immigrants who created the concept of "a nation of immigrants," and the original rural frontier settlers. The latter were landless or land-poor peasants given "free" (stolen) land on the edge of the colonies (later the states of the U.S. Republic). The price they had to pay for land and potential wealth was blood—to drive out the indigenous farmers, the Indians. They lived in terror, isolated, surrounded.

Of course, some made it and some didn't. Those who made it, like Andrew Jackson, were able to purchase, or sire, African slaves and become a wealthy planter and even a general and the president of the United States. Those who didn't make it, and even some of those who did, moved on, shed blood opening new lands, usually lost again, and moved on again. Foot soldiers of empire I call them/us. They unleashed rivers of blood, torrents of blood, unimaginable violence, murder, slaughter, which we refuse to acknowledge and confront but which cannot be dislodged from our collective memory. In the process of that struggle the trekker, the frontier settler, imagined himself and his progeny transformed into *the* native Americans, the true Americans. *Blood-right*, it could be called.

I come from a segment of white trash called "Okies."[1] They were the white, rural Oklahomans (and other southwesterners) who migrated to find work (and the American dream) in California during the Dust Bowl and Depression in the thirties and during World War II to work in defense plants. Before, during, and after that dramatic exodus, the people who came to be known as Okies formed a social construct and cultural identity which obliterated class and class consciousness. They were the end-of-the-line colonial trekkers—the majority of them also poor white—like the Boers of South Africa, many of the French "Pied Noir" of Algeria, failed British farmers in Kenya, Rhodesia, and for that matter the Hispanic poor of northern New Mexico and more recent trekkers to the rain forests of Central America and Brazil—marginal people, border people, people on

the edges of empire who can topple off with the slightest gust from transnational capital.

The Okies are those tough, land-poor losers whose last great hope in the American dream was born and died with the "opening" (theft from the Indians) of Oklahoma and Indian territories to white settlement at the end of the nineteenth century. Their great shame, like all white trash and colonial dregs, is poverty; that is, "failure" within a system which purports to favor them. As with the toss of the dice or spread of the cards, some win and some lose; the majority lose, and they are "white trash," colonialism's riffraff. So they are to blame for their failure, if not then who or what is? The system, of course. And that cannot be; even those losers themselves find blaming the system unacceptable, if not blasphemous.[2]

Unfortunately, and significantly, the story of those frontier settlers (Daniel Boone, et. al.) is ordinarily rationalized or romanticized by historians and popular culture, even by Marxists.[3] In looking at other cultures of colonialism, U.S. patriots—left and right—have little problem in acknowledging that in other locales colonialism/capitalism chews up and spits out its own settler/cannon fodder, and these become despicable pariahs. The difference with the United States is, first, we refuse or are reluctant to treat our history as a process of colonialism, although leftists acknowledge U.S. *imperialism* (post 1898). Since we are indoctrinated from birth in the ideology of "manifest destiny," we find it nearly impossible to truly distance ourselves from that false ideology. Instead, both right and left, whether the right-wing militias or Jesse Jackson, and mainstream politicians, too, mouth the same platitudes, repeating the origin myth, all claiming to try to recapture the "original" motivations of the "founding fathers," the "true" meaning of the Text, that is, the Constitution, each claiming to be the "true patriot" while the other is the "traitor" to the "origin" of our blessed, surely near-perfect Republic. And the "pioneer"[4] (colonial settler actually) is a sacred symbol of Jeffersonian and Jacksonian democracy, an "empire for democracy," as Jefferson put it. Imprinted in our minds is the covered wagon as the expression of the courage and willfulness of the "pioneer." Even those who condemn and name the genocide against the Native Nations and Africans forced into bondage hang on to the origin myth and particularly the figure of the frontier settler.

We dregs of colonialism, those who did not and do not "make it," being the majority in some places (like most of the United States) are potentially

dangerous to the ruling class: WE ARE THE PROOF OF THE LIE OF THE AMERICAN DREAM. However, self-blame, a sprinkling of white-skin privilege with license to violence against minorities, scapegoating, and serving as cops and in the military (give them a gun and point to the enemy) conspire to neutralize or redirect our anger. But above all it's that dream and the ideology, the "sacred" origin myth—the *religion* of "Americanism"—which keeps us doped and harmless, that and alcohol and drugs and cheap consumer items, especially sex and violence. But without the dream/ideology none of the other tricks would work.

<p style="text-align:center">⊕ ⊕ ⊕</p>

For most of my adult life I have devoted myself to social justice movements, identifying more as a child of the sixties than a child of my family. Yet during all that time I have tried to figure out the role we (white trash, poor whites, Okies) play.

The first thing I did when I made the decision to commit my life to political radicalism was to sit down for two months, twelve to fifteen hours each day, seven days a week (I was living on a student loan supposedly writing my history doctoral dissertation, which I did eventually) to write what I called my "life history." Trained as a historian I applied those research skills and knowledge to myself and my family as a case study. At the time I was influenced by psychoanalytical theory and practices, particularly Jacques Lacan and R. D. Laing. I believed that as a historian I had to do the same kind of historical self-analysis that a psychoanalyst does in personal analysis. That is, I had to master my own life history and reveal who I was in writing any other history.

I was, after all, a child of the times—"the personal is political"—so my methodology turned out to be widespread among the social rebels who were a formidable force at that time; surely that methodology is one of the most important and lasting contributions to come out of those turbulent years. But I rarely met anyone from my own background. All I could figure out to do was reject and condemn my people, my history, as middle class white radicals were doing.

On the night of the assassination of Martin Luther King, alienation from my own past and from everything about the United States and its history ravaged my mind. I wrote what I called "Dirge for White America My Home," filled with hatred:

I can only wish to see your surly redneck contemptible Smile
Turn to terror when you find yourself surrounded by Panthers
Or shot down by a woman too good to even spit on you after
You kick a Black kid or attack or hiss at a woman alone.
Maybe in that one minute you will regain your Humanity
And beg to die in your self-revealed Maddening horror.
I depart the dead body of my people and lead a Revolution
Against you. SLAVERY WILL BE NO MORE.
3 April 1968 Berkeley.[5]

Of course this vitriolic negation of my people was also a negation of myself and was by no means the final word. My ambivalence to my heritage remains alive and well—maddening as ever—today in my middle age.

The poor whites (white trash) I come from, Okies and their descendants, were those who formed the popular base for the post–World War II rise of the hard right in Orange County, California, Richard Nixon the anti-Communist was their man. They were the "little people" and "silent majority" addressed by Richard Nixon as President, then by Ronald Reagan. They were among the bigots, including my father, who supported George Wallace. During the 1980s, they helped swell the ranks of the Christian Coalition, promoting anti-abortion and anti-gay initiatives. They fall in and out of the owning and working class, unreliable in union struggles. Depending on economic times they may be self-employed or reluctantly working for a boss, but their dream is always to acquire land. We are descendants of peasants and cling to that world view mixed with a common history of struggle to acquire land, blood for land, to seize the promised land, implement the Covenant. We are the true Chosen People.[6]

A populist tradition is associated with poor whites,[7] yet often my people hate the rich only out of envy. Hostile to "big government," they are in the vanguard of defending their country claiming to want to "save" it. As Okie country artist, Merle Haggard, sings: "When you're runnin' down my country, hoss, you're walkin' on the fightin' side of me." Many have been eager cannon fodder as well as officers in America's foreign wars. They believe they are the designated beneficiaries of the theft of land from Indians and to the booty of empire and the whole world is a stage.

In the end the only advantage for most has been the color of their skin and the white supremacy, particularly toward African Americans, that pervades the culture; what they are *not*—black, Asian, foreign born—is as important as what they are—white, "true" Americans—in their sense of propriety and self-esteem.

When Richard Nixon died in the spring of 1994, television cameras focused on his Orange County home. Clusters of simple white people gathered silently, placing flowers, lingering. Soon thousands had gathered, Nixon's "silent majority," trekkers and their descendants paying tribute to their favorite son, his political base for forty-five years. He had won his first political race for Helen Gahagan Douglas's seat in Congress by red-baiting her. A former actress, Helen Gahagan Douglas had been in the forefront of publicizing the plight of the Dust Bowl Okies and was their champion in Congress. All that might appear harmless enough, reflecting the last gasps of a dinosaur. But why did President Clinton order flags at half staff and attend the funeral along with every other notable? The polls took note of those milling white mourners.

The most painful part of my quest for identity has been the juggling of my poor white experience and my knowledge of the power of white privilege in this society. Becoming an internationally oriented social activist, a scholar and a writer, I largely evaded coming to terms with "white trash," which is fundamentally a class question. Although my means of escape is not typical of people from my kind of background, it comes down to the same resolution—escape poverty, leave that life behind. Novelist Ken Kesey puts the dilemma succinctly:

> Let me tell you what being an Okie means: Being an Okie means being the first of your whole family to finish high school let alone go on to college . . . Being an Okie means getting rooted out of an area and having to hustle for a toehold in some new area . . . Being an Okie means running the risk of striving out from under a layer of heartless sonsabitches only to discover you have become a redneck of bitterness worse than those you strove against.

Survival dynamics are acknowledged and well-known about African Americans, Latinos, Native Americans, and ethnic communities in the United States, but are hardly known to exist with poor whites. That hasn't always been so; during the three periods of leftist surges this century (the nineteen-teens, the thirties and the sixties), great attention and tribute were paid to the internal dynamics of poor white families and communities to the point of romanticization. Because social and economic status are so shaky for poor whites and self-blame or scapegoating so prevalent, class consciousness is damaged. The false consciousness of poor whites in the U.S. is an example, in Marxian terms, of "superstructure" (ideology) overriding "economic base," or economic self-interest.

Despite fantasies of becoming a movie or sports star and get rich fast schemes, the two most successful means of class-climbing among poor whites, like other poor groups, is marrying up and/or education. Marrying out and up is probably more possible for women than men and is certainly something my mother preached to my sister and me. Indeed marriage was my way out of my class and into the middle class. It was during those six years of marriage and that transformation that I slowly comprehended the class question.

I was eighteen and he was nineteen when we married. Jimmy had grown up on the family estate outside Oklahoma City. The house, which his father had built himself, was out of an English novel—a rambling five-bedroom, two-bath, native-stone mansion with a stone, wood-burning fireplace, thick carpets, fine antiques, chandeliers, and cut-glass crystal and bone china displayed in mahogany "breakfronts," as they called the glass-front display cabinets. The place was surrounded by a stream and woods and gardens. At the end of a long stone path was a huge stone patio and barbecue pit. There were even two oil wells.

As Jimmy showed me around the first time he took me to meet his family, I kept saying to myself: "This is where Jimmy grew up," followed by "Why does he love me?" I couldn't even comprehend such a life. The land had been homesteaded by his mother's Scots Irish family who farmed it. When his mother married his carpenter father, who was descended from Dutch Protestants, they lived there, then inherited the land. They were simple farming people, potentially poor whites, but during the Depression and World War II the construction company Jimmy's father worked for grew huge and rich off government contracts, and he climbed from journeyman carpenter to chief superintendent. After the war he sold some of the land to the state to build the Tulsa Turnpike, invested in real estate (slumlord), then built the new house before Jimmy was born. Jimmy grew up rich. The only blight on his and the family's life was that his mother—he called her "an angel"—had died just before I met him.

Jimmy's father fit my image of a patriarch or an English country gentleman out of one of my favorite novels at the time, *The Forsythe Saga*, a man of property. He wore a fine cashmere overcoat and a fur cap. I had never seen anyone with a fur cap. He greeted me by shaking my hand. He was different from any man I'd ever met. A strange thought passed through my mind as I walked down the aisle holding my father's arm. Initially Jimmy's

father's construction company grew rich off New Deal WPA construction contracts during the Depression. It occurred to me that my father when he worked for the WPA may have had my new father-in-law for a boss. The thought made me feel like a traitor and haunted me during the marriage.

If my father had asked me, "Do you really want to go through with this?" I would have said, "No Daddy oh no, please take me away." But he did not ask and instead of taking me away he gave me away.

One reason for marrying Jimmy was so I could go to college, or that was his argument in persuading me to marry him right away. His father offered to pay both our college expenses and provide a free place for us to live. Yet within a week after the wedding Jimmy announced that he wanted us to be self-supporting and persuaded me to work and wait to go to college.

"You support me until I graduate then I'll support you to go back to school, it's only three years," he'd argued, adding the clincher: "My sisters think you might be a gold digger just looking for a free ride off the family but if you work they would know that's not true." What Jimmy's older sisters thought of me mattered a great deal, to him and to me. I agreed to work.

Jimmy and I lived in the three-room garage apartment near the "big house." I idolized Jimmy's family and adopted them as my own, especially his sister Helen who lived with her husband in a cottage they built nearby. She called me "a diamond in the rough." I accepted the role and submitted to being polished. Helen said I was from good peasant stock like Tolstoy's characters and embodied the nobility of the peasantry enriched by being part Indian. I shivered with pleasure when she told me those things.

The whole family opposed racism and segregation. Despite his wealth and being a boss Jimmy's father was pro-union and thought racism resulted from the ignorance of poor white people. Even before the Supreme Court decision on school segregation he'd fought for integration, not very successfully, in the Carpenters Union and as a superintendent on jobs had hired black laborers and hod-carriers. He invited his construction workers and their families including the Blacks to his famous barbecues. I imagined that he was like my Wobbly grandfather, although when I asked him once what he thought of the Wobblies he said they had been anarchists and crazy and un-American.

Everyone in the family read *Time* and *The New Republic* and knew all about what was happening in the world. I soaked up everything they said and I read and read.

I began to wonder about the price I had to pay for my new class status when one summer Saturday afternoon Jimmy and I went to drink beer with his sister and her husband in a tavern we hadn't been to before. The barmaid turned out to be a woman I knew growing up, from a very poor white family.

"Darla, what are you doing here, how is your family?" I said. I was so happy to see her.

Darla wore a tight-fitting red sun dress. Her bosom protruded seductively. She looked different, not so much older but somehow hard, her skin rough. Yet she remained strikingly beautiful with her mane of thick black hair, her smoky skin. Darla hesitated and I thought she didn't remember me. I followed her eyes—she was studying my companions.

"Fancy seeing you here, how are you stranger?" she said, a teasing tone in her voice. Then I realized she was shocked because she had known me as a devout teetotaling Baptist. She looked amused and approving.

"I got married, Darla, this is Jimmy, and his sister and brother-in-law," I said.

Jimmy looked up at her sideways and said, "Howdy do." Suddenly I was aware that Jimmy did not approve of Darla. He glared at me as if I were a stranger, or a traitor.

When Darla returned to serve us she handed me a slip of paper with her phone number on it. "Give me a call, I'm off now." She left with a man who had been sitting at the bar.

"You got some outstanding old friends, Roxie," Jimmy said, not with a smile.

"She's from my hometown. I used to baby-sit for her, you remember me telling you about her." I heard apology in my voice, and shame.

Later when we were alone Jimmy said, "You're not going to call that woman, are you?"

"I thought I might, why not?" I said.

"She's a prostitute," he said.

"She's my friend," I said.

"Not any more. You associate with low-life like that and you will become like them," he said.

I said nothing and never called Darla and never saw her again.

Other contradictions arose which disturbed me—for instance, when Jimmy and I drove to Colorado to see the scenery, my first trip outside Oklahoma.

All along the highways were broken-down cars and pickups with women and children and old people sitting in the shade while a man worked under the hood. They beckoned for us to stop and help. Jimmy passed them by.

"Why don't we stop?" I asked. No one in my family would ever have passed up a stranded motorist, but then we never strayed far from home.

"They're hustlers, rob you blind, highway bandits," Jimmy said.

"How do you know?"

"I just know, they use the kids and old people for bait to get you to stop, then rob you, they're transients, fruit pickers, white trash."

I stared at the sad faces as we passed by and tried to see the con artists and criminals behind the masks. But they merely looked familiar, like my own relatives.

Yet we got plenty of help on the highway. Practically everything that could go wrong with a car plagued ours—the radiator burst, the regulator busted, the carburetor spewed gas, even the ignition wire broke, flat tires on several occasions. Each time we broke down, always in the middle of nowhere, someone stopped to help us or gave Jimmy a ride to the next station.

"How come they don't think we're highway robbers?" I asked. The people who stopped to help us were invariably driving old cars or pickups and looked a lot like the people who tried to get us to stop. New cars whizzed on by.

"They can tell," Jimmy said.

I began to suffer frightening symptoms. For no apparent reason I would be overcome with a blinding white rage. I could see and hear and control my movements, and it seemed to me that I chose to scream or to run and hide or to kick a chair or slam a door. Yet I couldn't prevent or stop it. The fits would last from a few minutes to hours. Inside the fit I felt terror and sometimes a strange euphoria, a feeling of safety. The first time it happened I thought Jimmy would leave me but he wrote me a page-long note saying I was too good for the evil world around me, that I had a pure mind and soul, that I was perfect except for that tiny flaw in my personality which came from my inferior background, and that it was his destiny and mission in life to protect and care for me.

On other occasions Jimmy would shake me awake, saying I was grinding my teeth. Once he recorded it for me to hear. The sound was loud and eerie. Insomnia plagued me. I was afraid to go to sleep not knowing what I would do. Control became the center of my life and I would go long periods with-

out fits or nocturnal sounds. During those times I had blinding, disabling migraine headaches and nausea.

Jimmy and his family believed in inherited traits, either through genes or socialization. They never let me forget, by so carefully helping me, how much I had to overcome with my poor upbringing, the possibility that I was a "bad seed."

One autumn day in my third year of marriage I was home sick with the flu and found myself the only person on the grounds. I had never been alone there before. The place was so serene and lovely, the oak leaves bright yellow, a maple tree flaming red, the blackjacks burnished copper. The huge lawn that sloped down to the creek was still a carpet of green thanks to the sprinkler system.

I sat down on the stone bench in the patio that was halfway between the creek and the big house. Even though I was only thirty-five miles from where I grew up it was so different, rolling hills with trees rather than flat and barren, no cannibalized old cars and junk around.

"How lucky I am," I said aloud and felt like yelling it since no one would hear. I could never have dreamed of being a part of that kind of life three years before. Jimmy's family had taken me in as one of their own. Forever and ever I would be safe and secure and loved. I loved my sisters-in-law and father-in-law as if they were my own flesh. I would never be poor or want for anything again. I tingled with happiness, tears of joy streaming down my face.

The sound of a car startled me out of my reverie. The mail carrier. He always brought everyone's mail to the big house and put it on the back porch where we could each fish out our own. I strolled up the hill to check. Rifling through the pile I saw a letter to Helen from the sister who had moved to California. The letter was barely sealed, just at the tip. I stuck my little finger under the flap and it popped open. I slipped the letter out of the envelope and unfolded the two pages.

My eyes fell on the middle of the first page and the words hit me like a blast of icy wind: *I think you are right that it remains to be seen if Roxie will drag Jimmy down to her level or if he can pull her up to his. Coming from her background she may be beyond rescue. I wish Jimmy would leave her.*

I had to sit down to keep from falling from dizziness. I could not believe what I was reading, and that there had been other letters and conversations, letters about me ruining Jimmy.

The letter was almost entirely about me, mostly a discussion of the condition of "white trash," whether it was genetic or social, and the "complication" that I was part Indian. I read the letter a second time telling myself they were concerned about me because they loved me and wanted to help me. But it wasn't there, only concern for Jimmy and the wish that I would disappear or had never appeared. The letter ended by saying that Jimmy had met me at a vulnerable time in his life just after their mother's death, and I being a gold-digger and devious had entrapped him and pressured for a quick marriage.

I felt like running, packing a suitcase and leaving without a word. I would not be able to tell Jimmy because he would know I'd opened the letter. I vowed to remain quiet, to finish what I'd started, sending Jimmy to school. He would graduate in three months, then I would insist that we leave. I would carry out my part of the bargain and I would not lose Jimmy. And so we did move to San Francisco; my husband sent me through college, where I learned, among other things, about being a class traitor. I went my own way, away from him, and threw myself into the struggles of my generation, determined never to forsake my class again.

---------------------------- **NOTES**

1. See my research essay, "One or Two Things I Know about Us: Okies in American Culture," in *Radical History Review* 59:4–34 (1994). My immediate family did not join the exodus—my father says we were too poor to make the trip—to California; although many from my extended family did, and eventually three of the four of us children moved to California. California was definitely "the promised land" of my childhood.

2. The militia movement and other right-wing populist groups are using the term "the system" to identify their enemy—international capital, politics and military, the IRS, FBI, SATF, etc. See the "bible" of this anti-government network: Andrew Macdonald (William L. Pierce), *The Turner Diaries* (Hillsboro, WV: National Vanguard Books, 1978).

3. There are signs of change in mainstream culture. In 1993, the Pulitzer Prize for drama was awarded to the eight-hour play *The Kentucky Cycle*, which is significant because it is the true history of the fate of the frontier settlers, and because it won the prestigious award. Kevin Costner, himself a son of poor white Okie migrants, bought the film rights and is producing it for HBO.

4. "Even in those early years of settlership, however, forces were at work which helped to produce in the collective consciousness of the invaders a strange new self-image. In the first place, their land seizures were fiercely resisted by the peoples whom they first encountered. . . . Thus began a tribal resistance to colonization . . . in the course of which [the settlers] even when victorious, came to regard

themselves as physically and culturally isolated and hemmed in. Their symbol for this sense of isolation became . . . a defensive circle of covered wagons."

The above is from a study of Boer nationalism in South Africa (Anthony Holiday, "White Nationalism in South Africa as Movement and System," in Maria van Diepen, ed., *The National Question in South Africa* (London: Zed Press, 1988: 79). Certainly we have more in common with the Boers than the Bolivars.

5. Published in *No More Fun and Games: A Journal of Female Liberation* 1:1 (August 1968).

6. "Three ideas seem closely linked to the idea of a 'chosen people'. The first is that this chosen people is endowed with the 'divine mission' of guiding and civilizing . . . The second is that this 'chosen people' cannot and must not interbreed with other peoples . . . The third is that the 'chosen people's' right of ownership over the land is inalienable, because it is the 'promised' land given by God." (Marianne Cornevin, *Apartheid: Power and Historical Falsification*, Paris: UNESCO, 1980: 33).

7. My grandfather Dunbar was a Wobbly (Industrial Workers of the World—IWW) in western Oklahoma and a life-long socialist, as were a large number of trekker descendants who ended up losers on the last frontier. My father is named after the founders of the IWW—Moyer Haywood Pettibone Dunbar. See my research essay, "One or Two Things I Know About Us," cited above. For the most comprehensive study of agrarian socialism in Oklahoma, see James Green, *Grass-Roots Socialism: Radical Movements in the Southwest 1895–1943* (Baton Rouge: Louisiana State University Press, 1978).

PART II
WHITE TRASH PICTURES

Crackers and Whackers

The White Trashing of Porn

Constance Penley

WHITE TRASH THEORY

Before getting into my topic—porn's predilection for white trash looks and tastes—I want to say something about the benefits to one's theoretical formation that can accrue from growing up white trash. This brief comment is not a digression from my topic, because it was precisely my white trash upbringing that gave me the conceptual tools to recognize that predilection and the language to describe and explain it. I cannot imagine any better preparation for grasping the intricacies of contemporary theory and cultural studies than negotiating a Florida cracker childhood and adolescence. I

understood the gist of structuralist binaries, semiosis, the linguistic nature of the unconscious, the disciplinary microorganization of power, and the distinguishing operations of taste and culture long before I left the groves of central Florida for the groves of academe. At the University of Florida in Gainesville, the University of California at Berkeley, and the Ecole des Hautes Etudes en Sciences Sociales in Paris, I encountered the ideas of Saussure, Lévi-Strauss, Barthes, Althusser, Lacan, Foucault, and, somewhat later, Certeau and Bourdieu. In those ideas I immediately recognized the home truths of white trash or, as Barthes would say, white trashnicity.

How does such theoretical precociousness emerge in cracker culture? Consider, for example, the intense conceptual work involved in figuring out the differential meanings of white trash—what it is because of what it is not, a regular down-home version of honey and ashes, the raw and the cooked. A Southern white child is required to learn that white trash folks are the lowest of the low because socially and economically they have sunk so far that they might as well be black. As such, they are seen to have lost all self-respect. So it is particularly unseemly when they appear to shamelessly flaunt their trashiness, which, after all, is nothing but an aggressively in-your-face reminder of stark class differences, a fierce fuck-you to anyone trying to maintain a belief in an America whose only class demarcations are the seemingly obvious ones of race.

If you *are* white trash, then you must engage in the never-ending labor of distinguishing yourself, of codifying your behavior so as to clearly signify a difference from blackness that will, in spite of everything, express some minuscule, if pathetic, measure of your culture's superiority, at least to those above you who use the epithet "white trash" to emphasize just how beyond the pale you are. This is hard going because the differences between the everyday lives of poor blacks and poor whites in the rural South are few and ephemeral. I am not denying the difference of race—and how that difference is lived—but trying to point to the crushing weight, on all those lives, of enduring poverty and the daily humiliations that come with it.

Even someone with as impeccable white trash credentials as my own can recall only one "distinction": white people don't eat gopher but blacks do (gopher is crackerese for a variety of land turtle). Perhaps I remember the socio-anthropological distinction "gopher/not gopher" because it intersected with so many other distinctions marked by race, gender, and

economic class that would, as I came to realize, both help and hinder me as I grew up and out into the world.

I made money as a kid by catching the slow-moving gophers in the white-owned groves and selling them for a quarter each to my teenage cousin Ricky, already a reprobate but a shrewd entrepreneur. Ricky would turn around and sell the gophers for fifty cents in East Town, the black neighborhood where I, as a white girl, was not allowed to go. I progressed from being grateful to my cousin for giving me the odd quarters to chafing at the restrictions on my mobility and my own budding entrepreneurship. This was especially so after Ricky had rounded up a crew of gopher-catchers from whose labor he was able to extract for himself at least as much as the minimum wage Disney pays its workers now toiling on our old hunting grounds.

But crackers are not always content merely to learn the complex stratagems of maintaining the tenuous distinctions of white trash culture; they sometimes go beyond that understanding to devise the critical method of using white trash against white trash. The epithet "white trash" can be deployed in a similar way to the original usage of "politically correct" within left circles, where a group would adopt the phrase to police its own excesses. My brother and I had a favorite game, which was to try to figure out which side of the family was the trashiest, our mother's Tennessee hillbilly clan or our father's Florida cracker kin. The point of the game wasn't to come to a definitive conclusion (we agreed it was pretty much a toss-up) but to try to selectively detrash ourselves, to figure out just how trashy we were so as to monitor and modify our thinking and behavior as much as possible. We vied to amass the most self-humiliating family statistics by claiming for mom's or dad's side the greatest number of cousins married to one another, uncles sent up the river for stealing TV sets, junked cars on blocks in the front yard, converts to Jehovah's Witnesses, or grandparents who uttered racist remarks with the most vehemence and flagrancy. Why my brother and I came to want to engage in this funny but painful detrashing project is a long story that must wait for another day, but the fact that we created this game demonstrates that whitetrashness does not just involve the effort to make distinctions in response to a label coercively imposed from above ("Hey, at least we don't eat gopher!") but can also be a prime source for developing the kinds of skills needed to grasp the social and political dynamics of everyday life.

Growing up white trash, then, can give one the conceptual framework for understanding the work of distinction and the methods of criticism. But the real advantage lies in the way that upbringing helps a nascent theorist grasp the idea of agency and resistance in an utterly disdained social group whose very definition presumes it to have no "culture" at all.[1] The work of distinction in white trash can be deployed downward, across, but also up, to challenge the assumed social and moral superiority of the middle and professional classes.

------------------- WHITE TRASH PRACTICE

Considering the ways that white trash can be deployed up as a form of populist cultural criticism brings me to pornography. We already have several good discussions of the class nature and class politics of pornography, although the research on earlier periods is more extensive than that on the products of today's commercial industry. The contributors to Lynn Hunt's *The Invention of Pornography: Obscenity and the Origins of Modernity, 1500–1800* give a wealth of examples of the way pornography was used during that period to challenge absolutist political authority and church doctrine, variously linked as it was to free-thinking, heresy, science, and natural philosophy.[2] In *The Literary Underground of the Old Regime* Robert Darnton describes the workings of the eighteenth-century literary underground, a counterculture that produced smutty, muckraking, libelous literature and images that mocked and eroded the authority of the Old Regime.[3] In *The Secret Museum: Pornography in Modern Culture* Walter Kendrick argues that nineteenth-century pornography had no typical content of its own but consisted solely of dangerous and seditious images and ideas that the ruling classes wanted to keep out of the hands of the presumably more susceptible lower orders.[4] Defense attorney Edward de Grazia's *Girls Lean Back Everywhere: The Law on Obscenity and the Assault on Genius* tells story after story of early and mid-twentieth-century attempts to defend books such as *Ulysses*, *Tropic of Cancer*, *An American Tragedy*, *The Well of Loneliness*, *Howl*, and *Naked Lunch* against the efforts of the state, the police, and religion to ban this material from public and popular consumption.[5]

But where are the defenders of contemporary works like *Tanya Hardon*, *The Sperminator*, or *John Wayne Bobbitt: Uncut*? The more mass-cultural the genre becomes, and, it seems, the more militantly "tasteless," the more

difficult it is to see pornography's historical continuity with avant-garde rev-olutionary art, populist struggles, or any kind of countercultural impulses. Add the feminist anti-porn polemic and this low-rent genre appears unre-deemable artistically, socially, or otherwise. Exceptions do get made, of course, for quality politically oriented gay male videos, such as Jerry Douglas's *Honorable Discharge*, about gays in the military; Candida Royalle's "couples erotica"; Fatale's lesbian-made videos for lesbians; and educational porn, which includes Gay Men's Health Crisis's safer sex videos or porn star and feminist Nina Hartley's guides to better fellatio and cun-nilingus. But within mass-commercial videos, the great majority of the titles are seen to merit little critical, much less feminist, interest.

Two writers have suggested why this might be the case. In the "Popularity of Pornography" chapter of Andrew Ross's *No Respect: Intellectuals and Popular Culture*, Ross argues that the feminist disdain for pornography is a Victorian holdover, a conditioned middle-class female revulsion for anything associated with the lower orders, a revulsion that leads directly to, as Judith Walkowitz has shown in the case of nineteenth-century feminism, the political strategy of legislating an outright ban (the temperance movement) or engaging in moral reform and public hygiene efforts (getting prostitutes off the street and into "proper" jobs as maids and factory workers).[6]

Laura Kipnis builds on Ross's argument about feminism and the class pol-itics of porn in "(Male) Desire, (Female) Disgust: Reading *Hustler*."[7] She tells us how she made herself overcome her revulsion for the magazine to be able to sit down one day and actually look at it. Kipnis discovered that this most reviled instance of mass circulation porn is at the same time one of the most explicitly class-antagonistic mass periodicals of any genre. *Hustler*, she found, was militantly gross in its pictorials, its cartoons, its edi-torials and political humor, with bodies and body parts straight out of Rabelais, all put to service in stinging attacks on petit-bourgeoisiehood, every kind of social and intellectual pretension, the social power of the pro-fessional classes, the power of the government, and the hypocrisy of orga-nized religion. Although Kipnis remains grossed out by *Hustler*, her reading of the magazine gives herself and us an invaluable insight into the class-based reasons for that revulsion and the social and political uses of grossness. She is careful to point out, however, as Darnton does in his study of the eigh-teenth-century French literary underground, that the libertarian politics here

are not always or necessarily progressive but still serve an important role in questioning repressive and pretentious assumptions of morality and authority. You can be sure that if Newt Gingrich is *Hustler*'s "Asshole of the Month," Oprah Winfrey will have the honors next time (and they did, in consecutive months, 1995).

What Kipnis calls *Hustler*'s grossness could also be characterized as an ingenious deployment of white trash sensibilities. Don't look to this magazine for the kind of witty and bitter barbs that issue forth from the mouths of Brecht's working-class anti-heroes. When *Hustler* maneuvers into class position, it stations itself firmly on the bottom of the socio-cultural chain of being. Its deliberately stupid humor, savaging of middle-class and professional codes of decorum, its raunchiness and sluttiness all scream white trash. But this kind of lumpen bawdiness is not unique to *Hustler*. It pervades contemporary mass-commercial porn as well as the entire history of U.S. porn production, far more so than does the "classier" tone of *Playboy* and *Penthouse*.

To me and to the students in a course I teach on pornography as a popular American film genre, the most striking feature of the films we survey, beginning in 1896, is the ubiquitous use of humor, and not just any kind of humor, but bawdiness, humorously lewd and obscene language and situations.[8] From the teens to the late sixties the predominant form of pornographic film was the short, usually black and white, anonymously produced film known variously as the stag film, blue movie, or "smoker," so called because of the smoke-filled rooms where men would gather for clandestine screenings organized by itinerant projectionists. In a recent sympathetic evaluation of Linda Williams's *Hard Core: Power, Pleasure, and the Frenzy of the Visible*,[9] the (yes, I'll say it) *seminal* book on pornographic film, Peter Lehman worries that she misses some crucial aspects of porn by overestimating the importance of narrative structure and neglecting the role of "fleeting moments of humor in porn."[10] His argument about the relatively greater importance of "fragmentary pleasures" over narrative resolution is persuasive but his assessment that there are only "fleeting" moments of humor in porn falls short. Stag films are full of humor, and the narrative, which, as Lehman notes, is often more vignette than fully developed story, is itself structured like a joke. And here we are talking about really bad jokes, ranging from terrible puns to every form of dirty joke—farmer's daughter, traveling salesman, and Aggie jokes. Of course not all of the sexually explic-

it films of this period exhibited the bawdy, farcical character of the stags. The short peep show loops consisted of earnestly direct views of sexual action with little setup and no story. But the majority of the few hundred American stag films made for collective male viewing depended on this popular brand of humor. This is especially the case with the pre–World War II films that were made on the edges of the entertainment world and thus shared the qualities of both burlesque and silent film comedy.[11]

Given the enormous success of the feminist antiporn movement—and their strange bedfellows, the religious right—in shaping the current prevailing idea of porn as nothing but the degradation of women and the prurient documentation of the most horrific forms of violence waged against women, it may be difficult to recognize that the tone of pornography—when one actually looks at it—is closer to *Hee Haw* than Nazi death camp fantasies. Also difficult to recognize because it so goes against the contemporary typification of porn as something *done to* women, is that the joke is usually on the man. And if the man is the butt of the joke, this also contradicts Freud's description of the mechanism of the smut joke, in which any woman present at the telling of the joke is inevitably its butt.

On the Beach (a.k.a. *Getting His Goat*) is a classic stag film from 1923 that illustrates both the kind of humor and the level of commentary on masculinity found in the typical stag film of the era. The narrative is that of a practical joke, played on a hapless man. The man (Creighton Hale, better known as the professor in D. W. Griffith's *Way Down East*), is daydreaming while leaning on a fence at the beach. "Idylwild Beach," the intertitle tells us, "Where the men are idle and the women are wild." He spies three playful, laughing women who disrobe to go for a swim, and steals their clothes. The women agree to have sex with him to get their garments back, but only if he forks over money and has sex with them through a hole in the fence. The punning alternate title of the film tells you what's coming next: what the man believes is "the best girl I've ever had" is a goat the women back up to the hole in the fence. The women take all his money, which he happily gives, and prance away down the beach. At some unspecified time later, the three women reappear. On spotting the erstwhile daydreamer, one tucks a pillow under her dress to simulate pregnancy, and the women again extract money from the bewildered man, once more "getting his goat." The women in the film are not portrayed as motivated by some intrinsic female evil but rather a kind of charming mischievousness, and the man is shown

deserving what he gets because of his sexual and social ignorance. "Watch your step. There's one born every minute," says the final intertitle in a cautionary address to the male audience not to be fools to their own desires.

The low-level humor of many stag films can be traced back to the bawdy songs and dirty jokes that inspired them. If Linda Williams's breakthrough was to get us to think of pornographic film as *film*, that is, as a genre that can be compared to other popular genres like the western, the science fiction film, the gangster film, or the musical (porn's closest kin, she says), and studied with the same analytical tools we take to the study of other films, the next logical step, it seems, would be to consider pornographic film as popular culture. We would then be able to ask what traits pornographic film shares with the production and consumption of a whole range of popular forms.

Reading through Ed Cray's *The Erotic Muse: American Bawdy Songs*, it is striking to see, for example, the similarity between the lyrics of the dirty song tradition and the plots of stag films. Anticlericalism is big, of course, in both bawdy songs and porn films, as it is in the endlessly recyclable joke, "Did you hear the one about the priest and the rabbi" Cray tells us that songs about licentious ecclesiasticals were so popular that English obscenity law evolved from court actions to suppress them.[12] In the several versions of the bawdy song "The Monk of Great Renown," the monk engages in rape, anal intercourse, and necrophilia. The somewhat tamer stag films that I have seen prefer to attack the hypocrisy of the clerical class by having the priests and the nuns get it on in all sorts of combinations. Most of the anticlerical films were imports from France or other heavily Catholic countries, except for the classic *The Nun's Story* (1949–52). The American stag films preferred to mock the mores of the professional classes, which were depicted as exploiting professional power for sexual purposes, in films such as *The Casting Couch* (1924), *The Dentist* (1947–48), *Doctor Penis* (1948–52), and *Divorce Attorney* (1966–67).

Surprisingly (although why should it be?), stag films also share with bawdy songs an emphasis on female agency, with the woman both initiating sex and setting the terms for the sexual encounter. In "The Tinker" and related bawdy songs, the housewife cajoles the workingman into having sex with her and then all the other women in the house, but turns on the tinker when he decides to screw the butler too. In one stag film from the late teens or early twenties (that looks like a French import) two women undress, drink wine, and fondle each other. One says to the other, "I brought Jacques,"

and straps on a dildo. A few moments later an intertitle tells us that the hairdresser is at the door. One woman fellates the hairdresser while he works on the other woman's hair and then they pull him into a three-way. In another film of the same period two women are out mushroom-hunting in the woods and come across a penis poking through the underbrush. They examine the penis with a magnifying glass before deciding that they've discovered a new species of mushroom. An intertitle tells us that "the mushroom was enjoyed in all kinds of sauces" and we then see the two women, and the naked man revealed to be attached to the penis, in various combinations. In *Goodyear*, from the forties, a man and a woman are sitting on a couch and the woman pulls a condom out of her bag and demonstrates its use to the man. After a blow job, intercourse, and another blow job, the woman flips the man's limp penis from side to side, shaking her head with disappointment. In *The Wet Dream*, from the Horny Film Corporation (1935–45), the woman in the man's dream won't let him get on top after she's been on top of him. He finally does manage to get on top but only after she has put a French tickler on him, presumably for her pleasure. This film also ends with the woman's disappointment with the man's now completely limp penis. In one of the best known stag films of all time, *Smart Aleck* (1951) with Candy Barr, she refuses to go down on the man, especially when he starts to force her. She gets up in disgust and calls a female friend who does want to have oral sex with the man. While that's going on, Candy gets back into the scene to get the man to go down on her. Here, like the lady in "The Tinker," it is the woman who orchestrates the sexual activity.

Another important trait shared by the bawdy song and the stag film is the theme of the penis run amok. Such penises appear, for example, in meldings of the bawdy ballad and the sea shanty, where you get descriptions like "With his long fol-the-riddle-do right down to his knee" (Cray, 35) or "Hanging down, swinging free With a yard and a half of foreskin hanging down below his knee" (Cray, 36). The Tinker rides to the lady's house "With his balls slung o'er his shoulder and his penis by his side" (Cray, 31) but gets in trouble by fucking the butler when he is supposed to be fucking all the ladies and, in another variant, fucks the Devil. Wayward and wandering giant organs abound in everything from fraternity songs, such as "Do Your Balls Hang Low?", to cowboy and Vietnam-era lyrics about efforts to exert some control over the penis, such as "Gonna Tie My Pecker to My Leg" (Cray, 336–37; 192–93).

Animated films of the stag era, unconstrained by physical reality, were able to depict the amok penis better than live action films. *Buried Treasure*

(ca. 1928–33) features Everyready Hardon. Poor Everyready's penis runs off on its own, gets bent and has to be pounded back into shape, goes after a woman but accidentally fucks a man, and runs into the business end of a cactus, among other, often painful, mishaps. In *The Further Adventures of Super Screw* (also ca. 1928–33) the hero's penis is so big that he must drag it along on the ground, where it gets bitten by a dog and then run over by a bus. While his gargantuan penis is in a sling at the hospital a nurse decides to cut it down to size. After they have ribald sex, he goes into the lab and starts screwing a chimp who impales him on its own giant penis. After returning to the operating room to get his penis restored to its original dimension, he finds an ape to screw. Since the producers and consumers of these films were unquestionably male, the ubiquity of this theme of male humiliation demands to be accounted for in some way.

Laura Kipnis points out that in *Hustler*, as we have seen in the films, jokes, and songs noted above, sex is an arena of humiliation for men, not domination and power over women: "The fantasy life here is animated by cultural disempowerment in relation to a sexual caste system and a social class system" (Kipnis, 383). Rather than offering the compensatory fantasy found in the more upscale *Penthouse* and *Playboy*, where the purchase of pricey consumer goods will ensure willing women and studly men, *Hustler* puts into question a male fantasy that represents power, money, and prestige as essential to sexual success, which "the magazine works to disparage and counter identification with these sorts of class attributes on every front" (Kipnis, 383). *Hustler* puts the male body at risk, Kipnis says, which helps to account for its focus on castration humor and ads that are addressed to male anxieties and inadequacies, such as ads for products promising to extend and enlarge penises. *Hustler* and other deliberately trashy magazines (my favorite is *Outlaw Biker*)[13] are the print progeny of the stag films and related forms of smutty folklore.

Ed Cray underestimates the centrality of bawdy humor to the porn film when he contrasts what he sees as the lack of prurience in folk balladry to the dearth of humor in pornography. Although he recognizes that folk balladry can easily veer toward the pornographic and does so often, he is not as ready to acknowledge that pornographic titillation can incorporate bawdiness; "pornography is rarely humorous" (Cray, xxviii), he says. But ribald humor is equally important to the two forms and, moreover, bawdy songs are often much wilder sexually than porn films. Only the animated

films can play with the kind of hyperbolically exaggerated body parts and wildly impossible sexual positions that are a staple of the bawdy song. It would be more accurate to say that both popular forms are fundamentally based in a kind of humor that features attacks on religion (and, later, the professional classes), middle-class ideas about sexuality, trickster women with a hearty appetite for sex, and foolish men with their penises all in a twist, when those penises work at all.

It is illuminating to see which forms or figures from popular culture are cited in the stag films to reinforce these themes. The soundtrack added on to *The Casting Couch* is a recording of Mae West's riff on the importance of education, where she gives a man a lesson in mathematics: "Addition is when you take one thing and put it with another to get two. Two and two is four and five will get you ten if you know how to work it." Subtraction is when "a man has a hundred dollars and you leave him two." Another film of the same era, *The Bachelor Dream*, ends with a shot of *Mad Magazine's* mascot, Alfred E. Neuman.

While it is true that stag films borrowed heavily from the oral culture of joketelling, it is also important to note that the films were themselves oral culture in the way they were consumed by male audiences. The American Legionnaires, Shriners, Elks, Dekes, and Kappa Sigs counted on the films' humor to help them manage a relation to the sex on screen and to each other, a kind of "comic relief" regulating the guilt and discomfort of the viewing. No film exists without its audience, but the stag film especially so because the backtalk and verbal display sparked by the film is an integral part of the film experience. Thomas Waugh's history of gay male photography and film briefly suggests that such humor may have appealed to gay men in the audiences as well, even though it has long been recognized that the linguistic antics surrounding the films traditionally functioned to shore up the homosocial heterosexuality of the audiences against any hint that a bunch of men looking at penises together were gay.[14] Waugh thinks it would be a stretch to claim that stag film humor reflects a gay camp sensibility but he does believe that "the stag film's coy mixing of levels of cultural affectation with sexual innuendo and vulgarity would not have fallen on deaf gay ears" (Waugh, 320). If Waugh found few gay male films among the stag films he researched, he still thinks it is possible that gay pleasures were nonetheless to be found in both the straight stag films and the oral culture in which they were embedded.

Although porn is usually conceptualized and debated as a stigmatized "other," completely beyond the moral and cultural pale, its desires, concerns, and uses are not that different from those found in other popular forms throughout U.S. history. Here, I took the example of bawdy songs but those other forms include the dirty jokes told everywhere, everyday in offices, on playgrounds, and now in faxes and on the Internet. Folklorists like Alan Dundes and Gershon Legman tell us that smutty joketelling is the warp and woof of American working life, a kind of humor that is a major form of symbolic communication that expresses and forms our changing ideas and anxieties about a number of issues but especially sexuality and the relations between the sexes.[15] Other closely related popular forms are *America's Funniest Home Videos*, *Mad Magazine*, and WWF wrestling, which, like porn, is a physical contact sport requiring a similar suspension of disbelief.

When my course on pornographic film was protested by the local anti-porn group (based in local churches) and Pat Robertson in a *700 Club* special on godlessness in public schools, it became clear that my critics' biggest fear was that studying pornography as film or popular culture would normalize it. That's why Pat Robertson called my course "a new low in humanist excess" right after making the wonderfully curious statement that "a feminist teaching pornography is like Scopes teaching evolution."[16] And if the anti-porn people have been following the culture wars, they would also know that another danger lurked for them beyond the threat of normalization: the risk that scholars who take popular culture seriously might start asking of porn what they ask of all other forms of popular culture. These questions would include "What is the nature of the widespread appeal?" "To what pleasures and ideas do these films speak?" "What desires and anxieties do the films express about identity, sexuality, and community, about what kind of world we want to live in?" "What kind of moral, social, and political counterculture is constituted by the producers and consumers of porn?"[17] If the study of porn as film and popular culture reframes it as a relatively normal and socially significant instance of culture, this goes a long way toward disarming those who depend on its typification as sexual violence to crack down on moral and political dissidence. But enough of cracking down, let's get back to the issue of cracking up.

The bawdy humor, at the expense of the man, tends to drop out of porn films only during the so-called "golden age" of 1970s big-budget, theatrically released, feature-length narrative films like *Behind the Green Door*, *Inside*

Misty Beethoven, *The Resurrection of Eve*, and *The Story of Joanna*. In an era in which the makers of adult films were trying to respond at once to the sexual revolution, Women's Lib, and the possibility of expanding their demographics beyond the raincoat brigade and fraternal lodge members, the narratives began to center, albeit very anxiously, around the woman and her sexual odyssey. While there are some eruptions of egregious punning and willfully vulgar humor in these "quality" films meant for the heterosexual dating crowd (for example, Linda's friend in *Deep Throat* who asks the man performing cunnilingus on her while she leans back and puffs away on a cigarette, "Do you mind if I smoke while you eat?"), they are far more "tasteful," even pseudo-aristocratic, in their demeanor and depicted milieu than the great majority of films of the earlier stag era. But the stag films, which Linda Williams characterizes as lacking in narrative and more misogynistic in their "primitive" display of genitals and sexual activities than the golden age pornos, may not be as misogynistic as Williams says if they can be recognized more as strong popular joke structures than weak film narratives.

What I have observed is that as porn films "progressed" as film, technically and narratively, and began to focus on the woman and her subjectivity, they became more socially conservative as they lost the bawdy populist humor whose subject matter was so often the follies and foibles of masculinity. And while it is true that stag films usually just peter out, so to speak, without any narrative closure, such closure may not be so desirable. Most of the golden-age pornos have closure, all right: like Hollywood films they end in marriage or some other semi-sanctioned kind of coupling, while the stag films are content to celebrate sex itself without channeling it into the only socially acceptable form of sexual expression, heterosexual monogamous marriage. It may also be that insofar as the golden-age films focus on women's sexuality and subjectivity, the pat solution of the marriage ending may have been an attempt to resolve anxieties those films inadvertently raised in the course of a narrative about women's new sexual and social freedoms.

Fortunately, in the eighties and nineties, porn films got trashy again as producers threw off the "quality" trappings of the golden era to start manufacturing product for the rapidly expanding VCR market. Suddenly, many more people, women included, could consume porn and many more people could produce it, even those who lacked money, technical training, or a sense of cinema aesthetics. Sure, there are always going to be pretentious

auteurs in porn as everywhere else, such as Andrew Blake and Zalman King, but during this period amateur filmmaking ruled. So popular were amateur films that the professional adult film companies started making fake amateur films, "pro-am," in which recognizable professionals, even stars, would play ordinary folks clowning around the house with their camcorder, or were paired with amateur "video virgins." As porn became deliciously trashy again, it coincided with a new female media deployment of white trash sensibilities against the class and sexual status quo not seen since the goddesses of burlesque reigned. Roseanne, Madonna, Courtney Love, Brett Butler, and Tonya Harding would certainly be on the list but it should be extended to include some significant male talent.

Howard Stern and Mike Judge (the creator of *Beavis and Butthead*) would have to be ranked among the most ingenious of such deployers, with *Saturday Night Live*'s Wayne and Garth in the running, but not really, because their raffishness is shot through with too much redeeming sweetness. All of these white trash theorists and practitioners understand the politically strategic value of making a spectacle of masculinity. Jeff ("You're a Redneck If . . .") Foxworthy, offers, by comparison, just a soft celebration of hick manhood.

When James Garner called Howard Stern "the epitome of trailer trash," Stern responded, in his typically scatological fashion, "I can't believe this guy wants a war with me. He should be busy worrying if he's gonna have a solid bowel movement." We know, of course, from Stern's now two best-selling memoirs that neither his parents nor his own Long Island suburban family live in a trailer. His non-trash origin goes to show that you do not have to be white trash to use white trash sensibilities as a weapon of cultural war, although the fact that white trash's rocket scientist, Roseanne, grew up so solidly trashy, reinforces the argument that early training counts. In a real shocker, feminist artist and critic Barbara Kruger came out as a Howard Stern fan and defender, on the cover of *Esquire* no less, claiming that his

> sharp, extemporaneous brand of performance art, his unrelenting penchant for 'truth'-telling, serves as a kind of leveler: a listening experience that cuts through the crap, through the deluded pretensions of fame, through the inflated rhetoric of prominence . . . Zigzagging between self-degradation and megalomania, political clarity and dangerous stereotyping, temper tantrums and ridiculously humble ingratiation, he is both painfully unsettling and crazily funny.[18]

One feminist friend who is a longtime admirer of both Kruger's art and her critical writing expressed dismay and disappointment that Kruger could defend such a sexist, racist, homophobe. Is this postfeminism ad absurdum, she wondered? A couple of weeks after the shock of seeing Kruger's *Esquire* article, my friend called to tell me that she had been up late the night before and channel-zapped into something called "The Lesbian Dating Game." As she was marveling at the funniest, most nonjudgmental representation of lesbians she had ever seen on television or in the movies, she was chastened to realize that she was watching—and loving—the Howard Stern show.

Laura Kipnis argues that *Hustler* publisher Larry Flynt's obscenity trials did more to ensure First Amendment protection for American artists than any of the trials prosecuting much more culturally legitimate works of art and literature. In the same vein, Howard Stern's trashiness does more to counter the angry white men of America's airwaves (and elsewhere) than any liberal commentator because his target is precisely that masculinity that perceives itself to be under attack from all sides, a masculinity no longer sure of its godgiven privilege and sense of entitlement that was for so long the taken-for-grantedness of law, government, and religion. Stern puts his body on display, phobic, farting, flailing, a male body lashing out at all the feared others—women with beauty, smarts, and power; strong, sexually confident blacks; those men with the kinds of superior qualities that attract women but who willfully choose to be gay. He also makes it clear that he wants more than anything to be those others and to *be with* them. Feeding his hysteria then is his not having a clue how to pull that off. Who, after all, wants a skinny, neurotic (if not psychotic) white guy "hung like a pimple"? *This* angry white man gives us a brilliant daily demonstration of what that anger is all about. Rush Limbaugh and his ilk dress up their anger in the trappings of a (male) rationality and knowledge. Howard Stern needs all the trailer trashness he can muster to cut through the false decorum of that unexamined fury.

Beavis and Butthead, too, have never lived in a trailer but they did burn down a trailer park. And the shabby den in which they watch TV makes Roseanne's house look like an Ethan Allan showroom. All of the pundits and parents who worry about kids mimicking these two delinquents have either never watched the show or have no idea of the way kids watch TV. Instead of simply modeling themselves after Beavis and Butthead, kids use these cartoon lumpen to teach themselves a very important social fact: that the

only people who get to be that stupid and live are white guys, and they just barely do. A sure sign that *Beavis and Butthead* detractors do not know the show itself is that they never mention the role of Daria (called "Diarrhea," of course, by Beavis and Butthead). Daria is the smart, hardworking little girl who knows that she can't afford to be stupid and is more often than not the audience for the boys when they are variously humiliated by their out-of-control bodies or their sudden recognition of the limits of their stupidity.

Although the use of gross, dumb humor has been heavily censored in the television version of *Beavis and Butthead*, the two boys' trashiness still thrives in the album and comic book format. In *The Beavis and Butthead Experience* they get to play air guitar with Nirvana, sing along with Cher, and party on the Anthrax tour bus. The point of their greatest abjection comes when a member of Anthrax shows Beavis and Butthead some girly photos and Beavis runs off to the bathroom with them, where it becomes apparent to Butthead and the band members that Beavis does not know the difference between shitting and coming. The more you get to know of Beavis and Butthead, by the way, the more you realize that Butthead has a tad more IQ points than Beavis, of both the intellectual and emotional kind. The relatively (only relatively) greater awareness of Butthead means that he is often able to offer a critical perspective on their polymorphously perverse antics, to a lesser extent than Daria, of course, because he is, after all, a full participant in them.

For example, in the second issue of the *Beavis and Butthead* comic book the two young chicken-chokers decide that it would be cool (that is, not suck—see Lévi-Strauss, Bourdieu) to sneak into the morgue of a funeral home. The following dialogue ensues:

> Butthead: Whoa! Huh-Huh-Huh Look at all th' stiffs? They're . . .
>
> Beavis: . . . NAKED! Heh-Heh-Heh Yeah . . . there's one stiff on that slab . . . and one in my pants. Heh-Heh
>
> Butthead: Uhhh . . . I'm afraid I've got some bad news for you, Beavis . . . Huh-Huh These are all naked GUYS!
>
> Beavis: Oh . . . Heh-Heh Yeah, I forgot! Heh-Heh

Beavis's sexual orientation is only one of many things he can't quite keep track of and Butthead is always there, not to straighten him out, but to remind him of the price to pay if he fails to achieve standard issue masculinity, as if Butthead has a chance himself. If Howard Stern takes on the

psychopathology of angry white men, Mike Judge addresses the panicky arrogance of these horny pale adolescents as they try to figure out what they are entitled to, as white guys, even though they know (or Mike Judge and we know) that they have zip going for them other than what used to be the automatically privileged white guy status. Where Beavis and Butthead fail is that they don't even know how to work the one advantage they sort of have. They also are not capable of noticing when Judge throws in their path a way out, a possible ally, but Beavis and Butthead fans do.

The first story, "Dental Hygiene Dilemma (Fart 1)" (March 1994), of the first *Beavis and Butthead* comic starts off with an extended homage to feminist performance artist and NEA Four member Karen Finley. The two boys pull up their bikes to a small store called Finley's Maxi-Mart that seems to sell only yams, recalling the yams that the artist stuffed up her vagina in one of her many performances on the powerful desires of women and the social and psychical wounds inflicted on their bodies. Beavis and Butthead cheat an elderly man, a customer at Finley's Maxi-Mart, out of his money and his yams. "Diarrhea" walks by (perfect timing) and chides the boys for their cruelty while explaining the idea of karma to them, trying to get them to understand that their stupid actions will have consequences for them later.

Mike Judge would have been even more appreciative of Finley's strategies for attacking the sexual and social status quo if he had known then the details of the second censorship scandal she would be involved in. In early 1996 Crown Publishers canceled its contract to publish Finley's decidedly Beavis and Butthead–like parody of domestic tastemaker Martha Stewart's *Living Well* when they found it just too gross with its tips on coffin building, rude phone calls, and cuisine that mixes Oreos, Ring Dings, and beer. For Valentine's Day, Martha Stewart recommends choosing chocolate with care, since taste varies considerably: "Choose Valbrona chocolate from France or Callebaut from Belgium." Finley, of course, is almost as well known for smearing chocolate on her nude body as for the yam insertion trick. Crown, also Martha Stewart's publisher, decided that graciousness and grossness do not mix.[19]

Jesse Helms is more right than he knows when he calls Karen Finley's work "pornographic," because so much of the sensibility of her performances and writing, like that of Howard Stern and Mike Judge, arose from the porn world's now decades-long use of such trashy, militantly stupid, class-iconoclastic, below-the-belt humor. But my interest here isn't to demonstrate porn's trickle-up influence on art and media even if it is illustrative to chart just how large that influence is.[20]

Rather, I want to show that the male popular culture that is pornography is a vital source of countercultural ideas about sexuality and sexual roles, whether those ideas are picked up by the more legitimized areas of culture or not.

One of contemporary porn's most brilliant organic intellectuals has to be Buttman, John Stagliano, the white trash Woody Allen, who has made a score of films documenting Buttman's travels and travails as he goes around the world (and Southern California) seeking the perfect shot of a woman's perfect ass. Buttman, played by Stagliano himself, gets mugged, evicted, bankrupted, rejected, and ridiculed, all in his single-minded quest for perfection. Licking ass, caressing ass, ogling ass, and only occasionally fucking ass, if the woman insists, Buttman does for anal fetishism what Woody Allen does for neurosis, and it's not always a pretty picture. In thrall to his obsession, things get even worse when he doesn't stay true to his own fetishistic commitments. In *Buttman's Revenge* (1992), the erstwhile ass worshiper falls on hard times after foolishly trying to branch out by making a disastrous "tit film." No longer a star, his business associates and friends reject him and he ends up living on the street, although they later relent and help him with his comeback by surprising him with Nina Hartley, celebrated for having the most beautiful ass in the business. As in so many of the stag films, the man, this time Buttman, is the butt of the joke.

In *The Hearts of Men* Barbara Ehrenreich constructs a history of male rebellion against the status quo from the cold war era through the seventies, and men's production and consumption of porn deserves a place in that history.[21] The gray flannel rebels, the Playboys, the beats, the hippies, all tried to conceive of less restrictive versions of masculinity, ones not subject to the alienation of the corporate world, alimony hungry wives, dependent children, monogamy, or mortgages. Ehrenreich appreciates the impulse fueling much of this masculine refusal but faults all of the various strategies for either disregarding or blaming the woman. When we put porn into this history we find a male popular culture that, by contrast, neither disregards nor blames the woman in its attempt to renegotiate the sexual and social status quo, a male popular culture that devotes itself—to a surprising degree—to examining the hearts of men. What's in the hearts of men according to porn? A utopian desire for a world where women aren't socially required to say and believe that they don't like sex as much as men do. A utopian desire whose necessary critical edge, sharpened by

trash tastes and ideas, is more often than not turned against the man rather than the woman.

How else to explain that *John Wayne Bobbitt: Uncut* is practically a feminist chef d'oeuvre? 1995 was a glorious year for the white trashing of porn, to which much credit must first be given to Tonya Harding. The porn industry couldn't resist recreating Tonya's story again and again, including circulating the wedding night videos that her ex-husband put up for sale to the highest bidder. Of the several porn takeoffs of the scandal on ice, the best has to be *Tanya Hardon*, which revels in "Tanya à la Cardigan"'s trashiness over and against "Nancy Cardigan"'s pseudo upperclassness. Tanya and her husband Jeff shove empty beer cans off the kitchen counter to fuck while planning how to wreck Nancy's skating career with a blow to the knee. Although one could point out how reminiscent this scene is of Roman Polanski's brilliant rendering of the eroticism of the Macbeths' roll in the marital bed as they plot the killing of the king, that wouldn't be the point, now would it? *Tanya Hardon* celebrates Harding's white trash verve over Kerrigan's refined pathos ("Why *me*, why *me*?") but also the whole genre's love of white trash sensibilities to deflate upper-class pretensions and male vainglory. In the best scene in the film, which has fairly high production values for an adult film—there are even insert shots of a skating rink—Tanya has stolen Nancy's boyfriend and is sharing him with another skater in the rink's dressing room, when Nancy walks in on the threesome. Aghast yet riveted, she blurts out, "Why *not* me, why *not* me?" but Tanya is so mean that she won't let Nancy join in. Jeff, of course, is dead meat by this time, having hooked up with the Beavis and Butthead of henchmen to carry out the knee-whacking operation.

Former porn star Ron Jeremy's direction of *John Wayne Bobbitt: Uncut* is the epitome of how white trash can be deployed to criticize male attitudes and behavior. Given the chance to tell "his own story," the on-camera Bobbitt doesn't realize that the film is telling a story about his story, and it's not flattering. The deeply dim ex-Marine, called Forrest Stump by *Esquire*, narrates and reenacts the night his wife, Lorena, cut off his penis and doctors labored for nine and a half hours to reattach it. The ever-so-slightly fictionalized aftermath of the surgery shows women everywhere, from Bobbitt's hospital nurses to the porn stars he meets because of his new celebrityhood, avidly pursuing sex with him to find out if "it really works." It sort of does.

Early on in the video we see Bobbitt and his buddies at a nude dance club, drinking beers and ogling the performers. When he arrives home, late and drunk, and falls into bed, Lorena (played by Veronica Brazil) is already asleep after a hard day's work at the nail parlor. He climbs on top of his sleepy wife who rouses only to complain about the late hour and his drunkenness and to tell him clearly that she doesn't want to have sex with him. He pays no attention to her refusal, screws her for a few seconds and then, just as Lorena is starting to wake up and get into it, falls off and passes out. The unhappy and sexually frustrated Lorena muses to herself for a while before leaving the bed to get a knife. Standing over her unconscious husband, she tries repeatedly to wake him, to get him to respond to her needs, before she resorts to cutting off his penis in despair at his insensitivity and inattentiveness. (Because contemporary porn won't show even a hint of violence, we get no special effects of the penis being cut off but only, hilariously, a shot of her hand clutching the severed penis and the steering wheel as she flees the house in her car.)

Although the film offers a sometimes disparaging portrait of Lorena—for example, showing her stealing money from her boss at the nail parlor—the film's sympathies are with the wife whose husband thinks marital rape is how a man has sex with his wife. The more we see of John on screen, the more we hear his attacks on Lorena and his rationalizing of the faults in their marriage, the deeper a hole he digs for himself. Julie Brown's 1995 HBO spoof of "Lenora Babbitt" was, by contrast, much less sympathetic to a Lorena it portrayed as entirely unreasonable in her demands for mutual sexual satisfaction. So, too, Brown's companion spoof of "Tonya Hardly" exhibited little of the affection for the skater's trashiness found in *Tanya Hardon*. In both HBO stories it's the women who get their comeuppance, not the men. Also to be noted is that Julie Brown's version, the supposedly more progressive, even avant-garde rendering of these characters and events, offers a racial stereotyping of Lorena—Carmen Miranda with a blade—much more blatant than anything found in the porn version.

Radical sex writer Susie Bright says she can't believe John Wayne Bobbitt lets this video be shown because it demonstrates for all the world to see that "this man does not know how to give head to save his life," and indeed he doesn't.[22] Nor is he good at much else. In one unscripted scene in the film where two women are laboring mightily to get John hard, without much success, and he seems to be tentatively trying out cunnilingus, Ron Jeremy

walks into the scene and begins expertly giving head to two other women that he has brought onto the set. Lore has it that Bobbitt did not know that the director was going to put himself into the movie; he certainly didn't know Jeremy's plans for shamelessly upstaging him, the supposed hero of this video. Next, and in pointed contrast to Bobbitt's scarce tumescence (his two fluffers are clearly flagging at this point) Jeremy whips out his own much larger and fully functioning penis, which he applies immediately, and again expertly, to the female talent. Jeremy may have lost his porn star looks, staying behind the camera these days for good reason, but here he reappears on screen to make a pedagogical point, to remind us that porn's expertise, what it promises to teach viewers, is good sexual technique.

What's the moral of *John Wayne Bobbitt: Uncut* for men? If you don't learn better sexual technique and start being more sensitive to your partner's needs, you're going to get yours cut off too, and, what's more, YOU'D DESERVE IT! Who would have thought that the porn industry would give us the nineties version of Valerie Solanas's *SCUM Manifesto*, brilliantly disseminated in the form of a tacky, low-budget (by Hollywood standards) video sold and rented to millions of men.

That tackiness also takes aim at Hollywood. The center of commercial adult film production is North Hollywood and Northridge, making those two shabby cities the tinny side of Tinseltown. The adult industry so loves producing knockoffs of Hollywood films that it is impossible to keep track of all of them. The knockoffs can't be intended simply to ride the coattails of popular Hollywood films because most consumers know that the porn version seldom has much to do with the themes, characters, and events found in the original film. What is more likely, as Cindy Patton says of films such as *Beverly Hills Cocks*, *Edward Penishands*, and both gay and heterosexual versions of *Top Gun* (*Big Guns*) is that they are meant as "an erotic and humorous critique of the mass media's role in invoking but never delivering sex."[23] I would add the gay male film *The Sperminator* to her list because of the way it rewrites *The Terminator* to expose the closeted homoeroticism of so much Hollywood film (Kyle Reese and John Conner get together to "sperminate" the Sperminator). In the new videos, Patton says, types of sex are rarely presented as taboo in themselves, only as representationally taboo—what Hollywood or television is unwilling to show. With Hollywood under attack by the family values crowd and liberals and conservatives alike clamoring to V-chip to death television's creativity (the industry having

immediately caved in), porn and its white trash kin seem our best allies in a cultural wars insurgency that makes camp in that territory beyond the pale.

-------------------------- NOTES

1. In *Roll, Jordan, Roll: The World the Slaves Made* (New York: Vintage, 1972), Eugene D. Genovese argues that white trash folks have no culture of their own because it is entirely borrowed from poor blacks. He, too, as I did, claims that the everyday lives of poor blacks and poor whites are very similar, and were so even during the period of slavery. But he credits those similarities to a massive poor white appropriation of black culture, seeing in white trash culture a degraded version of black food, religion, and language. He even says that white trash folks lacked the desire for literacy and education that was so strong in black culture. Genovese would not, then, buy my argument, admittedly a slightly tongue-in-cheek one, that growing up white trash offers one of the best possible preparations for a theoretical and political engagement with the world. To do so he would first have to acknowledge the productively creative hybridity of white trash culture in its exchange with black culture, and the corresponding capacity for white trash social agency, both of which he disavows in his book. Genovese does, however, have a fascinating and persuasive account of the origins of "white trash" as an epithet. He believes black slaves derived the term, but their hostility toward poor whites was fostered by wealthy landowners wanting to prevent any interracial unity that might be turned against a system that oppressed both blacks and whites. Like the epithet "fag hag," then, it is meant to drive a wedge between natural allies.

2. Lynn Hunt, ed., *The Invention of Pornography: Obscenity and the Origins of Modernity, 1500–1800* (New York: Zone Books, 1993).

3. Robert Darnton, *The Literary Underground of the Old Regime* (Cambridge, Mass.: Harvard University Press, 1982).

4. Walter Kendrick, *The Secret Museum: Pornography in Modern Culture* (New York: Viking Press, 1987).

5. Edward de Grazia, *Girls Lean Back Everywhere: The Law on Obscenity and the Assault on Genius* (New York: Random House, 1992).

6. Andrew Ross, *No Respect: Intellectuals and Popular Culture* (New York: Routledge, 1989). Judith Walkowitz, *Prostitution and Victorian Society: Women, Class, and the State* (New York: Cambridge University Press, 1980).

7. Laura Kipnis, "(Male) Desire and (Female) Disgust: Reading *Hustler*," in *Cultural Studies*, ed. Lawrence Grossberg, Cary Nelson, and Paula Treichler (New York: Routledge, 1992), 373–91. Hereafter referred to in the text as Kipnis.

8. I teach the course on pornographic film in the Film Studies Program at the University of California, Santa Barbara. I would not have been able to put together a historical survey of the genre without the help of the Institute for the Advanced Study of Human Sexuality in San Francisco, which provided

many of the films and much needed historical information on producers, venues, and collateral industries such as magazine publishing and sex toy manufacturing.

9. Linda Williams, *Hard Core: Power, Pleasure, and the "Frenzy of the Visible"* (Berkeley and Los Angeles: University of California Press, 1989). Thanks very much to Linda Williams and the students in her fall 1995 "Pornographies On/Scene" class at UC–Irvine, where I first tried out the arguments in this essay that I had been developing with my students at UC–Santa Barbara.

10. Peter Lehman, "Revelations about Pornography," *Film Criticism* (1995), 3.

11. The figures on the number of stag films are understandably not as reliable as one would want. At this point I am relying on the fact that the few researchers on the stag film are all using approximately the same figures, which are based on Ado Kyrou's "D'un certain cinéma clandestin," *Positif* no. 61–62–63 (June–July–August 1964), 205–23; and Al Di Lauro and Gerald Rabkin's *Dirty Movies: An Illustrated History of the Stag Film, 1915–1970* (New York: Chelsea House, 1976). Di Lauro and Rabkin base their figures on their own viewings in Europe and America, Kyrou, the Kinsey collection, Scandinavian catalogs from the sixties and early seventies, and the catalog listings of a private collector who did not want his identity revealed. Thomas Waugh says these figures match what he has found thus far: "The corpus of the stag film seems to include about two thousand films made prior to the hardcore theatrical explosion of 1970, of which three quarters were made after 1960. Of the group made prior to World War II, which is the present focus, I have found documentation for only about 180, about 100 American, 50 French, plus a sprinkling of Latin American, Spanish, and Austrian works." *Hard to Imagine: Gay Male Eroticism in Film and Photography from their Beginnings to Stonewall* (New York: Columbia University Press, 1996), 309.

12. Ed Cray, *The Erotic Muse: American Bawdy Songs*, 2d ed. (Urbana: University of Illinois, 1992), 40. Hereafter referred to in the text as Cray. Cray does not neglect women's talent for bawdiness. He collects, for example, the songs known among sorority women as the rasty nasty, with lyrics that celebrate the women's nastiness and sluttiness, such as "We Are the Dirty Bitches" (351–52). For further evidence of this talent he refers the reader to Rayna Green's "Magnolias Grow in Dirt, The Bawdy Lore of Southern Women," *Southern Exposures* 4, no. 4 (1977)

13. Thanks to Deborah Stucker for her analytical insights on *Outlaw Biker* and its role in the creation of a lumpen or working-class sexual and social counterdiscourse for women and men.

14. Thomas Waugh, *Hard to Imagine: Gay Male Eroticism in Film and Photography from their Beginnings to Stonewall* (New York: Columbia University Press, 1996), 319–20. Referred to hereafter in the text as Waugh.

15. Alan Dundes and Carl R. Pagter, *Urban Folklore from the Paperwork Empire* (Austin: American Folklore Society, 1975) and *When You're Up to Your Ass in Alligators: More Urban Folklore from the Paperwork Empire* (Detroit: Wayne State University Press, 1987). Gershon Legman, *Rationale of the Dirty Joke: An Analysis of Sexual Humor, First Series* (New York: Grove Press, 1968) and *No Laughing Matter: Rationale of the Dirty Joke—An Analysis of Sexual Humor, Second Series* (New York: Breaking

Point, 1975). Carl Hill's *The Soul of Wit: Joke Theory from Grimm to Freud* (Lincoln: University of Nebraska Press, 1993) has a good discussion of class bias in joke theory in chapter seven, "At Witz End," where he shows Freud's (failed) attempt to separate the high-minded Witz from the lowly Komik.

16. The special on godlessness in public schools was broadcast during April 1993.

17. For a discussion of pornography as a moral counterculture, see Paul R. Abramson and Steven D. Pinkerton, *With Pleasure: Thoughts on the Nature of Human Sexuality* (New York: Oxford University Press, 1995), especially chapter 7, "Porn: Tempest on a Soapbox."

18. Barbara Kruger, "Prick Up Your Ears," *Esquire* (May 1992), 95. A slightly different version of the article appears in Kruger's collection of essays, *Remote Control: Power, Cultures, and the World of Appearances* (Cambridge, Mass.: MIT Press, 1994), 25–30.

19. "What Is a Book Publisher to Do When a Parody Hits Home?," *New York Times* (Feb. 12, 1996) C1, 4.

20. For porn's influence on contemporary art see Carla Frecerro, "Unruly Bodies: Popular Culture Challenges to the Regime of Body Backlash," in *Visual Anthropology Review* (Fall 1993), 74–81 (on Madonna and 2 Live Crew); Elizabeth Brown, "Overview of Contemporary Artists Interacting with Pornography," lecture for the Sex Angles Conference, University of California, Santa Barbara (March 8, 1996); and Linda Williams, "A Provoking Agent: The Pornography and Performance Art of Annie Sprinkle," in *Dirty Looks: Women, Pornography, Power*, ed. Pamela Church Gibson and Roma Gibson (London: British Film Institute, 1993), 176–91.

21. Barbara Ehrenreich, *The Hearts of Men: American Dreams and the Flight from Commitment* (New York: Doubleday, 1983).

22. Susie Bright made this comment in "Deep Inside Dirty Pictures: The Changing of the Guard in the Pornographic Film Industry and American Erotic Spectatorship," a lecture she gave at a conference on "Censorship and Silencing: The Case of Pornography," at the University of California, Santa Barbara, on November 5, 1994.

23. Cindy Patton, *Fatal Advice: How Safe Sex Education Went Wrong* (Durham: Duke University Press, 1996).

White Trash Girl

Laura Kipnis with
Jennifer Reeder

W hite Trash Girl slunk into my office wearing a short, striped polyester miniskirt I'm positive I myself owned in junior high, a clashing paisley button-down shirt of some petroleum-based miracle fiber, topped off by a too-tight, powder-blue vest of tired, stained faux-suede. Bleached white-blonde hair peeked out from beneath some sort of go-go cap. There were some supremely clunky black platform shoes that you could hear clicking rhythmically up the hallway as she approached. It was like Mary Richards on acid. This was Art School of course, and you got pretty used to seeing the more disastrous moments of 70s fashion bearing down on you in the halls, like déjà vu all over again.

I was doing some part-time graduate advising of MFA candidates, and White Trash Girl (a.k.a. Jennifer Reeder) sought me out because she'd read an article I'd written on the class and body politics of *Hustler* magazine, and it said the kind of thing she was trying to say in her work—her work being this invented persona—but that she didn't quite yet have the precise language for.[1] I was pleased to have attracted such a plucky and stylish young acolyte, and one who had invented the alter ego of a female action superhero named White Trash Girl, as she proceeded to explain. White Trash Girl had her own promo video and a set of trading cards featuring her and her pals. There were plans in the works for a line of action dolls. She said "fuck" and "cocksucker" a lot, talked trash in her trailer-park southern twang, and shopped from the kitten-with-a-whip rack at Salvation Army. (I, on the other hand, while having an ambivalent affinity for low taste, the female grotesque, and the pornographic sensibility, shop at Saks: you can imagine my somewhat complicated and vicarious interests in this encounter.)

Our point of connection was a mutual understanding that improper bodies have political implications, and are particularly valenced in relation to issues of class. Bodies that defy social norms and proprieties of size, smell, dress, manners, or gender conventions; or lack the proper decorum about matters of sex and elimination; or defy bourgeois sensibilities by being too uncontained and indecorous—these bodies seem to pose multiple threats to social and psychic orders—although not threats whose effects have any predictability, I'd add as a proviso. But if, as anthropologist Mary Douglas has pointed out, the body invariably symbolizes the social and is universally employed as a symbol for human society, then control over the body is always a symbolic expression of social control.[2] And if the body and the social are both split into higher and lower strata, with images or symbols of the upper half of the body making symbolic reference to the society's upper echelons—the socially powerful—while the lower half of the body and its symbols makes reference to the lower tiers, to those without social power (this is *Hustler*'s métier, and White Trash Girl's as well)—then symbolic and aesthetic inversions of these hierarchies have a certain political resonance.[3]

Symbolically deploying the improper body as a mode of social sedition also follows logically from the fact that the body is the very thing that these various modes of power—whether state, religious, or class privilege—devote themselves to keeping "in its place." Control over the body has long been considered essential to producing an orderly work force, a docile populace, a passive

law-abiding citizenry. Just consider how many actual laws are on the books regulating *how* bodies may be seen and what parts may not, or *what* you may do with your body in public *and* in private, and it begins to make more sense that the out-of-control, unmannerly body is precisely what threatens the orderly operation of the status quo.

This was White Trash Girl's project: to deploy the classed and improper body onto the art world at-large. Because while art world habitués may play at poverty chic and disdain bourgeois conventionality, class hierarchies are still entrenched and rigid, and the wrong class origins or the wrong sort of anti-style still mark you as the interloper, the gate crasher at the citadels of Culture. Hence the birth of White Trash Girl, invented just to discombobulate the fairly unexamined social relations of the art education biz.

Nobody fucks with White Trash Girl; she fucks with you. She's a mean mama with a scatological sensibility, a right hook, and skin thick as cheap vinyl when it comes to public opinion. Fuck *me*? No, fuck *you*.

Jennifer, on the other hand, was kind of upset because a few days before, at an end-of-the-semester critique panel, a prissy local art critic had given her a hard time about appropriating these idioms with what he apparently assumed was a cross-class snideness. According to Jennifer, he said things like "You're not allowed to do that." Although he was a jerk and an asshole, she felt somehow trumped by his criticism, or at best, misunderstood. I suggested that White Trash Girl's run-in with the Art Critic reenacted precisely the kind of class dynamic it was meant to elicit, and that this work of hers would always risk inviting the class-trumping that Mr. Art Critic availed himself of. After all, wasn't the function of White Trash Girl to be exactly this kind of lightning rod? Well yes, but Jennifer wanted the work to undermine those relations. Her idea was to transform White Trash into a form of power (specifically, female power), stopping everyone dead in their tracks by foregrounding all their class biases, jarring the art world to class consciousness. But it didn't always seem to work that way.

Conversing more about the issues in the work, I was interested to discover that White Trash Girl was merely the latest expression of Reeder's theoretical conviction (and this was what she was in the midst of figuring out how to articulate) that modes of inhabiting social classes are both embodied and performative. It emerged that Jennifer's previous modes of bodily performance spanned an early career as a ballerina and an adolescent death trip as an anorexic and bulimic, before finally arriving at the art world–sanctioned identity of performance *artist*. White Trash Girl was the latest in a series of female identities,

all of which employed the female body (specifically, Jennifer's) to articulate the contradictions of gendered class identity in the late twentieth century.

Clinical literature tells us that eating disorders are predominantly afflictions of the upper-middle-class female. And of course, the class connotations of the ballerina body—whatever the actual class origin of that body—are similarly upscale. (It's well known that eating disorders plague the ballet world; on the one hand there are obvious utilitarian explanations—the demand for excessively thin bodies in this milieu—but they also seem to enact a symptomatic rebellion against the contained, imploded, excessively proper ballerina body).

But as Jennifer describes it, the experience of anorexia is an embodied discourse of class, in the sense that symptoms "speak." The female body is utilized as an expressive medium, a repository of class aspirations, identifications, rebellion, and particularly, internal class conflicts. The cliché of anorexia is that it's a fashion ideal gone into overdrive: anorexia just takes the social pressure and preference for thinness a bit too far. I've also always assumed it was the case that the preference for extreme thinness expresses an identification upwards in terms of class—particularly because the fat body is so heavily burdened with downwardly mobile class connotations.[4] But in Reeder's understanding of the anorexic experience, the knowledge that one is turning oneself into a grotesque is also never very far away from the experience: it's another aesthetic confrontation with the social normativity that proper bodies, in their own way, maintain and uphold.

White Trash Girl, though, was something of a departure from these previous class embodiments—although none of these various class identities precisely represented Jennifer's own (as far as I could tell), which was, as she relates it, somewhat hybrid. Perhaps this accounts for the rampant mobility of these classed identities she assumed. Obviously the ethos—and the fantasy—of class mobility (or to be specific, *upward* class mobility) fuels all aspects of American class ideology, from the fascination with stories of millionaires-who-started-with-nothing (how many magazine covers have Bill Gates and Steven Jobs graced in the last year?), to the runaway success of regressive taxation in the form of state lotteries which promise to meteorically transport you from a have-not to a have-everything. But in Reeder's case, class mobility takes the form of a certain parodic and performative embodiment of how particular classes wear their aspirations and identifications. Nearly starving yourself to death may be taking this role to a self-destructive extreme, but Reeder is a dedicated artist.

At the beginning, in a time before this time, there was
a girl. A young girl named Cherry. Cherry had an uncle,
a funny uncle, or maybe he was her brother. This funny
uncle used to come to Cherry late at night...he would
kiss her neck and run his fat sweaty hands along the
soft insides of her thighs. Sometimes he would fuck
her. But always before he went away, he would rough
her up a little to keep her quiet.

One morning, Cherry didn't feel so good. She was preg-
nant. She was going to have a baby—a pissing, shit-
ting, puking, drooling, squirming little baby. The day
came when Cherry had her baby. It was a girl—she
flushed her down the toilet.

We met and talked at Jennifer's apartment a few weeks after our initial meeting. The conversation began with the somewhat lurid origins-myth of White Trash Girl (all superheroes must have a mythic origin), spanning the connotations of Reeder's past and present performance work, the experience of the eating-disordered body, toxic body fluids, the class politics of the art school world, and the relation of women in their early twenties to feminism, old and new.

⊕ ⊕ ⊕

Laura Kipnis: Who exactly *is* White Trash Girl?

White Trash Girl: (with fake southern accent) White Trash Girl is an inbred biological disaster turned superhero. She's the product of a fourteen-year-old girl and her funny uncle. She comes out of this really abhorrent rape-incest situation. As soon as she was born her teen mother flushed her down the toilet, then a fight ensued between the teen mother and her uncle in which both were killed. Or maybe Cherry—that's the mother—kills her uncle, then throws herself out of a window. Meanwhile baby White Trash Girl is continuing to develop in a sewer, in all the sludge and piss and shit and puke, and she's taking it into her lungs and it's coursing through her tiny little baby veins. So little White Trash Girl develops these superpowers from being raised in that sewer. She has these toxic body fluids, and she's really strong because of the situation she was born in. If you're the product of a rape-incest, what else awful can happen to you? She may have come out of this awful situation, but the bottom line is she's never been a victim.

But she's also kind of an anti-hero. She doesn't always fight for truth and justice, she might get into a fight with the fry guy at McDonald's who's been harassing the girl who runs the takeout window. Or she might get into a fight with some guy who shoves her on the bus, or she might get into a fight with other superheroes, like Postmodern Girl. You can't pigeonhole White Trash Girl—she's very unpredictable. There's this core of characters in each episode: other people she could fight, or other superheroes, or whoever I might be mad at. The first episode is how White Trash Girl came to be, and each one is the further adventures of White Trash Girl, or Clit-o-matic.

LK: And Clit-o-matic is . . . ?

WTG: It's like this big pussy with big teeth on top of a V-8 engine. It's like power and femaleness, and explicitness. Everything that clit power and the explicit body means when it goes into auto pilot and destroys everything in its wake.

LK: Can you describe White Trash Girl for us?

WTG: She's about five-seven, and she's got long, long, long, blonde hair—although not feathered unfortunately. She wears a big white cowboy hat, lots of short skirts and tight t-shirts that say things like "I'm baby soft" [this is the t-shirt White Trash Girl happens to have on today], and go-go boots or a lot of white leather. She's a waitress during the day and she drives—I'm thinking she drives a Camaro.

She doesn't really have any heroes, she's her own hero. Or her heroes are her friends who are topless dancers. White Trash Girl is played by me. So I can be a star, a superhero. She's pretty glamorous in that White Trash Girl way. And of course, she's a superhero: she has her own trading cards, a TV series that I'm submitting to cable access—it's a video-comic book with hyper-action, like a video-zine. It's trashy, low-budget, flying by the seat of your pants. Keep them wondering what the fuck is going on.

LK: So how did this all start?

WTG: Well, my first semester at grad school, things weren't going so well. It was really a semi-hostile environment. I was coming to the end of my rope with the people in my department, these kind of snobby art folks. I was doing a lot of reading about different sex and gender stuff, and thinking about white power. I told someone offhandedly that if I were a superhero, I'd be White Trash Girl. Her main super power would be like screaming at people. Like when somebody was giving her a hard time, she would just have this piercing [screams] "Fuck you, you fucking fucker!" And they would die of agony from hearing this piercing, screaming noise. Then reading other stuff, like your article about *Hustler*, and finding this articulate way of saying that there's this power in being trashy.

But as far as art school, okay, on the one hand I was consciously putting myself on the low end of these low art/high art debates. But then at the same time I realized that, actually, none of these high art types wanted anything to do with me. I was taken aback at first. But I thought hey, wait a minute—they were also a little bit afraid of me, like I was this sort of loose cannon.

LK: This was after you adapted the White Trash Girl persona?

WTG: No, no, this was before. So then I decided to go ahead, and make White Trash Girl a real thing. Over Christmas break, when I had gone back to Columbus to spend about a week and a half with my family, I thought: I have to go back to Chicago and kick some ass. And that's where she was born.

LK: Was there something about being with your family that inspired the invention of White Trash Girl? Is your family "white trash?"

WTG: Well, my father worked his entire life for White Castle—the pinnacle of white trashiness. And my parents' house is full of White Castle memorabilia. Magnets, and junk and this huge stained glass window that says White Castle on it.

LK: That's too perfect.

WTG: Yeah. My dad was born and grew up in West Virginia, and he told us great stories about driving coal trucks when he was thirteen. He grew up without a father—his dad abandoned his family when he was a little tiny kid, and he and his three brothers would just get in to all sorts of trouble in West Virginia.

But in terms of class, I'd have to say that we were probably middle-class. We never did go without anything. We ate, we dressed, and all that, but I wore my brother's clothes, I wore hand-me-downs and we ate a lot of leftovers . . . I remember like wanting Jordache jeans, or wanting jeans that fit, even, I wanted my mom to buy me a pair of jeans. And not being allowed to. Or wanting to get a perm, or wanting to get my hair cut by somebody better than my mom.

LK: So you were middle-class, but with something of an outsider status in relation to consumer culture. But not white trash?

WTG: Yeah, I think we were kind of a trashy white family more than a white trash family. There was this family fascination with, like, farting, and we all constantly made these really awful jokes, which included a lot of racist jokes and sexist jokes. All of that sort of repressed nasty stuff. My mom freely talks about shitting. . . . Still, to this day, if our entire family is together, by the end of the night we'll be talking about puking episodes. It's inevitable.

LK: So it seems like there was also a sort of an outside status about not adhering to all the body norms of polite society, or of polite middle-class culture anyway—if you're talking about farting at the dinner table.

WTG: Yeah, I only became aware of that spending time with other people's families. [laughs]

Cherry's baby wiggled around in the sewer sludge for days. Days became weeks and weeks became months. The baby continued to grow and develop there in the muck and excreta. The ooze fed and nourished the baby. It made the baby strong—really strong—super strong! The baby's tiny baby body was becoming more toxic and vile with every tiny baby breath and every tiny baby heartbeat. Cherry's baby was turbo-charged. This was a super baby—a little tiny super hero. This was . . . WHITE TRASH GIRL!!!

Now WHITE TRASH GIRL!!! is a little older and she is waging biological warfare on anyone who asks for it. WHITE TRASH GIRL is built for speed. She waits tables by day, cruises around in her big bad white-trash mobile by night, and she is always ready to kick some ass. Her body is toxic and she sure knows how to use it. She might shoot you with her "Beaver blaster," she might blind you with a blood clot, she might try and strangle you with your own intestines—you know that if you cross her, you are going to get it!

LK: What about sex? Was the family equally open about that? I mean, White Trash Girl certainly deploys her sexuality in a pretty blatant way.

WTG: Oh, gosh no—there was this whole Catholic mom trip, you know, where she made me fear sex and everything that was sexual. Her family was Irish Catholic, and I think that's where more of the tight-lipped stuff came. My mother had all this weirdo Irish Catholic stuff going on about repression and denial of female bodily functions. She talks about not being able to take a shower when she was menstruating. Her mother just wouldn't let her take a shower.

LK: So you could talk about shit and puke freely, but not sex?

WTG: Yeah, and I think that all of those things really fed into my later eating disorders. I remember my mother saying you can't have sex until you get married, so I was really terrified of anything sexual and of my own sexuality. Until I was out of high school. And of course, being a ballerina, too.

LK: When were you a ballerina?

WTG: From about age eight until about nineteen or twenty.

LK: That's a pretty upward aspiration!

WTG: Totally, totally!

LK: So how did the eating disorders start?

WTG: It started with a dance teacher saying, "hold in your stomach," all the time, and I remember thinking that if I lost five pounds it would be easier for me to hold in my stomach. And then of course five turned to ten, and then ten to twenty, twenty-five. I wasn't heavy to begin with and I dropped down to like I don't know, ninety pounds or something like that, and I stayed that way for about four years. I can remember having these wars with this one girl I took dance classes with who was the richest girl in the class. She and I were always up for the same parts, but in that arena I felt like I could compete. She might have had on a more expensive outfit, but if I wanted to I could dance circles around her. So that's how I started. It was a way to say, well you might be richer, but I'm skinnier.

LK: So it was a way to compete with girls who had more money?

WTG: My best friend had just moved into this really rich neighborhood, and she started going to this private girl's school and she just abandoned me. I think it was between that, and starting high school, and being in dance class five or six times a week and realizing that most of the girls in dance class were from a better part of town, and could afford better shoes and better clothes, and I was still wearing hand-me-downs. And it became really obvious to me that I would never be a part of that.

There's something about being raised around a lot of money that makes you act different and makes you know when to do certain things and know when not to do certain things. I realized then that I would never have that, and that there was them, and there was me. And with my girlfriend who dropped me when we got into high school—now I have this great feeling of revenge. Cause she's just this awful suburban mother. And I'm not. And I look at her life, and it's just like being chained to something, chained to this big lump of shit.

LK: Did you ever want that? Or envy it?

WTG: No I didn't, because those people were always mean to me. I associated it with just bad stuff. But then at the end of my anorexia, I started to become bulimic. I had stopped menstruating, which was really important to me because it meant my body fat was too low, which was like a victory. I wasn't a woman yet. It kept me in this bizarre preadolescent state: I didn't look like a woman. I had no breasts and no hips. Anorexic woman will grow an extra layer of hair on their body and so I had this funny little hairy face, and my back was really hairy—not like black arm hair, but like a goose down kind of hair. And because you don't eat, your stomach sticks out in a funny way, because it gets swollen from malnutrition, and then the juices in your stomach begin to change because they can't digest anything so your breath stinks, your saliva changes. It's really incredible the changes that your body goes through.

LK: How did it end?

WTG: I got busted when I was a senior in high school by this woman who had been anorexic and who said, "I know exactly what you're doing." And I had read about bulimics who become so bulimic that their teeth would rot and fall out, and they ruin the inside of the stomach and their esophagus is ruined and you can only eat baby food. I thought, this has got to end somewhere. I had been in and out with doctors and at my skinniest, probably about six months before I had become bulimic, I had ulcers and in treating that, they found out that weird stuff was going on with my kidneys. My body was dying. And thought, oh god, where is this going to end?

I called up the National Anorexic Aid Society and did that sort of classic sobbing on the phone, and they said that I should come to an open meeting that night. So I went to that and just cried the whole way through it. I was in this room full of woman—some of them were older women from the rich part of town, and some of them were these trashy white girls, teenage

girls, and the thing we had in common was that we had puked into garbage bags and hidden it from our husbands or families. Or we had said we were going to eat, and then flushed our food down the toilet. It was like this family. I did go to see an actual therapist about three times and of course all she wanted to talk about was my relationship with my mother, which just didn't help at all. What helped was going to meetings and meeting other eating-disordered women.

I still have a really "interesting" relation to my body and its functions, and I still have a "funny" relationship with food. I think it makes sense that I'm still really drawn to the scatological, and the trashy and the gross, and it just keeps coming.

LK: I was thinking about the "origins story" of White Trash Girl having been born in a toilet, and it's hard to miss the connection with how central the toilet is in the life of a bulimic. This origins story seems like a way of symbolically transforming bulimia and all those "toxic body fluids" into a form of power: rising out of the toilet and taking over the world.

WTG: That's exactly it. And for someone who's anorexic and being hyperaware of your body and bodily fluids, it's kind of this low-class thing, because there's the idea that only the lower-class "smells." The upper classes don't shit or smell or anything, but the lower class can shit and barf and puke and acknowledge it. So White Trash Girl uses all those low-class body functions against other people. Like this toxic puke: you puke on someone and he dies or chokes and it becomes really powerful. It's about being able to say, yeah, I'm like that. I smell, I have a body—and what of it? What are you trying to say about it? Like yeah, so I menstruate, so what? I'll throw a big toxic blood clot on you.

LK: So is that how you'd describe the aesthetic strategy of White Trash Girl: a transformative one of appropriating everything that's held in contempt by the larger culture and translating it into a form of power?

WTG: Yeah, it's a form of re-representation, using the tools you have already, but using it all: peeling the scab off and letting it bleed and get all pussy, then see what happens. I hope White Trash Girl creates more problems than she offers solutions. I'm not about making things neat and clean and giving answers—that's still all about anal retentiveness, about not talking about shit and piss and puke and menstruation and sex and the body. Nothing should be neat, it should be all oozing and out of control.

LK: It's quite a contrast with the class connotations of the ballerina's body.

WTG: I actually think they're kind of similar.

LK: How is that?

WTG: A lot of times I think about white trashy bodies as either being like really big and fat and sweaty, or like really really emaciated.

LK: What about boobs? You were talking before about coming out as "busty" in your video. Ballerinas aren't supposed to have them right?

WTG: Yeah, that's why I'm adhering to this white trash aesthetic now, and why it's so appealing to me. Because I am busty, and I am loud, and I love bad taste. I *am* bad taste. It's like a way for me to be all of those things that I wasn't when I was growing up—to be really comfortable with my body now, because I spent so long being anorexic and being really skinny, I mean, really gross skinny. I wanted people to think I was really gross, actually. I wanted to get these comments like, "Oh, you're so skinny." I wanted people to stare at me. Not because I was beautiful, but because I wanted to kind of gross them out.

LK: Why?

WTG: There was a lot of self-hatred. Anorexia is just this prolonged suicide.

LK: Did you consciously think at the time "I want to gross people out?" Or do you think that now in retrospect?

WTG: I just pictured myself in this realm all by myself, with my own rituals, and with my own system of beliefs. And it was really safe in there, and if people were grossed out maybe they wouldn't come and join me. They wouldn't come near me.

LK: Isn't that similar to how you were describing the experience of being in art school? Wanting people to fear you and have contempt for you?

WTG: Yeah, because it's true that White Trash Girl emerged after I realized that these art school fucks didn't want to have anything to do with me either.

LK: In a way that you perceived as having something to do with class?

WTG: Yeah, maybe. There's just this way that they let you know what you could or couldn't do.

LK: Like what? Cause I thought anything goes in art school.

WTG: Well, people *are* starting to be accepted in the art world who have this scatological approach—there've been exhibitions like that. But I think I'm taking it to this other level, by talking about this aspect of white culture that's really trashy, and bringing it into this high art world, where a lot of people just don't want to associate with it.

WHITE TRASH GIRL. She is an inbred toxic disaster turned super-hero. WHITE TRASH GIRL means business and she is coming at you faster than you can say "hatchet wound."

WHITE TRASH GIRL and CLIT-O-MATIC will be coming soon to a trailer park near you. So be warned, you creepy little shit-eaters. And remember what WHITE TRASH GIRL says . . ."Put Out or Get Out!"

LK: The outsider position has been a traditional place for artists to speak from—the whole Romantic tradition.

WTG: Yeah, being on the outside has its advantages. Upsetting the apple cart, and upsetting certain faculty members. Not all. I've found people at my school who really are into it, but I've also found plenty of people who are offended that I'm even talking about white trash. It's like they don't even want to acknowledge that's there's this aspect of white culture that exists.

LK: Do they think you're making a racial slur? Or a class slur?

WTG: Yeah, but I wonder if they're actually listening to what I'm saying. There are these white liberal folks who want to say that the "white trash" will be offended. I think that *they're* offended, because it goes to, like, the very heart of the way that we behave daily, and the way that we perceive things around us, and it talks about their own prejudices. They're offended by White Trash Girl's approach to situations that she encounters. She's this anti-hero with these toxic bodily fluids; she just uses her body as her weapon—whether it's throwing shit at someone or like pulling out somebody's intestines and strangling them with them. Or her language—like she calls herself or other females "cocksuckers," or "cunts" or whatever, and that's her power. Nothing is insulting to her.

LK: But isn't she insulted when people are offended? Or rather, aren't you insulted when people are offended?

WTG: I'm still taken aback when people who I *mean* to offend like it. Or the reverse. Like, for instance, X [an instructor] hated, hated, hated, this cable access TV show I did with me playing a white trashy characterette, and he just hated it and refused to talk about it, and so I made this immediate enemy of him.

LK: Why had he not liked it? Does it have anything to do with his own background? Isn't his background southern, like—

WTG: It's like white trash! [both laugh] And he's somebody who's tried to escape it and super-deny it. He's like hyper, hyper P.C. you know, down with every cause. And I think that's ridiculous. Like do it if you really need to do it, but don't do it to compensate for an upbringing that you feel is embarrassing. I think that it's about being white, the experience of being white in this country. It's a really confusing place to be, and I think that has everything to do with why he didn't like this work.

LK: Did he think that you didn't have an entitlement to talk about that class, or that his own relation to that class was a more legitimate one?

WTG: No, I think it's that he feels embarrassed to be white. I think a lot of people have this white guilt, so any reference to white culture becomes about white supremacy. Or if you talk about white culture, it means you're not talking about black culture, or Hispanic culture, or Asian culture. I'm *white*, I can't trace my roots out of this country. So I'm just this white girl, and what about that? It's part of my identity. It describes a certain aesthetic, but I think it's also a socioeconomic situation, and a way of perceiving the world around you and your own place in the world. I think X associated that with racism and ignorance. And rather than really try to understand what I was talking about, he was immediately defensive, jumped in there for all the people he felt weren't being represented.

For me it's not like that. It *is* about race and class and gender distinctions, but not about being racist or being sexist, or anything like that. He's not my video hero. So when he was putting down my stuff, it was really easy for me to walk out, and think, fuck you, you're not my video hero. I didn't care. I could walk away from that and know that he wasn't my audience. And he'd get his.

LK: So is White Trash Girl going to pull out his intestines and wrap them around his throat?

WTG: Potentially, yeah.

LK: It seems like before, as an anorexic and a bulimic, you were sort of a "private" performance artist and now you're a "public" performance artist, but still using the body in similar ways. What's the distinction between doing it in private and in public?

WTG: When it was private it didn't really help me at all—it just kept caving in on itself. And now, although I haven't done any work that specifically says: this is about eating disorders or recovery from that, it still references that. Like White Trash Girl and her toxic bodily fluids. It's about her relationship with her body, and my relationship with my body. And realizing that your body isn't going away. White Trash Girl doesn't feel any inhibitions about her body and its power, there's no denial of her body functions. They have this incredible power, and she's still really smart and overtly sexy and all that. It's cathartic for me and therapeutic—oh that awful word. But it's not about Jennifer saying, "Woe is me, oh my shitty life." It's like saying "Get out of my way!" Stomping around, and taking this situation that

was once disempowering—like not having access to money or power—and switching it around.

LK: Are there distinctions between you, Jennifer, and White Trash Girl?

WTG: White Trash Girl doesn't know about there being a time and a place to do certain things, whereas Jennifer unfortunately realizes that you can't always walk into a room full of people and say, "Get the fuck out of my way!" White Trash Girl has no concept of that whatsoever. White Trash Girl is to the limit, no holds barred. Balls out. So to speak.

When I realized I was going to do all this, I became a completely different person. At school, where before I would walk down the halls mumbling to myself and putting people at ease, now I came back screaming down the halls. And it's just going to get worse from here.

LK: I'm interested in this rage that White Trash Girl has. Would you say that this rage has more to do with femaleness in a way that crosses class lines, or more to do with class? Or maybe the question is, what's White Trash Girl's relation to feminism?

WTG: She's from the new school of feminism. She's much more Riot Grrrl [a loose movement of post-punk, post-feminist, girl-based rebellion] than she is that old school of, [whining] "I don't want to shave my legs . . . " That just doesn't mean anything to me, it doesn't help me because right now what I want is to kick someone's teeth out, just be able to acknowledge female anger and craziness. I expect a certain amount of criticism to come from that old whiny school of feminism that still says "I hate the 'c-word.'" I acknowledge them as paving the way for younger women to do the things they can do, but it doesn't mean anything to me. What matters is taking back all those negative things. And having this fuck-you attitude of "Oh yeah? And what else? What of it?" White Trash Girl isn't a man-basher—which is also kind of old school. She's about taking responsibility for yourself and your place in the world. She'll fight guys, but she doesn't automatically hate guys. But if you cross her you'll get it, and that's just the way it goes. I think she's a good role model.

LK: So would you say that you're rejecting an earlier feminist idea that women as a class are oppressed and therefore there needs to be collective action, and saying instead, on an individual level, women can have personal power and transform things that are disempowering into power?

WTG: Yeah. I think a lot of young girls have that in them. There are these all-girl bands, all-girl 'zines, that are all about hot sweaty all-clits-out girl

power. And this is happening with twelve or thirteen or fifteen-year-old girls. It's all about being angry and acknowledging being female and refusing to say that there's no power in that. It just cuts to the chase. I went to see Courtney Love and Hole and I just wanted to come all over myself. She was singing and these young girls were singing along with her . . . She plays with one foot up on the amp so you have this great beaver shot. All these contradictions—these are things that exist in my life. It's not predictable. And new feminism isn't predictable—you can be a bombshell and wear black panties and still be really smart.

LK: Do you imagine any time when White Trash Girl will outlive her usefulness? Will you kill her off?

WTG: I admit this is really juvenile work. It's *Mad* Magazine and *Beavis and Butthead*. People say, I hate to tell you this, but it's kind of stupid and I say, yeah, *and* . . . ? What are you trying to say?

LK: That's another despised category, the juvenile.

WTG: Yeah. I guess I don't expect to be doing this in ten years. It'll evolve into something else, but who knows what? I showed it to this guy, this asshole, a guy who I got a tattoo from who turned out to be really judgmental. I showed him the trailer and he said, "It's bordering on the—" And I said, "Don't say 'offensive.'" And what he said was, "It's bordering on the stupid." And I thought, well great.

-------------------------- **NOTES**

1. Laura Kipnis, "(Male) Desire and (Female) Disgust: Reading *Hustler*," in *Cultural Studies*, ed. Lawrence Grossberg, Cary Nelson and Paula Treichler (New York: Routledge, 1991). See my *Bound and Gagged: Pornography and the Politics of Fantasy in America* (New York: Grove, 1996) for an extension of this argument.

2. Mary Douglas, *Natural Symbols: Explorations in Cosmology* (London: Barrie & Rockliff, 1970), 70.

3. On this topic see Peter Stallybrass and Allon White, *The Politics and Poetics of Transgression* (Ithaca: Cornell University Press, 1986).

4. See Laura Kipnis, "Life in the Fat Lane," in *Bound and Gagged*.

White Savagery and Humiliation, or A New Racial Consciousness in the Media

ANNALEE NEWITZ

In *Planet of the Apes* (1967), we watch the future of planet Earth unfold through the eyes of a very white, very male astronaut named Taylor (Charlton Heston). He and his crew have agreed to go on what amounts to a suicide mission: blasted from "the present" into deep space, they will not be returning to Earth for more than 2,000 years as a result of space-time dislocations. When Taylor and his crew crash-land on a planet, they do not recognize it and they assume that they have somehow missed Earth on their journey back from deep space. Upon reaching "civilization," they discover a large group of white savages, dressed in rags, munching on fruit and unable to speak any language. Along with these savages, Taylor and his

crew are rounded up by humanoid apes on horses wielding whips and guns; Taylor himself is tied up, beaten senseless, and taken to a lab where he is going to be used as a lab animal. Taylor spends a great deal of the movie in a cage with a large leather collar around his neck, beseeching one of the ape scientists—who patronizingly calls him "Bright Eyes"—to recognize his humanity and set him free. When he is finally able to escape, Taylor discovers a corroded and abandoned Statue of Liberty slowly sinking in the sand off the shore of what we assume was once the United States. The truth is that humanity has destroyed itself, and Earth has been taken over by apes, once-savage animals who are now essentially human. Apes are also, of course, associated in racist discourse with "developing" peoples and blacks. *Planet of the Apes* could therefore be described as a white-authored fantasy about the abolition of white power: whites have become the primitive slaves while civilized "others" rule the Earth. Where in the white imaginary does such a fantasy come from?

It's tempting to say that *Planet of the Apes* is a white racist's nightmare, but white racial self-representation is far from simply racist. To analyze representations of whiteness like those in *Planet of the Apes*, one needs to ask two basic questions about them: how do they reflect the ways non-whites view whites, and how do they reflect the way whites view themselves? These are the same questions, in reduced and simplified form, that racial minorities and minority scholarship have had to answer for several decades about whites, in part because whites wouldn't do it for themselves. In her essay "Representations of Whiteness in the Black Imagination," for example, bell hooks describes the way blacks associate whites with "the mysterious, the strange, and the terrible,"[1] and reports that white students in her classes are often amazed when they hear blacks view them this way. They are in actuality, she continues, amazed that they can be "viewed" at all, since whites have tended to imagine themselves racially invisible. Whites are said to consider themselves a neutral universal category, hence non-racial and superior to "racialized" others. Their self-image as whites is thus both underdeveloped and yet extremely presumptuous. In too many cases, perhaps, this is true. But as critics such as Eric Lott have pointed out, white "dominant culture" oftentimes implicitly acknowledges a secret or not-so-secret beholdenness to people of color, and even exhibits a sense of shame at having abused traits in non-whites that whites know to exist in themselves.[2] In other words, there is certainly a self-critical, and self-conscious, aspect to white identity,

however faint, which demonstrates that whites are able to see themselves in the same way oppressed racial groups often see them.

But where do we go from there? It would seem that whiteness only becomes visible to itself when whites discover their racial particularity in the imaginations of racial others. Yet, as we have seen in *Planet of the Apes*, whites themselves can generate images of a whiteness which is marked, imperfect and disempowered. Whites, in other words, are capable of generating stereotypes about themselves which are far from flattering. Sander L. Gilman has suggested that people create stereotypes when, as children, they divide the world up into "good" and "bad" objects, which they internalize as "good" and "bad" selves. Hence, all images of the world are filtered through these early "good" and "bad" stereotypes. Problems arise, however, when we question our control over the boundaries between what we consider "good" and "bad":

> When doubt is cast on the self's ability to control the internalized world that it has created for itself, an anxiety appears . . . We project this anxiety onto the Other, externalizing our loss of control. The Other is thus stereotyped, labeled with a set of signs paralleling (or mirroring) our loss of control . . . The "bad" Other becomes a negative stereotype; the "good" Other becomes the positive stereotype. The former is that which we fear to become; the latter, that which we fear we cannot achieve.[3]

Monolithic, stereotyped Others are created when we experience a loss of control over categories we once trusted to remain stable in their "good" or "bad" character. We can trace the new "bad" images of whiteness to precisely this kind of anxiety. Partly as a result of the criticism directed at whiteness by civil rights groups and minority intellectuals for the past several decades, whites are slowly undergoing a transformation which involves reevaluating racial stereotypes. Not surprisingly, however, this reevaluation is causing an internal instability within whiteness. It has generated a stereotyped white Other which is called, among other things, "white trash."

My contention is that one way we might understand white racial identity at the close of the twentieth century is as a social construction characterized most forcefully by an awareness of its own internal contradictions. These contradictions are manifested in white-on-white class conflicts, fears about the unattainability of a total "white power," and a crippling sense of guilt caused by an (often repressed) acknowledgment of white racism. As a result, white racial self-consciousness is based in large part on various forms of divisiveness and self-loathing. The question I want to address here is how

whiteness tries to hide this divisiveness at its heart, and hide from its own social responsibilities in the process. Cultural stereotyping is one powerful way contradictions are masked, and for this reason it is precisely with white self-images that I wish to begin an answer. In contemporary U.S. culture, a form of self-loathing is coming to stand in for white self-consciousness: one which celebrates, and thus solidifies, the internal antagonisms which constitute a specifically white form of racial consciousness.

---WHITE SELF-REPRESENTATION: SAVAGE MURDERERS, BRUTAL COPS

Perhaps most sensationally, whiteness emerges as a distinct and visible racial identity when it can be identified as somehow primitive or inhuman. For example, to see a white as a white, rather than "just another person," that white needs to be marked out as different from those whites who—implicitly or explicitly—observe him. As J. W. Williamson notes in *Hillbillyland*, an exhaustive study of representations of "mountain people" in Hollywood film, the hillbilly figure designates a white who is racially visible not just because he is poor, but also because he is sometimes monstrously so.[4] Williamson explores how the rural, impoverished white trash cultures of the mountains, in films from *Deliverance* to *Evil Dead 2*, are a source of realistic and fantastical menace to white middle-class tourists. Key to this menace is the way mountain whites appear to be primitive versions of their big city counterparts, separated from "normal" whites only by a less "civilized" demeanor, and not by the color of their skin or a foreign nationality.

As Marianna Torgovnick points out, the idea of "primitive peoples" is an invention of the West which assumes that non-Western (usually non-white) cultures are under-civilized. She proposes that one way racial difference gets talked about is as a kind of temporal discrepancy, where white Westerners exist in "the present" and non-whites are living in a more savage, natural, and authentic past—a past which the West has left behind.[5] Racialized identity is linked to a primitive past, whereas "neutral" whiteness is not. To understand how racist discourses of the primitive work to produce a racialized whiteness, we need to look for signs of the savage in whiteness. When middle-class whites encounter lower-class whites, we find that often their class differences are represented as the difference between civilized folks and primitive ones. Lower-class whites get racialized, and demeaned, because they fit into the primitive/civilized binary as primitives.

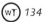

Researching the native habitats of white primitives is in some sense the goal of white middle-class writer Brian in the movie *Kalifornia* (1993). Broke and down on his luck, Brian and his partner Carrie decide to move to California—as they drive there, Brian will research a book he's writing about serial killers by visiting famous murder sites and trying to figure out what went on in the savage minds of his subjects. Brian places an ad for carpoolers on a bulletin board at a local university, which is answered by a young white couple, Early and Adele. Meeting them, Brian comments in voiceover, "If you looked in the dictionary under 'poor white trash,' a picture of Early and Adele would have been there." And as it turns out, Early is a perfect example of what Brian is researching: he is a genuine serial killer who seems to enjoy efficiently killing middle-class whites in order to take their money or avoid paying them. In his first on-screen murder, Early takes out his landlord, who has been badgering him for a rent check. Early proceeds to kill and rob a man in a gas station, and later he shoots a worker at a convenience store he is robbing. The movie ends with a climactic scene in which Early attempts to murder an older middle-class couple. Becoming gradually more unhinged during this sequence, Early kills Adele, and kidnaps Carrie in an attempt to make her "his girl." Early's murderousness is clearly connected to his class status—not only does he kill for money, but most often he kills people who seem to be middle-class. Moreover, his final killing spree ends when he steals Brian's middle-class girlfriend Carrie and tries to make her his own, which would seem to give life to middle-class men's fears that their wives and daughters might be taken from them by the lower classes.

But Early's murders are ultimately not the only behaviors that make him offensive in the eyes of the film or the middle-class whites who populate it. Carrie is initially unnerved by Early when she observes his habit of taking off his old, dirty shoes and socks at the dinner table; he also snorts and spits instead of using Kleenex, which seems to bother her as well. After the shoes and socks incident, she remarks to Brian that it's clear Early and Adele are broke (although her only evidence for this is that Early and Adele haven't ordered breakfast), and that surely she and Brian will end up paying for them. In other words, she begins to fear and dislike Early because she associates his bad manners with being "broke" and a potential for social destructiveness. Later, she discovers that Early beats Adele, which confirms her sense that bad manners may lead to more dangerous behavior.

While Early's murders are certainly shocking, they are not what make him remarkable as a villain—his knifings and shootings are the stuff of generic slasher films, and nothing more. Ultimately, Early seems most vicious and brutal because he refuses to behave in a "socially acceptable" way and pass as middle-class. His homicidal impulses are portrayed as some apocalyptic convergence between his low-class behavior and his shamelessness about it. Indeed, when Early becomes most enraged at the end of the film, it seems clear that his violence is directed not just at middle-class people, but their culture as well. After torturing them, Early ties up Brian and Carrie and starts looking through Carrie's photography, which is supposed to resemble the s/m erotic work of Robert Mapplethorpe. Early sneers at it, tears it up, and dubs it "stinky," demonstrating both a lack of "artistic appreciation" and the kind of knee-jerk conservative response to art which artists and writers have attributed to the lower classes for centuries. Early is horrifying because he kills out of a lack of respect for the middle class and its taste preferences—a penchant for murder becomes one more demonstration of his bad taste.

Like disappearing Indian "savages" recorded on film and in early twentieth-century narratives by ethnographers, white primitives like Early are likewise documented in contemporary American culture as if they were a separate species both repulsive and yet somehow fascinating. Stereotypes like those in *Kalifornia* suggest that poor whites are trash who don't deserve the benefits of social welfare, sympathy, or national power. But, at the same time, such stereotypes maintain—in a contained, taxonomic sense—images and narratives about poor whites in order to provide something against which "civilized" whites can measure themselves. White trash, by occupying the position of "bad" Other, offer a perspective from which "good" whites can see themselves as a racial and classed group. Yet this perspective is repulsive, even insane. Although a figure like Early may inaugurate Brian and Carrie's awareness of their class position, he does it in such a way as to invite his own well-deserved containment and destruction. Thus, it is often in violent class conflict that white racial self-consciousness gets registered, only to be abruptly dismissed as too disturbing to contemplate.

Kalifornia understands police intervention as one possible way to end white trash violence. The police, who have tried already to help Brian and Carrie, arrive to save the day just as Brian has killed Early. Yet, in many other contexts, police violence is integral to representations of white brutality. Far

from "curing" poor whites of their violent and primitive ways, the police are often cast as extensions of poor white violence. Since many police officers come from lower-class white backgrounds, images of violent police culture could be said to grow out of already-existing stereotypes of a brutal, ignorant white working class and to feed back into real social relations between the police and the poor as a catalyst for more white violence and frustration. That is, clashes between white police and civilians are another locus of conflict which allows white racial awareness to surface.

Nowhere has this relationship between the police and lower-class white violence been more evident than in discussions of the Rodney King video, in which we see three white Los Angeles Police Department officers severely beating a black suspect. The Rodney King video has become a kind of allegorical representation of white police brutality, demonstrating that white cops are uncontrollably violent and immoral. Spike Lee even incorporated footage from the video into the opening credits for *Malcolm X* (1992), clearly intending it to function as a symbol for white violence towards blacks historically and in the present. While the Rodney King video can be read as evidence of police brutality towards blacks, reality television show *Cops* (1989–present) uses "real life" video footage to record how much more complex the violence and identity politics of police culture can be. Admittedly, *Cops* is a show which is sympathetic towards the police officers in it—cameras travel with the cops rather than with suspects, so audiences are invited to "see" from the perspective of the police rather than civilians. Yet videos from *Cops* can be read against the grain in much the same way the Rodney King video has been. While many of the police officers on the show are polite and seem to want to do their jobs well, others are downright cruel, tormenting "drunk and disorderlies" with snotty jokes or responding coldly to victims of domestic abuse. Most of the officers on *Cops* are white. Notably, many of the most degraded suspects are also white, and live in poor or rural areas.

Unlike the Rodney King video, *Cops* offers us images of white officers abusing other whites.[6] Scorn and violence between working-class white police and "low-class" whites are a staple of the program. In one episode, for example, a white woman in a rural Southern area tries to get police to keep a drunken, violent (white) man away from her house. The woman is clearly illiterate, and when police ask her to fill out a complaint form, she is unable to do so completely. At this point, the police give up in humorous

disgust, shrugging and mocking the woman behind her back. As they leave, they confess to the cameras (and us) that there's nothing they can do for the woman if she won't help out by following through with the complaint. Although they know she can't read, and she has already told them she doesn't have a car to drive to the courthouse and file the paperwork, the police officers claim it's her fault that they can do nothing else to protect her from violence. In another characteristic episode, a white biker is beaten and thrown to the ground by white police who suspect that the biker is dealing drugs. He turns out to be carrying only a small packet of speed, but the police continue to believe that he must be part of a "ring." We assume they believe this because he is a white biker, and fits the Hell's Angels stereotype of low-class white males who wear leather and ride Harleys. This kind of logic—informed by racial and class prejudice—drives police officers in other shows to behave violently with inner city blacks wearing high-priced sporting gear.

What we are seeing in all these representations from contemporary Hollywood and the mass media is a growing familiarity with—if not acceptance of—lower-class whiteness as racially marked and made Other. White trash criminality, cops, and violence are commonplace in contemporary media representation: *Kalifornia* is only one of dozens of such movies, from *Bonnie and Clyde* (1967), to *River's Edge* (1986), *Natural Born Killers* (1994), *Love and a .45* (1994), *Cape Fear* (1962 and 1991), *Bad Lieutenant* (1992), and many more. Furthermore, police brutality, when it is raised as an issue, is invariably *white* police brutality against non-whites and whites alike. Associated with images of white violence and police brutality is a representation of whiteness that is savage and more primitive than other kinds of whiteness. Clearly civilized whiteness is middle and upper-class whiteness, which does not bear the degrading mark of race after having sloughed off a low-class white other who is both criminally violent and the embodiment of juridical corruption. Whites who are not "trash" here seem innocent of racially marked whiteness and its attendant brutality.

----- SELF-PUNISHMENT AND THE ESCAPE FROM WHITE POWER

As critic Shelby Steele has observed, whites cannot experience their racial identities as innocent unless they undergo a degree of punishment and penance. In spite of his more controversial claims, Steele correctly identifies one of the more pernicious aspects of white racism when he criticizes ways in which whites imagine they can receive a form of racial absolution and

innocence by participating in various self-shaming rituals. These rituals, for Steele, can mean anything from adopting affirmative action policies to compulsively confessing to white racism. Aimed at easing the white conscience, these rituals tell us more about methods of white self-representation than they do about genuine efforts to end white racism and injustice. Steele writes, "Guilt makes us afraid for ourselves and so generates as much self-preoccupation as concern for others. The nature of this preoccupation is always the redemption of innocence, the re-establishment of good feeling about oneself."[7] That is, whites use images and acts of victimization to reimagine themselves as civilized and just. White humiliation often becomes what Steele astutely calls "the *look* of redemption, the gesture of concern that will give us the appearance of innocence."[8] The *appearance* of white racial redemption, in Steele's estimation, often takes the place of real action or self-awareness intended to eliminate social injustices.

I want to suggest that Steele's "*look* of redemption" is achieved in a number of movies which do not, on the surface, appear to be explicitly addressing questions of racial identity. These are movies which concern white self-hatred, particularly hatred directed at the white middle class by the white underclass. Movies about white self-loathing are often implicitly dealing with white-on-white class combat. Such films follow a rather generic narrative: privileged whites are ambushed by low-class, monstrous, or criminal whites; the privileged lose their social power when they are tortured and some of their number killed; and ultimately this experience frees them from guilt over having ever exercised power unfairly or with prejudice. Racially speaking, this narrative structure frees whites from taking responsibility for white domination, in part because the attacks on white privilege are an in-house affair, coming only from other whites. One might understand these narratives as fantasies about whites resolving their racial problems without ever having to deal with people of color. Focusing entirely on the racial angle, however, is also deceptive: as these movies reveal, white power is not merely racial—it is also financial.

White power is spectacularly and exuberantly punished in a number of movies featuring middle-class white protagonists who are ambushed and tortured by lower-class or rural whites. *The Sadist* (1964), *Two Thousand Maniacs!* (1964), *The Hills Have Eyes* (1977), *Near Dark* (1987), and *Copycat* (1995) are but a few of these movies. Notably, each of these films invokes a kind of racialized class difference in depicting its low status whites,

some of whom are literally monsters or mutants. For example, in *Near Dark*, a young, well-to-do farmer is captured, bitten, and forced to suck blood by what Leonard Maltin calls "hillbilly bloodsuckers," a family of vampires who travel the American South in a mobile home. It's interesting to note that, in this movie, physical differences between the human whites and the vampire whites (who, significantly, live in the dark) seem to refer to physical differences between whites and non-whites. In *Two Thousand Maniacs!*, white tourists happen upon an abandoned Southern town, which turns out to be inhabited by angry Confederate ghosts who reappear every year to torture and kill Northerners. One Southern ghost uses an ax to chop off the arms of a Northern girl he is in the process of seducing; another Northerner is rolled down a hill inside a barrel with nails driven into it, as the Confederate ghosts shout with glee. In both films, "undead" white bodies get revenge on living ones, foregrounding white bodily difference without seeming to mention racial differences.

What these films share is a preoccupation with a form of white-on-white torture in which "civilized" whites are humiliated and destroyed by their "monstrous" counterparts. William Ian Miller, in his book on the subject, explains that humiliation is an emotional or social state we associate with the transgression of hierarchy, especially when the "high" are brought low. Humiliation is reserved for the individual who attempts to claim a high status which he may not deserve. Miller writes that "humiliation depends on the deflation of pretension."[9] He continues:

> The high are more likely to be humiliated—that is to be seen as humiliating themselves—in the eyes of the low . . . One of the pleasures, I would imagine, that people who belong to minority groupings experience is seeing the members of the majority culture humiliate themselves with such insistent regularity. It provides the substance of revenge for the humiliation they may occasionally feel at the hands of the majority.[10]

If we read films like *Two Thousand Maniacs!* as fantasies of racial self-punishment and humiliation, we might also consider them a way of heading interracial revenge off at the pass. Although white guilt is usually accrued as a result of whites mistreating non-whites, these films demonstrate the extent to which whites want to imagine their repentance for this mistreatment solely as an intraracial affair.

The Sadist (1963), which is an early and much cruder version of *Kalifornia*, tips us off to another way humiliation works in the context of the white self-image. Here the victimization of middle-class whites

becomes their redemption. This cult film features Arch Hall Jr. as the "sadist" Johnny, a Neanderthal-like white teenager who joyfully degrades three high school teachers whose car has broken down on the way to a Dodgers game. Johnny has gone on a killing spree in Arizona and California with his girlfriend Judy, and the three teachers are his last prey. All the action in *The Sadist* takes place at a gas station outside Los Angeles where the teachers have stopped for assistance. Johnny has already killed the gas station owners, and holds the teachers at gunpoint until they agree to fix his car. The younger of the two male teachers, Carl, knows something about engines, and he works on Johnny's carburetor as Johnny torments the older male teacher, Ed, and Doris, a hysterical young math teacher. When he realizes Ed has nothing to offer him, Johnny forces him to his knees and says he'll shoot him in the head. In response, Ed acts the part of professional teacher, lecturing Johnny about the foolishness of his actions, informing him that he'll surely be caught. Finally Johnny shoots him, giggling and saying, "You just keep talkin'. You think you're so smart." Already, we see that murder is only part of Johnny's revenge on these teachers for thinking they are his betters. Having humiliated—and murdered—Ed for thinking he's "so smart," he places Carl in the position of mechanic, which is precisely what all three teachers took Johnny for when they first pulled up at the station. Indeed, when they surveyed the gas station lot before Johnny appeared, Doris expressed her dismay at its "bad" condition. At that moment, we hear Ed remind her that "not all work is white collar work," and this knowledge returns to them with a vengeance as the narrative progresses.

Although Carl *can* perform the blue collar labor necessary to fix cars, he is utterly incompetent when it comes to defending himself and his colleagues against a mortal threat. Indeed, Carl is as much a stereotype of the middle class as the lumbering, sneering Johnny is of "white trash." Refusing to engage in physical combat, thin, pale, and fussy, Carl is singularly ineffective at coming up with a strategy to escape Johnny's clutches. He is unceremoniously killed when Johnny corners him in a dead end behind the gas station. Carl launches himself awkwardly towards Johnny, as if finally about to attack him, but he can do nothing save run straight into Johnny's gunfire. What is perhaps most striking about this sequence is the way the teacher, who is supposedly "smarter" than Johnny, actually ends up looking stupider than Johnny himself. In this way he is brought "lower" than Johnny, for all Carl really has going for him is his education, and yet he is

outsmarted by a young man portrayed as moronic. Johnny humiliates the male teachers by lowering them to apparent stupidity and cowardice before killing them. Their deaths are brought about because they refuse to fight Johnny on his own terms. Doris, however, survives precisely because she acts like a lower-class woman.

Johnny's treatment of Doris, and her response to him, demonstrate most profoundly how *The Sadist* conceives of white punishment and innocence. Doris is what Carol Clover has called "the final girl" of a slasher film—she survives attacks from a psycho because she is both morally good and capable of standing up for herself in a way which might be coded as masculine. She is also, however, violated and degraded in ways which the men are not.[11] In *The Sadist*, Doris is forced into a semi-rape situation with Johnny, who takes her around to the back of the gas station, away from the men, before he has killed them. While he does not molest her, he leers and forces her to operate a water pump for him, saying, "You think I'm dirt, don't you?" He then throws her to the ground, yelling, "EAT THAT DIRT!" Symbolically, speaking, she is asked to fellate the very dirt she clearly associates with a white trash type like Johnny. Her humiliation is therefore both sexual and classed: Johnny forces manual labor upon her and gets her dirty so she will look like a low-class woman, while at the same time suggests that she is somehow (erotically) partaking of his own "dirtiness" in the process. Johnny also steals her jewelry—those markers of a middle-class income—and gives them to his girl Judy.

At the end of the film, Doris escapes from Johnny by running away and hiding. Accepting her status as victim, she behaves like an animal: unlike the men, she makes every effort to escape without "thinking" about it. As if to underscore the way Johnny has been outdone by an animal associated with femaleness, we watch him die when he falls into a pit of snakes while trying to catch Doris. Repeatedly bitten and growling in agony, Johnny is killed while Doris straightens her hair and slowly wanders back to civilization. The film ends with a dazed Doris listening to the Dodgers game over the car radio, a "civilized" event she will surely reach now that her encounter with Johnny is over. As the "final girl," Doris is innocent because she is not overtly sexual and exhibits a kind of courage, but she is also in some sense *made* innocent by her ordeal. That is, the spectacle of her humiliation at Johnny's hands secures innocence for her—her mere survival is "proof" that she is no longer guilty. Although she needed to be taught by Ed that "not all work is

white collar work," it appears she is the only teacher who has learned that lesson. She wins in class combat with the white underclass because, paradoxically, she willingly participates in "low-class" animality and victimization. Put another way, Doris has eaten dirt, and now she has that dirt in her. One might argue that she is no longer guilty of white middle-class privilege, as she has been drained of social power and subsequently given it back only after having been victimized and "dirtied" for her elitist corruption.

But how might such a spectacle work for audiences watching this film? Kathleen Moran has argued that spectacle, aside from being a way to reify images, is important in contemporary film as a way to grant cynical audiences a visceral, bodily reaction to what they consume on-screen. While the tired plot of "violence and revenge" may be formulaic and predictable to an audience watching a movie like *The Sadist*, they nevertheless manage to experience "something . . . like behavior and somatic conditioning" when recoiling at its more dramatically violent moments ("EAT THAT DIRT!").[12] If we consider spectacle to be a form of conditioning, then an audience for films like *The Sadist* is being trained to have strong bodily reactions to images of white middle-class humiliation and destruction. Importantly, these physical reactions take place entirely within the safety of a movie theater or TV room. Whites don't even have to be punished physically to be "purged" of their guilt over white power—they need only *respond physically* while consuming *images* of violence. It is no wonder that such somatic conditioning is often pleasurable for white audiences, and marketed as entertainment: ultimately, it reassures them that watching images of white humiliation can cleanse them of their guilt in the same way real social action might.

Moreover, spectacular white self-punishment works to disavow white racial and economic power simultaneously. White pretension and its explosion through humiliation are wedded as much to racial inequalities as they are to economic ones. We see this demonstrated in *The Hills Have Eyes* (1977), in which a white middle-class family gets lost in a desert nuclear test site while on vacation. They are subsequently terrorized and some of their members murdered by a family/militia of white mutants who live in the desert hills. Communicating military-style over walkie-talkies and sporting animal skins and bones, the mutant family burns the patriarch of the civilized family to death, then shoots and rapes some of the women. Looking something like Native Americans, and something like genuine mutants, this family is biologically *and* economically Other; hence, like the white vampires

and ghosts I discussed earlier, their difference from the middle-class white family is racialized and classed. Ultimately, the surviving members of the civilized family "win" against the mutants by becoming savages themselves, burning one of the mutants and shooting others. The movie ends with one of the "civilized" men stabbing the mutant leader to death over and over, his teeth bared and eyes wild. We zoom in on this crazed, white face committing brutal murder, the screen goes red, and the credits roll. This image, I would argue, lies at the heart of white self-hatred as punishment and redemption. It is a confession that in spite of white middle-class education and cultural hegemony, whites are only a few steps away from becoming amoral, rural savages who kill each other with their hands. By admitting their complicity in the savagery of their "inferiors," whites can convert their hatred of the other into a hatred of themselves. Directing racism and classism at themselves, whites appear free of both while at the same time clinging to them fiercely as a basic component of their identity.

Seen in this light, white self-punishment is a form of psychological defense; but it is just as importantly a politically reactionary form of *ideological* defense. To the extent that this hatred is dependent upon a class hierarchy, in which those at the bottom punish and cleanse those at the top, it holds class divisions of every sort firmly in place. Furthermore, it justifies the containment and scapegoating of the lower classes, whose purpose is reduced to perpetually proving the strength and innocence of their betters in acts of extreme violence. One might argue that these "descents" into savagery break down the distinctions between middle-class and lower-class, and in a limited way they do. However, breaking down class distinctions in *The Sadist* and *The Hills Have Eyes* are events which are catastrophic in the extreme. The classes and "races" get equalized by becoming primitives in combat, thus sustaining the notion that the only power the disenfranchised have is to bring the powerful down to a horrific, animalistic level.

In terms of economic class conflict, the idea that middle-class whites need to become savages to defend themselves is a perfect excuse for the middle classes to behave in outrageously cruel ways toward the lower classes. We might say the middle class is only "fighting fire with fire," and in addition it cannot bear responsibility for what it does in a savage state. Primitivist ideology holds that we're all savages underneath; civilized people are just repressing their inner brute. If the lower classes "bring down" the white middle class to their level, in essence they are "asking for it" when the

middle class turns savage and kills them off. Ultimately, middle-class whites can use the hatred they inspire in lower-class whites to justify their own violence and to claim that they can't help being violent anyway. After all, the middle classes are just savages too. Either way, whites secure their innocence by swapping punishment and hatred back and forth between classes locked in combat with one another.

It even becomes plausible to argue that a race that does such violence to itself is in the same position as the racial "others" created by whiteness. Whites become, in this formulation, a crippled race, a victim race, a divided race—not a race of conquerors. As long as whites can maintain violent class division, they can also simulate racial innocence and flee from the guilt of wielding white power over non-whites.

-------- ABOLISH WHAT? SOCIAL CRITICISM AS SPECTACLE

"I'm a loser, baby, so why don't you kill me?"
—*Beck, from the song "Loser" on* Mellow Gold *(1994)*

Henry Giroux suggests that if we want to understand what Cornel West has called "black nihilism," we ought to consider its white counterpart, a "nihilism that represents another type of moral disorder, impoverishment of the spirit, and decline in public life."[13] Giroux calls this nihilism "white 'supremacy'," but I think it would be more accurate to imagine white nihilism as a sense of failure which is separate from, but dialectically related to, white efforts to reign supreme over themselves and non-whites. This failure is partly occasioned by the contemporary (and necessary) critique of whiteness, but it is also a failure built into the structure of white supremacy itself. "White supremacy" is a kind of unattainable ideal, against which all individual whites can measure themselves and find themselves wanting. Certainly, poor whites would experience such "wanting" on an everyday basis, both materially and psychologically. Roxanne Dunbar, describing Okie culture, writes, "Their great shame, like all 'white trash' and colonial dregs is poverty, that is 'failure' within a system which purports to favor them."[14]

But how does such shame attach itself even to powerful whites? We might compare it to the way power and shame work within another context, that of gender hierarchy. In gender studies, we are accustomed to thinking of the "phallus" as that unattainable ideal of masculine power for which men constantly strive and, falling short of it, compensate for their lack by growing tyrannical and abusive towards women or low-status men.

White supremacy, I would argue, is similarly the "phallus" of the white race. It is an ideal which cannot ever be achieved in a total sense. Even colonial imperialists found that their oppressed subjects refused to obey them at times, and many colonized peoples worked to undermine—indeed to revolt against—imperialist authority. This explains why, at the core of white supremacy, there lies a profound sense of inferiority and failure.[15] When whites are put in touch with that fear, a kind of self-destructive nihilism results, the logic of which goes something like this: if we can't be power-ful—or shouldn't take power for ethical reasons—we might as well die.

The epigraph I've included above from Beck's song "Loser" illustrates the principle of white nihilism I've just outlined. What makes Beck's work particularly important is the way it epitomizes the attitude of many young whites in the 90s—an attitude which is celebrated in popular "alternative" rock.[16] "Alternative" (or "indie") rock is largely white, and in many cases it is associated with working-class or underclass white cultures. Alternative cultural tastes (again, usually white and lower-class), on a more general level, are also responsible for the popularity of cult films like *Kalifornia*, and for the resurrection and revaluation of slasher/schlock movies like *The Sadist* and *The Hills Have Eyes*. Beck's song "Loser" is perhaps the most notorious homage to the doomed white nihilist, but other popular tunes have included Offspring's "Self-Esteem" ("I'm just a sucker with no self-esteem"); The Ass Ponys' "Little Bastard" ("They call him little bastard/They say it to his face/He say don't call me little bastard/Call me snake"); Radiohead's "Creep" ("I'm a creep, I'm a weirdo/What the hell am I doing here/I don't belong here"); and Hole's "Miss World" ("I'm Miss World/Somebody kill me/Kill me pills/No one cares, my friend"). Each of these songs describes a form of ironic self-loathing which paradoxically operates to make the speak-er both hip and impervious to criticism. William Miller calls this the strategy of "underground man," who "never allow[s] others to see him as humiliat-ing himself *before* he sees himself in that way." In addition, he notes that underground man—and here we might substitute "white alternative rock-er"—uses self-humiliation to prove his superiority:

> He needs [humiliation] to justify his superiority, the foundation of which is that he *feels* humiliated before or simultaneously with being seen as humiliating himself. Or, alternatively, because humiliation is the lot of us all, the nobility in such a world are those who possess that knowledge, using it as the basis for an elaborate parody of the human condition.[17]

In other words, preemptive self-hatred can confirm one's sense of superiority. White supremacy and nihilism are mutually determining, contradictory, aspects of white identity. Having lost, or losing, the social entitlements of whiteness, white indie rockers turn their very disenfranchisement into a source of pride. No one can insult you if you've insulted yourself first; and no one can threaten you with extinction if you've asked for it already ("Why don't you kill me?"). As a form of white self-naming, indie rock certainly avoids the potential failures embedded in white supremacy.

Indie rock has a kind of analogue in "alternative" academic press books and journal articles by whites about whiteness. Like the article you are reading now, most works on whiteness are intended to explode the myth of white supremacy. While there are numerous works in this tradition, what I want to focus on here is a recent trend in white intellectual self-representation which is sometimes called the "new abolitionism." Demonstrated most profoundly in Noel Ignatiev and John Garvey's anti-racist journal *Race Traitor*, it is also adopted by David Roediger in his latest collection of essays called *Towards the Abolition of Whiteness*, and to a lesser extent in Fred Pfeil's *White Guys*. In the words of Ignatiev and Garvey, the new abolitionism proposes:

> The key to solving the social problems of our age is to abolish the white race, which means no more and no less than abolishing the privileges of the white skin. . . . The existence of the white race depends on the willingness of those assigned to it to place their racial interests above class, gender or any other interests they hold. The defection of enough of its members to make it unreliable as a predictor of behavior will lead to its collapse . . . Treason to whiteness is loyalty to humanity.18

Whites must abolish themselves for "humanity" to be free. In this passage we hear vanguard whites who, like Beck or Hole, are nihilistic in the sense that they are self-critical to the point of being both self-destructive and self-celebrating. Unlike alternative rock culture or cult horror, however, whose self-criticism proceeds from an ambiguous source, alternative intellectual culture like the new abolitionism views its nihilism as a gesture of political emancipation, coming out of and undermining a racist culture. For this reason, we might say that the new abolitionism is in many ways an important step for whites to be taking if they wish to dismantle white dominance. It must be acknowledged that the idea that the privileged might "defect" from their positions in order to combat injustice is a potentially subversive one, and as such it needs to be heard. Yet, for many of the same

reasons horror is not always the best form of social critique, the new aboli-
tionism is not an unproblematic alternative to white domination.

If we take its namesake seriously, the new abolitionism suggests that white
domination is something imposed from without, a social and economic system
which enslaves us all, whites and non-whites alike. Thus, all that whites need
to do—as Ignatiev and Garvey suggest—is "defect" and "abolish" whiteness.
But whiteness, unlike slavery, is not just a social system. While whiteness is
undeniably linked to a series of oppressive social practices, it is also an identi-
ty which can be negotiated on an individual level. It is a diversity of cultures,
histories, and finally, an inescapable physical marker. Even if we understand
whiteness to be something like "dominant culture," what can we say about
white women, white homosexuals, white Jews, white low-status men, and the
white poor? These groups have certainly not unanimously experienced white-
ness as a ticket into the ruling classes. What, then, are we asking a white per-
son to do when we ask her to abolish her whiteness?

David Roediger offers a hint, when he notes in an uneasy moment of
autobiographical confession, "My question at age eighteen was why friends
wanted to be white and I didn't." This comment comes in Roediger's intro-
duction to *The Wages of Whiteness*, where he offers a brilliant historical
account of how the white working class adopted a strategy of racism to
maintain pride in degrading work and keep their jobs safe from an influx of
skilled black labor. Roediger's alternative to this working-class racism is the
new abolitionism, a solution symbolized by his youthful, anguished desire to
defect from a race he associated with violence and injustice.[19] In *Towards the
Abolition of Whiteness*, he concludes:

> The central political implication arising from the insight that race is socially
> constructed is the specific need to attack *whiteness* as a destructive ideol-
> ogy rather than to attack the concept of race abstractly [emphasis in orig-
> inal].[19]

Yet one of the most troubling aspects of Roediger's new abolitionism—
like that of Ignatiev and Garvey—is his seeming inability to untangle the
difference between whiteness as a social construction and whiteness as a
physical marker, or an indelible part of one's visible identity. When *Race
Traitor* and Roediger suggest that whites can somehow "defect from"
whiteness, or "not want to be" white, they leave the category of "white"
itself pretty murky. Sometimes whiteness seems like shorthand for "white
racism," and at other times whiteness is clearly a diverse category, subsuming

both antebellum slaveholders and New Left anti-racist radicals. On a rhetorical level, it would seem that the new abolitionism can't decide if white folks are the enemy, or if white racist domination is. Roediger exhibits this same indecision when he asks himself why his friends wanted to be white, but he didn't: what he really seems to be asking is why he can't actually be a non-white person, while at the same time he is also clearly questioning the idea that skin color determines one's social destiny. That is, Roediger has it both ways. Whiteness is and isn't a social construct; wanting not to be white is and isn't a desire to change one's actual skin color.

Rather than offering a way of understanding whiteness as a form of identity powerfully effected by oppressive social practices, the new abolitionists propose "abolition" (i.e., destruction) of an undefined white selfhood, and "treason" to it, as a solution to the problems of social injustice. Because whiteness remains undefined in this equation, one is left wondering whether to abolish white people themselves, or the social practices associated with white racism and social domination. We are asked to demonize whiteness rather than to deconstruct it. Although critics like Theodore Allen and Alexander Saxton have both described the way "whiteness" as a racial category was invented during the nineteenth century in order to consolidate American nationalism and pro-slavery agendas,[20] "whiteness" in the new abolitionism becomes the source (rather than an effect) of all that is wrong with American society. Abolishing whiteness—which seems to mean eliminating both whites and white power—suggests social problems are best solved through prejudicial destruction, rather than critical self-consciousness or progressive reconstruction. The strategy of new abolitionism resembles nothing so much as indie rock's "underground man," for its theorists themselves become "superior" at their critical work on the basis of their ability to critique themselves before anyone else does.

The new abolitionism offers a suggestive account of racist society, but its solution is no more helpful than indie rocker Beck's ironic request that he be killed, or images of white-on-white torture. Social problems like unequally distributed resources, class privilege, irrational prejudice, and tyrannical bureaucracy which we associate with whiteness are just that—*associated* with whiteness, particularly at this point in history. They are not essential to whiteness itself, any more than laziness and enslavement are essential to blackness, or any more than smarminess and incoherence are essential to femaleness. Informing whites that their identities are the problem, rather

than various social practices, makes it sound like whites should die rather than that white racism should. The ideologies of white power which make some white people socially destructive are the symptoms of American inequality and injustice, not its principle causes. There is, in the end, an alarming sense of hopelessness, brutality, and nihilism in any political strategy like the new abolitionism that takes as its fundamental goal the destruction of a highly generalized, demonized "enemy." Interestingly, even Noel Ignatiev seems to be acknowledging this possibility in his first book, *How the Irish Became White*, which is an historical treatment of how Irish immigrants to the U.S. were gradually assimilated into a racist U.S. nationalism.[21] Here he is clearly sensitive to the changing historical meanings of whiteness and its status as a contestable, constructed identity.

Ultimately, I am concerned that the new abolitionism may offer whites a way of having their cake and eating it too, at least within the context of anti-racism. For there is a danger that reading about or enacting the new abolitionism might function something like the spectacle of *The Sadist* does for a white audience. White self-representations which emphasize white self-punishment and degradation—white abolition, if you will—absolve whites of their guilt without explicitly suggesting that they do more than criticize themselves. After all, we might ask, what would be the "praxis" of the new abolitionism? Its proponents leave the "practice" part of "praxis" pretty open-ended in their writings. I am not denying that anti-racist consciousness can change the world for the better. But is the new abolitionism the theory by which we want to conceive of our anti-racist acts? Oftentimes, it seems to suggest that the only progressive task available to white anti-racists is a kind of contemplative self-destruction. Such a strategy will invite whites to confess publicly to historical and present misdeeds— often in a way which creates a spectacle of their humiliation—but little more. In a worst-case scenario, as many have pointed out, the spectacle of white humiliation in new abolitionist criticism might invite whites to continue their condescension towards non-whites, since non-whites can't criticize whites nearly as fast as whites can. In a luckier scenario, it may leave whites so humiliated that they become incapable of forging the kinds of interracial bonds of solidarity, friendship, and love necessary to abolish racist practice.

Fred Pfeil's work *White Guys* is, I would suggest, an example of where we might look for an alternative form of white self-criticism which seeks to redeem and deconstruct aspects of "dominant culture" (whiteness and,

especially, maleness) rather than abolishing it wholesale. Although Pfeil does not specifically refer to his work as part of the new abolitionist project, he is clearly grappling with issues similar to those raised by Roediger and the editors of *Race Traitor*. Looking at "contemporary mainstream masculinity," Pfeil calls attention to this dominant identity as it has been represented in American mass culture (i.e., "dominant" culture). Part of what is so hopeful about Pfeil's work is his ability to offer positive alternatives to "white guy" identity by taking seriously critiques from feminism, anti-racism, and Marxism. While Pfeil acknowledges in his introduction that he fears criticism from feminists who might reject the idea of a white man presuming to do feminist work, he nevertheless forges ahead and does not fall into the trap of humiliating himself for these imaginary feminists (or, sadly, not so imaginary). Indeed, he criticizes white male self-abasement in his discussion of contemporary "male sensitivity" films. He notes that these kinds of movies offer us images of white guys who are wounded or violated only so that they may return to a refortified and more innocent form of masculine entitlement. In reference to the 1991 film *Regarding Henry*, Pfeil explains that in these films—like the white-on-white torture films I've discussed—"the point is not finally to give up power, but to emerge from a temporary, tonic power shortage as someone more deserving of its possession and more compassionate in its exercise." Abolishing the white male may only make him stronger.

On another level, Pfeil's bits of autobiographical work in this book provide a complex assessment of white identity undergoing a progressive transformation, rather than nihilistic abolition. Pfeil takes full responsibility for his personal and political investment in so-called "white guy" popular cultures in movies, music, and social movements. He does not wallow in self-hatred, but tries to salvage what Fredric Jameson has called the "Utopian function" of dominant culture.[22] In his discussion of the men's movement, he critiques this male institution from within, freely admitting that many of its principles "work" for him, in spite of its obvious problems. Rather than bashing the men's movement, Pfeil takes a more measured view, giving its adherents credit for attempting to rethink their dominance rather than dismissing them as dupes of a racist, sexist, classist institution. What seems important about the moves Pfeil makes here is his refusal to reduce dominant culture to a monolithic and entirely oppressive series of cultural practices. White guy-ness is not just an immutable, ahistorical category which can or must be destroyed.

Rather, it requires radical refashioning. Most importantly, white hegemony is not the only source of social injustice; class and gender antagonisms need to be addressed alongside questions of race. Without a way of addressing race, class, and gender together—and without a constructive method of transforming, rather than punishing, white folks—white identity is doomed to remain trapped in a cycle of spectacular self-torture and self-celebration.

Moreover, white abolitionism does not question or criticize the degree to which poor whites are becoming America's new savages. For, as Ruth Frankenberg points out, there is a great deal of guilt that has attached itself to white racism against racial minorities, [23] although at the same time whites are still caught up in older forms of traditional racist thinking. While whites may not feel comfortable publicly calling non-whites "savage" or bestial, they nevertheless want to call *someone* those names—preferably a group which cannot speak for itself and answer back very easily. Ultimately, whites in poverty make a perfect target for displaced white racist aggression, for one can denigrate them but avoid feeling like or even being called "racist." Furthermore, the idea that poverty is "primitive" shores up many of the most cherished beliefs of a capitalist—and imperialist—culture. First, it confirms the idea that those who are mature, and hence deserving, always achieve upper or middle-class status. And secondly, it undergirds a myth of economic "progress," in which the developed First World is naturally superior to the undeveloped Third World; or, likewise, upper- or middle-class people in the First World should "lead" their urban and rural poor. As savage Others, poor whites in the U.S. and abroad become unruly children who need discipline, strict boundaries, and (coercive) guidance from the upper classes. And as the savagely humiliated, the upper classes are absolved of guilt—either by directly engaging in class combat, or by consuming images of white self-punishment at the movies, on TV and radio, and in social criticism.

-------------------------- NOTES

1. bell hooks, "Representations of Whiteness in the Black Imagination," *Black Looks: Race and Representation* (Boston: South End Press, 1992), 166.

2. See Eric Lott's discussion of the dialectic of desire and disgust in white relationships with blacks in his *Love and Theft: Blackface Minstrelsy and the American Working Class* (New York: Oxford University Press, 1995). Lott persuasively argues that white racism is also about envy, and that whites clearly identify with non-whites as much as they insist that they don't.

3. Sander L. Gilman, *Difference and Pathology: Stereotypes of Race, Sexuality, and Madness* (Ithaca and London: Cornell University Press, 1985), 20.

4. J. W. Williamson, *Hillbillyland: What the Movies Did to the Mountains, and What the Mountains Did to the Movies* (Chapel Hill and London: University of North Carolina Press, 1995), 149–72.

5. Marianna Torgovnick, *Gone Primitive: Savage Intellects, Modern Lives* (Chicago and London: University of Chicago Press, 1990).

6. Importantly, officers on *Cops* also degrade suspects of many different races and ethnicities. I don't mean to claim that whites are more abused than other suspects, but rather that they *are* often abused, and there seems to be no correspondence between being treated politely by officers and being white.

7. Shelby Steele, *The Content of Our Character* (New York: St. Martin's Press, 1990), 84.

8. Ibid., 85.

9. William Ian Miller, *Humiliation* (New York: Cornell University Press, 1993), 137.

10. Ibid., 144.

11. Carol Clover's analysis of the role of a "final girl" in slasher or psycho movies can be found in her excellent *Men, Women and Chainsaws: Gender in the Modern Horror Film* (New Jersey: Princeton University Press, 1992), 21–64.

12. From Kathleen Moran, "The New 'Cinema of Attractions'," unpublished manuscript. While Moran is principally discussing the visceral responses an audience has to special effects blockbusters, many of her insights might be applied in general to generic films which use shocking or violent images ("special effects") to elicit a physical reaction from audiences.

13. Henry Giroux, "Insurgent Multiculturalism and the Promise of Pedagogy," in David Theo Goldberg, ed., *Multiculturalism: A Critical Reader* (Cambridge, Mass.: Blackwell, 1994), 328.

14. See Roxanne Dunbar, "Bloody Footprints: Reflections on Growing up Poor White," in this volume.

15. For more on the psychology of imperial relations, see Albert Memmi, *The Colonizer and the Colonized* (Boston: Beacon, 1965).

16. For a complete discussion of self-loathing in the indie scene, see Ana Marie Cox, "Geek Chic," *Bad Subjects* no#19 (http://eng.hss.cmu.edu/bs/).

17. Both quotes from Miller, 172–73.

18. From *Race Traitor: Journal of the New Abolitionism* 4 (Winter 1995).

19. This solution is also developed at greater length in many of the essays in his *Toward the Abolition of Whiteness* (New York: Verso, 1994).

20. See Theodore W. Allen, *The Invention of the White Race, Vol. I: Racial Oppression and Social Control* (New York: Verso, 1994), and Alexander Saxton, *The Rise and Fall of the White Republic* (New York and London: Verso, 1990).

21. Noel Ignatiev, *How the Irish Became White* (New York: Routledge, 1995).

22. Fredric Jameson, "Reification and Utopia in Mass Culture," in *Signatures of the Visible* (New York: Routledge, 1990). Fred Pfeil, *White Guys: Studies in Postmodern Domination and Difference* (New York: Verso, 1995).

23. Frankenberg argues, in *White Women, Race Matters: The Social Construction of Whiteness* (Minneapolis: University of Minnesota Press, 1993), that part of what she discovered in the process of interviewing a number of white women was that they felt guilty about harboring racist feelings. Even if they realized that their feelings were based in myth, or leftover programming from childhood, they were very hesitant to admit their anxieties about non-white racial groups—especially if those anxieties might be perceived as racial prejudice.

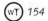

CaN WhiTENESS SPEaK?

The destruction of the racist complex presupposes not only the revolt of its victims, but the transformation of the racists themselves and, consequently, the internal decomposition of the community created by racism.

—Etienne Balibar

The time has come for us to take over the show and exhibit our own fears and desires.

—Laura Mulvey

Whether whiteness is a thing to laugh or cry about is undecidable. For a long time it was neither.

—Edward Ball

INSTITUTIONAL ANOMIES, ONTOLOGICAL DISASTERS, AND THREE HOLLYWOOD FILMS

MiKE HiLL

VISIBILITY BLUES: THE WHITENING OF CRITICAL RACE STUDIES

The juxtaposition of epigraphs above is meant to mark an irony that will remain central to this essay. The irony I have in mind adds a second peculiarity to the already peculiar historical fact of white existence, one which has to do with the status of whiteness today.[1] Whiteness is big news of late, the stuff of both mainstream and academic headlines.[2] The critical rush to whiteness could be developed this way: black scholars, black feminists in particular and Toni Morrison famously, have hailed white folks to turn critically to whiteness.[3] Rather than speaking on behalf of another,

constructions of the white racist imaginary might well be examined in and of themselves, and by those other than the ones historically *othered* by whiteness. The end of white racism might reasonably come after its lateral critique by white folks. But in the heady age of multiculturalism, "difference," and identity studies, it seems right to pause a moment over the spate of recent writing on majority discourse. For exactly how whiteness speaks, or more precisely, how white voices become present in race matters in ways that also eventuate in the "decomposition" of whiteness, remains difficult to say. It seems not unreasonable to point out that, in "our" anxiousness to "decompose" whiteness, "we" have continued to speak ever more and ever louder than "those" who might best be heard if "we" were quieter. Unregrettably but with undeniable awkwardness, whiteness, it seems, is damned if it does and damned if it doesn't.

The conditional damnability of whiteness is where this essay begins. At least potentially, renewed attention to whiteness, as dubious as that ought to sound, adds to identity politics the newly critical dimension of what could perhaps be called an "allo-identity politics."[4] In the case of the former, color marks a positive phylogenic difference which is inadvertently constituted by the unspoken category of whiteness. As a critical response to this, an allo-identity politics of white normativity would attempt, at the moment whiteness speaks, to return it to itself with a critical difference: whiteness as both marginally recognizable and different than it thought. Thus, among the risks of posing the question "can whiteness speak?" is the necessarily ambivalent response that it hails, or at least ought to hail, from white folks. The response is, well, "yes and no." For whether whiteness turns out to be "a thing to laugh or cry about"—whether, that is, the immanent whitening of critical race studies turns out to be progressively efficacious or just another conscientized "takeover"—depends partly, at least, on its eventual dis/articulation. In short, the whitening of critical race studies depends politically on how thoroughly whiteness is "trashed."

The term "trash" is rich with connotation. Most obviously it evokes class issues in the traditional economic sense. While I remain cognizant in what follows to the class issues hailed by the term "white trash," I am more interested in what I'll call the "classification" of whiteness. By this term I mean the marking of whiteness with an irrecoverable difference and the response of whiteness to that process of marking.[5] The term classification denotes a principle of reversibility whereby, in the process of trying to know others,

white identity is subject to differences that precede and produce it. So while keeping in mind the basic economic inequities that white unremarkability sustains, the purpose of what follows is to interrogate the place of whiteness in discourse. I want to know under what conditions whiteness speaks, and how whiteness bespeaks, or not, its own eventual "trashing."

What I want to argue specifically is that whiteness still exists at all by way of negotiating the dis/articulation paradox mentioned above. Whiteness, I propose, is made classifiable towards progressive ends dependent upon a complex negotiation between how whiteness speaks and how others bespeak it. My first objective will be to explain the production of white difference. Of course, the naming of whiteness in a way that robs it of internal neutrality produces varied and particular counter-strategies which are designed to keep whiteness unmarked. My second objective in this essay, then, will be to describe these counter-strategies. I want to argue that, although more obviously connected to race and class issues, whiteness sustains itself ultimately on sexual grounds.[6]

To make my case I tap into current theoretical tenets about knowledge and agency and, in relation to these, discuss three Hollywood films: *Medicine Man* (dir. McTiernan 1992), *Bonfire of the Vanities* (dir. De Palma 1990), and *Candyman* (dir. Rose 1992). These films are apt for three reasons: first, each addresses whiteness as a pervasive institutional problem, which is to say, inseparable from issues of knowledge production; second, the conflict in each film centers on the problem of white classification; and third, each film explores how whiteness, classified from without, enlists sexuality in the effort to reclaim its unremarkable status.

---PHANTASMS OF PROPHYLAXIS: WHITENESS AS A VERY MODERN THING

Knowledge which goes so far as to accept horror in order to know it, reveals the horror of knowledge, its squalor, the discrete complicity which maintains it in a relation with the most insupportable aspects of power.

—*Maurice Blanchot*

Because they think they are white, they believe, as even no child believes, in the dream of safety.

—*James Baldwin*

It is a lasting contribution of Marxism to have initiated the now well-worn path of subjectivity critique—in its short form—that social processes produce people, not the other way around. In more recent permutations of

Marxism, radical knowledge has taken upon itself the task of driving what Foucault calls an "odious wedge" into disciplinary forms of knowledge production. "Disciplinary" is meant here as the modernist practice of establishing a certain distance between the knower and what or who is known; in Althusserian terms, this would be a subject = object "adequation." It has become the defining feature of de-disciplinary knowledge to explore and exploit what it means to work otherwise.[7] One begins these days having either to make good on or willfully ignore the likelihood that all knowledge is mediated, relative, an effect of (and something that variously affects) power.

To take the critique of modernism on board, as common a practice as it has become, provides some complications that are perhaps less commonly addressed. Particularly nettlesome is what I'll call the proximity problem: if power is as sticky as Foucault's rejection of the repressive hypothesis contends,[8] then there simply is no position from which critique can be rendered without also implicating the subject doing the critique in the very processes it wishes to objectify. There is, in other words, no speaking *about* power in a way that remains critically anterior to it. According to the principle of overdetermination,[9] knowledge encroaches and wins influence over subjectivity and is seen as radical to the extent that the subject's presumption to have adequately "adequated" other objects is thwarted in the name of equity. Since subjectivity is generated ultimately from without and in ways it cannot know ahead of time, the idea that a subject remains neutral in relation to either the others it objectifies *or* ultimately, itself, becomes impossible. Ontological misfires such as this are summed up in what Ross Chambers calls "the rule of negativity," and it is upon the suspension of this rule that disciplinary knowledge and more analytical forms of ideology critique remain dependent.[10]

While it's not within my purview to resolve the post/Marxism debate that de-disciplinarity occasions, I do want to suggest that for addressing the question "can whiteness speak?" the postmodern condition is one politically worth having. I will even go so far as to suggest that postmodern theories of knowledge grant the most effective (if accidental) passage from an identity-based notion of phylocentricity to newly fashioned ideas about identity that reclassify whiteness as a politically charged racial construct. What makes postmodernism essential to the critique of whiteness is the efficiency with which it denies even the most stubborn forms of unremarkability.

If, as DuBois says, it is correct that "whiteness is a very modern thing,"[11] I take the general stakes of white critique to renegotiate the presence of whiteness in ways that simultaneously bring about its "decomposition," that is, in ways that mark whiteness differently than white. Judith Butler suggests that the white racist imaginary "postures [itself] as if it were the unmarked frame of the visible field, laying claim to the authority of 'direct perception.'"[12] White privilege is, thus, the omniscient and invisible force which does the "framing" without eventually taking its turn at, as it were, being "framed." Insofar as whiteness sustains itself as an "adequator" beyond "adequation," that is to say, something that speaks to avoid the eventual bespeaking of its own undoing (e.g. "I was framed"), it is indeed a very modern thing.

That whiteness existed at all and might go on to exist "unframed" depends upon negotiating an adequate relation to the margin *even*—as is arguably the case with vulgar multiculturalism[13]—when whiteness makes room for marginality to articulate itself as anything other than white. Thus, there is a critical extension here which begins with seeing whiteness as an economic class position and ends with bringing to whiteness a critical ontology, that is, a struggle for the classification of whiteness as differently marked. Whiteness as such is haunted by what Balibar calls "phantasms of prophylaxis," meaning that unless "prophylactically" secured, whiteness threatens itself with becoming something else again, a subject of difference: white difference, "white trash." The ontological "prophylactic" to which Balibar refers designates that habit of white modernism to remain the object "adequator" supreme, even as it is haunted by the possibility of an ontological reversal.[14] The alternative to white neutrality is to make whiteness speak (make re-marks) so as to differentiate (mark) whiteness as other than itself.

Hortense Spillers states that, from the vantage point of whiteness, "'otherness' declares itself as the infectious cultural property that bears a secret contamination."[15] The terms "infectious" and "contamination" are important here for indicating the ways whiteness remains unavailable to difference by going on unframed. For what happens in the eventual "framing" of whiteness, that is, the placing of whiteness against itself, is the critical split of white neutrality in such a way that makes it differently knowable. Thus, the term "property" is suggestive in a double sense. Just as one might say "trash" is (material) property gone wrong, the "trashing" of whiteness that

takes place once it is ontologically "framed" depends on the emergent visibility of newly differentiated "properties." What is most useful in Spillers' formulation for a postmodern critique of whiteness is the critical difference that the negative term "contaminated" takes on once it's attached to whiteness. "Contamination" becomes the site of political practices that do not hold whiteness vouchsafe as the unspoken constitutive factor of difference, that is, "propertyless." Instead, a politics of "contamination" reveals the ruse of white neutrality. It also shows the difficulty inherent in thinking about whiteness otherwise. "White trash" is the revenge of the ontological upon the economically "propertied," it might be said. To extend the metaphor, the gathering, separation, containment, and discarding of permanently unremarkable stuff—"trash"—returns in the postmodern critique of whiteness as an unwanted agent of white remarkability. That whiteness is made remarkable speaks precisely to the ambivalence of the question "can whiteness speak?" Again, the answer must be "yes and no."

The theoretical description for "trashing" whiteness, then, might be described as a tactically and locally arranged incommensurability between knowledge and (white) subjectivity, between what whiteness does to knowledge and what knowledge does to whiteness. This would seem to be the promise, if there was one, of opting for the lateral modes of critique that Foucauldian notions of power provide. Though such notions are awkward, they are necessary for maintaining the kind of revolutionary class critique held forth by Marxism. The articulation of white difference is a "class" struggle to be sure. But, to be precise, it is also a "classification" struggle. Less from above or below, but within, it is a struggle for the means by which to recognize the unspeakable "properties" of whiteness.

-------- Whiteness, New Knowledge, Three Films

The only endangered species is the white, Anglo-Saxon male.

—*Congresswoman Helen Chenoweth, Idaho-R*

In *Medicine Man, Bonfire of the Vanities*, and *Candyman*, whiteness and knowledge are inextricable and mutually pervasive problems. These films waver between postmodern allo-identification and dramatic acts of modernist recovery. In each, whiteness coheres around difference while struggling desperately and with great deliberation to resist classification in both the economic and ontological senses of that term. In each film, the internal

neutrality of whiteness depends on keeping knowledge a zero-sum game, one which is dictated as much by what is held outside the epistemological field as what is located within it. If only momentarily and to occasion its repair, whiteness is classified in these films in ways other than it would choose.

Medicine Man (hereafter *MM*) is the story of a research physician, Dr. Campbell, who travels deep into the Brazilian rain forest to find a cure for "the fucking plague of the twentieth century" (cancer, read racism). The movie begins after Campbell has found an antidote or, at least, a connection between an antidote and a particular flower which he harvests from the rain forest canopy. The task as the movie opens is to find a way to isolate what it is that's so special in the flower, purify it into an extract, and then synthetically reproduce it. Campbell's task is complicated in two ways: first, the Ashton Corporation, Campbell's employer but also his nemesis, is in the process of clear-cutting the rain forest, thus destroying the flower and its curative secret. The "march of profit" leads, Campbell is afraid, "to my front door." While Campbell's relationship to Ashton presents the urgency with which he must make his discovery, it also places him in a highly ambivalent relationship to the violently destructive forces of capital. Thus, Campbell's charge to resist classification, in the sense of having an undisclosed economic interest, begins here.

But the problem of classification plays out in less obvious ways than strict economics. These have to do with the ontological differences Campbell must bear despite the objectively neutral posture he wants to take as a scientist. Indeed, Dr. Campbell knows himself as a contaminate of sorts. We learn early on that the wild, often violently articulated obsession he has to "save humanity" is directly proportionate to the guilt he suffers from having inadvertently killed off a substantial portion of it. The Doctor is responsible for a "swine flu that killed [an] entire village." Doctor and disease, the invisible subject of science and the univocally identifiable object of disease, begin in *MM* as intertwined. The misfire in Campbell's identity that results from this slippage is due to an epistemological reversal that violates the first rule of modernity: subjectivity is classified as the object of its own work. Thus, in order to secure the distinction between Doctor and disease, Campbell is obsessed with masking. Both for medical reasons (he violently insists his Assistant, Dr. Crane "get masked" so as not to become a contaminate), and for reasons of keeping his own guilt under wraps (he gets drunk and dresses up in aboriginal masks), Campbell desperately struggles

to regain invisibility. The imposition upon Campbell as a white subject split by scientific and economic self-interest is intensified further by the fact that, to his surprise and protest, he is given the name "Medicine Man" by the people of the rain forest. This "pisses off" the original Medicine Man ("dep-swa") and befuddles Campbell further by making him appear a usurper of aboriginal agency when all he wants to do is help.

The problem in *MM*, then, is the problem of classifying whiteness. Its alleged purity is "contaminated" in all three senses: economic (his ambivalent relation to the Ashton Corporation), epistemological (his failure in medical objectivity), and ontological (his being unhappily misnamed). What is significant here is that the roles implicit in the pure/contaminated dichotomy begin in this film in a way that reverses common expectation. The white subject suffers the burden of difference. That white contamination, which is to say its "trashing," provides a "cure" for the human race is evidenced by the fact that the curative flowers are curative because of their tainted ants. *MM* begins with white subjectivity in crises, specifically, the crises of being objectified from without, forbidden to be constituted on its own or on neutral terms, just as the object of scientific knowledge refuses to be pure. Thus, Dr. Campbell is classified, and thus does whiteness haunt itself. White (scientific) neutrality is marked with differences it would choose to place elsewhere but cannot: "I am a monster," Campbell eventually confesses.

In *Bonfire of the Vanities* (hereafter *BV*), the processes by which whiteness is marked are nearly identical to those in *MM*. Whereas the classification of whiteness operates on the order of "contamination" in the former film, it operates by breaching "insularity" in the latter. *BV* begins, like *MM*, with a drunken white guy, "trashed," misunderstood. Peter Fallow, onetime "invisible" reporter and now newly famous author, begins in voice-over to tell the story about how he got his "big story." Fallow's "big story," and this is the story told in the film, is of "white Wall Street trash." Fallow traces the downfall of Sherman McCoy, who, while on the way home from cheating on his wife, has to take a detour through the Bronx where his girlfriend, Maria, runs over Henry Lamb. Lamb is a young Black local ambiguously portrayed as either somebody who wants to help or hurt the couple, but who, in any case, dies as a result of the hit-and-run. The phrase "white Wall Street trash," as contradictory as it sounds, goes precisely to the point of *BV*. This film tells a story about a way of telling stories whereby whiteness, in its allegedly untrashable form, in fact "trashes" itself. Thus, Fallow, in

uncovering the misdoings of a man once thought "impervious, insulated by wealth and power, master of the Universe," in the end surrenders him to the powers of the media. More precisely, Fallow surrenders McCoy to process-es of mediation where white identity is allo-identified.

Having entered a class "war zone" in the painfully material sense during his Bronx mishap, Sherman McCoy eventually becomes classified in ways he spends the majority of the film attempting to thwart. McCoy becomes both a suspect of the hit-and-run and, as an unwilling political player in the class and race struggles of a New York City mayoral election, the pawn in a media game where the marking of whiteness is strategically essential. The election is centered around the New York District Attorney, mayoral hopeful, Mr. Weiss (a Jew). His name, literally translated from the German, is Mr. "White." The play on his name foretells the breaking of white "insularity": Weiss enthusiastically proclaims that, if he could only "nail a WASP," Black folks would see him as "the first Black district attorney of Bronx county." Fallow (the only key WASP character other than McCoy) helps, against his better judgment, to produce such a man for Mr. Weiss with his "big story" of what went down in the Bronx.

That Fallow is himself eventually split by his own story of McCoy joins the story teller and his object in a way that makes WASPishness "trash" itself implicitly. "His name [McCoy's]," Fallow forewarns us, "would be inexorably tied to mine"; and "Sherman McCoy was my baby, my cre-ation," he insists. At McCoy's arraignment Fallow realizes: "Before he [McCoy] could even speak, he had been swept away. I began to appreciate the power, the magnitude, the sheer force that had been unleashed by my little story." This force has to do with the white dis/articulations "unleashed" by white-on-white critique. The "power" of Fallow's story is that it manages to undo both McCoy, his white object, and himself.

Fallow's upward ontological trajectory from invisibility to visibility (he's made known, rich and miserable) is different in kind but not effect from the "white . . . trash[ing]" experienced by McCoy (he's made known, poor, and miserable). Both end up in the film in highly agitated states of white *divisi-*bility, split by stories that pit WASPishness against itself. Both the subject and the object of the "big story" in *BV* come to be identified in ways incom-mensurate with their own interests and desires. McCoy, for example, has to join the crowd of protesters outside his apartment and, in fact, protest against himself by chanting and holding signs that read: "justice/racist."

Only by this forced mingling does he gain access (and, at that, through the service entry) to a dinner party thrown on his behalf. Even though "all the people are calling my name," McCoy has difficulty recognizing himself. Indeed, placing his cohorts at gun point, he screams: "I will never be Sherman McCoy again!" Shooting up his own house with a shot-gun and chasing off his onetime friends, McCoy is unwittingly and irrefutably reclassified as a class-warrior in spite of himself. The effect of this reclassification spills over to Fallow as well. It becomes clear that, in the course of McCoy's ontological decomposition, Fallow experiences a similar process as he both works on and is worked upon by the story: "It [his new visibility] should have been a very triumphant occasion . . . but it wasn't. My little encounter with the real Sherman McCoy was ruining everything. The truth has a way of doing that." In using the term "truth" Fallow indicates that he, like Sherman, is split over having "created" a McCoy different than McCoy would have it. Fallow is caught between, on the one hand, what Reverend Bacon calls "show business," where unremarkability is by definition impossible, and the empty liberalism of McCoy's father: as he says, the "ethical" obligation to "tell the truth"—or, when "it won't set you free, then lie."

Like *MM* and *BV*, *Candyman* (hereafter *CM*) is a film about whiteness and knowledge. Whereas the former two films address the classification of whiteness in the context of medicine and the media, *CM* brings the proximity problem closer to academia: this film is about whites in graduate school. It tells the story of Helen, who is studying the legend of "Candyman" and its presence at the Cabrini Green projects, as part of her dissertation; at the same time, it tells stories about Helen's husband and rival professor, Trevor, and Candyman himself, as he appears in his various manifestations. There are competing accounts in the film of the "Candyman" phenomena: the professorial and the popular. The professorial version of "Candyman" is that it is the name given to a nineteenth-century black slave/artist who fell in love with a white girl. The girl's father, upon discovering the affair, raised a lynch-mob to burn and torture him. By popular account, when you look in the mirror and say "Candyman" five times, he appears and wreaks havoc. As part of her dissertation, Helen tries to square the popular and the professoriate. Her research takes seriously undergraduate stories, the memories of black janitors, the residents of Cabrini Green, and the media. Helen works both for and against the academy in her work. While Trevor, her husband and rival, has a "curriculum to follow" (one that, in fact, spoils her research

by attempting to rid the undergraduates of "urban myth" and popular "delusion"), Helen wants to disestablish the establishment. She protests against "the same old crap" of instrumental reason, but she does so as someone enthusiastically committed to the likelihood that she's "gonna get published." That her research eventuates in her being placed "under arrest," that is, misidentified as the very object she pursues (Candyman), is what joins this film with *MM* and *BV*. All three place white neutrality in crises, classifying whiteness in ways that bring about a critical self-mis-recognition.

As in *MM* and *BV*, whiteness and difference are initially kept separate for economic interests. In the early phases of her research, Helen comes across and old newspaper article which reveals that her and Trevor's condo was initially slated to be the Cabrini Green projects. The view was too good, however, so the projects were pushed across the tracks and the original building sold off at an inflated price to the white folks who could afford them. Helen realizes that the floor plans of Cabrini Green and her own apartment are identical. In the bathroom, she removes the medicine cabinet mirror to find that it leads directly to the apartment next door. This gives her a material clue to the Candyman murders of Cabrini Green: he must have come in through the mirror. That Helen's research leads to the mirror brings forth the classification problem in the extra-economic sense. In her search for Candyman, she effectively finds herself.

In the second phase of Helen's research and, indeed before realizing the full significance of the mirror, Helen visits Cabrini Green. There she enters an abandoned apartment, removes the medicine cabinet and crawls through. On the other side, she attempts to decipher Candyman graffiti. The story cuts to a dinner she is having with Trevor and Archie, the latter of whom has published widely and reductively on the Candyman "legend." With a paternal smirk Archie refers Helen to his articles and asks to see her data. Consequently, she begins to experience a series of flashbacks that look and sound like her camera flash going off as she was earlier exploring the abandoned apartment through the mirror-passage way at Cabrini Green.

These flashbacks are emblematic. For they materialize the way that Helen, even as she searches for knowledge of Candyman, even as she attempts to bring the graffiti into a photographic frame, is also framed. Most obviously she is framed by her own recollection as Archie tries to look her over. But in that these recollections increasingly disorient her, she sees

herself as an exteriority, in the frame of another. Indeed, the image Helen repeatedly sees in her flashbacks is of herself crawling through the mirror-passage way, the hole in the wall of the abandoned apartment at Cabrini Green. Perceived opposite her point of view, it is revealed that the graffiti surrounding her passage way is of Candyman's open mouth. These flash-backs place Helen literally within the field of mediation that she calls forth by taking pictures. It is a field that becomes less and less her own but becomes one out of which she is classified anew. When in the process of her research Helen is at her furthest from "the same old crap," when as a result she is institutionalized by Trevor and the police for having allegedly per-formed the Candyman murders, she is able to simply look in the mirror, repeat Candyman's name, take her revenge, and to completely "black out."

As Candyman leads her in this process he repeats the words: "be my vic-tim." There is a very sophisticated sense of victimage operating in *CM*, one which has precisely to do with the classification of whiteness as other than internally neutral. Candyman defines himself to Helen as "the writing on the wall," "the whisper in the classroom," the "rumor" on the "street corner." The "writing" Candyman has in mind is the portrayal of himself by his investigator, just as it is the graffiti through which Helen literally emerges as differently constituted during her "black outs." That this "writing" disallows subjective adequation and initiates upon the subject a critical reversal aligns Helen's epistemological problem with that of Dr. Campbell in *MM* and McCoy in *BV*. All three characters, in attempting to know difference, become variously and, save for Helen, undesirably affected by it.

---RACE AS CLASS AS SEX: RENEGOTIATING THE OLD SWITCHEROO

In the very act of emptying the white-male-heterosexual position of all positive content, the p.c. attitude retains it as a universal form of subjectivity.

—Slavoj Zizek

In *Medicine Man*, *Bonfire of the Vanities*, and *Candyman*, the "universal form of [white] subjectivity" noted in the epigraph above is classified in ways that return it to itself as something other. I have tried to argue that in each film the institutional habits of subject/object adequation (implicit in medi-cine, reportage, social science) are at least momentarily reversed. The remainder of this essay moves from the issue of how whiteness is troubled by the processes of "contamination" inherent within it—how its "insularity"

is breached, or how whiteness is "framed"—to more difficult questions having to do with renegotiating white unremarkability. What follows extends the discussion of race and class in the three films to include sexuality. I want to suggest that each film draws upon sex to help renegotiate the fiction of unremarkable whiteness, but each film does so with three different levels of success.

The initial sequence in *MM* is the first in a series of cues that Dr. Campbell is working through the contamination problem at a sexual level. The developing love interest between himself and his newly arrived assistant, Dr. Crane, bears a direct relation to the problem of scientific examination with which he is confounded. When Crane arrives, portrayed as a woman too fond of creature comforts and naively wanting "a bath," she protests his patronizing remarks by saying: "I'm not a 19-year-old grad student." Nonetheless, Campbell proceeds both literally and physically to examine her. First, he "tests" her for disease: "Unbutton your shirt." Secondly, he examines her as would a teacher: "What am I analyzing?" In both cases, she gets "full marks." Because Campbell is still funded by Ashton, and because "Ashton is thinking of shipping [him] out," the irony here, as Crane reminds him, is that she is, in fact, his "judge and jury." In the most literal sense, then, Crane is Campbell's intermediary for working through his marked condition. How he may judge scientifically, and be judged economically, depends on his relationship to her.

The "take your shirt off" sequence is fundamental to Campbell's attempt to resituate himself beyond classification. Initially, Campbell transfers the "full marks" of difference onto his assistant. Second, he makes sure that she reproduces this process by learning to examine others accordingly. Only by reproducing the process of successful object adequation is Campbell able finally to "reproduce" the serum. The reproductive process of ontological transferal whereby Campbell moves remarkability outward is repeatedly associated with heterosexuality in the film. On several occasions the two doctors are shown lovingly engaged in scientific examination. Campbell gives himself away by saying, defensively: "I'm not proposing marriage, I'm asking you to biopsy a family of rodents." The emergent sexual relationship between Campbell and Crane, which is a relationship occasioned by science, works to remove the contamination Campbell experiences as a subject classed against his will.

Perhaps the scene most precisely to this purpose is where Campbell engages in mock-battle with his predecessor, the original medicine man

whom, in the course of contaminating and then curing the village with a "plop-plop, fizz-fizz," Campbell has humiliated and displaced. The sexual overtones in the scene dramatize the principle of reversal that Campbell has been fighting at the epistemological and economic levels all along: having "taken his [the medicine man's] stick," Campbell has now come "to give it back." But what this means, in fact, is that to give the stick back Campbell will have to take it. To get the information he needs from the "depswa" he has to voluntarily lose a fight with him. He explains to Crane: "Ever mouth off to a Dean and then need a grant"? And she responds: "So this is the kiss-ass contest? . . . O.K. so bend over, take three whacks and lets cut to the information."

This scene harkens back to Campbell's needing an uncontaminated and therefore reliable control group, not wanting to be accused by Crane of pulling "the old switcheroo." It harkens back to Campbell's need, in order to keep his funding, to (as he says) "cover my ass." The scene intimates Crane's unwanted classification in every sense: economic, epistemological, and now sexual. As Campbell does mock battle with the weaker medicine man (he is, as Crane protests, "only three feet tall"), he has to find a position between "bending over" and winning. While Crane watches in anticipation and encouragement, what stands between Campbell and the reassertion of scientific neutrality is a sexual "switcheroo."

As becomes clear in the final scene, Campbell's relationship with Crane stands as the heterosexual alternative to what almost goes on with the "depswa." By returning his stick to him as she does in the film's closing moments, by translating a forgiveness from his victims and his subjects, and by dropping her fiancé for him, Crane provides for Campbell a multi-leveled absolution in one fell swoop. With renewed energy and with Ashton hot on their tail, the film ends with the two headed further into the rain forest. Just out of capital's reach (although, now with assured funding), the two move fully beyond the burden of classification. They move towards heterosexual love and, as Crane insists, "co-authorship."

In *BV*, heterosexuality repairs whiteness in a no less evident way. However, the women characters in *BV* refuse to cooperate on the order of Dr. Crane. The making of Sherman McCoy as a media object and the remaking of him as a stranger to himself comes down to heterosexual sabotage. Maria outright refuses to absolve McCoy, even though the incident—a foray "into the jungle"—gave Sherman and Maria "the best sex we ever had."

Indeed, the heterosexual misfires that initiate the "power of the story" are rendered in an exceedingly literal and explicit way. Fallow only realizes that he's got a book on his hands by way of Caroline, a co-worker who has it in for McCoy because, in the course of his sexual indiscretions with Maria at her apartment, she loses her sub-lease. This decisive scene comes halfway through the film when it looks as if Fallow (with McCoy) is headed back into WASP invisibility for having lost the story. Caroline, however, gets drunk, gets naked and straddles an activated copy machine. While handing Fallow copies of herself she proceeds to give him the license plate number that undeniably connects McCoy to the crime. Thus, the scene puts the stakes of WASP classification in graphically sexual terms: "Tell him," Caroline remarks, "it was the little twat that did him in." Not only is McCoy "trashed" in this instance of feminized media reproduction, but in producing his book and the split white identity eventuated by it Fallow is himself turned into a self-proclaimed media "whore."

References to the media and mediation as sexual processes that decompose WASP hetero-masculinity are prolific in *BV*. As the platform of his mayoral campaign, Mr. Weiss proposes to "nail the wasp," and to "screw every white ass-hole from Albany to Park Avenue." In a particularly unsettling moment for McCoy, an anonymous TV producer says to him: "I'll suck your dick for the rights to this thing." The comment comes upon McCoy's returning home through the crowd gathered outside his condo, and his next words are not to the TV producer but to his one-time friend, Pollard: "Another word out of you . . . and you'll have an unacceptable situation right up your ass." McCoy's plea in an early scene with Marshal (the very un-Marshal looking family dog) to just "be men about this" (i.e., going out in the rain) seems all the more pathetic in relation to these scenes. That the phone call to Maria he goes out to make with Marshal is mistakenly placed to his wife is the first indication that his heterosexual interests are thoroughly implicated in the race and class matters to come.

But where "white Wall Street trash" is most undeniably marked with sexual politics is after the opera, upon McCoy's encounter with Audry Buffington. Buffington, it is proclaimed, is gay and has AIDS. He looks piercingly at McCoy and explains regarding *Don Juan*: "There he is, Don Juan, in the vice-like grip of fate, facing his crime, facing his entire life of selfish consumption, of profligate waste of himself and others." The charge is, of course, leveled at McCoy and the trashing of Wall Street. As is indicated by

169 (wT)

his obvious disorientation, McCoy's encounter with the film's only gay character signals a moment of critical self-misrecognition that places the problem of breached "insularity," here marked by the anonymous white socialite as disease, as a straight male WASP problem. This is repeated on the subway trip going home, where home is no longer available to McCoy but is the place where he renounces his identity and threatens to put "an unacceptable situation up [Pollard's] ass." On the subway, in the background but still conspicuous, is an AIDS awareness poster. McCoy takes a drink from Fallow, who is as usual already trashed, and in a moment of humility and resignation says simply: "Fuck it."

In these scenes the dis/articulation of whiteness becomes an explicit masculine heterosexual crisis. However, as distinct from MM, sexual interest in women does not return to save WASP men from the anxiety of classification. In BV the female characters explicitly refuse to cooperate in renegotiating the "old switcheroo." In the end, white unremarkability exists in BV in an extremely ambivalent and precarious sense. The "ethics" upheld by McCoy's father are emptied out and upheld in the final court scene as explicitly dependent upon a white "lie" of internal neutrality.

Whereas MM sexually repairs the classified white subject by locating Dr. Campbell in a neutral space between capitalist profit (Ashton's) and white guilt (his consciousness as a contaminate), and whereas BV suspends white reparation by making white Wall Street at least susceptible to a trashing, CM further raises the stakes: it is a horror film in which the monster wins. In MM and BV, the processes by which white subjectivity locates and exteriorizes difference hinge on sexual remediation. In CM the same is true, however, in explicitly sexual ways white neutrality becomes fully dis/articulated.

From the onset of the film with Candyman's orienting statement—"With my hook for a hand I'll split you from your groin to your gullet"—whatever Candyman is and does, the history, the game, the agent, has explicitly sexual associations. Helen gets her initial research from a "scary story" told, significantly, by a girl (who knows of another girl) who evoked Candyman upon the occasion of her first sexual experience. When her parents were away, she "decided to give Billy what she never gave to Michael." As things progress, Helen is told how the fictional girl stopped Billy and introduced the Candyman game: "wanna try it?" she is supposed to have said. And when they do, the (fictional) girl is killed, and Billy goes crazy. This adds to Helen's

research what Trevor's "curriculum," and his "urban legend" and media "delusion" theories lack: Candyman, while being the communicative currency of the poor, the black, and the unschooled, is also part of negotiating a women's identity in response to heterosexual objectification. This objectification is in the first instance Helen's own.

Indeed, Helen's developing epistemological rivalry with Trevor, her husband/professor, over the meaning of the Candyman story, occurs precisely at the level of the "groin." It becomes apparent midway through the film that Helen's eventual incarceration in the asylum is in Trevor's sexual interest because of his pursuit of another female student, one over whom he can have the epistemological upper-hand: "did you make a boo boo," he says, as she repaints the apartment as his new live-in lover. Trevor's sexual *qua* institutional interests bear directly on why he wants Helen re-institutionalized. By her persistent de-institutionalization of the Candyman story, having gone to Cabrini Green, having encountered Candyman as a myth that recreates her as its object ("be my victim"), Helen gives up the internal neutrality upon which Trevor's work depends. Helen's engagement with a form of knowledge production that frames the framer is contained, if Trevor succeeds, by an institutional counter-framing with Helen as the criminally insane. (In fact, we never know who really commits the murders in the film.)

However, Helen returns in the end to characteristically frame the framer, in this case Trevor, in the same way that Candyman via her flashbacks lead her to be framed. In the final scene of *CM*, Trevor looks longingly into the bathroom mirror. He sees himself for the first time in all his undeniable duplicity, racked with guilt and woefully unrecognizable to himself (he cannot respond to his girlfriend when he is called). Instead of the name "Candyman," he repeats "Helen" five times. She returns and "splits" *qua* Candyman (*qua* "urban legend") Trevor "from [his] groin to [his] gullet." Helen is portrayed here at the point of orgasm, her head tilted back in ecstasy, as she wields the hook upward through Trevor's body. Here, Helen/Candyman becomes knowledge as a material force. The burden of difference that splits the internal neutrality of white masculinity is literalized on the professorial body. That the epistemological justice handed out there is directly associated to issues of race and class is evidenced by the fact that the hook Helen uses is given to her by a procession of Cabrini Green residents who marched to her short-lived burial. The class-ification of whiteness occurs on every front in *CM*, as it were, from below.

----------------- In the Wake of Whiteness

The revenge of the angry white male is yesterday's news.

—*Richard Woodward*

Time Magazine's issue on the Oklahoma bombing featured a close-up of Timothy McVeigh on the cover. The headline reads: "The Face of Terror." Inside, reporter Elizabeth Gleick reveals that "a sense of guilty introspection swept the country when the FBI released sketches of the suspects, distinctly Caucasian John Does one and two." What is significant here to the problem of whiteness is the persistent surprise that whiteness is "distinct" and, moreover, that white "terror" is an effect of distinguishing it. To come face to face with "the face of terror" is ostensibly terrifying for *Time's* implied (white) readers because white subjectivity is fully implicated in what it thought exterior to and univocally differentiated from itself. But one wrongly assumes that what McVeigh allegedly did is incommensurate with his "Caucasian" looks. In response to the peculiarity that "whiteness" continues to be news at all, and in the hope that whatever news whiteness makes in the future might conceivably unmake whiteness, I have tried to interrogate John Doe's "terror." In the process, I have tried to make politically useful the ambivalence implicit in the question of whether or not whiteness can speak.

--------------------------- Notes

1. See W. E .B. DuBois, "The Souls of White Folk," in *W .E. B. DuBois: Writings*, ed. Nathan Huggins (New York: Library of America, 1986) and, more recently, Ted Allen, *The Invention of the White Race* (London: Verso, 1994); and David Roediger, *The Wages of Whiteness: Race and the Making of the American Working Class* (London: Verso, 1991).

2. Several academic, popular and alternative magazines have recently produced special issues on whiteness. See Liz McMillen, "Lifting the Veil of Whiteness: Growing Body of Scholarship Challenges Racial 'Norm'," *The Chronicle of Higher Education*, 8 September 1995, A23.

3. See DuBois, *Black Reconstruction in America, 1860–1880* (New York: Atheneum, 1935); James Baldwin, "On Being White And Other Lies," *Essence*, April 1994, 90–92. Among black feminist charges to examine whiteness, see bell hooks, "Representing Whiteness," in *Yearning: Race, Gender, and Cultural Politics* (Boston: South End Press 1990); and Hazel Carby, "The Politics of Difference," *Ms.*, September 1990, 84–85.

4. On the term "allo-identification," see Eve Sedgwick, *Epistemology of the Closet* (Berkeley: University of California Press, 1990).

5. In thinking about the marking of whiteness I owe Ross Chambers. See his "The Unmarked," *the minnesota review* 46 (forthcoming).

6. See Phillip Brian Harper, "Race and Racism: A Symposium," *Social Text* 42 (1995): 14–16. Harper calls for "the wholesale reconsideration of what counts as masculinity in this [white] culture" as a basis for interrogating the black/white racial paradigm" (14).

7. On the term "de-disciplinary," see Clifford Siskin, "Gender, Sublimity, Culture: Retheorizing Disciplinary Desire," in *Eighteenth-Century Studies* 28.1: (1995), 37–50. See Michael Foucault, "Truth and Power," in *Power/Knowledge: Selected Interviews and Other Writings* (New York: Pantheon, 1972).

8. Michel Foucault, "Discourse on Language," in *The Archaeology of Knowledge* (New York: Pantheon, 1972), 231.

9. On "overdetermination," see Louis Althusser, "Marx's Relation to Hegel," in Ben Brewster, trans., *Montesqieu, Rousseau, Politics and History* (London: Verso, 1971).

10. Ross Chambers, "Being Read and Misread: Irony as Critical Practice in Cultural Studies," *the minnesota review* 43 (forthcoming).

11. DuBois, in Huggins, ed., 25.

12. Judith Butler, "Engendered/Endangering: Schematic Racism and White Paranoia," in Robert Gooding-Williams, ed., *Reading Rodney King/Reading Urban Uprising* (New York: Routledge, 1993), 19. Moreover, whiteness, for Richard Dyer, is "the subject that . . . seems not to be there as a subject at all." See his seminal essay, "White," in *Screen* 29:4 (1988), 45–64.

13. For the term "vulgar multiculturalism" see Annalee Newitz and Matt Wray, "What Is 'White Trash'?," in *the minnesota review* 46 (forthcoming). For progressive critiques of multiculturalism, see also Peter McLaren, "Multiculturalism and the Postmodern Critique: Towards a Pedagogy of Resistance and Transformation," in *Between Borders: Pedagogy and the Politics of Cultural Studies*, ed. Henry Giroux and Peter McLaren (New York: Routledge, 1994) and Henry Giroux, "Consuming Social Change: The United Colors of Benetton," *Cultural Critique* 26 (1993–94), 5–32.

14. Etienne Balibar and Immanuel Wallerstein, *Race, Nation, Class: Ambiguous Identities* (London: Verso, 1991), 17.

15. Hortense Spillers, "Black and White in Color; or, Learning How to Paint: Toward an Intramural Protocol of Reading," in Jeffrey Cox, ed., *New Historical Literary Study: Essays on Reproducing History* (Princeton: Princeton University Press, 1993), 287.

PART III
PRODUCING AND CONSUMING POOR WHITES

Trash-o-nomics

Doug Henwood

I n the American mind, *poor* and *black* are virtually synonymous. There's less of a consensus on how to translate *white* into money terms; left of the political center, it's usually rendered as well-off; to the right, the spin is more in the direction of being put-upon, of falling in status at the expense of minorities who are the beneficiaries of special attentions, like affirmative action. White and right men usually add women to the list of parvenus who have them under siege.

Ostensible leftists have contributed no small amount to simple racial models of power in America. As class receded in interest, yielding to the now-familiar identities, white became synonymous with privilege, and

imperialism overwhelmingly a matter of race. White workers, once the focus of Old Left attentions, became, in the eyes of the New Left and its heirs, the warmongering, bigoted junior partners of empire. I've had feminist economists tell me that deindustrialization and deunionization were mainly the concerns of white guys, of little interest to the nonwhite nonmales who staff the service economy. I once watched in awe as a New York City tenant lawyer exclaimed, "Good!" when she was shown statistics about declining white male incomes.

An intellectual left dominated by such attitudes can only cope with rebellion in the white heartland by demonizing it as further proof of the warmongering bigots' true nature. Several thousand men in fatigues are taken as the avant garde of fascism, the armed wing of the white backlash, a violent reassertion of privileges that have been slipping.

Of course, the average white person is better off than the average nonwhite person, those of Asian origin excepted, and black people are disproportionally poor. But that sort of formula hides almost as much as it reveals; most officially poor people are white, and these days, a white household should consider itself lucky if its income is only stagnant, rather than in outright decline.[1]

This is very dangerous territory, so I want to make it clear that my point in emphasizing the white share of poverty and downward mobility is not to wax neoconservative and triumphantly announce the end of racism. The disparity between non-Hispanic whites and the black and Latino population is too obvious—not only on income and poverty issues, but also in matters of health and life itself—to sustain that Pollyanna-ish line. But failing to acknowledge the sizable material distress experienced by mid- and downscale whites makes the right's job of pitting the working class against the poor—typically racialized as white working class and black poor—much easier.

THE BROAD SWEEP

Average incomes of all families of all colors have remained remarkably flat over the last twenty years, a sharp contrast with the previous twenty or thirty years (see table 1).[2] Between 1947 and 1973, a period that corresponds pretty nicely with the Golden Age of American capitalism, white family incomes more than doubled in real terms, increasing 105 percent, for a yearly average of 2.8 percent. Black families did even better, increasing an average of 3.3 percent a year, or 131 percent over the whole twenty-six-year period,

meaning that the gap between black and white incomes narrowed. Since then, however, white incomes have risen a bit—an average of 0.1 percent a year, while incomes for black families have declined an average of 0.1 percent a year, and Hispanics fell even faster, 0.6 percent a year.[3] (While Asian-Americans have the highest incomes of any ethnic group, the Census Bureau has only reported their incomes since 1987, so it's impossible to say much about them historically.) At recent rates of increase, it would take 433 years for white incomes to match their increase over the 1947–73 period—and, of course, the incomes of blacks and Hispanics are in outright decline, so with the passage of enough imagined years, they could eventually reach zero, at least in a statistical simulation.

Many stories can be hidden behind averages, however. One way to get under the surface is to look at the distribution of income within racial and ethnic groups. That's the point of Figure 1, which shows the incomes at various levels for whites and blacks. Over the last twenty years or so, rich and middle-class blacks largely held their own against their white counterparts, though at much lower levels. But the black poor have done miserably, falling further behind poor whites. Between 1977 and 1993, the poorest quintile (fifth) of whites eked out a 1.4 percent increase in real incomes (total, not an annual average), while incomes of the poorest black quintile crashed 19.2 percent. For the other groupings, black and white fortunes moved roughly in tandem, with the middle quintile's incomes growing slightly (1–2 percent), and those of the richest 5 percent growing sharply (around 40 percent). Since the black poor did so much worse than the white poor, income distribution among blacks, which has always been more unequal than that among whites, has gotten more unequal and at a faster rate.

Figure 1

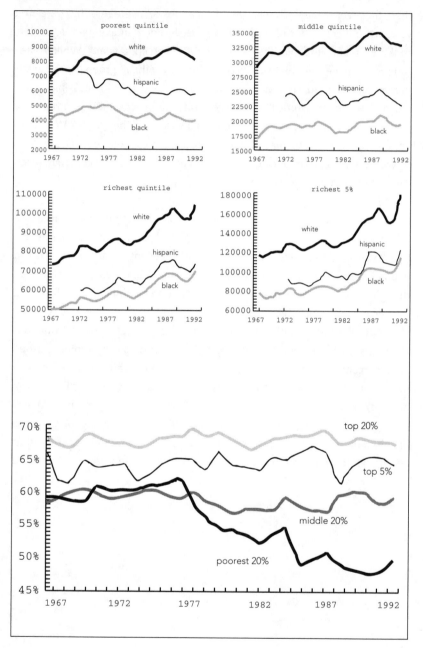

The picture for Hispanics is much less dramatic; their inequality falls between black and white levels. A chart for Hispanic income groups like the one shown here for black incomes would show all the income groupings clustering around 70–75 percent of the income of their white counterparts, with less stratification than among blacks. Incomes of the poorest Hispanics fell sharply relative to whites from the early 1970s through the mid-1980s, as new immigrants from Mexico, Central America, and the Dominican Republic joined the more prosperous Cubans and Puerto Ricans already here.

TABLE 1

REAL INCOMES BY SEX AND RACE
cumulative and annual average changes by period, families and per capita

family

	white	black	Hispanic origin
cumulative change			
1947/8–73	+104.5 percent	+130.9 percent	
1967–73	+17.6	+14.7	
1973/4–93	+1.9	-3.2	-11.3
1977–93	+2.7	-1.5	-9.4
annual growth rate			
1947/8–73	+2.8	+3.3	
1967–73	+2.7	+2.3	
1973/4–93	+0.1	-0.2	-0.6
1977–93	+0.2	-0.1	-0.6

per capita

	male					female				
	all	white	black	Hisp	Non-His white	all	white	black	Hisp	Non-His white
cumulative										
1947/8–73	+86.6	+86.9	+108.2			+53.8	+38.3	+187.4		
1967–73	+11.6	+11.2	+17.5			+19.4	+17.0	+34.2		
1973/4–93	-14.4	-15.1	-6.7	-23.7	-7.9	+29.0	+30.4	+21.9	-3.3	+27.3
1977–93	-8.8	-9.3	+1.5	-23.2	-6.3	+22.6	+23.2	+20.4	-3.4	+21.3
annual										
1947/8–73	+2.5	+2.5	+3.0			+1.7	+1.3	+4.3		
1967–73	+1.8	+1.8	+2.7			+3.0	+2.7	+5.0		
1973/4–93	-0.8	-0.8	-0.3	-1.4	-0.4	+1.3	+1.3	+1.0	-0.2	+1.3
1977–93	-0.6	-0.6	+0.1	-1.6	-0.4	+1.3	+1.3	+1.2	-0.2	+1.2

Figures for whites and blacks begin in 1948; for all races in 1947. Figures for Hispanics begin in 1974.
Source: see footnote 1.

Quintiles, since they're based on families and households, hide what's been happening between the genders. During the Golden Age, men of all colors did better than women of all colors; since 1973, however, the tables have turned, and men's wages have fallen while women's have risen—and white men, on average, have done worst of all. I'll return to this theme in a bit, when we look at wages by educational level—but non-Hispanic white men, though still the highest earners (almost matched by Asian–Americans), have watched their inherited skin and sex privileges wasting away for two decades.

------------------------- THE POOR

The poorest quintile is one way of thinking of "the poor"; the middle three, the middle class, and the top quintile, the upper middle class; and the top 5 percent, the upper class. Officialdom, however, has chosen to label a much smaller slice of the population than 20 percent as officially poor.[4] A mirror image of average incomes, poverty had been dropping rapidly during the Golden Age and then stopped when the economy went sour during the Nixon years. In recent years, this indicator has bounced around the 12–15 percent range, little change from the late 1960s/early 1970s.

FIGURE 2

POVERTY RATES
percent of population with incomes under official poverty line

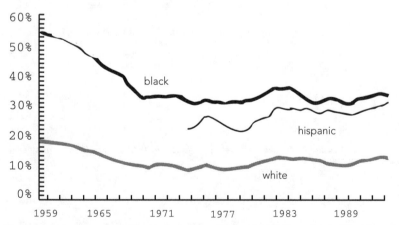

No poverty rates were reported for blacks between 1960 and 1965. I've estimated them from the white rate, which is why the line lightens for those five years.

The typical poor person in the American imagination is urban, black, and young—either a single teen mother or her issue. There are undeniably many such poor in America. But portraying poverty that way makes it easier for ruling ideologists to stigmatize the poor through appeals to white male bigotry. The American poor are a wonderfully diverse assemblage.[5]

Now there's no question that being black exposes you to great risk of poverty. In 1993, the poverty rate for non-Hispanic whites was 9.9 percent. The rate for Hispanics was three times as high, 30.6 percent, and that for blacks higher still, 33.1 percent. Worse, blacks and Hispanics were even more likely to be extremely poor—with more incomes under half the poverty level than whites. In fact, at 16.7 percent, the share of the back population that is extremely poor is over four times that of non-Hispanic whites (3.7 percent), and well above that of Hispanics (10.5 percent).

But since there are many more whites than "minorities," their numbers are much larger, and no analysis of poverty can afford to overlook the composition of the officially defined poor. Almost half—48.1 percent—of the poor are non-Hispanic whites; the absolute number of very poor whites is well above the black indigent.

Nor is the picture of poverty as largely urban a fair one. Again, the risk of being poor is high for urbanites; central-city dwellers had a poverty rate of 21.5 percent in 1993. This is over twice the rate for suburbanites (10.3 percent), but not profoundly higher than the rural rate, 17.2 percent. Rural single-mother families are poor at a rate only marginally below that for urban families of that same maligned type (46.2 percent urban, 42.6 percent rural). The clichéd figure of American utopia, the suburban married-couple family with young children (under 6) faced a one in ten chance of being poor, a fairly high number for what is supposed to be a socially esteemed household form.

---------------------- WORK AND RACE

WAGE TRENDS

Since most people between the ages of 18 and 64 depend on work for almost all their income, the forces underlying dispersion in incomes are mainly those of the labor market. Work by Jared Bernstein for the Economic Policy Institute sheds great light here.[6] While it's well known that real average hourly wages have been falling for twenty years, it's less well known that women's earnings have risen while men's have fallen. The real hourly

pay of white women rose 12 percent between 1979 and 1993, and that for black women rose 6.3 percent; but white men lost 5.7 percent and black men 10.4 percent.

Black men in every educational grouping earned a lower real hourly wage in 1993 than 1979, reversing the progress of the 1970s. Better-educated white guys did well until the Bush slump, but now even they aren't spared downward mobility. White men who didn't make it through high school have gotten hammered.

Of course, white dropouts still made a bit more than their black counterparts, despite their worse relative performance. And in most other categories, as the table shows, blacks did worse than whites. In fact, I've got to emphasize again that this catalog of white erosion shouldn't hide the vast gaps between blacks and whites at all educational levels—10–20 percent within the same class, 25 percent for men overall, and 11 percent for women. The point is to define the nature of white privilege a little more carefully than it's often done: white privilege these days means that your wages fall more slowly than those of nonwhites, unless you're a high school dropout, in which case racial advantage is actually eroding. The subjects of this volume have had an awful time of it in the labor market over the last twenty years.

TABLE 2

REAL HOURLY WAGE CHANGE, 1979–93 BY EDUCATIONAL CLASS
cumulative and annual average changes by period, families and per capita

	white		black	
	men	women	men	women
less than high school	-22.9	-11.0	-18.7	-6.6
high school	-16.0	-1.6	20.1	-6.5
some college	-10.3	+6.9	-15.9	-0.9
college	-2.5	+15.6	-2.7	+10.0
college plus 2 years	+7.6	+15.6	-6.2	+13.1
all	-5.7	+12.0	-10.4	+6.3

Covers workers between the ages of 18 and 64. Source: same as footnote 6.

Middle-class married-couple households sustained their incomes only because more married women were working at better jobs and for higher pay. But that sort of household is hardly the norm it's thought to be. Among whites, 73 percent of all households were married couples in 1970, 53 percent of blacks were, and 87 percent of Hispanics. By 1993, the share for all had fallen dramatically—to 58 percent for whites, 34 percent for blacks, and 55 percent for Hispanics. The female-headed household, so bemoaned by Clinton, Gingrich, and Charles Murray, has grown in a mirror image—to 10 percent of white households in 1993, almost 33 percent of blacks, and 19 percent of Hispanics. Also, almost 30 percent of all whites and blacks, and 20 percent of Hispanics, now live in nonfamily households (alone, or with friends, lovers, or roommates).

The growth in nontraditional households is often blamed for the economic troubles of nonwhites. This deserves rejection on principle alone: living arrangements should be a matter of affection and choice, not mean necessity. But principle doesn't cut much ice with the Trad Vals crowd; one can make the more technocratic point that many black men have had a pretty awful time of it in the labor market since the 1970s, as Bernstein's numbers show, making marriage less materially tenable than it once was.

Liberals, when they pause from moralizing about single motherhood, blame a lot of the racial money gap on an educational gap. Bernstein's report proves this wrong. While there was once a large gap between white and black high school completion rates, it has now almost disappeared, and the gap in reading and math proficiency scores has narrowed a lot. There is still a gap between white and black college attendance—mainly because of reduced financial support—but since well under half of today's young whites even enter college, and only one in five adults has a college degree, that disparity doesn't affect most workers. Were incomes as closely tied to education as we're told, black incomes should have gained on whites, but they haven't. Were affirmative action responsible for the overpromotion of black incompetents, this wouldn't be the case.

Why not? Blacks have been disproportionally hurt by deindustrialization (itself a function of automation and globalization); those who lost factory jobs have either stayed unemployed longer than whites, or gotten crummier replacement jobs in the service sector. One can summon all sorts of fancy reasons for this—economists use phrases like "a disadvantaged position in the hiring queue"—but they boil down to discrimination. The plunge in the

real value of the minimum wage and the decline of unions have also hurt—
two more reasons not unrelated to discrimination, since institutions like
these protect people subject to bigotry. Despite the line fashionable in right-
wing circles, minimum wages are not primarily earned by the teenage off-
spring of affluent whites; and despite the line fashionable in chic
postmodern circles, unions are not mere bastions of white male privilege.
Blacks are more likely to earn the minimum wage or something close to it,
and are more likely to be union members than whites.

Racism means that blacks are more likely to get hurt, and to get hurt
worse than their white counterparts. But whites have been hit by the same
forces, especially the most downwardly mobile whites, even if they don't
always understand this.

-------------------- THE COLOR OF JOBS

Occupations are still quite segregated by race and sex. White men have
a virtual lock on certain occupations[7]— they are 92 percent of airline pilots,
91 percent of tool and die makers, 90 percent of ship captains. White
women have their occupations, too: they make up 92 percent of dental
hygienists and 84 percent of secretaries. Black men are heavily present in
garbage collection (30 percent), as porters and bellhops (23 percent), and
as parking lot attendants (21 percent); black women, as private household
workers (30 percent), maids (22 percent), and welfare service aides (21 per-
cent). Hispanics share some of the "black" occupations, but are also found
heavily in farm and agricultural work. But note that the distinctively "minor-
ity" occupations contain lots of nonblacks. The ten blackest job categories
still have an average of 52 percent white men in them; the ten most
Hispanic, 51 percent. For women, the numbers are slightly lower; of the top
ten job categories dominated by black women, 43 percent are still held by
white women; the ten most dominated by Hispanic women still are nearly
half-filled (45 percent) by white women. Aside from suggesting that some
job categories are still highly gendered, it also shows that there are plenty
of white men and women doing our meanest work.

TABLE 3

TOP 10 OCCUPATIONS BY RACE AND SEX, 1990

(number and percentage group total)

white men	44,519,781	100.0%
Managers and administrators, n e c, salaried	3,024,916	6.8
Truck drivers	2,106,910	4.7
Supervisors and proprietors, sales occupations, salaried	1,715,855	3.9
Carpenters, except apprentices	1,124,393	2.5
Sales representatives, mining, manufacturing, and wholesale	1,078,264	2.4
Janitors and cleaners	1,059,736	2.4
Supervisors, production occupations	888,132	2.0
Automobile mechanics, except apprentices	747,463	1.7
Construction laborers	744,189	1.7
Farmers, except horticultural	656,812	1.5
black men	4,156,681	100.0
Truck drivers	337,125	8.1
Janitors and cleaners	329,540	7.9
Cooks	189,799	4.6
Construction laborers	145,635	3.5
Unemployed, no recent civilian work experience	141,597	3.4
Guards and police, except public service	135,332	3.3
Assemblers	133,334	3.2
Managers and administrators, n e c, salaried	109,449	2.6
Freight, stock, and material handlers, n e c	96,076	2.3
Stock handlers and baggers	90,148	2.2
Hispanic men	4,197,039	100.0
Janitors and cleaners	255,573	6.1
Truck drivers	240,989	5.7
Farm workers	207,238	4.9
Cooks	191,390	4.6
Construction laborers	188,082	4.5
Groundskeepers and gardeners, except farm	151,017	3.6
Managers and administrators, n e c, salaried	125,977	3.0
Assemblers	123,232	2.9
Carpenters, except apprentices	119,732	2.9
Supervisors and proprietors, sales occupations, salaried	105,892	2.5
white women	43,590,483	100.0
Secretaries	3,375,482	7.7
Teachers, elementary school	1,970,664	4.5
Cashiers	1,623,658	3.7
Bookkeepers, accounting, and auditing clerks	1,497,872	3.4
Registered nurses	1,488,663	3.4
Managers and administrators, n e c, salaried	1,383,619	3.2
Waiters and waitresses	1,025,935	2.4
Sales workers, other commodities	1,019,766	2.3
Nursing aides, orderlies, and attendants	977,397	2.2
General office clerks	918,998	2.1
black women	6,727,324	100.0
Nursing aides, orderlies, and attendants	466,404	6.9
Cashiers	340,508	5.1
Secretaries	288,645	4.3
Teachers, elementary school	254,799	3.8
Cooks	190,622	2.8
Janitors and cleaners	176,251	2.6
Unemployed, no recent civilian work experience	169,624	2.5
General office clerks	166,327	2.5
Maids and housemen	159,793	2.4
Registered nurses	155,076	2.3

Hispanic women	4,133,543	100.0
Secretaries	219,1125	5.3
Cashiers	199,779	4.8
Janitors and cleaners	124,696	3.0
Textile sewing maching operators	123,539	3.0
Nursing aides, orderlies, and attendants	123,131	3.0
Unemployed, no recent civilian work experience	104,939	2.5
Teachers, elementary school	104,645	2.5
Maids and housemen	103,022	2.5
General office clerks	95,836	2.3
Assemblers	93,822	2.3

OCCUPATIONAL CONCENTRATIONS BY RACE AND SEX, 1990
(jobs showing highest percentage of featured group)

white men	42.6
Airplane pilots and navigators	91.6
Sales engineers	90.7
Tool and die makers, except apprentices	90.5
Ship captains and mates, except fishing boats	89.8
Tool and die maker apprentices	89.6
Marine engineers	89.4
Supervisors, firefighting and fire prevention occupations	88.6
Supervisors, electricians and power transmission installers	88.5
Farm equipment mechanics	88.3
Supervisors, plumbers, pipefitters, and steamfitters	88.3

black men	4.9
Garbage collectors	30.1
Stevedores	28.9
Longshore equipment operators	27.8
Baggage porters and bellhops	22.9
Taxicab drivers and chauffeurs	20.6
Parking lot attendants	20.5
Concrete and terrazzo finishers	19.7
Elevator oprators	18.9
Guards and police, except public service	17.2
Transportation, communications, and other public utilities	17.1

Hispanic men	4.8
Supervisors, farm workers	27.6
Farm workers	27.3
Plasterers	27.0
Nursery workers	21.0
Groundskeepers and gardeners, except farm	20.5
Elevator operators	19.4
Helpers, mechanics, and repairers	19.2
Parking lot attendants	18.6
Concrete and terrazzo finishers	18.5
Helpers, construction trades	17.5

white women	35.3
Dental hygienists	92.2
Secretaries	84.0
Speech therapists	83.7
Dental assistants	81.2
Family child care providers	80.8
Occupational therapists	79.5
Registered nurses	79.0
Stenographers	78.2
Bookkeepers, accounting, and auditing clerks	77.9
Receptionists	77.1

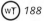

black women	5.4
Private household cleaners and servants	30.6
Housekeepers and butlers	29.4
Cooks, private household	28.8
Nursing aides, orderlies, and attendants	25.1
Maids and housemen	22.4
Winding and twisting machine operators	22.0
Welfare service aides	20.6
Pressing maching operators	18.5
Licensed practical nurses	17.1
Unemployed, no recent civilian work experience	17.0
Hispanic women	3.3
Graders and sorters, agricultural products	37.0
Housekeepers and butlers	31.4
Private household cleaners and servants	25.2
Production samplers and weighers	19.7
Textile sewing machine operators	15.8
Graders and sorters, except agricultural	15.6
Maids and housemen	14.5
Dressmakers	14.2
Child care workers, private household	14.0
Packaging and filing machine operators	12.2

The first table shows the top ten occupations by race and sex. For example, 4.5 percent of white men were truck drivers in 1990. The second table shows the ten highest occupational concentrations by race and sex, with the first line of each section showing that group's share of the total labor force. For example, 42.6 percent of the workforce consisted of white men in 1980, but 91.6 percent of all airline pilots were white men. *Source for both tables: author's analysis of U.S. Census Bureau EEO data, electronic Cendata version.*

⊕ ⊕ ⊕

If you look at raw numbers rather than shares you can get a flavor for both segmentation and more egalitarianism than convention suggests. The largest occupational category for white men in 1990 was salaried managers and administrators, a title that also appears on the top ten list for black men (#8), Hispanic men (#7), and white women (#6). Secretary is the leading job label for white women—but it's also number one for Hispanic women and number three for black women. Truck driving is the leading employer of black men—but it's second for both Hispanics and whites. "Janitors and cleaners" is the biggest occupation for Hispanic men, and second for black men—but sixth for white men. More black women are nurses aides and orderlies than any other occupation—but it's the ninth-biggest employer of white women. The privileged titles usually appear higher and more often for whites, especially men, but there's no shortage of awful jobs for white folks either. Bob Reich's symbolic analysts are in notably short supply in these top-ten lists.

----------------------- Political Coda

Tim McVeigh's bomb brought forth a gusher of liberal angst about mid- and downscale whites as the shock troops of a new American fascism. "The militias" came to stand for a whole array of resentments among non-elite whites that have roots in loss of income and status, and the transformation of American mobility from the upward to the downward kind. The right has cannily channeled this resentment away from the folks who inhabit corporate boardrooms and bond-trading desks and towards the usual substitute targets—immigrants, the cultural elite, welfare moms, and their criminal teenage issue.[8] That job is made easier when that cultural elite demonizes the rebels and sics the FBI on them, and the intellectual left, a subset of that elite, concocts elaborate theories of why the concept of class is as dead as the dinosaurs and a challenge to capital can no longer even be imagined.

-------------------------- Notes

1. Statisticians define the "color" of a household or family by the self-identified color of the "householder," the person whose name is on the deed or lease. It's shocking how rare interracial families are. In 1993, only 2.3 percent of marriages in which at least one partner is white or black were "interracial," and only 0.5 percent are between blacks and whites. Over a quarter of all marriages involving Hispanics, however, have a non-Hispanic partner. U.S. Bureau of the Census, *Statistical Abstract of the United States* (Washington: U.S. Government Printing Office, 1994), table 62, p. 56.

2. I use family, rather than household, data because the family figures go back to 1947, while household coverage doesn't begin until twenty years later. Unfortunately, "family" excludes individuals living alone or in arrangements not recognized as familial by the authorities. Non-family households have lower incomes than family ones. Unless otherwise noted, historical income figures are computed from spreadsheets distributed by the U.S. Bureau of the Census at its Internet site, <ftp://ftp.census.gov//pub/income/>.

3. By official definitions, "Hispanic origin" is not a race, nor is it a term everyone likes. It is, however, what government statisticians use. In the Census Bureau's yearly income and poverty reports, about 90 percent of Hispanics identify themselves as white. Their higher poverty rate and growing numbers have the effect of boosting the "white" poverty rate by over 20 percent, to 12.2 percent. This disparity argues in favor of the worth of "Hispanic-origin" as an analytic category. These are approximations only; there's no guarantee that different demographic groups claim whiteness to the same degree. The official "white" figures are misleadingly high, if you consider "Hispanics" not to be fully white—but if people consider themselves "white," who's to second-guess them? I'll leave defining the perimeters of whiteness to someone in cultural studies. In a lot of what follows, I focus on black-white relations. I'm aware that race in America is no longer a simple matter of black and white,

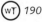

but black-white relations have long been one of the central melodramas of American life, and will probably continue to be for a long time.

4. The poverty line was set in the early 1960s on the basis of 1950s spending patterns and has simply been adjusted for inflation ever since. A more honest redefinition, either one based on a modern market basket or one set on relative to average incomes (e.g., a poverty line at 50 percent of the median) would result in poverty rates of 20 percent or higher. Doug Henwood, *The State of the USA Atlas* (New York: Simon & Schuster, 1994), pp. 48–48, 111–112.

5. The snapshot of the poverty population in this section is based on figures from the U.S. Bureau of the Census (1995). In most cases, I've adjusted official white rates to simulate non-Hispanic white by removing 90 percent of the Hispanic population in each analytical category. This is no doubt reckless, but it's done to sharpen contrasts.

6. Unless otherwise noted, pay data in this section come from Jared Bernstein, *Where's the Payoff?* (Washington, D.C.: Economic Policy Institute, 1995), table E, p. 30.

7. The 1990 Census data is from the EEO files on Cendata, the electronic service of the U.S. Bureau of the Census available through CompuServe and Dialog.

8. The 1994 Republican Congress won because downscale whites—male *and* female—either didn't vote or voted more Republican than they did in 1990 or 1992. Doug Henwood, "RIP, Dems?," *Left Business Observer*, no. 67 (December 1994), pp. 1–2; Ruy A. Teixeira and Joel Rogers, "Who Deserted the Democrats in 1994?," *The American Prospect* (Fall 1994), pp. 73–76.

WhiTE TrɑsH ,RELɪgɪON

Matt Wrɑy

THE END OF HISTORY

For me, the Apocalypse is a vivid memory. It has already happened. I live in its shadow. Yet much of the current writing about apocalypse culture tends to present the Apocalypse as a metaphor for the present. There has been a veritable deluge of books and articles full of dire predictions and apocalyptic warnings about contemporary social life. Theorists on the left and right rant about the end of history, the crises of modernism and/or postmodernism, the rapturous triumph of liberal democracy, the decline of Western civilization, the new decadence under late twentieth

century capitalism, and so on.[1] For all the differences among these theorists, several point to the mid-seventies, especially the years 1973–1978, as the beginning of the end. These academic accounts have a strange and eerie resonance for me because those years are the exact same years I've been secretly remembering all of my life.

These memories of The End haunt me still. For years, I've worried over their meanings, tried desperately to banish their spectral presence in my life. They always return, ever more distorted and hallucinatory than before. They trouble my politics—my progressive stances on social and political issues always seem to me to be a thin veneer covering over my retrograde desires and wishes for mass destruction. This self-doubt and cynicism has often crippled my activism. I've felt deeply split, unable to integrate my politics with my most secret desires.

Recently though, I've started to see things differently. I've begun to understand that, broadly speaking, the onset of apocalyptic fantasies, in individuals and in groups, signals a kind of resistance to mainstream culture and politics, offering a means of voicing protest against existing or emergent social orders. Throughout ecclesiastical history, apocalyptic eschatologies have played a foundational role in forming religious and political movements, often blurring the line between religion and politics. Fundamentalist millenarianism in its various historical guises has had this effect.[2] For fundamentalists, many of whom suffer from some form of economic, social, and political disenfranchisement, apocalyptic fears and fantasies of collective death are powerful aspects of individual and group identity formation. Fundamentalist beliefs enable those within the group to resist, at least ideologically and symbolically, unwanted societal change and transformation.[3] In fundamentalist apocalyptic scenarios, global death is less a negation than it is an affirmation. The Apocalypse represents a final confirmation of the truth claims of fundamentalism, a fulfillment of righteousness, and a total liberation from a fallen world of sin and misery.

Given this element of resistance in apocalyptic thinking, it is perhaps not surprising that in American religious life, belief in the Apocalypse as an imminent, world-ending, world historical event is seldom found in its strongest forms among the mainstream Protestant denominations. Apocalyptic religious belief is in many ways deeply at odds with the ideology of success and the triumphalism which lies at the core of mainstream American Evangelicalism.[4] Visions and prophecies of the coming Apocalypse flourish

not in the center, but at the margins of mainstream Christianity, among various fundamentalist sects, independent non-denominational churches, and Christian cults. Apocalyptic themes are especially popular with charismatic and Pentecostalist congregations. While most mainstream denominations hold that the so-called "apostolic gifts" of the Pentecost (speaking in tongues, healing, prophecy, interpretation, and so on) died out with the early church, charismatics and Pentecostals believe in the active, contemporary presence of The Holy Spirit and teach that the gifts of the Spirit are available to present day believers.[5]

Ecstatic Christian practices are popular (by no means exclusively so) with the economically downtrodden—the poor and working classes who inhabit the margins of social life. Images and stereotypes of poor folks' religion, whether the emotionally charged, poison-sipping, snake-handling worship of white Appalachians or the gospel song and dance of African American church traditions, have been with us since at least the turn of the century. More recently, the late 1960s and early 1970s witnessed the rise of the "Jesus People," a.k.a. "Jesus Freaks" and "born-agains," those hordes of counterculture youth who dropped out, turned on, and tuned in to Christianity, becoming born-again hippies, bringing to Christianity some aspects of the radical anti-establishment subcultures from which they arose. The Jesus People forsook acid and other mind-altering drugs in favor of the bread and wine of Christian communion and the ecstasies of charismatic worship. This historical recurrence of popular charismatic and Pentecostal fundamentalism raises many questions. What is it that makes ecstatic religious experiences so appealing?[6] How did the re-emergence and rise in popularity of charismatic and Pentecostal beliefs and practices in the early 1970s help shape American religious beliefs and practices of today? What was it about the 1970s that provided the social conditions necessary for this rise in enthusiastic, ecstatic belief?

The fact that the 1970s witnessed both the rise of apocalyptic cultures and rhetoric and the emergence of ecstatic religious practices suggests that there may be interesting connections between the two. In what follows, I try to make sense of these questions, drawing largely on my own experiences growing up poor and religious in rural New Hampshire. As I seek to understand the culture and politics of 1970s, I am simultaneously trying to make sense of my own stories and experiences of those years. I'm trying to understand how these very public and secular discussions of the social,

cultural, and especially the economic apocalypse(s) of the early 1970s con-
nect with my experiences and my private memories of a very religious,
mythic, and still mysterious Apocalypse.

----------------------- THE RAPTURE

I'll never forget the feeling—waking up to an empty house that chilly
April morning in 1973. I knew, as I opened my eyes, that something was
wrong. It was too quiet and much too cold—none of the usual Sunday
morning sounds, no heat rising from the wood stove below. My clock read
3:05 AM- it must have stopped in the night. I looked across the room to my
brother's bed and saw that it was empty, the sheets and blankets lay twist-
ed and coiled. Strange—Luke always slept later than I did. Something was
definitely wrong. Still groggy from sleep, I crawled out of bed and crossed
the room, dragging my sheets and blankets, wrapping them around me to
warm myself in the crisp air. I lay my hand on his mattress, feeling the shal-
low depression his body had left. It was cold.

I shuffled across the hall to Mark's room and slowly pushed open his
door. Calling out his name in a whisper, I peered into his room. Another
empty bed, unmade. Mark always made his bed. A panicky rush hit me in
the gut. "Mom!" I called out. "Mom, where are you?" The silence made me
shudder. Wide awake now, I drew the sheets more tightly around me and
rushed down the stairs to my mother's room. Her door ajar, her unmade bed
cold and empty.

A second wave of fear and revulsion hit me. I crumpled to the floor and
began to cry. Jesus had come and taken my family away. He had come, like
a Thief, and taken them home, as He said He would. The Rapture had
occurred while I slept. I felt the crushing weight of my sins, the guilty shame
of having abandoned Jesus. I knew that He had rightfully abandoned me. I
shivered and whimpered, lifted my head and stared up into the long mirror
which hung on my mother's door. My reflection there startled me—I,
Matthew, whose name means Gift of God—shivering pale body dressed in
white, alone and crying.

I turned and looked out the window and there, across the street, in the
church parking lot, sat our car. And the cars of others in our church. In my
confusion, it took a few seconds to register. Of course—it was Easter
Sunday. I was to have awakened early to go to the ecumenical Sunrise ser-
vice. To greet other believers with smiles and say "He is risen. He is risen."

My mother must have been unable to wake me and I slept through it all. I drew my little body up, blew my snotty nose into the sheets and went upstairs to dress. Bundled up against the sub-freezing cold, I crossed the street to the church where I found my brothers and my mother sipping coffee and hot cocoa and munching on doughnuts. I found my mother, wrapped myself in her arms, and began to cry like a little child. I didn't stop, not even when I heard one of the Deacons say that I was too old to cry like that. Choking on my words, I told her only that I'd had a bad dream. I didn't, I couldn't tell her what I had really feared—that my family had been taken up and I alone left behind. I couldn't tell her that because it would be a sign that I lacked faith, that I had profound doubts and fears about whether or not I was truly saved. These were signs I was not willing, not able to give.

The Holy Spirit had begun to move strongly in my church. A number of charismatic born-agains had arrived at the sleepy little church where my father had been a minister. These young people, newly converted by the Jesus Movement, turned things upside down, insisting that our church needed renewal through the gifts of the Holy Spirit. While many of the church leaders (all men) resisted these new Pentecostalist influences, several of their wives experienced baptism of the Spirit and began speaking in tongues. These women testified to the power and truth of the gifts of the Spirit, and soon the nature of our Sunday services began to change. My father, not given to belief in the gifts, was soon ousted from the church in a public excommunication, the reason for his dismissal being that he had an adulterous affair and, according to the new pastor, he would not repent.

About this same time, our new pastor became increasingly convinced that the signs of the Apocalypse were all around us. According to his reading of Revelations and Daniel, we were living in the End Times. He preached that God was commanding us to prepare ourselves for His imminent return. Like all true fundamentalists, Pastor Jack strongly believed in the literal and inerrant truth of the Bible—the Holy Scripture, he was fond of saying, was history written in advance. Through Jack's teachings, the Bible became for us a sort of textbook for living in the eschaton. His weekly sermons drew heavily from current world events. We heard sermons on the Satanic dangers posed by Trilateralism, an economic policy aimed to disguise the global plot by the internationalist banking elite and their allies, a mysterious group called the Illuminati who were seeking to establish a one-world government. Thanks to the teachings of the Scriptures and the visions of true

prophets, we could recognize these as signs of the coming of the Anti-Christ and resist their evil influence. We were exhorted to switch to a cash-only basis in our money transactions as credit cards and electronic funds transfer were seen as especially pernicious attempts to wrest away our control over our personal finances. In reality, few of the members in our church were financially secure in the first place. Few had any sense of control over money—money, it seemed, controlled us. More than anything else, lack of money set our limits, defined our educational horizons, determined the level and quality of health care we received—poverty deeply affected our life chances. This often lead to attempts to control money *spiritually*. My mother, seduced by the promises of wealth offered by televangelists, began sending "seed money" to Oral Roberts and Pat Robertson's 700 Club, as evidence of her faith that God would somehow return the money to us ten, even one hundred fold. It was, I suppose, a kind of heavenly mutual fund, a sincere belief in truly fictional capital. This investment strategy was in many ways at odds with our apocalyptic vision. We seemed to be investing in a future we were never sure we were going to have. But, somehow this deep contradiction never surfaced for us—we ignored it as we did so many other contradictions we faced every day. And sometimes the money did come back to us, in seemingly miraculous ways, like the time our heating oil bill was paid off by a total stranger.

In part, we were able to deal with these paradoxes because our lives were not all gloom and doom. In fact, life in the Spirit was new and exciting. There were dramatic healings, prophecies, people were "slain in the Spirit," passing into semiconscious, ecstatic trance-like states, and more and more people began to speak in tongues. Our twice-weekly worship services were filled with shouting, dancing, stomping, and wailing. And music— powerful and uplifting music. I played trombone in the church band, with my older brother Mark on trumpet and my younger brother Luke on drums. Together with lots of guitars, piano, and electric organ, we filled the church with joyful sounds. Sunday worship services often lasted three hours. Many of the older, more conservative members of the congregation left, but they were quickly replaced by a seemingly endless flow of young converts. Ex-drug addicts, motorcycle gang members, and reformed backsliders flocked to our services. Our numbers grew steadily—35, 50, 80, 100! We nearly outgrew our place of worship, an old converted barn attached to a farmhouse. In keeping with our sense that the time of trials and tribulations was

just ahead, many church members, the hardcore post-millenialists among us, began to stockpile canned goods—some even converted their basements to fully equipped apocalypse shelters, complete with seven years' worth of dried food and water. We all began to think and pray about how to survive the End, how to remain faithful in the time of darkness.

A prophecy came forth one Sunday. Jesus was coming back soon—very soon. My brothers and I would not finish college before the dreaded events so vividly described by the Apostle John in the book of Revelations would come to pass. Although not everyone believed it,[8] this prophecy had a profound effect on me and my brothers. My older brother Mark really took the prophecy to heart—a few years later, when he graduated from high school at the top of his class and all of his teachers expected and encouraged him to go to college, he decided he wouldn't go. "What's the point?" he confided in me. "I'd never be able to finish my degree." Personally, I became very afraid. That's not enough time!, I thought. I need more time to get ready, to strengthen my faith. Although I had accepted Jesus into my heart when I was eight years old, the church's ill treatment of my father, the way he was cast aside and publicly shunned, and the humiliation and pain this caused me, had introduced a lot of doubt into my heart. In addition, my parents were separating. Despite his infidelity, my father did not want to lose his family, but my mother insisted he leave because God had told her that Father's "darkness was overshadowing our light." This seemed strange to me—why would God want to split our family? I was told that this was a test of my faith. Publicly, I said I understood why God's will must be done, but privately I had a hard time accepting this on faith. This doubt and my Easter morning waking nightmare convinced me I wasn't quite ready for the End Times.

A few weeks later our pastor interrupted the service to pass out maps. Strange maps they were, crudely drawn, mimeographed sketches of the church property. Dotted lines marked the pathways in the trees down by the river and solid lines marked the fences and stone walls of the property boundaries. Little crosses were scattered about at random, all over the map. These, he told us, were Bible maps. The Holy Spirit had commanded him to began setting aside part of each weekly offering to buy Bibles, "just in case." He took the money down to the religious supply store in nearby Manchester and bought as many King James Version Holy Bibles as the congregation's tithes would allow. He had fifty brand-new Bibles. They weren't fancy—no

Thompson Chain Reference Bibles—the preferred Bible of hardcore funda-mentalists, but they were sturdy and whole. He went on to explain that, just as the Spirit had instructed him, he had carefully wrapped these Bibles in plastic bags. At night, he had buried them all over the church property. These buried Bibles, he sermonized, would act as a spiritual protective fence, protecting us from the Satanic forces of the Anti-Christ and the Beast. And, when the Anti-Christ/Beast came to power, when religions were outlawed, and when the Bibles were destroyed or altered, we'd still have Bibles! All we'd have to do is follow these Bible maps he'd prepared and we'd have freshly unearthed Bibles to read and meditate upon. For without the word, the people will perish.

That night I had a dream. I dreamed I saw Pastor Jack, dressed in black, dragging a heavy sack through the woods by the church. He carried a large policeman's flashlight and on his back, an army shovel and a knapsack. He'd stop by a tree or a large stone and begin to dig. A shallow pit for each Bible, I thought. I watched him from a distance as he reached into bulky sack and pulled out the plastic-wrapped bundles. Cradling them in his hands, he placed them gently into the holes. He buried them quickly and efficiently, shoving the dirt over them, patting down the earth with his bare hands. Carefully, he withdrew a clipboard from his pack and marked his master map under the white light of the heavy flashlight. At one such hole, I drew clos-er to him. I could hear him speaking quietly in tongues, a whispered mantra. His hands were shaking, from what I couldn't tell—exertion, the Holy Spirit? And then I noticed his fingernails. They were torn and bloody. This shocked me, that his hands were bloodied. Had he torn them in the rough earth? I watched as he pulled another bundle from the sack. This one had come unwrapped and he set it down in the freshly turned soil. Then, under the harsh glare of the flashlight, I saw something that terrified me. For there, carefully wrapped in the translucent plastic, was the perfect blue face of a small, lifeless baby. Pastor Jack was burying babies, not Bibles. I screamed myself awake.

---------------------- JUDGMENT DAY

As a young boy, I made sense of these events by believing that, whatev-er might happen, God was my protector and that His Will was being done. But now, twenty years later, no longer believing in God, how can I make sense of this history, my own stories, memories, and nightmares? How can I

reconcile my past beliefs in the coming End with my experience of living a future I never imagined possible?

Socio-economic theory has helped. Many theorists have argued that it is possible to isolate certain events of the early 1970s which gave rise to the end of one historical period and the emergence of a new one. The first major global economic recession of the postwar period occurred in 1973. Many were touting the advent of computerized new information technologies, the rapid globalization of the economy, and the emergence of new modes of production and work organization as the means to bring an end to scarcity. Others noted that these events of the late 1960s and early 1970s were the hallmarks not of a post-scarcity society, but rather of a new mode of capital accumulation, one which threatened to deepen existing economic crises and further immiserate those on the lower ends of the economic scale.[9] From this perspective, the 1970s marked the beginning of a transition from "Fordist" economies (named after the Ford Motor Company's innovation structures and production techniques)— marked by vertically integrated corporations, scientific management of labor, and large-scale mass production and consumption—to "post-Fordist" economies. Under post-Fordism, corporations were shifting to horizontal mergers and diversification, global labor and commodity markets, small-scale batch production, and computer-driven technological innovations for sources of new profits. According to many analysts, a new epoch of "advanced capitalism" was being born.

Documenting the seventies, the Marxist cultural critic and geographer David Harvey carefully traces the movement from Fordist to post-Fordist economies and shows how these economic shifts were crucial in shaping the culture and politics of advanced capitalist societies. These shifts, brought on by recurring crises within capitalism itself, are evidence of the cyclical process whereby excess capital must create and find new markets, new territories, new investment strategies, even new modes of production in order to maintain its value in the face of declining profits and productivity.[10] This is a process that Marshall Berman, borrowing from the economist Joseph Schumpeter, has called "creative destruction," since in its relentless, pathbreaking searches, capitalism leaves a wake of destroyed markets, economies, environments, and workers. This most recent shift (which Harvey dates from 1972) involved serious cultural upheavals, upheavals we can observe in almost every sphere of life.

So the years 1973–78 were apocalyptic years not just for me, but for the millions upon millions of people around the world dominated by capitalism. For many Americans, especially those in the North and Northeast, the economic conditions in the early 1970s were in fact quite brutal. Between 1970 and 1977, one million jobs disappeared. The rapid and massive displacements of capital and jobs due to increasing globalization and deindustrialization caused immense human suffering for those on the lower levels of the economic ladder, compounded by chronic stagflation and deep cuts in social spending under the Nixon administration.[11] Add to these economic crises the political and cultural turmoil of the early 1970s stirred by the Watergate revelations, the abandonment of the gold standard for currency, the energy crisis, the ignominious retreat from Vietnam, and *Roe v. Wade*.[12] For many people, these economic, political, and cultural upheavals made for apocalyptic times indeed.[13]

While much of the writing on this period in U.S. history has focused on the devastating effects these economic shifts had on the urban poor and working classes in cities like Detroit, Pittsburgh, and Newark, the rural poor were not spared these devastations either.[14] So it was that in one year, 1973, my church, a small church in a "trashy"[15] New Hampshire factory town of 2,000 people, was hit hard economically. Indeed, as 1974 came to a close, the economic situation worsened. The local light bulb factory, the town's only real industry and biggest employer, was retooling its machinery and restructuring its production process. My parents split, my father left, and we went on welfare that year, something that was deeply shaming given our New England ethic of self-reliance. We were pitched, collectively, into unexpected poverty.

Economic displacement fostered a broad and growing sense of crisis, but that sense of crisis was not articulated as a concern for our economic well-being or survival. Rather it was voiced as a concern for the survival of the Church, the faithful few. Looking back, I can see that our sense of crisis, precipitated by the economic displacements of a shifting capitalist economy, in turn was displaced from the material, economic realm to a spiritual realm. Our sense of the impending apocalyptic crisis mirrored the global economic crises of a world capitalist system in transition. This mystification and misrecognition of material and economic realities was made possible by the religious ideology which ruled our church community, an ideology which took the spiritual realm as the true ground of knowing and being.

As with displacements and shifts in capital, this displacement to a mystical, spiritualized realm was both destructive and creative. Our old church community was destroyed, as was the stability of my family (my parents separated in 1973 and divorced two years later). In place of these, a new church and a new extended family emerged, bringing with them a new sense of community and collective identity. This new "church-family" had few economic resources and little experience in organizing, yet we undertook many new projects. We converted the church basement into an emergency services/fallout shelter. With voluntary labor we set up a day care center which soon grew into a K–5 Christian school. We created community gardens on the church property so church members could grow their own food. We assembled and published a listing of all church members and the talents, skills, and equipment that each was willing to barter in exchange for labor, building materials, whatever. Out of this list grew a sort of Tribulation survival guide, complete with instructions on how to protect one's family and friends from the authorities. The Bible maps hung by magnets on the refrigerator, the basement apocalypse shelters were stuffed with dry goods and survival gear. We tried everything we could to move away from dependence upon the World. Self-sufficiency became the key. Need upon need was met and money was seldom exchanged.

So, in this way, the threat and promise of the Apocalypse drove us to experiment with religious utopia. We believed we were creating the Kingdom of Heaven on earth. It is clear to me now that we were, in part at least, seeking to free ourselves from the oppressive and chimerical nature of capitalist social relations.[16] Contrary to the ugly, hateful stereotype of unsophisticated and ignorant rural poor folk who know little of current cultural affairs and even less about global trends, we were acutely and uncomfortably aware of the economic and cultural drift taking place in the 1970s. We sought, on a very local level, to resolve, spiritually (through our religious ideology) and materially (through our exchange practices), that which we could not fix at large. We struggled to survive the transformation of capitalist economic structures which were proving to be so unstable and oppressive and to replace them with a set of local strategies and practices designed to enable the entire church community to survive.

Barter and gift exchange became central practices for creating and maintaining our sense of community. This emphasis on sharing gifts reflected our understanding of the spiritual realm. The Holy Spirit set the example by

freely bestowing gifts to each member of the church—these gifts we recognized as manna, crucial to the life and vitality of our community. The fantasy of free riches, so unlike earthly treasures, was enacted and performed every Sunday. To some were given the gifts of healing, to others prophecy, to others word of knowledge, and to others, the gift of tongues. We understood that these spiritual gifts were given to us to help the church grow and to edify the Holy Spirit. In this way, the gifts were a sort of spiritual start-up capital. However, unlike economic capital, these gifts circulated freely among the church members: men and women, young and old, the poorest and not-so-poor, all received and shared these spiritual gifts. We created a circuit of spiritual capital which compensated (in some ways) for our lack of money. We symbolically resisted globalization by identifying, among other things, trilateralism and the loss of the gold standard as signs of the advent of an evil one-world government, one to be run by Satanically corrupt politicians and leaders. In so doing, we fostered a new sense of community and collective identity, one geared towards economic self-sufficiency and partially realized through strategies of mutual aid. We did not ultimately see ourselves as victims, but as victors.

⊕ ⊕ ⊕

My nightmares continued. I lived in fear of the Beast. My horrific fantasies were fueled by reading the graphic religious tracts of Joe Chick and by creepy movies like *The Exorcist* and *Omen*. My mother began to worry, as night after night I ran into her bedroom to tell her the demons were keeping me up again. She explained to me that my nightmares were a form of spiritual warfare, manifestations of Satan's struggle to regain my soul. Those nightmares soon spilled over into my waking life, and vivid daydreams of seas of burning fire and suffering souls, mine included, began to haunt my days. These visions would come to me during the long Sunday worship services, which often carried on for two and three hours. During these moments, I was gripped by a demonic urge to hurl myself through the church window, shattering wood and glass as I crashed to the gravel parking lot below. I had to strain against my shaking body to keep it in place, my little hands gripping the hard steel of the folding chair beneath me. I struggled mightily to hold on, praying constantly, and when these temptations, these invitations to possession had passed, I had to pry my stiffened

fingers off the chair. The red and white stripes which cut across my fingers seemed to me something like sacred stigmata, signs that I had endured the temptations.

These tests of faith continued and intensified until the following summer of 1975. Along with several other church members, our family attended Fishnet '75, a large annual gathering of charismatic Christians on an old farm in Pennsylvania. There was a full schedule of Christian rock music, teachers, healers, and inspirational speakers. It was there that I received the Baptism in the Holy Spirit and my Gift. One of the elder men in our church, gifted with the Word of Knowledge (the Spirit-given ability to know things about the private lives and sins of others), said that the Spirit was calling me to be baptized. I had already been baptized in water, but now it was time for my second baptism, baptism in the Holy Spirit. I was afraid, but more afraid of what would happen if I refused. I felt him place his hands firmly on my head, as he began praying, speaking in tongues. As he prayed, I felt strange heat shooting through my body, a humming energy traveling up and down my spine, my body seeming to vibrate under his touch. He asked me if I felt anything unusual and I said yes, I had. Lifting his hands, he said, "Praise Jesus, now we wait for the gift." I smiled and nodded weakly, not really understanding what was going on.

Later that night, as I huddled against the frost in my sleeping bag, I began to feel the warmth once again, spreading through my body like a glowy heat. My teeth began to chatter and my body began shuddering and shivering as the strange heat rippled up and down my spine. I have never felt anything like this before, I thought. I felt overwhelmingly happy and excited knowing that the Spirit was moving through me, but I was afraid to open my mouth, too frightened to make a sound. Minutes passed as my small body shuddered and twitched in ecstasy, as I struggled to keep still and stay silent. Finally, I began to whisper through my clenched teeth. My tongue seemed to have a will of its own as it pushed against my teeth, prying them apart. Strangely beautiful sounds came pouring out of me and I felt as I believed, that I was worshipping God in a pure, sanctified tongue, singing his praises with some purely divine language. As I spoke, my vibrating body seemed to drop away. I could still feel it, but it was though it belonged to someone else. I may have whispered in these tongues for only five or ten minutes, but when they ceased, when the powerful flows of energy stopped, I felt totally renewed and cleansed—exhausted, but *clean*.

This experience, I understood, was possession by the Holy Spirit, a form of direct ecstatic communication with God. I knew I was ready for the Rapture now. My nightmares soon came to an end. True, I still suffered from nightly terrors, but as I woke from them, I found myself already speaking in tongues, murmuring to God in the dark, casting out the demons and warding off the fears. Tongues made me feel safe and powerful. Never before had I received a gift which made me feel so potent, so loved, so strong. I was eleven years old.

Over the next four years, from 1976 to 1980, the apocalyptic fever in our church began to wane. Pastor Jack moved on, and the church split into splinter groups called house churches. The gifts of the Spirit began to die out, and few talked of the impending time of troubles anymore. Our church dwindled in numbers and, due to financial and other pressures, sought to merge with another local independent church. This new church, following the more strictly fundamentalist doctrines of J. N. Darby and the Plymouth Brethren, moved us away from the gifts of the Holy Spirit. More and more people who did believe we were living near the End adopted a pre-millennial view: all good Christians would be raptured before the time of Tribulations. I remember one Sunday when a man in the front row started shaking spasmodically, his head snapped back and he fell writhing to the floor. One of the deacons who knew him well rushed to his side and held him down. As the man's fit subsided, he turned to the congregation to let us know that it wasn't a case of demon possession—this man had just had an epileptic seizure and needed medical attention. Somehow I was disappointed—I wanted us all to wrestle with the demons. Church services got kind of boring after that.

Unlike my older brother, after graduating from high school I went on to college, having received a full scholarship to go to the local state school. Once in college, I began to experiment with new ideas and new belief systems. I needed powerful myths to replace the ones I was losing. Unlike most of my classmates, I studied Enlightenment rationality and secular humanism as an outsider (they were, after all, an alien tradition to me, the cursed twin enemies of fundamentalist belief), and as I studied, they began to draw me in. At twenty, I turned away from church and family. I began to understand that, in order to survive, I had to now convert to the World, yet I found it extremely difficult to let go of my theistic beliefs, my lifelong habits of knowing and being. In 1984, I walked away from my scholarship, dropped

out of college, and started kicking around in the trades, picking up jobs wherever I could, just like my high school buddies were doing back home. With few friends or family to support my intellectual and spiritual explorations, I went into deep depression and had several breakdowns. I spent much of my time feeling slightly insane and borderline psychotic. Nothing made sense to me anymore. It was as though I had been given a new lease on a life I no longer wanted. I remember the acute, ironic despair I felt at that point in my life, thinking that the church prophet was right: a ten-year-old church prophecy was being fulfilled. There I was, only two years into college and my world was coming to its End. I was devastated—I hadn't ever imagined the Apocalypse would be such a personal event.

THE LAST THINGS

Growing up poor, white, and religious, I learned to believe that the world was essentially an evil and unjust place. Poverty and human suffering were explained as natural, enduring, and unchangeable consequences of humanity's fall from grace. The economic deprivations and hardships of our lives somehow seemed our due, as if it were somehow right that we, fallen creatures that we were, should suffer for our sinful nature. Others may live in denial and reap the pleasures of worldly goods, but they would answer for their sins on Judgment Day.

Though not all the members of our church were poor, poverty was primary among the social conditions which helped shape our religious identity. For those who were financially more secure, it was perhaps their sense of social and political alienation which led them to identify with and embrace these practices and beliefs. In this respect, I don't think our church experience was exceptional. In general, charismatic Christianity brings a sense of spiritual power and righteousness to those who, because of their positions within capitalist economic structures, suffer from a fundamental lack of social and economic power. In addition, for those who hold deep antipathies towards modern life, charismatic and fundamentalist Christian belief offers a powerful ideology of refusal and resistance to the existing and/or emergent social and cultural orders. But it would be a mistake to romanticize this movement. Despite its clearly counter-hegemonic potential, charismatic Christian belief is in many ways regressive and usually has the political effect of demobilizing and tranquilizing the economically oppressed. In this way, the gifts of the spirit, the semi-conscious trances and possessions, the bartering of

 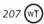

goods and services which characterized our church practices can all be read as dual signs—signs of both resistance and capitulation to the dominant economic and social order. And this presents a curious contradiction, one that I failed to grasp as a Christian: our simultaneous assertion and denial of human agency, the will and ability to change our social conditions coupled with a deep-seated desire to give God the credit.

As a young boy, I looked forward to The End with both fear and anticipation. I dreamed of dead and dying babies, the death of possible futures, futures killed by apocalyptic thinking. And I fantasized a glorious unending eternity in Heaven. I longed for certainty in what was becoming an increasingly uncertain world. Now, as the end of the millennium draws near, and as I face turning thirty-three, my sense of the future is still uncertain. But I am certain of one thing: the future will be made by human effort, not by God. This may not sound like much of a conclusion, but I've traveled a very great distance to come to this belief. Now I hope The End will never come.[17]

------------------------------ NOTES

1. The literature on the end(s) of history is voluminous. I can do no more here than draw attention to some representative works. See Hans Magnus Enzensberger, "Two Notes on the End of the World," in *New Left Review* 110 (July–August 1978); Frances Fukuyama, *The End of History and the Last Man* (New York: Free Press, 1992); Marshall Berman, *All That Is Solid Melts into Air* (New York: HarperCollins, 1982); David Harvey, *The Condition of Postmodernity* (Cambridge: Blackwell, 1989); essays by Jürgen Habermas, Fredric Jameson, and Hal Foster in Hal Foster, ed., *The Anti-Aesthetic* (Seattle: Bay Press, 1983). For an evocative theoretical meditation on how the end of history looks from Detroit, Michigan, an important northern urban bastion of white trash culture, see Jerry Herron, *After Culture: Detroit and the Humiliation of History* (Detroit: Wayne State, 1993).

2. See Christopher Hill's *The World Turned Upside Down* (New York: Viking, 1972). Hill demonstrates how the apocalyptic theology of the Ranters, Diggers, Levellers, and others helped shape the political hegemony of Puritans in seventeenth-century England.

3. See Charles Strozier's *Apocalypse: On the Psychology of Fundamentalism in America* (Boston: Beacon, 1994). Strozier, a historian and psychotherapist, gives us a well-researched and incisive look into the psychohistory of American fundamentalism. I regret that I only discovered this book very late in the writing of this essay.

4. For a critical analysis of this theme of triumphalism, that complex blend of apocalyptic optimism, turn-of-the-century American patriotism, and strict morality, see Douglas Frank, *Less Than Conquerors: How Evangelicals Entered the Twentieth Century* (Grand Rapids: Zondervan, 1986).

5. Charismatics and Pentecostals typically lay claim to 1 Corinthians, ch. 12 and numerous passages in

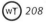

the book of Acts as biblical precedent for these practices.

6. For an anthropological discussion of how the production of religious ecstasy might relate to the social circumstances of those who produce it and of how religious enthusiasm rises and falls in different social conditions, see I. M. Lewis, *Ecstatic Religion: A Study of Shamanism and Spirit Possession* (London: Routledge, 1971).

7. Of course, American Pentecostalism has a long history, a proper analysis of which exceeds the scope of this article. Briefly, however, I want to note that in our church, we traced the rise of twentieth century U.S. Pentecostalism to its emergence in 1906, with the well-publicized events surrounding the Azusa Street Mission Revival in Los Angeles. The first two decades of this century, a time of volatile and tumultuous social change, saw the rapid spread and growth of Pentecostal revivalism and fundamentalism in general. See George Marsden, *Understanding Fundamentalism and Evangelicalism* (Grand Rapids: Eerdmans Publishing, 1991) and Nancy T. Ammerman, "North American Protestant Fundamentalism," in Martin E. Marty and R. Scott Appleby, *Fundamentalisms Observed* (Chicago: University of Chicago Press, 1991).

8. Knowing which prophecies were true and which were false was a constant problem the church leaders faced. This was especially difficult concerning prophecies of the Coming End. While everyone in our church believed in some form of premillennial dispensationalism, there were widely differing opinions about when the Rapture and Second Coming would actually occur. Would it come before, during, or after the seven years of Tribulation prophesied in scripture? No one knew, and those who claimed to know were viewed with suspicion. Thus, while the question of when exactly the parousia would occur was taken quite seriously and deemed important, differing views were tolerated and exchanged. My own fantasies and fears focused on a post-Tribulation scenario, where we would be taken up to heaven only after seven years of trials, temptations, and persecution.

9. The Fordist/post-Fordist divide is widely debated. For a critical summary of the theoretical work which undergirds this perspective, the work of the so-called Regulation School, see Robert Brenner and Marc Glick, "The Regulation Approach: Theory and History," in *New Left Review* 188, pp. 45–120.

10. For a useful and lucid explanation of the processes of capitalist economic growth and decline and their regional effects, see Michael Storper and Richard Walker, *The Capitalist Imperative* (London: Blackwell, 1989).

11. For a brilliant socio-economic history of American life in the 1970s, see Mike Davis's *Prisoners of the American Dream* (New York: Verso, 1986), ch. 5.

12. At the time of this writing, Norma McCorvey (the Jane Roe of *Roe v. Wade*) has made national headlines for her decision to convert to a charismatic Christian faith. Her ill-treatment at the hands of middle-class feminists, due to her background as "poor white trash," is well known. Is she in some way responding to the silent call within Pentecostalism to fight the values and ideologies of middle-class mainstream America?

13. Of course, the very real and overwhelming prospects of nuclear holocaust hovered over all of these

events. The threat of nuclear apocalypse, made possible in large part by the rampant militarization which characterized U.S. economic policy in the 1950s and 60s, continued throughout the 1980s. On the relation of Cold War politics and nuclearism to apocalyptic themes in U.S. culture, see Strozier, pp. 66–74 and passim.

14. For a classic study of the effects of and responses to deindustrialization in a rural community, see John Gaventa, *Power and Powerlessness: Quiescence and Rebellion in an Appalachian Valley* (Urbana: Illinois, 1980).

15. Of course, we never considered ourselves trash. Trash is always in the next town over, where people keep broken-down cars and washing machines in their front yards. But, as a community ringed by many wealthier townships, we were often viewed as a "trashy little factory town" by outsiders.

16. I say, "in part" because I know that my experiences are not reducible to mere reflections of larger economic structures. Our struggle and resistance were waged against cultural, political, and social, not just economic forces. In that struggle our identities were continuously made and remade.

17. An earlier version of this essay appeared in *Bad Subjects: The Apocalypse Issue* (Berkeley, California, 1994). This essay would not have been written without the benefit of many conversations with my teachers Doug Frank, John Linton, Susan Harding, and Annalee Newitz. Their clarity and insight into my visions of the End helped make it possible for me to rethink my past and reimagine my future.

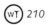

Telling Stories of 'Queer White Trash'

> The stories I told about my family, about South Carolina, about being poor itself, were all lies, carefully edited to seem droll or funny.
>
> — *Dorothy Allison*[1]

> It's the dirtiest secret of the lesbian community, the only thing that no one wants to talk about. . . And it's the one thing that threatens us—individually and collectively—more than any other issue in our community. Class.
>
> — *Victoria Brownworth*[2]

RACE, CLASS, AND SEXUALITY IN THE WORK OF DOROTHY ALLISON

JILLIAN SANDELL

S torytelling is an important way in which we make sense of the world and our place within it. Because they are always grounded in communities of memory that are socially, culturally, and historically formed, stories are only meaningful within the context of a community of people who can hear and understand them. While the rite of storytelling is not a recent invention, a form of storytelling that *is* particular to contemporary Western culture is the trend to tell stories about one's personal life—stories that, when told, are presumed to enable and foster the creation of social and political communities. Indeed, as Ken Plummer writes in his recent book, *Telling Sexual Stories*:

> Stories need communities to be heard, but communities themselves are also built through story tellings. *Stories gather people around them.* . . . Stories help organize the flow of interaction, binding together or disrupting the relation of self to other and community. Rape stories, coming out stories and recovery stories feed upon and into community—shifting the spheres of what is public and private, secret and known about [emphasis in original].[3]

For Plummer, stories of coming out or recovery share a basic narrative structure of suffering, surviving, and surpassing. In order for these stories to be successful, moreover, there must be social worlds embodying community support to receive them.[4] Even though Plummer is primarily interested in stories about sex, his formulation is useful for other stories, since, as he argues, all stories share the fact that they are "social actions embedded in social worlds."[5]

Despite the proliferation of personal storytelling in recent years, and the shift in social conditions that has facilitated these stories being told and heard, there are still certain stories that *cannot* be told—either because we have no language with which to articulate them or because there is no interpretive community to hear and understand them. These stories become, instead, secrets and lies—stories that signal social isolation and disempowerment rather than connection and strength. One such story within contemporary culture, as the epigraphs from Dorothy Allison and Victoria Brownworth suggest, is the story of class—a story that often only becomes tellable as a lie, joke, or dirty secret. This is especially the case with the category of "white trash." Indeed, as David Reynolds argues, while the white trash character is deeply engrained in the American literary consciousness, it is a character frequently made accessible either through the trope of "the grotesque" and/or through humor. In Erskine Caldwell's *Tobacco Road* (1932), for example, the spectacle of depravity was offset by its comedic tone.[6] Films such as Andy Warhol's *Trash* and John Waters' *Pink Flamingos*, and television's *Roseanne* similarly satisfy the twin impulses of desire and denial that lies and jokes typically solicit. Some stories about class are easier to tell, in other words, when couched in terms of humor, irony, or deceit.

Dorothy Allison thus provides an important couterpoint to this problematic because of the ways she consciously engages with the "lies," "jokes," and "secrets" circulating about impoverished white in the United States. Writing from the perpsective of her (self-named) identity as "queer white trash," Allison's essays, short stories, poems, and best-selling novel *Bastard*

Out of Carolina depict "white trash" life as being characterized by violence, poverty, hardship, and a pervasive sense of hopelessness.[7] Her work refuses the usual distinction between the "good poor"—the romanticized vision of the noble, hardworking, and undeserving as found, for example, in James Agee's *Let Us Now Praise Famous Men* (1941)—and the "bad poor"—the lazy, ungrateful, and grotesque of Caldwell's *Tobacco Road*. Allison tempers her portrayal of poverty with the strength and courage of her characters and family members, while also showing their flaws and mistakes. Indeed, as Amber Hollibaugh writes of *Bastard Out of Carolina*, "[it] defies our terrible amnesia and confusion about poverty, gender and race."[8]

In a culture that promotes storytelling and the confessional narrative to almost hyperbolic proportions, the fact that stories about impoverished whites have been virtually *un*tellable suggests a profound collective anxiety about what such narratives might reveal. Lies, secrets, and jokes operate, after all, as a form of displacement—either in terms of the content of the story or the teller's feelings about that content. As such, it is interesting that the one forum in which stories about class *have* been able to be told and heard is as commodities to be consumed within the marketplace. Certainly, commodities satisfy needs and desires, but they do so at the price of masking the human and economic relations that create the commodity. Commodification operates, in other words, as another form of displacement, but one that—unlike jokes and secrets—has a public and legitimate place in the market economy.

That Brownworth's article on class and economics appeared in *Deneuve*, a glossy lesbian magazine pitched at middle-class women, underscores the fact that the issue of displacement vis-à-vis class stories operates at the level of both production and reception. Thus, while the popular imaginary of the United States has proven largely unable to address or challenge oppression based on economic inequality, the widespread acclaim of Allison's *Bastard Out of Carolina* demonstrates that people have no such difficulty in consuming and enjoying stories about class in the marketplace. To put it another way, issues of economic marginality can be tolerated and articulated within the logic of liberal pluralism, so long as they can then be circulated as cultural, rather than economic, issues. Indeed, capitalism has proven to be notoriously efficient in its ability to recuperate radical ideas and turn them into commodities to be consumed within the market economy. By turning the experience of class-based oppression into stories that

are circulated in the marketplace, the act of articulation (rather than the issue itself) becomes the object of cultural consumption. Certainly, this kind of recuperation is one way ideas are made meaningful and audible within the social economy, but since the visibility and circulation of commodities relies upon the *in*visibility of the labor that creates them, the buying and selling of class narratives runs the risk of remystifying precisely those social and economic relations they aim to expose. The threatening aspect of class that Brownworth articulates, therefore, suggests that its divisive potential operates at the level of political communities rather than cultural stories.

If the telling of stories as a strategy for social change is successful only so long as there is a community to hear that story, the commodification and recontainment of class issues as a story to be consumed in the marketplace presents a troubling scenario. While the economic reality of class status is not interchangeable with representations of it, the discursive and social formations of class identities are, nevertheless, related. Although Allison's *Bastard Out of Carolina* engages with the issue of impoverished whites, it does not, for example, alleviate class oppression, or even necessarily challenge the status quo. Such a situation is typical of many marginalized groups in the United States, for whom the marketplace frequently offers a limited, but contained, space within which to articulate some measure of resistance to the dominant social order and to form communities. In the context of their work on minority discourse, for example, Abdul JanMohamed and David Lloyd argue that while the market economy of liberal pluralism "tolerates the existence of salsa, it even enjoys Mexican restaurants, . . . it bans Spanish as a medium of instruction in American schools."[9] In a rather more celebratory tone, Michael Warner argues that market relations have been constitutive in the formation of queer communities, writing that "[i]n the lesbian and gay movement, to a much greater degree than in any comparable movement, the institutions of culture-building have been market-mediated: bars, discos, special services, newspapers, magazines, phonelines, resorts, urban commercial districts."[10] Clearly, it is imperative to think critically about whether marginalized groups having access to the marketplace constitutes a form of resistance or whether it simply means substituting consumerism for politics. To the extent that commodity culture can be productive of meaning, however, such a process should not be rejected out of hand. The proliferation of stories about class-based oppression suggests that such stories provide a language with which to articulate these

experiences and an interpretive community to hear them, albeit a community organized primarily (although, as I will later suggest, not exclusively) around consumption.

The problem, however, is that discursive representations can sometimes serve to remystify the hegemonic relations of exploitation and oppression in society so that, within the circuit of capitalist exchange, the telling and hearing/reading of stories is seen as a replacement for concrete economic and political change. The displacement between consuming a narrative and participating in a community becomes collapsed by producers and consumers alike into interchangeable acts. This slippage between the discursive and the socio-economic means that the production of cultural stories often treads a fine line between, on the one hand, being complicit with hegemonic ideology and, on the other, being a form of liberating practice.[11]

With this in mind I want to interrogate the status of Dorothy Allison as a figure of "queer white trash" in America and investigate the extent to which her storytelling operates both hegemonically and as a liberating practice. Although "white trash" had often been used as a term of degradation and shame, Allison resists this position, arguing that shame implies that poverty only happens to people who deserve it. She describes her project in *Bastard Out of Carolina*, for example, as being:

> To tell the truth and to pay homage to the people who helped to make me the person I've become.

> I show you my aunts in their drunken rages, my uncles in their meanness. And that's exactly who we are said to be. That's what white trash is all about. We're all supposed to be drunks standing in our yards with our broken-down cars and our dirty babies. Some of that stuff is true. But to write about it I had to find a way to pull the reader in and show you those people as larger than that contemptible myth. And show you *why* those men drink, *why* those women hate themselves and get old and can't protect themselves or their children. Show you human beings instead of fold-up, mean, cardboard figures [emphasis added].[12]

Allison reclaims, therefore, the label "white trash" as a political strategy to expose class-based discrimination in the United States and to emphasize the structural, rather than volitional, nature of economic oppression. She also calls herself "queer" to reclaim those aspects of her identity that have defined her as marginal among lesbians, and to emphasize the social (as well as sexual) aspects of such an identity:

> I use the word queer to mean more than a lesbian. Since I first used it in
> 1980 I have always meant it to imply that I am not only a lesbian but a
> transgressive lesbian—femme, masochistic, as sexually aggressive as the
> women I seek out, and as pornographic in my imagination and sexual
> activities as the heterosexual hegemony has ever believed.[13]

Allison writes that much of the hatred that has been directed at her sexual preference is really class hatred, and vice versa, which underscores the ways in which both her sexuality and her class status are constructed as falling outside the normative (and overlapping) moral orders of the middle-classes and the queer community. While work such as that by Allison can and does articulate connections between individual experience and the wider social context, they do not always articulate a direct relationship between the "real" and the "represented." To get at this relationship, literature can be read symptomatically as a place in which the repressed of culture gets acted out, operating, therefore, as another form of displacement within communities of storytellers and audiences. The commercial and critical success of *Bastard Out of Carolina* suggests, for example, a profound collective desire to engage with the issue of impoverished whites in the United States, while at the same time it suggests a form of disavowal that keeps such issues at arm's length—class issues become safely located in books and popular culture to be consumed as a leisure activity.[14] Since Allison is often claimed as "queer" rather than as "white trash," this acts as another form of displacement since sexuality is even more commodified in contemporary United States than is class. Within a capitalist mode of economic relations, talking about sexuality is often easier than talking about class because the semiotic markers, language, and consumer goods that can signify such identities are more accessible.

Indeed, Allison herself writes about the ways in which the contradictory impulses of desire and denial that accompany any form of displacement shaped her own understanding of class and sexuality. She says there was a period, for example, when the only way she could survive was to compartmentalize the separate aspects of her life and attempt to blend in with whichever community she was currently part of. As she later admits, however, blending in and compartmentalizing her life demanded that certain other aspects of her past be forgotten—some stories, in other words, had to remain untold and unheard. As she writes:

> often I felt a need to collapse my sexual history into what I was willing to
> share of my class background, to pretend that my life both as a lesbian and

as a working-class escapee was constructed by the patriarchy. Or conversely, to ignore how much my life was shaped by growing up poor and talk only about what incest did to my identity as a woman and as a lesbian. The difficulty is that I can't ascribe everything that has been problematic about my life simply and easily to the patriarchy, or to incest, or even to the invisible and much-denied class structure of our society.[15]

Allison's earliest adult encounters with public storytelling were within Atlanta's middle-class feminist community, which she joined after first leaving South Carolina. She has said in interviews that speaking out about her background and about being poor saved her life, making her feel like a "human being instead of a puppet."[16] During the 1970s and 1980s Allison worked for the feminist magazines *Quest* and *Conditions*, which were committed to publishing personal stories by and about women. The economic reality of feminist writing meant that she rarely got much of her own creative writing done and instead spent most of her time writing grant proposals and trying to raise money. When she did begin writing, Allison says that many feminists regarded fiction as a "crime." The goal for women, and especially lesbians, was to instead "tell the truth" and keep it "real."[17] While she agreed that personal narratives and "truth telling" work well at an individual level, Allison decided that stories told "in a crafted, intended way" had more potential in their power to transform the world.[18] She remains committed to narratives of "self-revelation," however, and sees them as an important aspect of political activism.[19] As both a writer and an activist, Allison has explored the ways in which class, race, gender, and sexuality (re)inscribe each other in identity construction, arguing that "class, gender, sexual preference, and prejudice—racial, ethnic, and religious—form an intricate lattice that restricts and shapes our lives."[20]

Allison has said that in *Bastard Out of Carolina* she was trying to perform what Minnie Bruce Pratt calls "practicing memory." She uses the narrative form as a safe space to hold culturally specific memories and family stories. For Allison, then, writing *Bastard Out of Carolina* was both a political act to engage readers with society's "biggest secret"—its deep-rooted classism—and a personal act, motivated by a desire to recollect her family stories and pay tribute.[21] Taking memories as a starting point, Allison then expands upon them through the novel's protagonist—and bastard of the title—Ruth Anne "Bone" Boatwright. Indeed, *Bastard Out of Carolina* tells the story of how Bone, who is beaten and raped by her stepfather Daddy Glen and later deserted by her mother Anney Boatwright, nevertheless finds strength in

her extended family of aunts and uncles and is able to survive and surpass the physical, sexual, and psychological abuse she experiences. Allison has also said that is was a book she "had to write," saying that "it's not a lesbian coming-of-age story, not a charming portrait of growing up poor in the South of the fifties and sixties. Rather it is a frankly harrowing account of family violence and incest."[22]

Allison uses the trope of storytelling in the novel to deconstruct the notion of coherent and stable identities and communities, and to explore identities that fall outside of the normative, white, heterosexual matrix. *Bastard Out of Carolina* addresses the ideologies of social identities and the ways in which individuals become interpellated by them. Since interpellation works when an individual hears and recognizes a cultural story and understands his or her place within it, this becomes a way in which Allison is able to emphasize a relational sense of identity. Her work articulates, in other words, the fact that subject-positions are always constructed within the context of human, social, and economic relations and stories. In this way, storytelling becomes for Bone a way to understand her place within the Boatwright family community. Staying with her Aunt Ruth in the weeks before she died, Bone is told stories "about things that had happened long before I was born and [that Ruth] imagined no one had told me yet." Determined that Bone should know all the stories, her Aunt Ruth "talked continuously," anxious that Bone should understand who her people were and what they had done.[23]

Allison's emphasis on storytelling also demonstrates how meanings and histories are always both relational and contestable. There is no single truth, only versions of the truth. As Bone says of her grandmother, "she would lean back in her chair and start reeling out story and memory, making no distinction between what she knew to be true and what she had only heard told."[24] For Bone the telling of stories—whether true or false—is also a way for her to feel like she is part of the family. When she tries to find out more about her father, for example, she says, "It wasn't even that I was so insistent on knowing anything about my missing father. I wouldn't have minded a lie. I just wanted the story Mama would have told."[25] Indeed, as Ann Ross argues, when Bone moves to a new school and tells her teacher that she is Roseanne Carter from Atlanta, even though she is lying about who she is and where she is from, "to speak her name would render an equally fictitious story from the community; a story of white trash, violent and stupid

and ill-bred folk."[26] The Boatwrights all engage in a particular form of storytelling that disabuses the easy distinction between truth and lies: "I could never be sure which of the things [Granny] told me were true and which she just wished were true. . . All the Boatwrights told stories, it was one of the things we were known for, and what one cousin swore was gospel, another swore just as fiercely was an unqualified lie."[27]

By engaging with cultural narratives about family and identity in this way Allison affirms the possibility of recreating alternative identities through discursive practices. Family identities that are constructed to appear as natural only maintain the illusion of coherence because of what they exclude. Most of *Bastard Out of Carolina*, for example, concerns the Boatwright family, yet we learn that their sense of identity as white trash has less to do with some innate quality they share than it does with the comparison drawn between, on the one hand, the Boatwrights and, on the other hand, the Waddells and Pearls. Daddy Glen's family, the Waddells, are middle-class and reject Glen because he married Bone's mother. Yet, as Bone articulates, their difference from the Boatwrights has to do with both their economic position and their attitudes and beliefs. "It was not only Daddy Glen's brothers being lawyers and dentists instead of mechanics and roofers that made them so different from the Boatwrights. In Daddy Glen's family the women stayed at home."[28] The Waddells also smoke cigarettes in the bathroom or kitchen, "pretending the rest of the time they didn't have any such dirty habits."[29] As such, Bone articulates the shifting and multiple understandings of "class" that circulate within the United States. Class can mean, in other words, the relationship to the means of production (either working for wage labor or for a salary); it can refer to crude income levels (the rich and the poor); or it can mean a set of values either held by a class of people or assigned to them. Bone's insights about the Waddells' economic identity underscores the complicated nature of "white trash" as an economic identity—that it refers not only to poverty and non-ownership of the means of production, but also to a set of behaviors that, in turn, become a signifier of economic status.

The shame Glen feels in relation to his family of birth has, however, as much to do with his inability to provide for his family as it has to do with the fact that Anney, his wife, works. Since Glen desperately wants a son but Anney is unable to bear his child, his sense of failure is related both to his inability to be middle-class and his inability to be (what he considers)

appropriately masculine. His solution is to take his family further and further away from the Boatwright clan (thereby destroying Anney's support network), as if being away from that which defines him as a failure will allow him to recreate his sense of identity.

Daddy Glen's violence toward Bone is both sexual and physical in nature, and is intimately tied up with his feelings of inadequacy about his class status. Allison underscores the complicated relation between sexuality and violence in the masturbatory fantasies Bone has about being beaten by Daddy Glen:

> My fantasies got more violent and more complicated as Daddy Glen continued to beat me with the same two or three belts he'd set aside for me. . . .

> I was ashamed of myself for the things I though about when I put my hands between my legs, more ashamed for masturbating to the fantasy of being beaten than for being beaten in the first place. I lived in a world of shame. I hid my bruises as if they were evidence of crimes I had committed. I knew I was a sick disgusting person. I couldn't stop my stepfather from beating me, but I was the one who masturbated. I did that, and how could I explain to anyone that I hated being beaten but still masturbated to the story I told myself about it?

> Yet, it was only in my fantasies with people watching me that I was able to defy Daddy Glen. Only there that I had any pride. I loved those fantasies, even though I was sure they were a terrible thing. They had to be; they were self-centered and they made me have shuddering orgasms. In them, I was very special. I was triumphant, important. I was not ashamed. There was no heroism possible in the real beatings. There was just being beaten until I was covered in snot and misery.[30]

Sex and power remain linked in Bone's fantasies, and the fantasies become a safe space within which she can confront and overcome Daddy Glen. Indeed, this is one of the places in *Bastard Out of Carolina* where Allison uses not just the trope of storytelling to empower Bone but specifically the trope of therapeutic recovery. The language of therapy is, after all, one of the ways in which we learn to tell stories about shame and trauma. Bone's fantasy about her abuse is more than a symptom, therefore, since it contains an articulatable narrative. Indeed, as Judith Herman and others have suggested, remembering and telling stories about traumatic events is essential both for the restoration of the social order and for the healing of individual victims.[31] Bone's therapeutic narrative remains, however, an individual coping strategy since she has no interpretive community to hear and understand her story. The link between sexual abuse and sexual pleasure

acts, moreover, as another form of displacement for her anxiety about her relationship with Daddy Glen. Since the Boatwright history is buried in this kind of secrecy and shame, Bone's attempts to collect stories about her family and make them heard demonstrates her desire to restore and heal both her own life and the social order.

As is common in situations of child abuse, Glen forces Bone to remain silent about the abuse but

> He never said "Don't tell your mama." He never had to say it. I did not know how to tell anyone what I felt I could not tell Mama. I would not have known how to explain why I stood there and let him touch me. . . . Worse, when Daddy Glen held me that way, it was the only time his hands were gentle.[32]

Even though Bone wants to have access to the stories of other members of her family, she is, herself, unable to speak to anyone of Glen's abuse. She becomes trapped in the shame and secrecy that has constituted so much of the Boatwright history. The complicated relation between sex and power is here portrayed in graphic relief so that Bone's silence, and the eroticization of Glen's violence, are seen to be an understandable, if ultimately unhealthy, coping strategy.

Secrets only work, however, as long as people keep them, and once Bone's Aunt Raylene discovers the bruises and scars on her legs and realizes that Glen has been beating and raping her, the stories Bone has been telling herself about her abuse can no longer be sustained. As she says; "Things come apart so easily that have been held together with lies."[33] The stories Bone's mother has been telling herself about Glen's violence also fall apart. Even when she says to Bone, "I never thought it would go the way it did. I never thought Glen would hurt you like that," Bone still wants to protect her. "I wanted to tell her lies, tell her that I have never doubted her, that nothing could make any difference to my love for her, but I couldn't. I had lost my mama."[34] Ultimately, Anney has to choose between Glen—who she still loves in spite of herself—and Bone, and she chooses Glen. Such a decision, however, must be understood, at least in part, as a need for economic survival. Notions of "choice," in other words, must be understood within the context of larger social and economic relations. Indeed, the fact that Anney's need for Glen is both psychological and economic is articulated by Alma, Anney's sister, when she says, "[she] needs him like a starving woman needs meat between her teeth."[35] In choosing Glen over Bone it is Anney

who most vividly embodies James Baldwin's quote (used as the epigraph for *Bastard Out of Carolina*) "People pay for what they do, and still more, for what they have allowed themselves to become. And they pay for it simply: by the lives they lead." Ending *Bastard Out of Carolina* with Anney betraying Bone was, however, a conscious strategy of Allison's to expose the lies women often tell themselves about loyalty among women: "Pretending that our mothers do not fail us, pretending that our mothers do not literally betray us, just puts a gloss over this gaping wound which allows it to lie there and fester the rest of your life. You'll never get out of it, you'll never get over it."[36] Indeed, the original ending had Anney and Bone together kill Glen. But, Allison says, her lover and her agent both told her that the heroic ending was not as powerful.[37]

Bastard Out of Carolina has received almost exclusively favorable reviews in both the mainstream and alternative presses and was mentioned in "best of" lists for 1992 and 1993 in publications as diverse as *Library Journal*, *New York* Magazine, *The New York Times Book Review*, *The Progressive*, *Publishers Weekly*, *The Times Literary Supplement*, and *The Voice Literary Supplement*. This diverse and positive reception suggests that Allison's appeal is not limited to those communities she represents in her book, and that people from "non-white trash" backgrounds enjoyed, and valued, her stories. As bell hooks has written, however, "it is not the work of cultural critics to merely affirm passively cultural practices already defined as radical or transgressive [but to] cross boundaries to take another look, to contest, to interrogate, and in some cases to recover and redeem."[38] It is imperative, therefore, to carefully examine Allison's work in relation to the social contexts from which her stories are produced and within which they are consumed. Indeed, Allison herself acknowledges the potential problems in achieving mainstream success, commenting after her nomination in 1992 for the National Book Award, "I worry sometimes that if the big boys notice me that maybe it isn't because I'm doing something right, but because I'm doing something wrong."[39] To that end, it is essential to interrogate what is at stake in the success of *Bastard Out of Carolina*, and, correlatively in the relative marginalization of Allison's other work—her short stories, essays, and poems. Does the success of *Bastard Out of Carolina* signify, in other words, the recuperation of its radical content, or, does literature have, as Allison suggests, "the power to transform"?[40]

Certain aspects of Allison's work have become occluded in different contexts, so exploring how her works have been received by mainstream and marginal audiences provides an opportunity to examine the limited vocabulary currently available to talk about class in the United States. Reviewers of *Bastard Out of Carolina* who focus on Allison's identity as white trash, for example, frequently obscure questions of gender and sexuality. Similarly, reviews of Allison's essays and short stories frequently emphasize her gender and sexuality at the expense of race and class. Indeed, one reviewer of *Skin* explicitly criticized Allison for not talking about race, thereby reiterating the problematic notion that whiteness is some sort of unmarked, unracialized category.[41] Allison's work articulates, however, the extent to which no one element of an identity—whether class, sexuality, gender, or race— can be understood except in relation to the others. To try to separate them is to always experience a sense of alienation. *Bastard Out of Carolina*, for example, was received primarily as a novel about southern working-class families, although many of the reviewers also emphasized the issue of sexual abuse. Allison's other work, on the other hand, despite covering similar territory to that addressed in *Bastard*, has been almost universally claimed as books about and for women. While this is, no doubt, in part because all her other books are published by feminist presses, the reception of these other works in the mainstream press suggests it would be true even if she had published elsewhere. Publishing magazines such as *Choice*, *Publishers Weekly* and *Library Journal*, for example, recommended *Bastard Out of Carolina* for general fiction collections but her other works for women's studies and lesbian studies collections. When *Bastard Out of Carolina* is categorized as a queer text, it is typically because Allison herself is lesbian (and, therefore, the book is presumed to be of interest to other queer people) rather than a perception that the book is "about" lesbians per se.[42] For Allison, however, "[*Bastard Out of Carolina*] is not a lesbian novel, it's a working-class novel. But it's *about* a lesbian, there is certainly the aspect of that hidden reality there."[43]

Allison's short stories in *Trash* have similarly had a mixed reception. While most reviewers agree that the stories are concerned with the overlap between sexuality and violence, one reviewer claimed it as lesbian erotica while others understood it more accurately to be about sexual abuse.[44] Indeed, the stories in *Trash* are explicitly about Allison's experiences of violence—the violence of poverty, and the violence of physical and sexual

abuse—and how these experiences shape her understanding of her own, and other women's, lesbian identity. These stories also employ the theme of lies and storytelling that is used to such powerful effect in *Bastard Out of Carolina*. In "River of Names," for example, she writes:

> Jesse and I have been lovers for a year now. She tells me stories about her childhood, about her father going off each day to the university, her mother who made all the dresses, her grandmother who always smelled of dill bread and vanilla. . .
>
> "What did your grandmother smell like?"
>
> I lied to her the way I always do, a lie stolen from a book. "Like lavender," stomach churning over the memory of sour sweat and snuff.
>
> I realize I do not really know what lavender smells like, and I am for a moment afraid she will ask something else, some question that will betray me.[45]

This lie about Allison's grandmother also underscores the ways in which gender, sexuality, and class intersect in their relationship to the body and to memory. Allison's anecdote articulates, in other words, a specifically gendered, as well as classed, fantasy. Later, in "Monkeybites," the lies are explicitly related to the different stories lesbians tell each other about sex and love. Describing an affair she had in college with a woman who considers her a "Southern dirt-country type," Allison writes, "

> Sometimes when I wanted to make her feel good, I would make my own eyes widen, intensify my gaze, and give her the look of love she was giving me at that moment. For me it was lust; only in her eyes did it become love. . . "Love," Toni whispered. "Sex," I told myself.[46]

While Toni wants commitment, connection, and love, Allison's sexual desires are passionate but also violent. The class-based assumptions of appropriate lesbian sexuality are made even more explicit in "Her Thighs," when Allison's lover, Bobby, seeks to tame her desire for passionate sex.

> Bobby believed lust was a trashy lower-class impulse, and she so wanted to be nothing like that. Bobby loved to fuck me. Bobby loved to beat my ass, but it bothered her that we both enjoyed it so much. . . .
>
> Bobby loved the aura of acceptability, the possibility of finally being bourgeois, civilized, and respectable.
>
> I was the uncivilized thing in Bobby's life.[47]

Allison articulates here how the discourses of class are linked to the discourses of proper sexuality and reminds the reader of the stories lesbians tell themselves about how they are, and how they should be.

For Allison, her queer identity is not only related to her white trash identity, but it is what enabled her to see her life differently and tell stories about it:

> If I wasn't queer, I wouldn't be a writer. I'd live in a trailer park. Probably in Greenville, South Carolina. I would probably have six kids. I would probably beat them. I would probably drink. I would probably be dead. I'm forty-three. In my family that's a long time to live. I think that being a lesbian gave me the possibility to see my life in different terms.[48]

By the same token, however, being a lesbian writer at this point in time is, as Allison suggests, almost by definition to be poor.[49] For her, then, it is impossible to separate her identities as a writer, as queer, and as white trash. She says of her time in New York, "The real work of my life was writing and trying to piece out what it meant to be the expatriate Southern lesbian in a place that barely tolerated queers."[50] Indeed, Allison embraces the term "queer" as an inclusive term that can accommodate marginality from realms other than that of the sexual. "They knew I was queer," she says in an interview, "I was weird. That's what my family thought of it——Dorothy's weird."[51] And in another article she suggests that it was her interest in books, as much as her sexuality, that made her feel "really queer" among her family. Her outsider status was confirmed, moreover, by being the first in her large family to finish high school.[52] Even though Allison received for *Bastard Out of Carolina* the largest publisher's advance ever given to a lesbian writer, "largest" is a relative term, and the $37,000 she received was her entire income for three years.[53] Few writers, and especially lesbian writers, can make a living from writing, and Allison is not unusual in having taken many other jobs to support herself.

Allison's writing and activism as a working-class lesbian is part of a tradition that has, until recently, been largely ignored. Recent works such as Joan Nestle's *Restricted Country* (1987), Lillian Faderman's *Odd Girls and Twilight Lovers* (1991), Madeline Davis and Elizabeth Kennedy's *Boots of Leather, Slippers of Gold* (1993), and Leslie Feinberg's *Stone Butch Blues* (1993), as well as Audre Lorde's earlier *Zami* (1982), argue, like Allison's work, that working-class women have always existed within lesbian culture; they have just not always been acknowledged as being there.[54] Indeed, working-class women were among the first who came out and established

the "bar-dyke" scene that constituted much of the early urban queer cul-
ture in the United States, thereby reiterating Warner's contention that mar-
ket relations and public consumer culture has been instrumental in the
formation of the queer community.

Certainly, the proliferation of stories about class and economic oppres-
sion within consumer culture do run the risk of operating hegemonically by
being made available and circulated as commodities within the marketplace.
Since commodities are one of the ways in which desire is organized in con-
temporary culture, even when non-normative identities are recuperated
within the market economy their circulation can suggest the kinds of collec-
tive social fantasies such commodities might satisfy. But by claiming identi-
ties like "white trash" and "queer," which have become, at least in part,
commodities rather than signifiers of economic and sexual oppression, is
Allison complicit in the displacement of classism and homophobia onto the
realm of consumer culture?

Consumer culture promises a sense of fulfillment through personal
strategies but cannot change society—it merely displaces feelings of alien-
ation and unhappiness into the realm of individual acts of transformation.
Indeed, participating in the marketplace is often perceived to be a stand-in
for collective social change. Certainly white trash has become, in many
ways, a commodity associated with a particular kind of clothing and style.
But while Allison's stories circulate as books and essays—as commodities, in
other words—the community of readers she creates is one based, at least in
part, on the telling and sharing of stories. Indeed, a community based on
shared stories (even when sharing those stories requires participation in con-
sumer culture by buying the books) does not require forging an identity on
those acts of consumption. As Plummer suggests, moreover, the sharing of
stories can break down or challenge—rather than reinforce—the public/pri-
vate distinction upon which both capitalism and class relations rest. While
many stories about white trash have, until now, participated in a scape-
goating function—displacing the ills of society *onto* white trash—by writing
from the perspective of queer white trash Allison challenges this stereotype.
She has said, moreover, that writing her stories affirmed her ongoing desire
to live and was her way of resisting the "ocean of ignorance and oblitera-
tion."[55]

Ultimately, while Allison's work certainly contains the possibility of recu-
peration, it *can* operate as a political strategy. Popular consumer culture sat-

isfies very real social and political desires and, as Warner and others have suggested, enables the formation of alternative communities for marginalized groups. Stories can and do exist outside of the realm of the commodity, and a community based on the production and consumption of stories can facilitate discursive and social change. Allison's use of the trope of storytelling, for example, is not simply a postmodern strategy to destabilize and deconstruct notions of truth and fiction since she *is* clearly describing a reality of poverty, child abuse, and rape. There is, in other words, a "real world" that Allison addresses and that exists as the realm within which her work is consumed. Indeed, the interactive nature of storytelling as cultural intervention and political praxis is evident in the extent to which reviewers of Allison's work will confess their own white trash or queer identity when writing about her work. Reviewers clearly felt affirmed in reading about people similar to themselves.[56] While it may not be catalogued in the same way, presumably readers often have the same experience. In the end, acknowledging that class-based oppression exists, creating a language with which to speak of it, and fostering a supportive community to hear such stories are, as Allison suggests, all important in the battle to overcome economic injustice.[57] To that end, the work of Dorothy Allison constitutes a major contribution to the urgent political project of critiquing and dismantling the oppressive system of class relations in the United States.

------------------------------ NOTES

I would like to thank Sharon Marcus, Annalee Newitz, and Matt Wray for their helpful comments on earlier versions of this article.

1. Dorothy Allison, "A Question of Class," in *Skin: Talking About Sex, Class and Literature* (Ithaca: Firebrand, 1994), 22.

2. Victoria Brownworth, "Class Conscience," in *Deneuve*, July/August 1994, 19.

3. Ken Plummer, *Telling Sexual Stories: Power, Change and Social Worlds* (London: Routledge, 1995), 174.

4. Ibid., 16.

5. Ibid., 17.

6. David Reynolds, "White Trash in Your Face: The Literary Descent of Dorothy Allison," *Appalachian Journal* 29:4 (Summer 1993), 360–61.

7. Dorothy Allison, *The Women Who Hate/Me* (New York: Long Haul Press, 1983); *Trash* (Ithaca: Firebrand, 1988); *The Women Who Hate/Me: Poetry 1980–1990* (Ithaca: Firebrand, 1991); *Bastard Out of Carolina* (New York: Plume, [1992] 1993); *Skin: Talking About Sex, Class and Literature*

(Ithaca: Firebrand, 1994).

8. Amber Hollibaugh, "In The House Of Childhood," *The Women's Review of Books* 9:10–11 (July 1992), 15.

9. Abdul JanMohamed and David Lloyd, Introduction, "Toward a Theory of Minority Discourse: What Is To Be Done?" in JanMohamed and Lloyd, eds., *The Nature and Context of Minority Discourse* (New York: Oxford University Press, 1990), 8.

10. Michael Warner, Introduction, in Michael Warner, ed., *Fear of a Queer Planet: Queer Politics and Social Theory* (Minneapolis: University of Minnesota Press, 1993), xvi–xvii.

11. cf. Arif Dirlik, "Culturalism as Hegemonic Ideology and Liberating Practice," in JanMohamed and Lloyd, eds., *The Nature and Context of Minority Discourse* (New York: Oxford University Press, 1990), 394–431.

12. Amber Hollibaugh, "Telling a Mean Story: Amber Hollibaugh Interviews Dorothy Allison," *The Women's Review of Books* 9:10–11 (July 1992), 16.

13. Allison, "A Question of Class," 23.

14. Indeed, since the desire for leisure is the story we tell ourselves to make work within capitalism seem fair, even the notion of leisure time operates as a form of denial about the material reality of class relations.

15. Allison, "A Question of Class," 15–16.

16. E. J. Graff, "Novelist Out of Carolina," *Poets and Writers* Magazine 23:1 (Jan./Feb. 1995), 43.

17. Brownworth, "Writer Out of Carolina," 46.

18. Graff, "Novelist Out of Carolina," 43.

19. Allison, "A Question of Class," 35.

20. Ibid., 23.

21. K. K. Roeder, "Carolina on Her Mind," *The San Francisco Review of Books*, April 1991, 21.

22. Vince Aletti, "Review: *Bastard Out of Carolina*," *The Voice Literary Supplement*, June 1992, 2.

23. Allison, *Bastard*, 121–26.

24. Ibid., 26.

25. Ibid., 31.

26. Ann M. Ross, *White Trash: Dorothy Allison and the Construction of the Working Class Subject* (San Francisco State: M.A. Thesis, 1993), 67.

27. Allison, Bastard, 53.

28. Ibid., 98.

29. Ibid., 102.

30. Ibid., 112–13.

31. Judith Lewis Herman, *Trauma and Recovery: The Aftermath of Violence—From Domestic Abuse to Political Terror* (New York: Basic Books, 1992).

32. Allison, *Bastard*, 108–109.

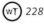

33. Ibid., 248.

34. Ibid., 306.

35. Ibid., 41.

36. Hollibaugh, "Telling a Mean Story," 16.

37. Graff, "Novelist Out of Carolina," 47.

38. bell hooks, *Outlaw Culture: Resisting Representations* (New York: Routledge, 1994), 5.

39. Victoria A. Brownworth, "Writer Out of Carolina: An Interview with Dorothy Allison," *The San Francisco Bay Times*, December 3, 1992, 46.

40. Graff, "Novelist Out of Carolina," 43.

41. Chrystos, "Moving Toward Truth," in *Sojourner: The Women's Forum*, November 1994, 8.

42. cf. Roy Olsen, "Out of the Closet and Into the Forum," in *American Libraries* 23 (June 1992), 536; Roy Olsen, "By Gays and Lesbians, For Every Library," in *Booklist* 88 (June 15, 1992), 1814; and Tamis Parr, "A Cornucopia of Lesbian Novels," *New Directions For Women* 22:3 (May/June 1993), 28.

43. Brownworth, "Writer Out of Carolina," 46.

44. Victoria A. Brownworth, "Review: *Trash*," in *The Lambda Book Report* 2 (May 1991), 13; Liz Galst, "Review: *Trash*," *The Women's Review of Books* 6 (July 1989), 15; Anonymous, "Review: *Trash*," in *Kirkus Reviews* 56 (Oct. 15, 1988), 1484; Roland Green, "Review: *Trash*," in *Booklist* 85 (Nov. 15, 1988), 537.

45. Allison, "River of Names," 13.

46. Allison, "Monkeybites," 89–90.

47. Allison, "Her Thighs," 119–21.

48. Hollibaugh, "Telling a Mean Story," 17.

49. Ibid., 16.

50. Dorothy Allison, "Looking For Home," *The San Francisco Bay Guardian Literary Supplement*, September 1994, 5.

51. Trish Thomas, "Under Dorothy Allison's Skin," *The San Francisco Bay Guardian*, July 13, 1994, 38.

52. Graff, "Novelist Out of Carolina," 42.

53. Brownworth, "Writer Out of Carolina," 46.

54. Madeline D. Davis and Elizabeth Lapovsky Kennedy, *Boots of Leather, Slippers of Gold: The History of a Lesbian Community* (New York: Routledge, 1993); Lillian Faderman, *Odd Girls and Twilight Lovers: A History of Lesbian Life in Twentieth-Century America* (New York: Columbia University Press, 1991); Leslie Feinberg, *Stone Butch Blues* (Ithaca: New York, 1993); Audre Lorde, *Zami: A New Spelling of My Name* (Freedom: The Crossing Press, 1982); Joan Nestle, *A Restricted Country: Essays and Short Stories* (Ithica: Firebrand Books, 1987).

55. Mary Hawthorne, "Born Out of Ignorance," *The Times Literary Supplement*, no. 4663 (Aug. 14, 1992), 18.

56. Hollibaugh, "In the House of Childhood," 15; Pamela Annas, "Down Home Truths," in *The*

Women's Review of Books, 1 (September 1984), 5–6; Jackie Cooper, "Review: *Bastard Out of Carolina*," in *The Lambda Book Report* 3 (May 1992), 42; Charles Wilmoth, "Hickory Switch Tough," *American Book Review* 14 (October 1992), 17; Leslie Feinberg, "Review: *Bastard Out of Carolina*," in *New Directions For Women* 21 (Nov./Dec. 1992), 29; Liz Galst, "Review: *Trash*," 15.

57. Brownworth, "Class Conscience," 21.

Acting Naturally

CULTURAL DISTINCTION
AND CRITIQUES OF
PURE COUNTRY

Barbara Ching

C ountry music has the fastest-growing audience in America, but it is still
rather scandalous for an intellectual to admit to liking it. Contemporary
cultural theory—which is to say cultural studies—has thus had practically
nothing to say about it. At first glance, it may seem that everything has
already been said. I know well enough that many people find country music
to be dumb, reactionary, sentimental, maudlin, primitive, and so forth. Still
others, perhaps influenced one way or another by the Frankfurt school,
sneer at what they feel is the contrived, hokey, convention-bound nature of
the music: they hear a commodification and cheapening of the same sup-
posed folksy authenticity that so disgusts the first type of critic. But the issue

is not just authenticity. Behind this issue lies the more sensitive and distinctly contemporary question of sophistication. Put bluntly, whether people question the authenticity of country music, or whether they feel the authenticity of it is too powerfully crude for them, they are often imagining some pitiful (but perhaps good-hearted) rube who happily sings along. And their bemused or puzzled reaction to intellectuals who actually like country music indicates that they want to preserve that image of the rural unsophisticate. The authenticity of the music, then, is seen as either impossibly degraded or impossibly innocent, but this double-binding condemnation never questions the authentic, uncultured "nature" of country music's benighted listeners. As such, they are either innocent pawns being debased or preserved by their music. Either way, "sophistication," an ironic and pleasurable confidence in, or allusion to, a high degree of cultural status is the one thing that this double bind of authenticity excludes.

In this essay, I will be talking about how country music re-presents, disseminates, and critiques this double bind of rustic authenticity, a double bind that also silently underlies many prominent theories of the postmodern condition. At the same time, I will be describing how the music itself explains why we need this particular countrified spectacle to love or to loathe.[1] While the sociological facts of the matter indicate that country music and its listeners are not limited to the rural backwaters of the South and West,[2] the music consistently portrays and addresses itself to a psychic geography that is at least metaphorically rustic. I know because I respond to this address: I'm from Dubuque—the classic hick town thanks to Harold Ross's refusal to edit *The New Yorker* for old ladies who happen to live there. Country music simply reverses Ross's logic. It thus situates its listeners in what Pierre Bourdieu has called a habitus: the life-space created by both the socio-economic determiners that form individual taste and the choices made by individuals based on their tastes.[3] But since the term cultural "tastes," with its allusion to a sensual, natural response, is easily conceived of as an innate rather than a socially constructed quality, those whose taste is "bad" seem to deserve their fate, while those with good taste seem to merit the distinction which the social order confers upon them. A similar logic is at work in the separation between country music lovers and haters. While not necessarily rural, country music listeners are not often found among the elite. Sociological research indicates that country music plays in the space of white Americans who are on the whole less educated

and hold low status jobs.[4] Although perhaps relatively privileged by virtue of its white skin, this is a population that lacks, again in Bourdieu's terminology, "cultural capital," a lack announced in a range of labels from the somewhat romanticized yet rustic "cowboy" to the more pejorative "bumpkin," "cracker," "hayseed," "hick," "hillbilly," "redneck," "rube," "simple folk," "yokel," and the name that includes most of the above, and strips away the euphemistic raillery of those other names: "white trash."

As a cultural phenomenon, then, country music can be heard as the music *chosen* by the unsophisticated. At the same time, the music itself expresses this group's lack of sophistication. In fact, country music often proudly signals its lack of sophistication—a quality that in its terms is decidedly contemporary and urban. But this skeptical picture of urbanity in itself is neither surprising nor interesting. Instead, what interests me is the critique of pure country that such skepticism can produce. The most flamboyant country music—the lyrics, the characteristic instrumentation and vocal techniques, and the stars of country music, taken together—often functions as a sly, even campy, announcement of the fact that it is a *performance* rather than a spontaneous expression of some pure emotion or state of being. In other words, country music is capable of performing the rural role in such a way as to underline its construction and social purpose rather than its presumed natural essence, innocence, and/or bad taste.[5] Instead of legitimating the cultural choices that create the distinction of the privileged, country music underlines the production and dubiousness of such distinctions. This is exactly what I like about it: rather than generating their message from an opposition between a rural immersion in *nature* and the artifices of an urban-based *culture*, many songs suggest that the rural persona is not at all natural although it may well be the "low other" that generates and defines urban sophistication.[6] (Garth Brooks' 1990 hit "Friends in Low Places" may be the quintessential expression of this sentiment.) Hence, country songs are often about being a hick, about being unable to participate in urban culture even while being bombarded by it. Country music songs are about why hicks—whether they be remote rustics or urban newcomers or perennially alienated city-dwellers—listen to country music.

Of course, theorists of the postmodern, Fredric Jameson, Susan Sontag, et al., have already implied that unselfconscious authenticity is no longer possible, but they're talking about the relatively high, and explicitly urban, cultural forms that embody this condition.[7] Nevertheless, some notion of

"rubedom," the corollary of a tortuous notion of authenticity, functions as one of the necessary and excluded opposites of this urbanity. When the subject of communing with nature and preserving the environment arises, this opposite may be mourned or praised. But many more overtly cultural expressions of a supposed unsophistication are simply unheard and invisible in descriptions of the post-modern condition. While most theorists of the postmodern argue that the boundary between high and low culture is increasingly blurred,[8] no theorist, as far as I know, has ever spoken of country music, although references to Mick Jagger, David Bowie, and David Byrne abound. In print, of course, critics rarely denounce country music; no one is quite so eager as they might be on my front porch to proclaim that there are still some cultural forms that are just too "popular" or low. Yet the silence that surrounds this very popular (in every sense of the word) music is telling. In order to measure what we've learned from Las Vegas, or from Paris, or even from the artful (and now taboo) contrivances of Pee Wee's Playhouse, we must imagine someone—poor unsophisticated soul—who remains untouched by contemporary culture. Preferably no one you know. Still, someone must be in Dubuque. Someone must be acting naturally.

So remote is country music from any of the most recent cultural analysis that for lack of a more contemporary vocabulary many of its advocates still talk about it in the traditional terms of the authentic versus the inauthentic. This dichotomy thus pervades the few available intellectual attempts to analyze country music for an audience of already enthusiastic readers. I've just given the categoric versions of the phony/real debate, but most sympathetic commentators on country music usually locate this dichotomy within the field of country music itself. Jimmie Rogers, for example, argues that the best-liked country songs create a "sincerity contract" between the singer and the audience.[9] The title of Nick Tosches' recent *Country: Living Legends and Dying Metaphors in America's Biggest Music* also alludes to this dichotomy. This book merits special attention because on the surface it has the credentials necessary to focus some intelligent public interest on its subject: the author is associated with *Rolling Stone*, and the publisher is in the venerable mainstream. Unfortunately, it is written with all the tedious bravado of a frat boy who knows what's in and what's out. Not for Tosches' "sophisticated" critical attention is the country music that most people actually hear on the radio or see in their local concert hall. Such mundanity apparently qualifies as the otherwise unspecified dying metaphors to

which his title alludes. Living legends, likewise left conveniently vague, seem to be those pure and authentic "artists" apparently untouched by the commercialism of the Dolly Partons and Willie Nelsons whom Tosches scorns. That these so-called legends are quite likely would-be or have-been commercial successes seems not to have entered into Tosches' picture; likewise the notion that any "artist" that has entered into that picture probably got there through some impure, commercially tinged medium has also remained conveniently mystified. The rockabilly days of Sun records—evidently not a commercial enterprise in Tosches' mind—are celebrated as the origination point of pure and creative country, followed by the inevitable decay into commercialism.

Some early country music does sound primitive in contrast to today's recording and mixing techniques—Ernest Tubb's records, for example, sound as if they were recorded in somebody's back yard. Hearing them, it might be easy to convince yourself that the music has a genealogical link to some pure form of expression. But a mass-marketed record, almost by definition, is packaged and produced; so country music, as long as it has been reaching us by recording and radio, hasn't been an authentic outpouring of simple folk emotion. Historical accounts of country music, such as Bill Malone's magisterial *Country Music USA*, easily demonstrate this fact. Malone's discussion of the history of instrumentation, for example, suggests that both the standard acoustic guitar and the steel guitar, now both *sine qua non* of the country sound, were practically unknown in the rural South until after the First World War, and were gradually added to performances and recordings throughout the 1930s and '40s.[10] Likewise, he links the pervasiveness of cowboy attire, and the cultural interchangeability of the geographically diverse terms "western," "hill-billy," and "country music" to the influence of the Hollywood image makers since the 1930s.[11] In fact, he suggests that the notion of country music purity is the product of earlier historians' wishful thinking: "an understanding of southern rural music was hampered by the reluctance of both folk scholars and high-art exponents to see it as it really was: that is, a thoroughly hybrid form of music . . . which revealed itself as both a commercial and a folk expression."[12] The critical vocabulary, then, needs new terms. Sympathetic or otherwise, the only way for a critic to really start thinking about this music is to escape this double bind of authenticity that can so readily dismiss or celebrate it.[13]

While country music is a uniquely American phenomenon, the cultural logic which puts it in this double bind has its origin in a long-standing strain of western discourse. A recognition of this heritage goes a long way toward explaining why concepts of authenticity and sophistication are ingrained to the point of inarticulation in much cultural criticism. This issue became quite vivid to me on a research trip to Geneva. Deprivation forced me to think about country music much more than I listened to it; I constantly scanned the radio dial, but I couldn't find any country music. Outside of French-speaking Switzerland I saw posters advertising country music concerts, some with big stars, but the Genevans didn't seem interested. Two of the city's most noticeable and contradictory characteristics account for this lack: it prides itself on being a sophisticated center of international finance and diplomacy, perhaps too sophisticated for such music. Yet the city's puritanical heritage, an effort to maintain a certain cultural innocence, is also very much in evidence. Here the double bind was put in another context that made some historical sense: I spent a lot of time wondering whether country music was the kind of urbanized spectacle from which Rousseau wanted to protect the innocent, Calvinist Genevans of his memory, or whether the music's hillbillies and cowboys could represent the kind of pre-cultural, egalitarian noble savagery and festivity that he so admired. I've already described the attitude that would equate country music with the kind of spontaneous, participatory festivity that Rousseau recommended to the city in his 1758 letter on spectacles, yet the virtual absence from the public airwaves of any kind of "folk" or country music, even indigenous, would seem to deny this theory. On the other hand, while it could be said that country music displays the very kind of theatrical artifice that Rousseau and some later cultural analysts feared, I'm not sure that they would fear its effect. It neither encourages its listeners to unsuccessfully emulate urban models of cultural distinction, nor encourages its audience to unquestioningly imitate the self-pitying laments and redneck boasting manufactured by the Nashville culture industry.

Yet Rousseau's critique of acculturation and its concomitant urban sophistication is worth remembering, since it confines, underlies, and justifies the kind of things that have been said about this music. But if, as I have said, one of the most fascinating things about country music is its power to uproot and escape these assumptions, what better place to prove it than on their home territory? Cowboy Kurt's "boutique western" is certainly odd

even with its address in Pâquis, Geneva's liveliest and most atypical neigh-
borhood, with a few second-hand stores, an occult bookstore, and prosti-
tutes so obvious they seem like parodies of prostitutes. On clear days the
shopkeeper places a larger-than-life papier-mâché sculpture of himself,
Cowboy Kurt, on the sidewalk, and from the open door you can hear coun-
try music—Buck Owens the first time I walked by, and Dwight Yoakam,
Buck's protégé and recent duet partner, the next. Kurt sells a selection of
tapes and albums as well as western-style clothing, jeans, cowboy boots and
hats, etc. The store does not do a booming business, but at least Cowboy
Kurt, a Zurich-born fan of country music and "western wear," gave me the
chance to hear Buck Owens every now and then.

When I reported on the state of country music in Geneva, though, I
received very little sympathy. The main thing people asked was if Cowboy
Kurt is an allusion to Pee Wee Herman's friend Cowboy Curtis, a black cow-
boy. What my postmodern, Pee Wee Herman–watching friends want to
know further underscores the dilemma of our ways of talking about coun-
try music. In their eyes, an allusion to Cowboy Curtis would show a know-
ing sophistication about the degraded status of country-western "cultural"
artifacts. If no allusion is intended, Cowboy Kurt seems comically and com-
plicatedly deluded since no trilingual cosmopolite can be what a country
music star or fan is supposed to be—a hick. In this case, it seems neither
natural, normal, nor deserved. In other words, the social construction and
social significance seems impossible to freely choose—why would anyone
choose to be a hick?

Yet Kurt's dilemma is one of country music's recurring themes: the odd
cultural constructions that are store-bought and storefront cowboys, that
are armchair, paper-pushing, or assembly-line hillbillies. Out of this uneasy
habitus comes what might be called "country camp." Such a term charac-
terizes the songs and stars (and Cowboy Kurt) that question the naturalness
of the habitus and call attention to its production and use. As Andrew Ross's
discussion of camp suggests, this overt emphasis on production is not nec-
essarily a celebration of the commodity form. Nor is it a debased expression
of once-pure sentiments. Rather, such use of camp can be seen as a self-
conscious, ostentatious, and deliberately comic "operation of taste," much
as Cowboy Kurt's inventory is simply an operation of taste, while his papi-
er-mâché statue of himself is camp since it is also self-conscious, ostenta-
tious, and comic. Because they are at once self-conscious and comically

communicative, such manifestations of camp are also acts of cultural commentary.[14] Similarly, Sontag's description of the camp sensibility inadvertently characterizes country music—at least in some of its forms—since it, like Sontag's camp, "sees everything in quotation marks."[15] In other words, country camp expresses a complex relationship to the range of country roles and habituses that extend from the romantically patronizing to the outright dehumanizing. These constructs also saturate most forms of American culture—think of the lovably dumb bumpkin Woody on *Cheers* or the deranged hicks of *Deliverance*. However, the "campy" way such roles can be performed in country music gives them a charge that they do not have elsewhere.

In fact, country camp is particularly interesting since the built-in sneer of the sophisticate, postulated in Sontag's, and especially in Ross' accounts of camp,[16] plays no part in it. Instead, the countrified version is often a response to this urban-based condescension. I think that much of what makes people uncomfortable with country music lies in its aggressive questioning of the notion of an urban-based sophistication perhaps best described in Sontag's "Notes on Camp"[17] but reiterated in different forms in other popular media and in many field reports from postmodern culture. For example, in *Details*, which supposedly covers Manhattan's downtown scene, one of my favorite country singers, Dwight Yoakam, answers an interviewer's typical either/or suggestion that he is only a parody of a country singer, "a talented opportunist playing dress-up," with the assertion that "what you saw at my show was not parody. It was real life, 1988."[18] I agree—what I heard and saw at the Greensboro Coliseum, the cardboard-cacti stage props, the satin cowboy suits, the loudspeaker that announces "Ladies and Gentlemen, from Hollywood, California, Dwight Yoakum"— was real life. Except I also think it was parody and dress-up—but no less "real life" for all that. Yet the interviewer's question doesn't allow for this nuancing. In fact, behind her question about the "authenticity" of Yoakum's persona lies the fear that even this alleged country boy is just as sophisticated—as talented an opportunist—as any postmodern reader of a slick magazine. He might not be a hillbilly. Or if he is, being a hillbilly doesn't mean what it seems to mean; it doesn't imply a well-deserved state of degraded unacculturation and unsophistication.

Although he wasn't asked, I suppose Yoakam is aware of this dynamic. After all, he consciously models himself on Buck Owens, and Owens, to me,

is the perfect country star, veering in and out of self-parody as he does. He has great clothes: an amazing parade of spangled, embroidered, braided, and sequined suits. He even wrote a song about his "closet full of Nudie suits."[19] Between 1969 and 1986, you could see him every week as the cheerful co-host of "the longest running comedy show of any kind in television history"—*Hee Haw* (1969–).[20] His happy songs, like "I've Got a Tiger by the Tail," are infectiously and ungrammatically nonsensical, and in his sad songs the steel guitar sounds like an upset stomach: "It's crying time again" could be the refrain for them all. They are overdoses of countrified expressions and instrumental twanging. In fact, these songs rely on the hyperbolic manipulation of country's acquired symbols. They are campy "operations of taste" on the part of both the performer and the accepting audience. Once seen as an interpretive stance, however, such phenomena cannot be so easily degraded by the vocabulary of authenticity or postmodernity.

As far back as I can remember, I can remember Buck Owens' songs. One of my favorite "real life" memories of my grandfather is of him singing along to "Tiger by the Tail" with Buck. We must have been at a family gathering, listening to the radio or jukebox in a restaurant in Dubuque. But I'm not sure that real-life memories "authenticate" this music, especially since another vivid memory I have from early childhood is watching *The Roy Rogers Show* and hearing him sing. Fifteen years or so later, I remember hearing a Barbara Mandrell song that addresses these mass-cultural memories: "I remember singing with Roy Rogers when the West was really wild." The eponymous refrain boasts that "I was country when country wasn't cool." So here apparently is that standard by which Cowboy Kurt is to be judged: Roy Rogers (born and raised in Ohio)—a white American movie and TV star. Real country music and real country music fans?—according to this song it has something to do with the kind of clothes you wear and how long you have listened to country radio—"I remember wearing straight-legged Levis and flannel shirts even when they weren't in style"; "I remember listening to the Opry when my friends were diggin' rock 'n' roll and rhythm and blues." The song draws no lines between country music, being country, and playing dress-up.

Although I don't like this song's teenage lingo, it certainly expresses the logic at work in the country music performance, especially in camp performances. Country music songs and stars often complicate or reject the

"natural," "uncultured" state they supposedly reflect. In such terms, real country, cool or otherwise, is a choice of favorite movie stars, singers, radio stations, and fashions. So as long as we choose to listen to this music, we're all store-bought cowboys and armchair hillbillies. This is not to say that there's nobody earning a living tending cattle, and that there are no rural Appalachians. What I'm saying is that the country music performance does not necessarily address such experiences except through the more complicated notion of signifying rusticity. So if there are examples of people who strongly identify with a country song, or a singer, or an image that the music conveys, such examples may say more about the interpretive and critical power of the music than about any "experience" that the music simply reflects or offers up for mindless imitation. This point should be fairly obvious at this stage in the history of cultural analysis; part of my argument, of course, is that when it comes to country music, it's not yet obvious. Does a song like Moe Bandy's "Hank Williams, You Wrote My Life" refer to the accuracy of Williams' powers of observation, or the charisma of his country performance? While such meaning may be present in the song, the tradition to which it alludes also conjures up the "country boy"-in-quotation-marks image that Williams projected with his sharp southern accent, his flamboyantly colloquial lyrics, and his flashy suits.

When turned into adolescently smug assertions about having the right clothes and being popular, the Barbara Mandrell song and most of Hank Williams Jr.'s productions seem facile. But my personal tastes aside, the point is that in all of these songs, the cultural construction of the "country boy" (and girl) are quite clearly displayed. And in these songs—perhaps especially in my least favorite ones—something even more significant is displayed: that aggressive critique, which I alluded to earlier, of the high/low, authentic/inauthentic, and now sophisticated (urban)/unsophisticated (rural) oppositions that serve to denigrate country music, and more importantly, country music listeners. Hank Williams Jr.'s songs and persona are among the most aggressive. With his beer-belly, black leather, and bad ol' boy lyrics, Hank Jr. enacts a grotesque country dandyism that may be one of the last effective ways to "épater le bourgeois." His song "Young Country," for example, raises the temperature of Mandrell's affirmation: "We know when it's hot, we know when it's not, if you don't mind, thank you." A recent interview with Barbara Mandrell proves this point more poignantly: she talks about her strong attachment to the song "I Was

Country When Country Wasn't Cool" (ten years old, but still getting con-
siderable airplay) in terms of her own childhood memories of the scorn
heaped upon her rural mannerisms by her schoolmates.[21] Like Hank Jr.'s
song, her song is a retort.

This same schoolyard malice, in an attenuated version, may explain the
absence of country music from contemporary cultural critique. Listening to
these songs makes us (I'm speaking now as an intellectual) confront our
investment in a particular form of hierarchy. This confrontation is what
makes some of these songs so uncomfortable because to re-imagine a rural
persona as a matter of choice, no matter how commodified, in the way that
Barbara Mandrell's (and Hank Jr.'s) song does clearly, is a powerful notion.
(On this point hear also Mary Chapin Carpenter's laugh-provoking "How
Do": "Where'd you get that accent, Son? It matches your cowboy boots").
It means that many people who could know better still choose to listen to
the country music they were innocently exposed to during their provincial
childhoods. It means that the distinction between the rube and the sophis-
ticate is disturbingly indistinct. That's why I'm never quite sure (speaking
now as a provincial) that a jokingly delivered "I can't believe you listen to
that stuff!" is *merely* a tactless remark. Likewise, the very existence of
Cowboy Kurt makes the element of choice inescapably obvious although it
may be ideologically painful to imagine that a European would *choose* to be
a rube. But clearly, the element of choice is more important and significant
for people who may bear the stigma of supposed unsophistication. In fact,
changing the meaning of that stigma is what makes these country perfor-
mances so appealing to their audience and so threatening to those who
have no need or desire to reinterpret this stigma.

Once country music is seen as a form of cultural re-presentation and cri-
tique, the question of "authenticity" should seem irrelevant. Some people
like country music because it allows them to re-configure their habitus. The
choice of country music is especially interesting, though, in the way that it
deviates from Bourdieu's theories about cultural distinction. Bourdieu argues
that the non-elite are faced with the "choice of the necessary": an illusion
of choice which leads people to label as "taste" what are in fact their only
options[22]—cheap, filling food, cheap practical clothes, and cheap, gaudy
decorations and entertainments that are at once poor imitations and val-
orizations of "higher choices."[23] However, the campy operation of country
taste, from the audience's point of view, at once calls attention to and refus-

es these constraints. Country camp acknowledges the spuriousness of these ostensible choices in the social space at large at the same time that it creates a *choice*; it allows listeners to see and hear the quotation marks that even a Bourdieu, pessimistically sympathetic with their plight, would put around their "choices." "We know what's hot," sings a snarling Hank Williams, so there's no need for your condescension or sympathy. What Bourdieu's analysis hasn't seen is that this hyperbole and stylization is an act of *aestheticization*, an act usually associated with the more powerful.[24] Most importantly, country music camp, whether from a creator's or an audience's point of view, and especially from a disdainful point of view, refuses to legitimize through pale imitation the tastes of the more sophisticated possessors of cultural capital. It refuses, except as camp, to be an expression of other people's unacculturation and unsophistication.

Even the more favorable versions of those terms, purity and authenticity, fall apart in many country songs. At the same time, camp, being a complex response to the exigencies of culture, acknowledges the utopian power of Rousseau's imagined state of authenticity before the fall into culture. Mark Booth, for example, compares the perception of camp to a "nostalgia for sincerity, the sort you might feel for a very dear and distant moment in childhood"[25]—no doubt much like my own childhood memories of music in Dubuque. Still, camp calls attention not so much to that innocence and sincerity as to our *inevitable* distance from these concepts. This observation is equally true of the country version; for example, country songs often turn the jukebox and the bottle into a recipe for an ironic form of nostalgia. While the nostalgia such songs express seems to be for earlier, and perhaps purer, versions of themselves, such historical self-reflexivity leads to an irony that makes it difficult for a listener to cling very hard or very long to a belief in pure country. "A Bottle of Wine and Patsy Cline," for example, is a sad song with a rhyme so tight it provokes a Brechtian laugh. Gene Watson's "The Jukebox Played Along" provides a list of those earlier versions of itself: Buck Owens' "Crying Time" is mentioned first, of course. George Jones is merely mentioned—no particular song is singled out (I'll say more about the symbolic power of this name later). Watson even mentions one of his own previous hits, by now ten years old, and perhaps the most self-consciously lugubrious song ever: "Farewell Party." With its melodramatic steel guitar slides and operatic high notes, this song waxes sentimental about an event that hasn't even happened yet: the singer imagines the woman who aban-

doned him attending his funeral, and wails that "I know you'll have fun at my farewell party." (Asleep at the Wheel's "Hello Everybody, I'm a Dead Man" leaves no doubt as to how seriously one is to take this proleptic conceit.) A decade later, encased in another song as it is now, "Farewell Party" can all the more easily be heard as country music camp, that is to say, as a song about being country.

Similarly, songs about performing country music can call attention to their own production and circulation. In a song that complains about performing in "rhinestone suits" and incessant concert tours, Waylon Jennings' hook is a repeated "Are you sure Hank [Williams] done it this way?" While Gaillard takes this chorus as a protest against the artificiality of contemporary country music,[26] there is no plausible way to make Hank Sr. into a symbol of an authentic and unproduced, almost unperformed, musical experience. The singer in this song may be adopting the belief in lost authenticity for rhetorical effect. In other words, he is re-presenting a disputable *belief* about country music. In fact, the opposite belief generates the song, and like Jennings' imagined interlocutor, I'm pretty sure Hank did do it that way. Anybody who really listens to country music knows how Hank did it, how the songs that we hear on the radio and jukebox so many times got there, and how Hank sang them in amazing braided and appliquéd suits.

One of the reasons I like Dwight Yoakam so much is that he doesn't even pretend to ask questions about how "Hank done it." In fact, his songs are often about the erosion of this myth of rural purity and authenticity. "Readin', Rightin', Route 23," for example, talks about acquiring the education and "the luxury and the comfort a coal miner can't afford" through migration to the big city. In this song, the country and its ways, although constantly revisited and even admired in the figures of Yoakam's grandparents, are not envisioned as an American paradise lost. Perhaps this explains the "Rightin'" in the title where one expects to see (and probably hears) "Writin'." Not that the city is imagined as a utopia: the chorus of one of Yoakam's songs announces that "the only things that keep [him] hangin' on" in the urban landscape are indeed an odd lot of things: "guitars, Cadillacs, hillbilly music." Moreover, these things are poor substitutes for another unspecified, and perhaps unspecifiable, kind of satisfaction. But Yoakam doesn't pretend to know what that might be; his song simply allows him to make *some* sense and pleasure out of a hillbilly's alienation. This song

nearly named his first album "Guitars, Cadillacs, etc.," and the second album, entitled "Hillbilly Deluxe," allows the constructed notion of the supposedly authentic, unacculturated hillbilly to resonate even more openly. The title provokes a discomfort that again explains the desire to question Yoakam's authenticity: if hillbillies can be deluxe, who can't?

A similar confrontational power makes George Jones so important in so many country performances. His songs make it clear that the worn-out consumer items and trite emotions that evoke the white trash versions of American life are in fact only bizarre representations of such experiences—not necessarily the "choice of necessity." His widely praised vocal techniques—his sliding pitches and affected phrasings which create rhymes you never knew existed—reinforce this sense of deliberate concoction. Moreover, Jones' songs never tell about rural idylls. Instead they talk about tacky trash in order to symbolize the sorrows of the unsophisticated. The title of one song sums it up: "Things Have Gone to Pieces." And Jones really is singing about things—burnt-out light bulbs and broken-down chairs. They are a metaphor for a state of mind, of course, but the "choice" of this "unnatural" junk, as opposed to, say, storm clouds or dead flowers, is revealing. The song is saturated with lowly and decayed cultural objects. A newer song, "The King Is Gone," is perhaps the definitive George Jones song with its portrayal of a playful yet recognizable sadness about the detritus that at once allegorizes and alienates life in the cultural sticks: in a mournful mood, the abandoned "I" of the song pours himself some whiskey from a "Jim Beam decanter that looks like Elvis" into a Flintstones jelly jar, then proceeds to narrate a conversation between himself, Elvis, and Fred Flintstone. "Yabba Dabba Doo, the King is gone and so are you" proclaims the chorus. Jones is neither glorifying nor mocking this hillbilly raving. Only the ear of an uninitiated listener hears an either/or simplicity. Jones' dips into the bathetic are deliberate, a sort of burlesque that incites both tears and laughter.

Jones has thus become a living synecdoche for this kind of campy embracing of the real yet reified status of the "simple folk." His name and his songs are constantly used to create meaning in other people's songs. Becky Hobbs' ingenious "Jones on the Jukebox" strings together quotes from Jones' songs to create an up-tempo lost-love drinking song. Sung from a woman's point of view, this song cheerfully re-presents the two-bit trading on countrified emotion that Jones' own performances mock: "I've got

Jones on the jukebox and you on my mind / I'm slowly going crazy, a quar-
ter at a time." Jimmy Martin's "Play Me Another George Jones Song" pro-
vides yet another example. As the persona in that song addresses his
bartender, the fact that "George Jones" signifies the simultaneous perfor-
mance and critique of a standardized exchange becomes clear. The cus-
tomer in a honky-tonk knows, because listening to Jones' songs tells him
(and he knows that's how he knows), how the evening will unfold: "Here's
where I live/ and some money in case/ I should end up on my face/ So fill
it up again, Joe/ and play me some more George Jones songs." The mere
mention of listening to Jones's songs in "I Was Country When Country
Wasn't Cool" is proof of the title's claims, and when Jones lends his voice
to a line in that song, the producer of this record is inspired to dub in the
din of a cheering crowd, undoubtedly assuming that all of us longtime
country listeners know what Jones is shorthand for.

Barbara Mandrell believes that "I Was Country When Country Wasn't
Cool" will "never be an old song."[27] And as long as some mystified notion
of sophistication remains a viable form of postmodern distinction, she may
be right. But finding another way to think about and hear country music
might diminish the angry appeal of this song's message. At the same time,
it would deal one more blow to the condescending critiques of mass culture.
I even think it would increase our skepticism about ostensibly neutral
descriptions (and more forthright celebrations) of the postmodern. For now,
both criticism of country music—whether found in some book or heard on
my front porch—and wider-ranging analyses of the postmodern condition
sustain the rhetoric of authenticity and the belief in other people's unso-
phistication that lurks behind it. Only Bill Malone's massive history of this
performance style erodes the myth as it pertains to the music. But the music
itself—the lyrics, the performers, the performances—explodes this myth in
the larger cultural realm. It may allude to its reputation for authenticity, and
to its listeners' reputation for uncultured innocence and bad taste, but only
to demonstrate what Oscar Wilde, an earlier camp performer, maintained:
"to be natural is such a very difficult pose to keep up."[28]

I was most delightfully reminded of this predicament on one of my first
days out of Rousseau's Geneva. As I washed dishes, I heard a song that I
hadn't heard for many years. It was Buck Owens singing "Act Naturally."
Suddenly a different goofy voice took over. It was Ringo Starr. I knew that
the Beatles had recorded this song after Buck did, but I had never heard the

Beatles' version. The combined version is new, the DJ announced at the end. As an Owens-Starr duet this recycled song is wonderfully silly, high camp in a way, especially since neither of them can sing very well anymore. The fact that for me, and I suppose for plenty of others, there's some memory strongly attached to this song can't really change this more complex reaction since it's built into the performance. The next day, on a dull trip to the grocery store, as I was driving along with the radio, hoping that I'd hear the song again, it occurred to me that the title, emblematic and oxymoronic as it is, sums up the appeal of country music: at once proclaiming the imperative that condemns its audience to rusticity, its enactment questions what that condemnation means. The singers and listeners are *acting* naturally, and *naturally*, they're acting. And naturally, not everybody likes to hear that.

-------------------------- Notes

I want to thank Mary Bellhouse, Amy Koritz, and Dana Phillips for very helpful conversations about earlier versions of this essay.

1. Rogers also discusses the social-psychological reasons for the widespread tendency to vociferously advertise an abhorrence of country music. See Jimmie Rogers, *The Country Music Message: Revisited* (Fayetteville: University of Arkansas Press, 1989), pp. 213–14.

2. For a discussion of the relevant data, see Richard A. Peterson and Paul DiMaggio, "From Region to Class, the Changing Locus of Country Music: A Test of the Massification Hypothesis," in *Social Forces* 53 (1975), 497–506.

3. See Pierre Bourdieu, *Distinction: A Social Critique of the Judgement of Taste*, trans. Richard Nice (Cambridge: Harvard University Press, 1984) pp. 101, 169ff.

4. See Peterson and DiMaggio, pp. 501–503, and Melton A. McLaurin and Richard A. Peterson, eds., *You Wrote My Life: Lyrical Themes in Country Music* (Philadelphia: Gordon and Breach 1992), pp. 8–13.

5. As in any cultural form, not every example is equally interesting. Many country songs are guilty as charged: some are simply tired reworkings of convention, just as others are cloyingly sentimental.

6. Peter Stallybrass and Allon White's *The Politics and Poetics of Transgression* (Ithaca: Cornell University Press, 1986) provides a good analysis of the construction of "low others" that characterizes western cultures.

7. See Susan Sontag, "Notes on Camp," in *Against Interpretation* (New York: Farrar, Strauss, Giroux, 1966), pp. 275–92. Jameson continues Sontag's analysis, and the urban landscape plays an important role in his argument. See his "Postmodernism, Or the Cultural Logic of Late Capitalism," in *New Left Review* (July/August 1984), pp. 77, 80ff.

8. Huyssen gives a clear statement of this argument in his book *After the Great Divide: Modernism,*

Mass Culture, Postmodernism (Bloomington: Indiana University Press, 1986). On the other hand, Collins argues that theorists of the postmodern (especially Marxists, Jameson in particular) have never really laid these terms to rest. In spite of his objection, Collins' examples of excluded popular culture don't seem all that popular. In this respect his analysis is quite like Jameson's. Collins, too, rounds up the usual suspects: detective novels, performance art, architecture, etc. See Jim Collins, *Uncommon Cultures: Popular Culture and Postmodernism* (New York: Routledge, 1989), pp. 122–24.

9. See Rogers, p. 17. McLaurin and Peterson's collection of essays about country music themes perpetuates the assumption that country music lyrics are straightforward statements from a singer to the audience.

10. Bill Malone, *Country Music USA*, revised ed. (Austin: University of Texas Press, 1985), pp. 24–26, 127.

11. Malone, p. 145.

12. Malone, p. 27.

13. Peter Guralnick's *Lost Highway: Journeys and Arrivals of American Musicians* (Boston: Godine, 1979), is a more enjoyable book, but it, too, is structured on the commercial vs. creative dichotomy. As in the Tosches book, Sun Records functions as the point of pure origin. Likewise, Frye Gaillard's generous attempt to describe the appeal of country music, *Watermelon Wine: The Spirit of Country Music* (New York: St. Martin's Press, 1978), works with these dichotomies. Interestingly enough, Gaillard associates creativity with an attempt to return to the roots of the music, assumed, of course, to be pure, uncommodified outpourings of the "white-man's soul" (p. 146). At the same time, he argues that imitating an isolated tradition is the death of creativity, and the death of that tradition. Nevertheless, the dichotomies he works with prevent him from articulating this insight any further.

14. Andrew Ross, *No Respect: Intellectuals and Popular Culture* (New York: Routledge, 1989), p. 136.

15. Sontag, p. 280.

16. Ross, pp. 152–53.

17. Sontag, p. 275.

18. Anita Sarko, "Dwight Lights, Big City," in *Details* (1989), p. 141.

19. Malone's explanation of this phenomenon is worth quoting at length: "Nudie Cohen (whose complete name is seldom printed) came to the West Coast from Brooklyn shortly after World War I and, after a brief career as a boxer, began sewing costumes for Warner Brothers. Before Tex Williams hired him to make costumes for his band in the late forties, Nudie had also had some experience as a brassiere and G-string manufacturer for the strip-tease industry back in New York City. The western suits supplied to the Tex Williams organization were tasteful and restrained, but the costumes commissioned thereafter became progressively more outlandish with their bright colors, ornate decorations, and fringe. Success for country musicians became almost defined by the number of Nudie suits in their wardrobe." He also notes that Porter Wagoner, another one of Nudie's steady customers, pays about $5,000 per suit. See Malone, pp. 203, 271.

20. See "A Couple of Cowboys Sittin' Around Talkin'," in *Spin* (1988), p. 46. As Marc notes, *Hee Haw* was on CBS until 1971. Then, in spite of the show's popularity, CBS decided to cancel it in order to rid itself of its rural image. Nevertheless, new episodes are still being produced and sold to individual stations. See David Marc, *Comic Visions: Television Comedy and American Culture* (Boston: Unwin Hyman, 1989), p.46.

21. See Michael Bane, "20 Questions with Barbara Mandrell," in *Country Music* 141, (Jan./Feb. 1990), p. 71.

22. Bourdieu, pp. 372–74.

23. Bourdieu, p. 386. Such a notion may in fact be too simple for American society where many low-status individuals often have considerable disposable income. Nevertheless, popular culture often suggests that the rusticity of rubes is unalterable; indeed, their relationship to the affluent society's commodities is famously vexed. For years one could watch this ideological drama played out in popular prime-time (and now widely syndicated) sitcoms like *The Real McCoys* (1957–63) or *The Beverly Hillbillies* (1962–71), in which affluent urban and suburban lifestyles were depicted as the commonsensical norm to which the rubes, no matter how wealthy, could not adjust. On this point, see Marc, pp. 77–78. On the other hand, the running gag of Minnie Pearl's hat with the forever dangling price tag, though similar, may not be the stuff of mass-marketable, once-a-week television comedy. Nevertheless, Minnie Pearl (Sarah Ophelia Colley) is a staple of Grand Ol' Opry broadcasts. But with no normalizing, "citified," sitcom background, she makes most of us uncomfortable since her humor cuts the other way: this "hick" is too clearly schtick. Sontag's campy quotation marks are inescapably there; one doesn't have to choose to see them.

24.Bourdieu, p. 376.

25. Mark Booth, *Camp* (London: Quartet Books, 1983), p. 9.

26. Gaillard, pp. 28–29.

27. Bane, p. 71.

28. Cited by Sontag, p. 282.

ThE KiNg OF WhitE Trash CULtUrE

ELVIS PRESLEY AND THE
AESTHETICS OF EXCESS

GaEL SWEENEY

"BLUE SUEDE SHOES": THE WHITE TRASH AESTHETIC

As with pornography, we know White Trash Culture when we see it. Rather than defining a people or a class, although both are implicated, it is an aesthetic of the flashy, the inappropriate, the garish. Unlike camp, which is a product of an urban, elite, and gay sensibility, White Trash has its roots in the South, the denigrated product of a rural-based under-class of poor whites, a culture in which the politics of identity and race is repressed and often politically and "culturally" incorrect. White Trash Culture is the denigrated aesthetic of a people marginalized socially, racially, and culturally. It

is an aesthetic of bricolage, of random experimentation with the bits and pieces of culture, but especially the out-of-style, the tasteless, the rejects of mainstream society: White Trash is an unwritten, folk aesthetic, the true American Primitive.

White Trash as an aesthetic is where the boundaries of taste and belief are not defined by New York, Washington, Los Angeles, or any other center of dominant American power. White Trash is also a castrated aesthetic: it privileges details, brightness, presentation; it fills a lack, covering every empty space with stuff and effect, powerless to do anything but collect junk and show it off.[1] White Trash privileges prints over solids, animal over vegetable, full over empty. White Trash wears lime green stretch pants, leopard-print tube tops, pink curlers, too-tight flared jeans, big belt buckles decorated with eagles or steers, Hawaiian shirts open to the beer belly, and high-heeled snakeskin boots. White Trash defines the self by display: it is not afraid to wear its philosophy on a tee-shirt or needlepoint it across a big pillow or proclaim it across the bumper of a pick-up, or tattoo it on an arm. White Trash lives in a trailer, but aspires to a deluxe double-wide with purple shag carpeting, red crushed velvet sofas, and gold foil wallpaper. White Trash has religion and is not afraid to push belief to the ultimate. White Trash hangs black velvet portraits of Jesus, Elvis, John F. Kennedy, and Hank Williams, Jr.[2] White Trash has heroes and is not afraid to iconize them. White Trash knows what it likes and it likes big, bright, and excessive. The construction of White Trash in popular culture is of total consumer and non-producer: White Trash is separated from the working class by their lack of connection with work or production, hence "lazy" and "shiftless" as common descriptive adjectives (compare to stereotypes of Blacks). The split between the producing man and the consuming female canonized in middle-class culture collapses in White Trash: both women and men love to shop, buy, dress, and display. A bus trip to a factory outlet store or a giant discount mall is a vacation for both White Trash women and men. Investigate the gift shops at any truck stop, roadside attraction, or at Graceland for the collectibles that accessorize White Trash existence: the snow globes, tapestries, decorative candles, dishes, and figurines.

But White Trash Aesthetic is not Camp Aesthetic.[3] Look at the films of John Waters, which he calls celebrations of White Trash. Actually, Waters' films are examples of a Camp Aesthetic: they are urban, arch, and self-conscious, which true White Trash never is. They also have the gay sensibility

that allows them to define themselves in terms of masquerade, to celebrate the artifice as artifice. The gay sensibility may read itself into White Trash, but White Trash doesn't comprehend the gay sensibility, the realm of Camp. Camp is elitist, of the upper middle class and urban, while White Trash is rooted in the rural and the working class. White Trash is sincere, where Camp is deliberate and parodic. Divine was an icon of Camp; Dolly Parton is an icon of White Trash; both privilege big hair, gold lamé, and exaggerated bodies, but Divine was a drag parody of a "trashy" woman, while Dolly's persona grew out of a Kentucky backwoods child's naive idea of glamour.[4] Camp and White Trash may buy the same portrait of Elvis and hang it proudly in the living room, but Camp displays it as parody, to outrage the dominant taste, while White Trash displays it because it is so beautiful.

-------"NOTHIN' BUT A HOUND DOG": WHAT IS ELVIS?

Elvis Presley is an icon of White Trash Culture: a figure of terror and the grotesque to the urban, mostly Northern, arbiters of "good taste" and a spectacle of excess and release for his Southern white fans. Elvis is variously described by his biographers, critics, and fans as poor white, country boy, hillbilly, redneck, good ole boy; if he were being defined today, in the Elvis-admiring Clinton Era, they'd call him a "Bubba," big brother, Southern-style. The term all the commentators repress is the one they all mean: White Trash. Elvis may have been born in Tupelo, in the heart of the country, but he came of age in Memphis, in urban slums and projects where he and his family lived with other poor whites and Blacks, many getting by on public aid and subsistence jobs.[5]

Film director John Waters holds that "it's the last racist thing you can say and get away with."[6] White Trash, as a social group and a class, are defined by their proximity in society and the Southern imagination to Blacks: in housing projects, in sharecropper's shacks, on chaingangs. Poor Black and White Trash are linked together in an almost symbiotic relationship of enmity and necessity while attempting to survive in the poorest states in the nation.[7] In the mainstream media, racism among Poor Whites and other rural, lower-class rednecks is seen as universal, endemic, and inbred, erasing the origins of secret societies such as the Ku Klux Klan among privileged elites in the South of the Reconstruction. The resurgence of organized and institutionalized racist groups among working-class Whites in the twentieth century was neither as simple nor as universal as films such as *Mississippi*

Burning would represent, nor were they confined to the South as a region or to Poor Whites as a caste. But White Trash is identified as such through being perceived as "acting like Blacks," which in the language of racism is worse than actually being Black because it constitutes a degradation of "racially superior" Whites. Southern writers from William Faulkner and Margaret Mitchell to James Dickey and John Dufresne have portrayed White Trash characters as the lowest of Southern society: labeled lazy, shiftless, no-account, diseased, ignorant, and degenerate, indeed, "worse than" the Poor Blacks whose conditions (and insults) they share, they are seen as degrading to dominant White culture because they reveal the lie of racism: that the so-called inferiority of the Blacks is embedded racially. But Elvis was the White boy who Sam Phillips, his discoverer and first producer, said had "The Negro sound and the Negro feel" he was looking for. Phillips, a civil rights progressive in the Memphis of his day and widely reviled as a "Nigger Lover" for Sun Records' recording of Black artists as well as White, believed that such a melding would not only help bring the races together, but also (not inconsequentially) make him a million dollars.[8]

White Trash holds a complex and contradictory position in American society with regard to race. They belong to the dominant race in American culture (White) and carry predominantly British-based surnames (English, Welsh, Scots, Irish), and yet they have been and continue to be marginalized. While some of this marginalization is admittedly class-based, the majority of discourse about White Trash centers on their "natural" and "innate" trashiness. While almost every society has scapegoated minorities (Jews in Germany, Irish in England, Basques in Spain, Gypsies everywhere), few of these seem so "like" the dominant group in race, religion, and background. Yet, there is something not quite "white" about White Trash. What this may be still needs to be explored, but it may be connected with the outsider stance of White Trash, their origins on the edges of society when they came to America as refugees or indentured servants, or even as slaves, and their persistence at remaining on the edges of civilization after they established themselves on this continent. The recognized pockets of White Trash origins are locations like the New Jersey Barrens, the mountains of West Virginia and Arkansas, the swamps of Louisiana and Florida, and the backwoods of Maine and Georgia: the inaccessible places where misfits escaped the law, or their masters, or the army, or simply society's rules. These were also places of refuge for other outcasts: Indians whose tribes

had been devastated, runaway Black slaves and White indentured servants, and Dutch, French, and Spanish colonials stranded in a suddenly enemy country. It is interesting how White Trash seems to grow out of these otherwise undesirable spaces. Sociologists have studied the marginalized Tri-Racial Isolate Groups, so called because although they usually appear White they are in fact a mixture of White, Black, and Indian. They are usually shunned and despised by adjacent communities, although an outsider probably would be hard-pressed to differentiate them from their neighbors. These groups intermarry and take pride in their outsider status, sparking rumors of inbreeding, degeneracy, and criminality. I would speculate that much of the disdain held for White Trash by the dominant society may be bound up in the foggy racial histories of such peripheral people and in a fear of miscegenation and contamination from mixing with them. This racial fear is translated into a fear of the marginal in general, the people with "no breeding" or unknown breeding: the root-less, the property-less, the race-less. It is fascinating that many of the icons of White Trash, from Elvis to Bill Clinton to Loretta Lynn, have acknowledged an Indian heritage, linking themselves at least in spirit to these marginal mixed-race groups. Of course, from the 1960s on, "a little" Indian blood has held a certain cachet, especially among entertainers (who represent another kind of social outsider, but that's another story!). Elvis, particularly among White Trash icons, has been claimed by Black fans, and whispers about Elvis' "secret Black father" have been widespread in Memphis's Black community since the 1950s. Any boy who moved like that and sang like that had to be Black, and many fearful White Middle Class parents must have concurred. But, Black, White, or Indian, White Trash has still canonized Elvis as the King. White Trash as a culture and as an aesthetic does not privilege purity in any form.

The Black body in American culture is forever linked with labor and the savage discipline of slavery: power, fear, and sexuality are joined to make a combination that was, to middle-class White teenagers, as alluring as it was illicit. When Elvis adapted Black music, dress, and style, he also appropriated some of the sexuality and scandalizing power of Black bodies. Elvis, the White boy who sang Black, was doubly dangerous because he could appear so innocuous and polite: reporters always commented on how Elvis always said "Yes, Ma'am" and "No, Sir" (in much the way of "good Negroes") and was so soft-spoken—right up until he began to sing and cause the daughters of Suburban America to have public orgasms. The nineties reader is

taken aback by the great fear and hatred spewed out by the fifties press on the subject of young Elvis, who, in retrospect, seems so clean and polite, shy and acquiescent, even beautiful, his crooning soothing and his rock 'n' roll raucous. Yet, that middle-class bastion *Time* Magazine, in a frenzy of loathing, described his luminous black pompadour as "five inches of hot-buttered yak wool,"[9] and began a review of Elvis' chaste debut, "Love Me Tender," with:

> Is it a Sausage? It is certainly smooth and damp-looking, but whoever heard of a 172-lb. sausage 6 ft. tall? Is it a Walt Disney goldfish? It has the same sort of big, soft beautiful eyes and long, curly lashes, but whoever heard of a goldfish with sideburns? Is it a corpse? The face just hangs there, limp and white with its little drop-seat mouth, rather like Lord Byron in a wax museum.[10]

And Elvis hasn't even started gyrating yet! But perhaps the real rub appears in the final sentence: "The message that millions of U.S. teenage girls love to receive has just been delivered." And that was the true fear: the message of pure sex, received like an arrow, straight into the White, middle-class heart of America. But as Elvis presciently answered his critics: "I don't mind being controversial. Even Jesus wasn't loved in his day."[11]

---------------- "Aʟʟ Sʜᴏᴏᴋ Uᴘ": Tʜᴇ Pᴇʟᴠɪs

According to the theories of Mikhail Bakhtin,[12] the carnivalesque inhabits the space that counters and subverts institutions of authority and repression, the dominant hegemonies of Church, State, and, in capitalist democracies, Industry. The pleasures of the carnival are subordinate pleasures: unruly and lower-class, vulgar, undisciplined. During carnival, the working classes are not working; they are out of their place and out of line. They are gambling in Las Vegas, partying in the streets in New Orleans, buying sombreros in Acapulco, off on package tours to Hawaii and Florida. These are also, not coincidentally, the locations of Elvis's movies (*Viva Las Vegas, King Creole, Fun in Acapulco, Blue Hawaii, Paradise, Hawaiian Style, Follow That Dream*).[13]

Carnival is the place of laughter, bad taste, loud and irreverent music, parody, free speech, bodily functions, eating and feasting, a place where excess is glorified. Carnival is a world not without rank, but one where rank is allowed to be reversed, showing the potential of a society without hierarchy. Liberation and creative play and freedom are allowed here. The body is

released from surveillance and societal control: screaming and yelling, as at an Elvis concert, is not only sanctioned, but encouraged. Laughter, eating, drinking, and excreting are common to all human beings and bring them down to a common level: carnival as the celebration of collective bodies. The carnivalesque overturns the order, and once things are overturned it is often difficult to get them back into place.

Carnival is designated space; its otherness allows the dominant culture to define itself by what it is not: *not* White Trash. To deny its threat, they label it ridiculous, unclassy, trashy. But the dominant orders remain fascinated by lower orders and the carnivalesque: they take their illicit pleasures there, in a socially safe space, away from the centers of hierarchical power: Las Vegas, New Orleans, Harlem. But what happens when one lives in the realm of the carnival all the time? This is the dilemma of fame, particularly rock 'n' roll fame, and the especial dilemma of Elvis as the Prisoner of Graceland: never knowing when to stop, never perceiving the boundaries of conduct because no one (Sonny, Red, Dr. Nick, the other members of the Memphis Mafia) will deny his desires.

Excess is meaning out of control.[14] It inundates the "needs" of the dominant ideology and control, spills its tackiness out into the open and refuses to be ignored. Excess aggressively calls attention to itself: the excessive body refuses to be ignored. The White Trash body is, by definition, an excessive body. The Elvis period most beloved by the White Trash Aesthetic is the seventies: white jumpsuited, overweight, and in your face. Think of the Duchess of Windsor's adage that you can never be too rich or too thin: this ideological construction of wealthy and privileged groups as simple, spare, thin, and understated equates the poor with the fat, the undisciplined, and the unworthy. This kind of dialectic also designates New England and the Puritan aesthetic as plain and pure, while the South is vulgar, hot, sensual, overeating, overweight, lazy, poor, backward. We can assume that the message from the dominant powers is: those who have little consume much—indeed, much more than they deserve! Hence the politics of Reaganism and trickle-down economics. Trash is always "garbage": the excess at the margins of society.

The working-class body is always read as excessive[15] because working-class consciousness is materialized there: workers show their labor on their bodies. While the middle-class audience has critical distance—it applauds, distances itself, reacts intellectually to performance—the carnivalesque

working-class audience is verbal, it reacts physically and emotionally: it often invades the performance space, wears colors or favors, mimics the performers, and intrudes upon the action, often with the tacit permission of the performers. All rock'n'roll audiences are of the carnivalesque: visualize Elvis, the Singing Truck Driver, defying CBS censors to churn his hips at the camera; or the Beatles shaking their moptops to induce an orgy of scream-ing while Ed Sullivan pleads for silence; or Jim Morrison egging on fans to resist the admonitions of the police to sit down. Even when rock'n'roll audi-ences are made up of middle-class fans, they take on the characteristics and attitudes of carnival and the lower orders. These are not audiences of polite discernment, but resistive, emotional, and passionate: after Elvis performed in New York, a quarter of the seats needed to be replaced because so many girls had wet their pants.

Rock'n'roll is situated in what Bakhtin calls the "lower body stratum": the center of procreation and excretion, where humans are reduced to the equality of their bodily functions. The body is the site of the struggle between power and evasion, discipline and liberation. Elvis the Pelvis, embodiment of the lower body stratum, was shown only from the waist up on *The Ed Sullivan Show* in an attempt to deny the power of the lower stra-tum, both societal and material. Elvis' body, when young and beautiful, epitomized the grotesque working class (and, later, the grotesque White Trash) body that reminds the dominant order of the "fragility of (their) dis-ciplinary power"[16]: the CBS television network executives wouldn't allow Elvis' hips to be broadcast, but they could not erase them: Elvis wore his hips in his eyes, on his lips, and within his heart. Even when agitating hips gave way to prodigious belly, Elvis retained the power to trouble the powers that be. The iconography of the sexy Young Elvis of the fifties gives way to the obese Elvis of the seventies, the latter especially stimulating fantasies of the grotesque, hysterical gorging, indulging in food, drink, and drugs, and of living a life larger (literally!) than ordinary human beings. A "defiantly grotesque"[17] and excessive body is a political act, particularly if it is offen-sive, fat, or dirty. This body evades, resists, and outrages the dominant social order—mainly the Northern middle class. While prisons, schools, and hospitals are institutions that physically restrain or train the body, societal controls include clothing, cosmetics, diets, and exercising. The fat, the ugly, and the badly dressed are uncontrolled and anti-social in a culture that worships thin, "buff" movie star forms; fat is "an offensive and resisting statement, a

body blasphemy."[18] Just as there is a feminist rejection of patriarchal views of fat, we could argue that beer bellies are an underclass resistance to the norms of the dominant order that seeks to control the literal body as it controls the body politic. Obsession with food and excess in White Trash Culture becomes an unconscious but graphic protest against marginalization. Elvis' early death has served only to feed his deification in a Southern culture already rife with cults and worship of the dead and the lost, from the myriad fundamentalist Christian sects to the adoration of the lost Confederate cause.

In his *History of Sexuality*, Michel Foucault[19] discloses the ways that Christianity labels the body as the terrain of the Devil, and rock'n'roll, the most bodily of forms, is officially the Devil's Music (see Jerry Lee Lewis). The body is a threat to the soul's purity: when chastity is the ideal, then the products of the body are inherently evil. Body and Soul are at odds. Women's pleasure in their bodies is denied and labeled hysterical: think of the psychologizing of and hand-wringing over the teenaged girls who screamed for Elvis and threw themselves at him at concerts during the fifties, as if to offer him the materiality of their bodies in exchange for his voice, the same women who screamed for him in Las Vegas twenty years later, offering him their scarves, like Veronica, to wipe the sweat from his brow.

--- "AN AMERICAN TRILOGY": THE PRESIDENT, THE KING, AND THE FAN

The most requested photograph from the National Archives is one taken on Monday, December 21, 1970 in the White House: it is of the President and The King. The White Trash Aesthetic constantly disavows its own marginalization, often to its own detriment: White Trash naively believes itself to be the norm and acts accordingly. Perhaps that is one of the reasons it often sets itself off from the objectives of other marginalized peoples, such as poor Blacks, Hispanics, and immigrant groups whose economic and social conditions it so often shares. Instead, White Trash distances itself from the social agendas of these minorities: the phenomenon of the Angry White Man in the Right-turning election of 1994 must in some measure be traced to this White Trash denial, a kind of redneck backlash.

Elvis, the icon of fifties rebellion and rock'n'roll, an addict himself (albeit to legal prescription drugs, compliments of the ubiquitous Dr. Nick[20]) aspired most of all to be a narc. He flew to Washington on impulse, deter-

mined to offer himself (as a loyal American) to his President, Richard M. Nixon, as an undercover drug agent in order to spy on his fellow musicians. He believed that the Beatles and other dope-taking 1960s bands were part of a Communist plot to undermine the morals of America's youth. Of course, adding to his paranoia, the Beatles, long-haired limey foreigners, had displaced him in the rock hierarchy, outselling and out-hipping The King at the very game he invented. And Elvis, with a true White Trash sensibility, saw no incongruity in meeting Nixon dressed in a purple crushed-velvet jumpsuit and matching fingertip-length cape, a huge gold-plated belt buckle, various gold chains and medallions, tinted shades, and a bejeweled walking stick. In this unobtrusive gear, Elvis flew from Memphis and, because he was "traveling incognito," checked into his Washington hotel under his preferred nom de Presley "Colonel Jon Burrows." As an offering, Elvis carried a collectable World War II Colt .45 in velvet presentation case, but what Nixon and his Secret Service agents couldn't know (for even in the White House who would dare frisk The King?) was that Elvis was also packing a two-shot der-ringer under his left armpit. Some members of his staff, including Dwight Chapin and Bud Krogh, who later would be convicted in the Watergate scandal, were anxious to make use of Elvis to push the Administration's agenda: one "talking point" in a memo to Nixon, was persuading Elvis to "encourage fellow artists to develop a new rock musical theme, 'Get High on Life.'"[21] Nixon, however, seemed to find a momentary soulmate in Elvis. "You dress pretty wild, don't you?" he commented, to which Elvis replied, "Mr. President, you got your show to run and I got mine!" Elvis received what he wanted, an official Bureau of Narcotics and Dangerous Drugs badge and complete set of creden-tials, but only after Nixon, noted control freak and imperial President, confided, "I don't have much power around here, you know, I'm really just a figurehead."[22] Elvis was able to relate.

This seemingly odd linking of the President and the King has become more acute in recent years. After Elvis' 1970 visit, Nixon's upper-eche-lon advisors were so uneasy about his meeting with Elvis (discussions of "High On Life" anti-drug albums notwithstanding) that news of the iconic event didn't leak out to the press for over a year. But in the nineties, the accidental proximity of their birthdays (January 8 and 9) has seen the spectacle of joint Elvis/Nixon birthday parties at the Nixon

Library in Yorba Linda, California, not to mention Elvis/Nixon tee-shirts ($14.50), watches ($45), and postcard with Elvis stamp ($3, but free if you buy a tee-shirt or watch) for sale in the Library giftshop.[23]

But the saga of Elvis and the President wouldn't be complete without consideration of the links between Bill Clinton, avowed Elvis fan and son of a dedicated Elvis fan.[24] Clinton's Elvis connection denotes him as a product of his generation, the Baby Boomers, and marks him off from the pre-war generation of Elvis skeptics: Clinton is the first major American political figure younger than Elvis and to have grown up in a Southern culture pervaded by his image and music. While this association stood Clinton in good stead during his governorship of Arkansas and throughout his presidential campaign,[25] once he was in the White House it left him open to attacks on his class position and regional affiliations; i.e., it exposed him to the label of White Trash.[26] Seemingly overnight, a graduate of Georgetown University and Yale Law School and a Rhodes Scholar became "Bubba," a hillbilly, and a good ole boy. One gossip columnist, reporting on a change in White House chefs, snidely cited "the Clintons' trailer-park tastes,"[27] specifically that Chelsea likes pizza and Bill burgers and steaks. Compare this to the attempt to humanize New England Brahmin George Bush by referring to his "love" of pork rinds and down-home country music. No one would ever mistake George Bush for a good ole boy, no matter how many pairs of cowboy boots he is photographed wearing, but Bill Clinton appears too much the genuine article to escape the stigma of White Trash origins: his Arkansas birth, his bouffant-wearing mother, Virginia, and ne'er-do-well brother, his love of food, his saxophone and infamous carpeted pickup truck, even his weight problem (signified by those pale white thighs so beloved of comedians) all brand him White Trash in the eyes of Northern establishment powers. Is this why *Time* magazine trumpeted that voters don't trust Clinton? Note how Clinton, considered a moderate among Southern Democrats, which would make him practically a conservative in Northern urban areas, and his programs (especially universal health care) are prey to charges of "socialism." Note how even the so-called liberal press, which is more accurately the establishment press (just review overall coverage of the Vietnam War or the Gulf War, for that matter) seems to use a different, more lecturing and condescending tone toward Bill Clinton than it ever used with Ronald Reagan or George Bush. Is the President of the United States a prisoner of

the "invisible" American class struggle and the victim of a severe White Trashing?

---"SUSPICIOUS MINDS": THE WHITE TRASHING OF THE MEDIA

Pierre Bourdieu's metaphor of cultural capital supports the construction of White Trash as tasteless and inferior. A society's culture is as unequally divided as its wealth and power, serving the interests of the Elite and "promot(ing) and naturaliz(ing) class differences."[28] Thus, high culture like the opera, ballet, and literature is authorized and supported by the elite, while popular forms such as Hollywood cinema (as opposed to art or foreign films), television, and pop music is ranked as middlebrow. But even lower would be the White Trash forms, such as the tabloids and cable TV (as opposed to PBS for the elite and network television for the middle class). This cultural capitalism holds that better people have better taste, they are "naturally" tasteful and discerning, while Trash just as "naturally" seeks trash. Says John Fiske: "Bourdieu's account of cultural capital reveals the attempt of dominant classes to control culture for their own fit interests as effectively as they control the circulation of wealth. The consistent denigration of popular culture, such as television, as bad for people individually and bad for society in general is central to the strategy."[29] In this vein, White Trash and White Trash forms are undergoing unprecedented scrutiny.

In August of 1994, *New York* Magazine published a tongue-in-cheek cover story, "White Trash Nation," that warned its urban readership of imminent cultural takeover by the nineties' "defining figure—and he hates your guts."[30] That "defining figure" is the White Trash icon: Roseanne, the Bobbitts, Joey Buttafuoco, Heidi Fleiss, Beavis and Butthead, and, of course, President Clinton. But why do these figures so terrify the powers that be? This kind of bottom-up celebrity overturns the accepted route to fame and fortune, which in our Puritan Ethic society is supposed to include morality, education, and hard work. But White Trash fame is by nature the fame of scandal and gossip. Writer Tad Friend labels White Trash "the allure of guilt-free freedom" that "best encapsulates the galloping sleaze that has overrun both rural *and* urban America."[31] Public sensations like the O. J. Simpson trial[32] blur the lines between the so-called newspapers of record and established media, like *The New York Times* or CBS, and tabloid newspapers and shows, such as *The National Enquirer* or *Hard Copy*. The tabloids push the bounds of "decency" established by the mainstream media when it aban-

doned its Yellow Journalism roots.[33] But what happens when mainstays of White Trash like *The National Enquirer* and *Inside Edition* move away from the margins and into the mainstream? What does it mean to the distinction between tasteful and trashy when *The New York Times* quotes *The National Enquirer* as a source? And what happens when Elvis begins to be seen not as a symbol of a certain marginalized segment of society, first rebellious teenagers, then White Trash Culture, but as a larger symbol of America in general? What happens when *Roseanne* is the highest-rated show on television, or when Roseanne appears with Connie Chung to discuss child abuse, spousal abuse, facelifts, and multiple personalities? Is Connie Chung a newscaster or a gossipmonger? Is there really a difference? If this White Trash Aesthetic threatens to intrude too far, the dominant culture must further marginalize: it must brand Elvis as just another drugged-out rock star destroyed by his own fame; it must censor Roseanne or discredit her as a kook, troublemaker, or feminist; or else it must incorporate the Trash discourse into its own and thereby quell that unruly voice by subsuming it.

----------"Burnin' Love": The Cult of The King

In 1982, Sam Phillips, Elvis' discoverer and first producer, told a group of fans in Memphis: "The two most important events in American history [sic] were the birth of Jesus and the birth of Elvis Presley."[34] The veneration of Elvis includes elements of Southern Pentecostal and ecstatic religious practices, as well as the collecting of relics (recordings and memorabilia), the display of icons and images (Elvis on black velvet paintings and laminated plaques, busts, plates, and figurines), pilgrimages to Elvis sites (Graceland and the Tupelo Birthplace, as well as Las Vegas and Hawaii), and the special phenomenon of Elvis impersonation. Since Elvis' death the phenomenon of spiritual testaments of Elvis-as-angel, detailed in tabloids such as the *Weekly World News*,[35] and books like *Elvis Sightings*[36] and *Elvis People*, recount his return to Earth to heal and guide his believers.[37] Almost seventeen years after his death, Elvis Presley has a hundredfold more healings to his credit than the average candidate for Roman Catholic canonization. Elvis Presley as the saint of White Trash may be laughable to the Northern intelligentsia, but his denigration by the elite only serves to underline his meaning to his fans.[38] The reconstitution of Elvis' image into a subculture verges on a neo-chthonic religion. This quasi-religious aspect of Elvis fandom is particularly vivid in the metamorphosis of Elvis Presley, the man and performer, into "The King"—a spiritual guide and savior to believers.[39] British religious

journalist Ted Harrison writes that "the Elvis cult could be nothing less than a religion in embryo," believing that it already possesses all the elements of a religion, needing only a St. Paul with the fervor to declare it as such.[40]

The ritualization of the Elvis cult is manifested most prominently through live performance. Elvis impersonation, while only one aspect of this veneration, offers a spectacle of the grotesque, the display of the fetishized Elvis body by impersonators who use a combination of Christian and New Age imagery and language to describe their devotion to The King. "True" impersonators believe that they are "chosen" by The King to continue His work and judge themselves and each other by their "Authenticity" and ability to "Channel" Elvis's true essence. True impersonators don't "do Elvis" for monetary gain, but as missionaries to spread the message of The King. Especially interesting are those who do not perform, per se: that is, they don't do an Elvis act, they just "live Elvis," dressing as The King and spreading His Word by their example.

The process of the ritualization of Elvis masquerade can be divided into stages. It begins with the "Revelation" or conversion to the cause of Elvis, usually by way of a vision from The King to carry on his work through imitation, then the selection of "Persona": period and performing style of the portrayal, whether Early Elvis, sixties Elvis, or most popularly, Late (seventies or Vegas) Elvis. "Persona" is the most important choice an Elvis impersonator can make, for it defines his identification with and homage to The King and sets the details of "Costume" (hair, belts, and scarves, as well as black leather or white jumpsuits) and "Repertoire" (the selection of featured songs and "Elvis raps" to the audience), as well as determining the degree of "Authenticity" that the performer is able to achieve, according to the accepted standards of the masquerade. The "Display" is the culmination of the performance: here all the elements are drawn together as the impersonator embodies The King and consummates his relation to Elvis by "Channeling" his spirit and becoming one with his idol. This is the ultimate tribute in that it involves virtual possession of the fan by the star.

The Elvis industry includes popular products from records, movies, and cookbooks to stamps, collectibles, and professional Elvis impersonator registries. *I Am Elvis*,[41] an international guide to Elvis impersonators, includes photos, repertoire, and personal testimonies that serve to materialize the phenomenon of Elvis impersonation and further institutionalize it, including female Elvises, child Elvises, Black Elvises, El Vez the Mexican Elvis, and scores of British, German, Greek, and Indian Elvises. The yearly EPIIA (Elvis

Presley International Impersonators Association) Convention is the official conclave for these high priests of Elvisania.[42] And the Elvis Cult has even been sanctified by the Federal Government: in January of 1993, post offices across the country hired Elvis impersonators en masse to preside over the official release of the Elvis stamp (featuring the young pre-lapsarian King). Scores of high-pompadoured, big-belted travelers were seen on Northwest Airlines flights on The Birthday (January 8) of 1994, taking advantage of discount fares to Memphis for all inhabited by the spirit of The King.[43] *Legends*, a documentary film about the tensions within a group of celebrity impersonators in Las Vegas, preaches the dangers of commercialization of what should be a sacrosanct homage. Recent comedies such as *Mystery Train*, *Top Secret!*, and *The Adventures of Ford Fairlane* evoke Elvis' image and cultural resonance to satirize American obsessions with fame, excess, and rock'n'roll.[44] In *Honeymoon in Vegas*, the Flying Elvises, a troupe of sky-diving impersonators, act as deus ex machina to bring about the requisite happy ending. And in recent neo-noir thrillers like *Wild at Heart*, *True Romance*, and *Natural Born Killers*, the Spirit of Elvis pervades a White Trash universe and acts as a catalyst for both love and death. Elvis and his surrogates have a transformative power for those who share a belief in the spectacle of Elvis as empowering entity.

In *The Golden Bough*, Sir James George Frazer[45] speaks of the "eating of the god" in order to contain His essence as the ultimate act of veneration: communion with the body of the god. By containing within them the essence of the King, Elvis impersonators are the true shamans of the cult of White Trash. But the spectacles of carnival always end with the specter of death: Mardi Gras followed by Ash Wednesday and Lent, gorging followed by fasting, license by prohibition, excess by penance. In death, Elvis Presley is more popular, and more profitable, than ever. Graceland (ironic, portentous name!) is a shrine as revered in its milieu as any holy place. His image has become an emblem of aspiration, excess, and immortality, especially to the reviled underclass labeled as White Trash, but also to American culture and society at large. Perhaps in postmodern America the meaning of Elvis Aaron Presley as an historic individual and performer can no longer be separated from the spiritual and cultural meaning of the One who dies, yet lives again—especially in Las Vegas.

Elvis has left the building, but The King remains.

------------------------------ Nᴏᴛᴇs

1. See Jane and Michael Stern's twin Trash tomes, *The Encyclopedia of Bad Taste* (New York: HarperCollins, 1990) and *Elvis World* (New York: HarperPerennial, 1990).

2. See Jennifer Heath, *Black Velvet: The Art We Love to Hate* (San Francisco: Pomegranate, 1994).

3. For the aesthetics of camp see John Waters, *Crackpot: The Obsessions of John Waters* (New York: Vintage, 1987) and *Shock Value: A Tasteful Book About Bad Taste* (New York: Delta, 1981); Morris Meyer, ed., *The Politics and Poetics of Camp* (London: Routledge, 1993); David Bergman, ed., *Camp Grounds: Style and Homosexuality* (Amherst: University of Massachusetts Press, 1993); and Susan Sontag, "Notes on Camp (1964)," in *A Susan Sontag Reader* (New York: Vintage, 1983): 105–19.

4. Kevin Sessums, "Good Golly, Miss Dolly!" in *Vanity Fair* 54:6 (June 1991): 106–10, 160–66.

5. See Peter Guralnick, *Last Train to Memphis: The Rise of Elvis Presley* (New York: Little, Brown, 1994); Jerry Hopkins, *Elvis: A Biography* (New York: Warner, 1972), and *Elvis: The Final Years* (New York: St. Martin's, 1980); and Albert Goldman, *Elvis* (New York: McGraw-Hill, 1981), for various takes on the life of Elvis. Hopkins' is the most fan-oriented biography, Guralnick's is the most thoughtful about Elvis' early years and his place in history, while Goldman's is infamously lurid about all phases of his life, as well as the most prejudiced against Elvis's White Trash origins. Countless other "biographies" written by relatives, ex-lovers, bodyguards, and various hangers-on must be taken more as artifacts of the Elvis Cult than as serious (or accurate) portraits of The King.

6. Quoted in Tad Friend, "White Trash Nation: White Hot Trash and the White Trashing of America," *New York* Magazine 27:33 (August 22, 1994): 24.

7. See W. J. Cash, *The Mind of the South* (New York: Vintage, 1941); Van K. Bronk, "Images of Elvis, the South and America," *The Elvis Reader: Texts and Sources on the King of Rock 'n' Roll*, ed. Kevin Quain (New York: St. Martin's, 1992): 126–58; and Linda Ray Pratt, "Elvis, or the Ironies of a Southern Identity," *The Elvis Reader*, ed. Quain: 93–103.

8. See Guralnick and Goldman for differing views of Phillips.

9. Quoted in Goldman: 323. *

10. Quoted in Goldman: 223.

11. Quoted in Jill Pearlman, *Elvis for Beginners* (London: Unwin, 1986): 84.

12. See Mikhail Bakhtin, *Rabelais and His World*, trans. Helene Iswolsky (Bloomington: Indiana University Press, 1984).

13. See Pauline Bartel, *Reel Elvis! The Ultimate Trivia Guide to the King's Movies* (Dallas: Taylor, 1994), and Howard Hampton, "Elvis Dorado: The True Romance of Viva Las Vegas," in *Film Comment* 30:4 (July/August 1994): 44–48.

14. On excess and containment see Peter Stallybrass and Allon White, *The Politics and Poetics of Transgression* (Ithaca: Cornell University Press, 1986), and Kathleen Rowe, *The Unruly Woman: Gender and the Genres of Laughter* (Austin: University of Texas Press, 1995).

15. See Pierre Bourdieu, *Distinction: A Social Critique of the Judgment of Taste*, trans. R. Nice

(Cambridge: Harvard University Press, 1984), and John Fiske, "Offensive Bodies and Carnival Pleasures," in *Understanding Popular Culture* (Boston: Unwin Hyman, 1989): 69–102.

16. Fiske 1989: 99.

17. Fiske 1989: 97.

18. Fiske 1989: 93.

19. See Michel Foucault, *The History of Sexuality, Volume I: An Introduction*, trans. Robert Hurley (New York: Vintage, 1980).

20. "Elvis Doctor's License Revoke Appealed," Reuters News Service (July 20, 1995).

21. Bob Greene, *He Was a Midwestern Boy on His Own* (New York: Ballantine, 1991): 34.

22. Goldman: 466.

23. See James Barron, "Nixon Is 80 (And Elvis Joins Party)," *The New York Times*, January 10, 1993, and Tom Kuntz, "It's Just a Hunka, Hunka Burnin' Nixon Americana," *The New York Times*, May 1, 1994.

24. See Greil Marcus, "The Elvis Strategy," *The New York Times*, October 27, 1992.

25. See Maureen Dowd, "Clinton as National Idol: Can the Honeymoon Last?" *The New York Times*, January 3, 1993.

26. See Peter Applebome, "At Home in Arkansas, Many Feel Under Fire, But Not Understood," *The New York Times*, March 20, 1994, and Mike Royko, "Arkansans Needn't Fret Over Reputation: Some Would Argue Whitewater Is Improving State's Image," *The Syracuse Herald-Journal*, March 25, 1994: syndicated column.

27. Richard Johnson, with Kimberley Ryan, "1st Chef Chickens Out in Cockfight," *The New York Post*, April 13, 1994: "Page Six" (gossip column).

28. John Fiske, *Television Culture* (London: Routledge, 1987): 18.

29. Fiske 1987: 18.

30. Friend: 23.

31. Friend: 24.

32. "Simpson Trial Blurs Tabloid TV, Mainstream News," *The Syracuse Herald-Journal*, September 27, 1994: *Los Angeles Daily News* wire story.

33. See James B. Twitchell, *Carnival Culture: The Trashing of Taste in America* (New York: Columbia University Press, 1992).

34. See Ted Harrison, *Elvis People: The Cult of the King* (London: Fount, 1992): 167.

35. See "The Ghost of Elvis Got Me Off Drugs," and "Elvis Phones President Clinton," both from *The Weekly World News*, August 15, 1995, among many others.

36. Peter Eicher, *The Elvis Sightings* (New York: Avon, 1993).

37. "'For me he is the Jesus Christ of the 20th Century,' said Silvie Schmidt, 25," quoted in "Fans And Impersonators of Elvis Flock to a 'Memphis of Germany,'" *The Chicago Tribune*, August 27, 1995, Associated Press story.

38. Greil Marcus, *Dead Elvis: A Chronicle of a Cultural Obsession* (New York: Doubleday, 1991), and Neal and Janice Gregory, *When Elvis Died: Media Overload and the Origins of the Elvis Cult* (New York: Pharos, 1980; reprint 1992).

39. See Ron Rosenbaum, "Among the Believers: Elvis, Healer," *The New York Times Magazine*, September 24, 1995: 50–57, 62–64, and A. J. Jacobs, *The Two Kings: Jesus/Elvis* (New York: Bantam, 1994).

40. Harrison: 9. See also Dr. Raymond Moody, Jr., "Encounter on the Road to Memphis," in *The Elvis Reader*, ed. Quain: 257–67.

41. *I Am Elvis: A Guide to Elvis Impersonators* (New York: Pocket, 1991).

42. Lynn Spigel, "Communicating with the Dead: Elvis as Medium," *Camera Obscura* 23 (May 1990): 176–205.

43. "Elvises Take to the Skies as Airline Promotions Get Wacky," *The New York Times* News Service, January 1994.

44. See Stephen Hinerman, "'I'll Be Here For You': Fans, Fantasy, and the Figure of Elvis," in *The Adoring Audience: Fan Culture and Popular Media*, ed. Lisa A. Lewis (New York: Routledge, 1992): 107–134.

45. Sir James George Frazer, *The Illustrated Golden Bough*, ed. Mary Douglas (Garden City, NY: Doubleday, 1978).

Contributors

ALLAN BÉRUBÉ is the author of the award-winning book *Coming Out Under Fire: The History of Gay Men and Women in World War Two* and co-author of a documentary film based on his book. A community-based historian who has since 1978 written, lectured, and presented slide shows on U.S. transgender, lesbian, and gay history, Bérubé is a 1994–95 recipient of a Rockefeller Fellowship and a 1996 MacArthur Fellowship. He is currently working on a history of how the Marine Cooks and Stewards Union in the 1930s and 1940s worked toward racial equality, working-class solidarity, and dignity for queens.

BARBARA CHING is an assistant professor of English at The University of Memphis. She is co-editor, with Gerald Creed, of *Knowing Your Place: Rural Identity and Cultural Hierarchy* (Routledge, 1997). Her book on hard country music is forthcoming from Oxford University Press.

ROXANNE A. DUNBAR is an historian and writer who teaches at California State University, Hayward. She has completed a memoir of growing up in rural Oklahoma, *Red Dirt*, forthcoming from Verso Press.

JOHN HARTIGAN, JR. <jhartiga@knox.edu> is an anthropologist and historian who received his Ph.D. from the History of Consciousness Program at the University of California, Santa Cruz. His work has appeared in *Visual Anthropology Review* and *Cultural Studies*. Formerly a fellow at the National Museum of American History at the Smithsonian Institute, he is currently Assistant Professor at Knox College in the Department of Sociology and Anthropology. His book, *Cultural Constructions of Whiteness: Racial and Class Formations in Detroit*, is forthcoming from Princeton University Press.

DOUG HENWOOD<dhenwood@panix.com> is the editor of *Left Business Observer*, a newsletter he founded in 1986. He is also a contributing editor to *The Nation* and host of a weekly show on WBAI radio (New York). His book *The State of the USA Atlas* was published by Simon & Schuster in 1994, and his book *Wall Street* is forthcoming from Verso in 1996.

MIKE HILL is an assistant professor of English at Marymount Manhattan College. He is the editor of *Whiteness: A Critical Reader* (from New York University Press), and is currently at work on *After Whiteness* (also forthcoming from New York University Press).

LAURA KIPNIS is a video artist and critic. She is the author of *Bound andGagged: Pornography and the Politics of Fantasy in America* (Grove Press), and *Ecstasy Unlimited: On Sex, Capital, Gender and Aesthetics* (University of Minnesota Press). She teaches in the Department of Radio-TV-Film at Northwestern University.

TIMOTHY J. LOCKLEY graduated with first class honors in history from the University of Edinburgh in 1993. He attended Queens' College and completed his doctoral research at Cambridge University. Presently, he teaches at Warwick University.

ANNALEE NEWITZ <annaleen@garnet.berkeley.edu> is a Ph.D. candidate in English at the University of California, Berkeley. She has published a number of articles on contemporary American culture in journals, newspapers, and books, and is co-founder and co-director of *Bad Subjects* <http://eng.hss.cmu.edu/bs/>. Her dissertation, *When We Pretend That We're Dead: Psychopaths, Monsters, and the Economy in American Pop Culture*, is about "economic horror," or the kinds of fantasies Americans have about work and economic identity.

CONSTANCE PENLEY teaches film studies at the University of California, Santa Barbara. She has written and lectured widely on film, feminism, psychoanalysis, cultural studies, and science studies. Her books include *The Future of an Illusion: Film, Feminism, and Psychoanalysis*, the forthcoming *Popular Science and Sex in America*, and the co-edited volumes *Male Trouble*, *Technoculture*, and *The Visible Woman: Imaging Technologies, Science and Culture*.

JILLIAN SANDELL <jillians@violet.berkeley.edu> is a graduate student in the Department of English at the University of California, Berkeley. She has published articles in *Bad Subjects* and *Bright Lights Film Journal* and has articles forthcoming in *Film Quarterly*, *Socialist Review*, and *"Bad Girls"/"Good Girls": Women, Sex, and Power in the Nineties*, edited by Nan Bauer Maglin and Donna Perry (Rutgers University Press).

GAEL SWEENEY is a Ph.D. candidate in the Department of English and Textual Studies at Syracuse University and has presented papers to the Society for Cinema Studies, the Graduate Irish Studies Conference, and the Society for Animation Studies. Her most recent publication is "The Face on the Lunch Box: Television's Construction of the Teen Idol," in *The Velvet Light Trap*. For five years she sang and played guitar with the all-girl band The Poptarts.

MATT WRAY <mwray@garnet.berkeley.edu> holds an M.A. in Social and Cultural Studies in Education from the University of California, Berkeley. He is a member of the editorial collective that produces *Bad Subjects*, an on-line 'zine devoted to cultural criticism and the politics of everyday life. In addition to publishing in *Bad Subjects*, his work has appeared in *minnesota review* and *Race Traitor*. He is currently a Ph.D. student in the Department of Ethnic Studies at the University of California, Berkeley.

Index